MW00442669

Advance Praise for

queer girls and
popular culture

"Susan Driver's marvelously rich and inventive account of queer responses to popular culture breaks new ground for media studies, queer studies, and gender studies. With chapters on *Buffy the Vampire Slayer*, queer magazines, subcultural music scenes, and online communities, Driver nimbly locates and characterizes the modes of interpretation that queer girls use to transform popular culture into their own playground. This is the first and only book of its kind and it is a powerful testament to the imaginative range of queer youth cultures."

Judith Halberstam, Author of
In a Queer Time and Place *and* Female Masculinity

"Through smart and provocative readings informed by queer girls' engagements with contemporary popular culture, Susan Driver enriches our understanding of the queerness within girl-centered media texts as well as queer girls' negotiations of that cultural terrain. Challenging the heteronormativity that has shaped both the academy's and the media industries' constructions of girlhood and girls' culture, *Queer Girls and Popular Culture* is a groundbreaking book and a welcome contribution to girls' studies, queer studies, and media studies."

Mary Celeste Kearney, Author of Girls Make Media

queer girls and popular culture

Sharon Mazzarella
General Editor

Vol. 1

PETER LANG
New York • Washington, D.C./Baltimore • Bern
Frankfurt am Main • Berlin • Brussels • Vienna • Oxford

Susan Driver

queer girls and popular culture

reading, resisting, and creating media

PETER LANG
New York • Washington, D.C./Baltimore • Bern
Frankfurt am Main • Berlin • Brussels • Vienna • Oxford

Library of Congress Cataloging-in-Publication Data

Driver, Susan.
Queer girls and popular culture: reading, resisting, and creating
media / Susan Driver.
p. cm. — (Mediated youth; v. 1)
Includes bibliographical references and index.
1. Lesbian teenagers. 2. Teenage girls in popular culture.
3. Gays in popular culture. 4. Mass media and teenagers. I. Title.
HQ76.27.Y68D75 306.76'630835—dc22 2006100658
ISBN 978-0-8204-7936-1
ISSN 1555-1814

Bibliographic information published by **Die Deutsche Bibliothek**.
Die Deutsche Bibliothek lists this publication in the "Deutsche
Nationalbibliografie"; detailed bibliographic data is available
on the Internet at http://dnb.ddb.de/.

Cover Photo by Carrie Gray

Cover design by Joni Holst

The paper in this book meets the guidelines for permanence and durability
of the Committee on Production Guidelines for Book Longevity
of the Council of Library Resources.

© 2007 Peter Lang Publishing, Inc., New York
29 Broadway, 18th floor, New York, NY 10006
www.peterlang.com

All rights reserved.
Reprint or reproduction, even partially, in all forms such as microfilm,
xerography, microfiche, microcard, and offset strictly prohibited.

Printed in the United States of America

For Carrie

CONTENTS

ACKNOWLEDGMENTS

I would like to express my deep gratitude to all the young people participating in this study. Queer Girls and Popular Cultures was inspired by the warm and open generosity of queer girls who talked to me online and face to face over the course of several years. I am especially thankful to the girls in my focus group who came together to talk passionately about popular culture during their summer break. The infectious enthusiasm and keen intelligence of these youth helped to shape the substance of this book and gave me the energy to keep writing. I would also like to thank my research assistant Rachel Matlow whose help has been invaluable to me throughout this process. Long before I began this book, stimulating conversations with my Women's Studies students at Trent University, the University of Guelph, the University of Waterloo and Wilfrid Laurier University pushed me to think about complex relations between girls and mass media. I appreciate how powerfully these students have challenged and enriched my thinking about youth and popular culture. My queer students deserve special mention for encouraging me to connect theoretical issues of identity and desire with the daily experiences and political activities of this generation of young people resisting heteronormativity. I hope that future generations of queer youth are able to continue to enrich their creativity and establish public cultures through which their bodies and intelligence flourish in bold and shameless ways.

This book would not have been possible without the hard work of feminist researchers working on girl cultures, and also queer theorists who enable new ways of understanding relations between embodiment, representations and social experience. I am also indebted to scholars working in the field of youth and media whose innovative ethnographic methods have taught me so much

about listening to young people and learning from their stories. I want to specifically thank David Buckingham and Rebekah Willett for giving me a chance to publish an earlier version of chapter six in their book Digital Generations, which came out of a very stimulating conference on youth and new media at the University of London in 2004. I also want to thank Timothy Shary and Alexandra Seibel for their feedback on an earlier version of my chapter on queer girls and film which is included in their edited collection Youth Culture in Global Cinema. I have also presented several papers related to this book at the annual conferences of the Cultural Studies Association, the Canadian Women's Studies Association, the Canadian Association for Cultural Studies, and Visual Evidence, where colleagues sparked my imagination by asking interesting questions at formative moments of my research. I have had the pleasure of working with Sharon Mazzarella, my editor at Peter Lang, who has guided me with attentive understanding and critical insights throughout this process. I also feel very lucky to have worked with Damon Zucca at Peter Lang who kindly and patiently supported my work on this project at its initial stages. Both Sharon and Damon were there for me from beginning to end whenever I had questions or needed assistance.

Although writing is a solitary endeavor, it is impossible for me to do this work without a supportive community of family and friends who keep me grounded and sustain my sense of humor and hope. I am forever inspired by my mother's loving curiosity and intelligence, which have nurtured me to pursue my dreams and take responsibility for my passions. Finally, I extend my deepest thanks to Carrie for listening with such intimate care to my daily struggles writing this book. Carrie's persistent desire, love, and strength are the erotic force behind my pursuits of knowledge, centering me in my thinking body and reminding me to continually connect my feelings and memories to broader social and political worlds.

· 1 ·

INTRODUCING QUEER GIRLS
AND POPULAR CULTURE

Popular culture is one of the sites where struggle for and against a culture of the powerful is engaged: it is also a stake to be won or lost in that struggle. It is the arena of contest and resistance.

Stuart Hall, "Notes on Deconstructing the Popular" (239)

For better or for worse, I think pop culture's fundamental. Particularly if you live in the countryside, and have grown up with no queer female role models, I think your sense of your own identity has to be shaped by the media. And when you embrace your identity, you embrace the pop culture that's relevant to it. You do your queer homework. Certainly, I did. I wish there were more queer females in pop culture and in the media, but I am grateful for what we have already.

Katie, age 17

Growing up in an era when mass media representations increasingly pervade their cultural environments and imaginations, girls are challenged to use popular images and stories to make sense of their lives and communicate their differences. Popular cultures are intensely passionate sites through which learning and enjoyment overlap in the daily experiences of girls. While they constitute public pedagogical tools of knowledge,[1] popular cultures are also realms in which girls derive pleasure, elaborate fantasies, and feel belonging. When it comes to popular cultures, girls' interests, interpretations, and identifications are hard to pin down; they are incredibly complex realms in which changing selves

and social languages converge unpredictably. In this way, popular cultures simultaneously regulate relations and spur questioning, they are controlling and permissive, and they reproduce conformity one minute and disrupt normative codes the next. While much attention has been paid to the normalizing powers of popular media in relation to young feminine subjects, this book is interested in exploring the desiring curiosities of queer girls as they trouble heteronormative ideals and elaborate alternatives. The enticements and incitements of popular cultures provide a productive meeting point between texts, subjectivities, and collectivities through which to consider queer girls. As Katie[2] suggests in the opening quote, growing up and coming out queer is not merely a personal process of identity, but involves a cultural process of reassessing, embracing, refusing, and combining media representations "for better or for worse." Within Stuart Hall's theorization of representation, what becomes critical are struggles to render meanings and uses of popular culture open to new possibilities through which queer girls articulate enjoyment and thoughtful resistance.

Framing this book around a notion of *queer girls* and popular culture is not an easy or certain task. While *queer* is used to specify particular girls and their desires, it is more readily deployed to encompass an interchange between cultural signs and socially embodied subjects, mobilizing the term *queer* as a verb rather than securing it as a noun.[3] This book pays attention to the representational work of queer girls, an ongoing process of signifying selves in relational, contextual and multivalent ways. At first glance, it may seem that this book entrenches what Eve Sedgwick has called a "minoritizing" approach to non-heterosexual girls as I stake out claims involving specifically queer female subjects.[4] But rather than fixate on queer girls as discrete sexual minority youth, I hope to disrupt the structure of binary discourses inscribing girls as either heterosexual or lesbian. Listening to the queer desiring voices of girls throws into question the very typologies that restrict girls, and in this sense my book fosters a "universalizing" orientation that has relevance for thinking about girls in relational and wide-ranging ways. Against attempts to rationalize youth in terms of sexual origins, or scripting identities in linear and hierarchal developmental scenarios, my goal is to foster ways of understanding prolific and unruly articulations that crisscross borders of gender and sexual identity. I worry about imposing a single word on a rich and fluctuating realm of discourses and experiences, but I also fear that forgoing a common way of naming risks dispersal and vagueness to the point of once again erasing the cultural relevance of girls who defy "straight" expectations.

My goal is to create a focus narrow enough to capture the specific contours of media representations and participation of those youth who are female born

but whose gender identifications and sexual desires vary in ways that contest heteronormative conceptions of girlhood without necessarily negating *girl* as a term of identification. Thinking about girls in queer ways, through active relations of cultural engagement, I hope to avoid the pitfalls of claiming to study queer girls or queer girl texts as entities with a definitive set of attributes. My emphasis is on active negotiations, interpreting queer identifications as a social praxis of cultural involvement and dialogue through which youth urgently express longings for love, friendship, and recognition. I deploy *queer* as a performative notion enacted by youth, focusing on contingent and varied modes of signifying intersecting identifications and desires. In Judith Butler's words:

> Identifications are invariably imbricated in one another, the vehicle for one another: a gender identification can be made in order to repudiate or participate in a race identification; what counts as "ethnicity" frames and eroticizes sexuality, or can itself be a sexual marking. This implies that it is not a matter of relating race, sexuality and gender, as if they were fully separate axes of power. (1993, 116)

Queer girl identifications are constituted within dense intersections of age, geography, sexuality, race, class, ethnicity, and gender, without being reducible to any isolated dimension of experience. Their status as social and signifying relations disrupts attempts to reify queer girls in terms of a single term of identity. I follow the cue of youth who repeatedly told me that "queer" spoke to them not as a prescribed label but as a tool through which to read and communicate multiple aspects of themselves and the world around them.

I settled on using *queer girls* as an imperfect term that is both distinct and purposefully pliable enough to allow for contestation surrounding the very boundaries that construct and restrict ideals of girlhood. Many of the girls I spoke with undo common sense ideas of what it means to be a girl, some go so far as to refuse gender categorization altogether. Twenty-one-year-old Lyn says "I'm a female-bodied gender deviant. By appearance, I seem to fit right in the middle of the butch/femme dichotomy, but am nowhere to be found in the polarized identities of girl or else boy. I believe that there exist as many genders as people." While all youth in my study were born female and claim to desire other biological females, many actively refuse to label themselves as boy or girl, lesbian or heterosexual, feminine or masculine. Sexual and gender queerness is lived through the specificity of their ethnic, racial, class, and nationality differences, eliciting multi-layered folds of self-understanding. Twenty-year-old Louise tells me that "as a queer African American, there are different expectations and fears that need to be dealt with within the African

American community. I like to know enough about popular culture so I can combat negative stereotypes but I like to remain distant so it doesn't affect the way I view myself." Naming throughout this book is a volatile and always inadequate process crisscrossing dominant cultural languages and intimately honed relations. Chapter one goes on to elaborate a tricky research terrain of naming and unnaming girls, but, for now, it is important to stress that this book is not about defining what, who, and how girls become queer. This book does not offer any generalizable formulas for unifying queer girls as psychological, social, or cultural subjects. It shifts away from seeking the truth about queer girls and their popular cultures towards listening, connecting, and reiterating the insights and questions raised by girls, as they variably and inventively queer heteronorms in the process of reading and talking about media texts.

This is a book that grapples with complex interactions between queer girls and popular cultures, focusing attention on media texts through and against the interpretive and cultural strategies of girls. Popular culture becomes fraught with contradictions as girls who identify beyond straight conventions do their "queer homework," becoming fans of a television character, fantasizing about a popular icon, reading a lesbian magazine sex advice column, joining an online queer girl community, analyzing a coming out film scene, or going to a queer festival to dance and listen to dyke bands. I study the active cultural practices of girls, soliciting participants from a wide range of online communities and queer cultural Web sites,[5] asking questions about the kinds of television shows, magazines, films, Internet groups, and music that interest and excite them. Through a series of surveys and interviews with girls via e-mail as well as face to face, I map out the responses of girls who articulate their identities in close relation with specific media texts. I then turn to close readings of the images and narratives constructing and eliciting cultural meanings circulated by interviewees. In the process of moving in-between girl talk and media representations, I unfold youth cultural engagements that are admittedly hesitant and ambivalent, leaving room for girls to figure out and name what they like and where they belong. Rather than being a sign of their failure, the ambiguities of queer girls' cultural investments within mainstream and marginal media are a productive part of the process of growing up queer today. Mass cultural texts interact dynamically with the lifeworlds of girls who challenge normative regimes of feminine heterosexuality. Simultaneously, media portrayals of queer girls have become partially constitutive of the very ways in which young female selves are named, recognized, regulated, and scrutinized according to binary gender and sexual norms. Changes in mediated images influence, and are influenced by, the experiential and symbolic

horizons of queer girls themselves that in turn shape the ways in which popular culture is approached, valued, and questioned. At stake throughout this book is an exploration of the very intelligibility of queer girls through creative dialogical practices of cultural engagement.[6]

In/Visibilities: Commodity Queer Girls

Queer Youth Visibility is so limited to the pop culture of the Internet, that when we walk away from our computers and out our front doors, we're no longer there.

Charmaine, age 17

Youth from all backgrounds can relate to most of the representations, for we all in one way or another have suffered discrimination, difficulty coming out, oppression, etc. I think that I can relate with a lot of this, because I was already a victim of all of these, before I came out of the closet. Sometimes I am frustrated with the portrayals because (1) they (queer women in the media) are all "ideal" looking and (2) mostly all are very feminine . . . (3) mostly (if not all) are European (few ethnic queer women in mainstream media).

Tania, age 19

This book connects queer girl identifications with popular culture representations. Yet the passage between these domains is not self-evident or straight forward. For some youth, such as Charmaine, queer girls are fleeting signs in cyberspace, hard to find within broader media environments of the offline world. Tania talks avidly about her interest in representations that address queer youth oppression while acknowledging the power of Eurocentric feminine ideals of beauty and value that continue to dominate mass media portrayals of sexual minorities. For almost all the queer girls with whom I spoke, engaging with popular culture is fraught with anticipations, excitements, disappointments, and frustrations. While becoming more and more visible as a site of popular representation, girls who desire girls enter the purview of mass culture under the power of transnational corporate interests and institutional codes. Not all girls enter fields of vision equally, and only some queer girls find brief glimpses of themselves within mass media images. At the same time, complicity within media-saturated environments increasingly dominated by visual culture is inevitable, even when it is lived through critical resistance. For eighteen-year-old Mel, her sense of queerness is emotionally connected to media portrayals while remaining critically independent. At one moment, she disavows the influence

of popular culture, and, at the next moment, she admits that watching a queer character is an undeniable basis for pleasure and pride. Mel tells me, "I could care less what 'popular culture' says about queers, it has no power over my sense of identity. But I cannot deny the warm fuzzies I get when a queer character is portrayed in a good light, making me proud of my identity." Mel's contradictory statements about popular culture having "no power over my sense of identity," immediately followed by a confession of its guilty pleasures, captures the ambivalence of queer girls seeing themselves projected on media screens.

Up until the early 1990s, it would have been very difficult to establish explicit connections between queer girls and popular culture in terms of content. Relegated to the subtexts of film and the side-kicks of television, girls desiring girls have long been shadowed in the mass media by shame and silent longings. For the most part, throughout the twentieth century, girls and women who defied heteronormativity were positioned as unpopular, and their cultural engagements were considered defiantly oppositional. As Kathleen Martindale points out, " 'lesbian/popular/culture' names a space where several lacks overlap, it's difficult to locate contemporary lesbian cultural productions securely either in high or in popular culture" (19). Martindale is referring to the legacies and predicaments of lesbian feminism and postmodern lesbian avant-garde texts in relation to adult reception, leaving little room to consider where the girls are within popular cultures. Whereas Martindale calls attention to the effects of cultural marginalization producing the "lacks" that not only erase lesbians but render lesbian popular culture an oxymoron within heterosexist societies, historical conditions have enabled widespread queer girl media visibility. For queer girls growing up today, their investments and status within mass media are notable, as they come into their identities simultaneously influenced by mainstream television shows such as *Buffy the Vampire Slayer* and alternative girl bands like Le Tigre. Such disparate media movements provoke critical questions: With the expansion of broad-based visible presence, what exactly is becoming intelligible as a *queer girl* within popular culture? Are queer girls becoming integrated into heteronormative media in ways that normalize and contain their differences? Does this presence intensify surveillance and regulation? Do popularized representations work to privilege a narrow range of gender, sexual, racial, and class ideals? How are images and stories used to create culturally viable and recognizable queer girl selves? What gets left out, devalued, ignored along the way? How are mainstream forms of representation being rejected, taken up, and transformed by queer girls themselves?

Recent depictions of adolescent girls in mass media provide an interesting starting point to consider a representational process that both constructs and forecloses queer girl desires. Michele Aaron writes that "popular culture no longer has to disavow queerness, but, of course, it still does—for to keep queerness at bay, safely restricted in its influence, ensures the impact of its interventions and, more than this, sustains the status quo" (11). What is needed is a critical contextualization of the relative status of queer girls within a media system that continues to valorize heteronormative ways of constructing girlhood. Idealized figures of sexually autonomous girls have been promoted within advanced capitalist marketing as a sign of post-feminist freedom and malleability. Catherine Driscoll calls attention to a postmodern moment in which "nonfixity is . . . already proper to feminine adolescence as a sign of both incompletion and promise, a figure that presents the girl as permanently queer" (161). Across advertising and entertainment industries, girls are being universally celebrated and marketed as ideally adaptable, preeminently desirable, fiercely independent, and infinitely open to change. Such girls are imagined as living without limits or restrictions, transcendent figures capable of becoming anything. While such notions are fantasy constructions that have little connection to the daily predicaments of how girls feel, think, and act, they have come to buttress hegemonic dream girl ideologies. A convergence of popular, commercial, and theoretical discourses valorizing the nonfixity of girls intersects with public representations of queer girls as not only fathomable but symbolically special and convenient in displaying the unique uncertainties of adolescent desires. At the same time, sharp boundaries are drawn between an abstract subjective fluidity of girls and their social lives. Specifically, postmodern fascination with the unpredictable movements of feminine adolescence often remains detached from the embodied and situated experiences of girls. And while a provisional and generalizable queerness of girls enters more and more into popular stories, momentary fluctuations of gender and sexuality remain highly circumscribed within teleological narratives of heterosexual maturation.[7] A brief shy kiss between girls, a tomboy transgression, an "innocent" crush, and playful flirtations are often valued only as temporary departures from a normative course toward feminine heterosexual adulthood. Within media portrayals, a girl's queer transgressions commonly reinforce, rather than disrupt, her development into a normal woman. In other words, elusive signs of gender and sexual variance become framed in terms of a privileged and inevitable heterosexual resolution. Suggestions of the queerness of girlhood are included in formulaic ways within popular accounts more and more without necessarily altering the

ideological structures or endings of heterosexual narratives. Judith Halberstam comments on the ambivalent status of the tomboy in films, writing that "the image of the tomboy is tolerated only within a narrative of blossoming womanhood. . . . Tomboy identities are conveyed as benign forms of childhood identification as long as they evince acceptable degrees of femininity and appropriate female aspiration, and as long as they promise to result in marriage and motherhood" (195). Halberstam shows how the nascent queerness of cinematic tomboys gets recuperated over and over again as popular narratives foreclose gender and sexual mobility.

Not only do conventions of popular storytelling delimit ways of recognizing and valuing queer girlhood, but dominant modes of commercial representation tend to fixate on abstract homogeneous images of sexual minorities. The contradictory predicaments of queer girl visibility in popular media are striking when it comes to a proliferation of commodity-image texts in which young attractive sexy lesbians, transyouth, and bisexual icons have entered celebrity and entertainment media spotlights. Queer youth and young adult presence on commercial media screens is increasingly privileged as evidence of liberal tolerance. Yet these brief and manufactured exceptions construct very narrow ideals of what constitutes an acceptable queer self. Images of K. D. Lang's butch seduction of Cindy Crawford, Hollywood fictionalizations of Brandon Teena's life, girl pop band t.A.T.u.'s video-recorded erotic embrace in the rain, celebrity gossip about Angelina Jolie's bisexual escapades, Britney and Madonna's MTV kiss, *The L word's* lesbian plots, and queer girl action flick *DEBS* are all evidence that girls are getting it on with girls (as well as butch girls and transboys[8]) like never before within corporate media spectacles. As glamorous erotic spectacles and marketable hip signs of transgression, queer girls seem to have gained a great deal of currency today, becoming palatable and intriguing to mainstream audiences. Anne Ciasullo writes that mainstream portrayals of the lesbian body are "at once sexualized and desexualized: on the one hand, she is made into an object of desire for straight audiences through her heterosexualization, a process achieved by representing the lesbian as embodying a hegemonic femininity and thus, for mainstream audiences, as looking 'just like' conventionally attractive straight women" (578).

Prevalent sexual commodifications of normatively attractive girls is not lost on queer girls who see through the marketing ploys addressing straight consumers. Seventeen-year-old Jane insists that "homosexuality is represented as a novelty in popular culture, or a kink. It's not, and it's most frustrating to be classified as some sort of creepy exhibitionist." As an extension of the hyper-

sexualization of youth across media genres, queer girls are included as titillating sights at the expense of social recognition and nuanced representations. At its most banal level, the commodification of girl-on-girl attractions isolates and simplifies differences. Normalization works to emphasize those differences easily categorized, othered, and divided into masculine/feminine, heterosexual/homosexual, black/white, and young/old types and assimilated back into an overarching ideal of sameness. In this way, differences constituting queer girls are reduced to simple images and recognizable formulas of either feminine straight-looking girls or masculine prototypes, with very little in-between. Jane goes on to assert that more complex renditions of queer "difference must be shown! Because right now it seems you're either closeted/lipstick lesbian or in the dykes-on-bikes section in the pride parade, or some tiny girl sporting a pixie cut . . . because people's sexuality is just more complicated than that!"

Media commodification centers on conventional images of beautiful white rich youthful slender feminine girls, such as Merissa and Alex on FOX network's teen series *The OC*, who become the defining sexualized appeal of mass-marketed visibility and seduction. Those who don't fit into such prefabricated models, including sexy fat femmes, poor dykes, queers of color, androgynous girl-boys, and butch and trans youth, are either othered as exotic or erased altogether from view. In many ways, prolific and heterogeneous enactments of gender and sexual queerness become obscured at the level of commodity star images of girls desiring girls. Sexual differences are abstracted and isolated from race and class relations in ways that imply that the lesbian difference of a girl becomes visible when embodied through the ideological normality of her whiteness and affluence. Differences and marginal types are segregated in these media formulas such that one is either a girl of color, a queer girl, a poor girl, or a disabled girl but never all at once. Girls desiring other girls are more easily accommodated within the mainstream so long as they are otherwise "the same," unless they are demonized as freaks, perverts, or outsiders. Such implicitly racialized and class-bound norms of who, what, and where queer girls are, are based on a failure to integrate queer relations across multiple subjects, contexts, and story lines that might throw into question the very powers that normalize what popular girls look and act like. In this way, layered and changing queer girl selves remain muted, but not completely absent, from dominant media purviews. It is important to learn to listen to the defiant refusal of girls to buy into commercial representations. Sixteen-year-old Randy says, "I used to try and be girly and into pop culture to fit in more and be less of a tomboy. Pop culture helped me hide from my sexuality for a long time. Right now, pop

culture can kiss my ass because i'm here, i'm queer, and i'm not going to fit into any specific mold that society has laid out for me."

Ambiguity, complexity, and change are contained within marketable icons, excluding those experientially textured aspects of queer girl styles, bodies, and cultures that might question and threaten mainstream sensibilities. Michael Warner writes extensively about the problem of media normalization in terms of its dequeering and desexualizing tendencies, transforming unruly possibilities of desire into safe and sanitized images for consumption. Warner calls this "the politics of shame" (7), silencing and stigmatizing those who don't fit into a homogeneous respectable model of gay or lesbian identity. Tamed and air-brushed to suit the aesthetic and moral ideals of a conservative mainstream audience, commodified images of girls lose touch with the troubling variability articulated in the performative speech, corporeality, and social relations of queer girls themselves. In the midst of such entrenched patterns of representation, it becomes crucial to understand that queer girl visibility and intelligibility continue to be constituted in close relation to the continuing dominance of binary and hierarchical ways of seeing and thinking about girls. Questioning the value of lesbian visibility, Amy Villarejo writes,

> To promote portraits of lesbian lives is to promote representational presence in public cultures and therefore to heighten public authority. And yet I argue, to present lesbian as image is to arrest the dynamism such a signifier can trigger . . . what visibility misses, in other words, is mobility. (14)

Villarejo raises doubts about the value of visibility as a mode through which to understand lesbian desires and differences, shifting attention onto the social contexts in which meanings are embodied and lived.

It is tempting to regard the normalizing tendencies of media visibility as the crux of analysis, to denounce commodification as the antithesis of queer girl empowerment, and to move onto more local grassroots representational arenas. A great deal of scholarly work contending with media visibility has either focused on the heterosexist parameters of popular culture or turned instead to investigate alternative subcultural production. While offering useful responses, these approaches tend to focus all critical attention onto the constraining dimensions of dominant media portrayals, reading them through a hegemonic lens and discounting more subtle and contextualized possibilities in between mass media production and queer girl consumptions. This book does not concentrate on ideological patterns commodifying girls in popular culture; however, they play a continual role in directing, intensifying, and/or deterring the

interpretive practices of queer girls. Yet it is not so much the inert presence of commodifying images that matters throughout this book as it is "the ways in which same-sex desire can be configured into mainstream texts to create new narrative, aesthetic, and political possibilities" (Pick 107). Referring back to Stuart Hall's opening quotation about the dynamic process of popular culture as a sphere of persistent struggle and resistance, it is crucial to follow how queer girls themselves navigate media landscapes. As I watch, listen, and learn from queer girls, I realize how adept they are at experiencing the pleasures of popular media while retaining a shrewd skeptical ambivalence, developing critical ideas in relation to media texts while nevertheless enjoying them. Such a capacity to combine textual enjoyment and critique with detailed subtlety is the crux of what I have come to regard as the wildly intelligent desires of queer girls in popular culture. Not only do these desires steer queer youth in the direction of alternative local subcultural practices, but they also enable them to work around and with commodified representations, inventing ways of seeing and learning as they approach texts from specific locations in personalized and creative ways.

Against media pressures toward normalization, queer girls invigorate visual and narrative meanings through their experientially mediated readings, parodic responses, and thoughtful disidentifications. Jose Esteban Munoz theorizes the concept of disidentification in terms of an artful hermeneutic process:

> a process of production, and a mode of performance. Disidentification can be understood as a way of shuffling back and forth between reception and production . . . decoding mass, high, or any other cultural field from the perspective of a minority subject who is disempowered in such a representational hierarchy. (25)

Munoz brilliantly elaborates how queers of color engage in a creative process of disidentification, decoding and recoding cultural texts in oppositional ways, becoming empowered as subjects to devise new ways of viewing, speaking, and understanding beyond the reifying parameters of dominant ideologies. Disidentification becomes framed in terms of "the survival strategies the minority subject practices in order to negotiate a phobic majoritarian public sphere that continuously elides or punishes the existence of subjects who do not conform to the phantasm of normative citizenship" (4). Munoz opens spaces in which to think about possibilities for queer youth who do not simply accept or reject, assimilate or repudiate popular media images, but engage with what is available in order to imagine themselves otherwise. Highly attuned to the politics, powers, and pleasures of representation, queer girls look not only for

what is obviously presented, but also for what is implicitly devalued and denied. They consider not only what is seen, but also, as Peggy Phelan states, those powerful dimensions of "the unmarked, unspoken, unseen" (7). When asked to comment on a film or television show, many of the queer girls I spoke with elaborated details, pointed to interesting comparisons, addressed what and who they think is missing from a picture or plot, and often elaborated alternatives. It is precisely the intricate ways queer girls use their imaginations to notice and evaluate popular culture beyond the intended codifications of commodified images that drives this book forward.

Queer Girl Strategies: Creative Cultural Engagements

I think icons are very important—for example, the band Le Tigre, who inspire me to want to create art and get involved in politics. Also, there are style influences from film and TV—particularly Shane from *The L Word*, who I think is fantastic. If I saw a particular look on her that I thought was interesting or cool, I might well try to copy it. . . . Furthermore, as one of the few bona-fide items of queer ("pop"?) culture available to me, DIVA has a great influence on how I see myself and others. The contents are truly relevant to me, and it is something of an outlet. The Internet has also been vital to my sense of identity. Through it, I have met other people like myself, and read widely about different aspects of queer culture, and through it have gained more confidence and become far more happy about who I am.

Katie, age 17

Although the limitations of mass media representations are substantial, a growing body of texts has enabled a much richer and open-ended field of engagement for queer girl readers. Over the past decade, queer characters and artists have begun to appear in popular culture as protagonists and subjects of desire. The emergence of TV shows, films, Internet sites, magazines, and popular music that speak not only to, but directly about, girls who desire girls is historically and politically significant. An expansion of public representations of queer girls as smart and interesting marks an important opportunity to overcome totalizing pressures of cultural invisibility and commodification towards nuanced conditions of visibility. Media appearances of queer girls are not simple reversals of marginalized unpopular subcultures into popular cultures, absence into presence, or negative images into positive images. Rather, such representational influx disrupts gender and sexual norms and ideals of girlhood within the popular imagination, as well as within the embodied and psychic lives of girls themselves. Over and over again girls tell me how alluring yet

limited popular culture is for youth looking for signs of same-sex love, queer communities, and gender diversity. Yet in their talk about specific films or television characters, it becomes possible to hear more than simple praise or dismissive complaints. Their words reveal active cultural engagements at the thresholds of what is representable, transforming images, stories, and icons into resources for survival, inspiration, and cultural dialogue. Personalized acts of reading and writing popular texts become integral to how queer youth locate and elaborate themselves. Such connections between literacy, coming of age and coming out have become the focus of autobiographical as well as critical accounts where it is common to focus on access to media and literary texts as a central means through which young people discover role models and develop languages for coming out and claiming relatively stable identities as gay or lesbian.[9] Yet little has been said about the queer possibilities of cultural literacy in which meaning-making may be convoluted and perpetually at odds with a chronological process of coming out or establishing clear-cut identities. Indeed, as many queer girls in this study suggest, readings may incur disruptive questioning, compelling sexual curiosities and spurring gender fascinations without narrative closure.

While femininity has conventionally been associated with gullible and irrational receptions of mass media, which becomes a basis for stereotyping girls as passive consumers who are easily swayed by alluring images and commodity spectacles, my research interrupts these assumptions by counterposing intelligent responses of girls enjoying media texts. The involvements of queer girls in relation to popular culture go beyond a linear and direct mode of receiving and consuming the content or meanings of representations, attending to complex ways media cultures are enjoyed and utilized. Culture is best understood not as a static entity that is taken; on the contrary, it is a realm that Michel de Certeau writes "consists not in receiving, but in positing the act by which each individual marks what others furnish for the needs of living and thinking" (68). Such thinking shifts away from reifying culture as a contained object to be consumed or a meaning to be known. It also helps to move away from the idea that youth draw upon sexual minority images to mimetically construct their identities. Against the tendency to posit cultural influences in totalizing and homogenizing ways, it becomes crucial to pay close attention to endeavors by girls to hone cultural elements in subjectively relevant ways, reading them inter-textually and contextually, tuning into their psychic resonance, staking out their social values as they establish connections and constitute differences. Educational theorist Deborah Britzman picks up on de Certeau's notion of culture to elaborate a

process of creative self-articulations in dialogical movement with others. Britzman extends this conception of culture to an understanding of sexuality in which rigid compliance to norms gives way to dynamic interrogations and fabrications driven by the affective longings of selves in relation to cultural languages circulating within specific spaces. For queer girls, making their popular cultural mark becomes a passionate activity that links them to the resources and limitations of their media environments without foreclosing the precarious openness of their desires. In Judith Butler's words, such configurations of selfhood suggest "a practice of improvisation within a scene of constraint" (*Undoing Gender* 1).

Popular culture is understood within this book as a process through which queer girls creatively imagine possibilities, forge connections, make meanings, and articulate relations. This book is most productively thought of in terms of a series of readings in which I create passages and orchestrate conversations between popular cultural texts and desiring girl responses that are always already engaged in back-and-forth emotional and analytical questioning. Thinking about how girls address media within the specific and often turbulent contexts of their lives is crucial here. It is a dynamic process, often taking place in spite of obstacles and against prohibitions. Even the practical process of finding and using cultural materials is often volatile and perilous. Seemingly simple enjoyments, such as flipping through a lesbian magazine, are often not a casual leisurely activity but, for many youth, a scary and often clandestine pursuit. For a girl who is not out, or not accepted by family and friends as a girl who desires other girls, to go to the store, buy *Curve* magazine, and take it home and read it is a risky undertaking. Girls worry that people might "see me reading something queer," they fear being humiliated by peers, and they suspect that there are dangers of being "found out" or "kicked out of the house" by parents. The stakes are high for youth under pressure to appear and act like so-called normal girls through their popular entertainments. Yet even when youth assert their desires for queer culture, access not only to independent media but even to gay and lesbian commercial media is often difficult, especially for those who live in rural areas or small towns. Twenty-year-old Jasmine writes that her "biggest concern is obviously access to popular culture. I can understand that most smaller cities are conservative and traditional in their ways of life, but denying youth the access to simple media such as magazines or films is censorship." Having trouble getting hold of media with queer content, Jasmine expresses her frustration and anger at restrictions to cultural diversity within rural communities.

Whether queer girls are bothered by commodification, fear homophobic backlash, lack access to queer girl images, or dream of queer alternatives, their response is not to forgo popular culture entirely, but to approach and use whatever they can find shrewdly, as a tool with which to construct highly personalized engagements. I have come to regard many queer girls as organic theorists of popular culture,[10] arriving at sharp insights out of intense longings and sociocultural experiences of exclusion and marginalization. Queer girl theorizing is not structured through detached logical argument but rather articulated within the flux of practical negotiations. Twenty-two-year-old Anne-Marie says,

> I am interested in pop culture for its kitsch value, really. Celebrity gossip, fashion [magazines] et cetera. I never buy them, but I do get pleasure from them when I read found magazines. To me, being queer (as opposed to being a "lesbian" or a "straight person") means defining my own identity the way I see fit, and so it's hard for me to truly appreciate mainstream media's insensitivity to my found identities.

While Anne-Marie doesn't buy magazines, she does get pleasure when they are "found," enjoying their kitsch value at a distance from hegemonic or literal meanings. As a means of playing with dominant images, recontextualizing them through her emerging perspectives, Anne-Marie is able to participate as a reader of popular culture while negotiating her investments and developing critical awareness. Like many other queer girls, Anne-Marie talks about her personal engagements through informal analysis and questioning. Describing her own queerness in terms of "found identities," she both relates with and disassociates herself from "mainstream media's insensitivity." As adept cultural scavengers, queer girls work with what they've got to create enjoyment and meaning in the ephemeral signs, gaps, and excesses of contemporary popular culture. In this sense, queer girls are innovative *bricoleurs*, extending Dick Hebdige's use of this term in relation to seventies punk subcultures towards the more heterogeneous and diffuse workings of contemporary queer girl cultural innovations. Bricolage involves a fragmentary activity of reconnecting cultural signifiers in changing contexts to create contingent individual and subcultural meanings. While there is not a single subcultural group or identity that comprises queer girls, there are common modes of cultural engagement that involve rereading, resignifying and redeploying images, story lines, and styles in ways that open up and complicate symbolic meanings and embodied performances. Judith Halberstam writes that queer subcultures "carve out new territory for a consideration of the overlap of gender, generation, class, race, community and sexuality in relation to minority cultural production" (155). But

whereas Halberstam studies queer subcultural differences against the predatory pressures of mass media absorption, this book emphasizes creative media receptions as an important part of queer girl cultural involvements and alignments.

There are productive tensions and overlaps between mainstream and minority cultural expressions that are revealed in the ways queer youth approach popular cultural texts. The very substance of what is regarded as "alternative" shifts according to youth tastes and locations. Many girls talk about making do with what is available within mass culture while also seeking out possibilities beyond its normalizing and commercial scope. Queer girls articulate complex pleasures and connections in between what is popular and what is unpopular, characterizing the latter in terms of the degree of queerness or departure from a heterosexually centered ideal of girlhood. Oscillation back and forth becomes a strategy through which to forge identifications inside/out un/popular cultures. Seventeen-year-old Frankie asserts that "I always kinda do my own thing. Doesn't matter if I look like a trendwhore or a total freak, I just do what I want, really." Queer girl self-representations throughout this book crisscross back and forth between mainstream trends and freaky alternatives, indicating cultural participation and resistance in which individual choice and agency is enacted as a social dialogue. While the very notion that "I just do what I want" is shaped by individualizing consumer cultural discourses that saturate youth media, for queer girls, the implications are more complex than postmodern theories of multiplicity or liberal free will suggest. Forging narratives of agency and choice in relation to popular cultures, queer girls are compelled to pay attention to the absences, constraints, and regulations that condition them. They elaborate fictions of self-invention and uniqueness to counter and overcome institutional homogenization and hierarchy in which their choices are reduced to devalued terms of opposition or novelties to be exploited. The very stakes of choice become framed through power relations that categorize and separate trendy inclusion and freaky otherness as options for queer girls.

There is no stepping completely outside the influences of popular media to find evidence of so-called authentic queer girls and their cultural affiliations. While it may seem compelling to seek out subversive youth cultural practice in opposition to dominant popular cultures, I argue that, for many queer girls today, such binary ways of thinking do not make much sense in the spaces and temporalities of their everyday lives. Rather than oppose commercial media consumption to creative acts of production, I have tried to open passages between them which resonate more fully with youth experiences. Even though several chapters focus on representations produced by adults within TV, film

and magazine industries, I make sure to gesture at the ways girls participate in online communities, make zines and play their own music. These areas of media production call for further research and analysis beyond what I have developed in the pages of this book, yet they are complexly inter-related with mass media receptions.[11] Mary Celeste Kearney's groundbreaking book *Girls Make Media* shifts attention away from mass produced texts to value an expansive range of girl produced media. In the introduction, Kearney makes a key point that it is important to avoid privileging

> girls' productive cultural practices over their consumer behavior. Indeed more thought needs to be given to how these activities are highly interdependent. Since girl media producers often appropriate and reconfigure commercial media texts when making their own films, music, websites and publications . . . Moreover, by examining the ways in which girls' acts of cultural production are related to their acts of media consumption, we can better understand how traditional conceptions of cultural practice are being troubled by those who resist the strict oppositions of production/consumption, labor/leisure, and work/play in their everyday practices. (2006, 4–5)

These ideas become useful for considering the productive potentials of queer girls and popular culture across many levels of interpretation, dialogue, and enactment.

Developing a methodology that stays close to the cultural discourses with which girls engage, I have chosen to focus on a wide range of distinct media texts and genres of popular culture in which queer girls are explicitly represented. In other words, I have focused attention onto those texts in which queer girls are included as subjects within the media content while also being addressed as viewers and fans. I am less interested in explaining why queer girls appear across more and more media today than I am in following the ways girls themselves read, resist and make media cultures. It is precisely at the level of queer girl experiences and perceptions that cultural visibility becomes transformative in specific ways rather than reducible to overarching and normalizing generalizations.

Qualitatively Queer Youth Cultural Research

> No matter how we stage the text, we—the authors—are doing the staging. As we speak about the people we study, we also speak for them. As we inscribe their lives, we bestow meaning and promulgate values.
>
> Laurel Richardson, "The Consequences of Poetic Representation" (131)

Although this book is about the discourses, hopes and insights of queer girls, I am the one who compiles and compares media texts, solicits responses, and shapes the narratives that follow. As I turn my attention to understanding queer girls today, my own memories are enfolded into my media pleasures, intellectual inquiry, and historical experiences of feeling and thinking about myself in queer ways. Over the years, it has become very clear to me that my lived experiences of articulating myself as a queer woman were inextricably bound to the mediated images, stories, and sounds that mesmerized, seduced, and challenged me as I grew into my queer girl/woman self. I write this book on queer girl culture as an adult woman deeply influenced by the unspoken queerness of my youth.[12] In many ways, I feel that I have not completely grown up to finally become a woman in any normative sense. I think I will always feel like I am in-between, coming of age, which may explain why I am still so swayed by queer teen romances and youthful girl cultural styles. I try to use my ongoing queer girl attachments to connect with the subjects of this book, while also being fully aware of how unique and changing their cultural relations and subjectivities are.

My approach follows feminist methodologies that work against detachment, acknowledging the subjective stakes and limitations of research.[13] In relation to youth, I am an adult researcher with a queer difference: I passionately want to hear their stories of seeing girl-on-girl desires on film for the first time; I intimately, if only partially, relate with their pleasures, shame, secrecy, and silence; I laugh with them in the queer parts of TV shows; I share their anger at public invisibility, their frustrations at clichéd images, and their rage at the symbolic violence of homophobic representations. Neither connected together in terms of sameness nor abstractly differentiated, I meet queer girls through various degrees of affective and social recognition. While we are separated by years, experiences, and power relations, there are unique yet ephemeral bonds between me as a queer woman researcher and the queer girls with whom I communicate. Intergenerational support and understanding between queer researchers and queer youth becomes a crucial part of a process of reassessing the divisions that have come to separate adults from young people and academic experts from cultural participants.[14] Being emotionally, intellectually, and politically implicated in the interpretive process takes on special significance when it comes to queer adult-youth relations and conversations. Deprived of institutional languages and support in which to affirm intergenerational passages and cultural exchanges, the girls and I share a vulnerable cultural status that becomes a crucial part of our exchange.[15] Fostering dialogues with queer girls from an adult position as an advocate and ally, I shift the focus of this book away from patronizing constructions of queer youth as social

problems, rebellious outsiders, or "at risk" victims, towards their innovative work as cultural knowers and doers.

Yet even though I intend to work against assertions of disciplinary mastery over the lives and mediations of queer girls, there is an ongoing tension between my role as a researcher pressured to create coherent knowledge and my interest in fostering the unruly desires of queer girls in popular culture. I ultimately try to make sense of, to organize, and to clarify media representations and readings of girls, carrying out a process of rationalization that is in striking tension with the evanescent impressions and longings of youth. Elizabeth Grosz warns that "to submit one's pleasures and desires to enumeration and definitive articulation is to submit processes and becomings to entities, locations and boundaries, to become welded to an organizing nucleus of fantasy whose goal is not simple pleasure and expansion but control" (226). Although I cannot avoid the control produced by my writing, I can try to avert its most insidious forms and effects by leaving room to appreciate and value unfinished and unknowable moments of perception and experience. At the heart of this book is an attempt to frame ways of thinking and generating questions about the creative processes through which queer girls participate in relations of popular cultural representation without foreclosing or reifying their desires and pleasures along the way.

Balancing analysis of media representations with queer girl talk about them, I move back and forth between images, narratives, songs, and the words of girls responding to these texts. Rather than interview a single group of girls about various forms of popular culture, I decided to reach out to a broader range of girls by using different approaches depending on specific popular culture genres and examples. I started this book by writing about the ways queer girls use the Internet, which taught me a great deal about the potential of talking to queer girls online. The Internet is an invaluable research tool for contacting and communicating with marginalized youth to whom I would otherwise have little access, especially queer girls who are not yet out and/or are rurally located. Putting messages on several lesbian and queer youth message boards, I heard back from eighty girls aged 16 to 23 years who volunteered to answer general questions about their queer identifications, as well as their tastes, interests, and reflections in relation to film, TV, music, magazines, and Internet media. I followed up broad questions with increasingly focused and in-depth questions about particular texts. I also interviewed girls in detail from specific fan sites for my chapters on the television character Willow and queer girl music. I have purposefully chosen geographically scattered and looser forms of correspondence that have allowed me to dialogue with queer girls with greater flexibility and

scope. While my online interviews provided some remarkably detailed and can-did responses and also gave me the ability to ask more questions and open up discussions in several directions, they lacked an embodied context in which to establish a situated dialogue. In order to be able to talk to young people in a more sustained, intimate, and informal way, I ran a queer girls and popular cul-ture focus group with five teens aged 16 to 18 years in Toronto during the spring and summer of 2005, and I also conducted one-on-one interviews with ten girls. I include quotes from interviews, personal correspondence, and focus group dis-cussions with the permission of all the girls, changing their names to protect and respect their privacy. While I have tried to be comprehensive and inclusive of a range of experiences and perspectives, I have no illusions that this book is rep-resentative of queer girls as a group, nor do I claim to represent the identities or ideas of individual girls. My aim is to elaborate dialogues and connect multiple threads of thoughts and discussions by and about queer girls and popular cultures.

While I interweave the voices of queer girls throughout all chapters of this book, I try to avoid treating them as final truths or raw evidence to support an argument or theory. I regard them more as elements of a multivocal theorizing process, incorporated into this book through my intervention as a writer who actively selects, positions, and links them together. I draw upon and quote the voices of queer girls as always already mediated responses and elaborations of cultural texts; these voices are used as resources not as proof or guarantees of truth. I follow arbitrary yet persistent cues of queer girls that suggest what is pop-ular, recognizing their partial and fragmentary form. Ultimately, it is my story-telling as an adult researcher that gives rise to the unfolding of a tentative knowledge about queer girl cultures that follows. There are multiple tensions, gaps, and incommensurable perspectives that pervade my reading of popular cul-tural texts and the ways girls interpret and make use of them. What I started out writing from my position as a cultural theorist often collided with what girls told me, and, many times, I learned things I would never have had the chance to encounter without the guidance of youth. Listening for what I don't know, for what is not so easily mapped into preexisting theoretical models, I read and quote interviews as part of a process of interpreting, questioning, and provok-ing new ways of understanding queer girl desires in popular culture.

Framing Queer Girls' Desires: Chapter Breakdown

This book is situated at a complex intersection of feminist girl studies and queer theory. In chapter two, I try to frame theoretical and methodological ways of

approaching media texts in relation to queer girls as popular cultural participants. There is an emerging field of feminist literature exploring girl cultures that has nurtured the very conditions for valuing the embodied and psychic resistance of girls to hegemonic ideologies of girlhood.[16] While I acknowledge some key arguments within feminist girl discourses, I also focus on the silence within many of these texts surrounding queer girl selves, meanings, and cultural practices. Providing tools with which to interpret the psychic, cultural, and social lives of girls, many feminist treatments nevertheless reiterate gender and sexual norms in uncritical ways. A pervasive heteronormativity within this body of work becomes a locus through which queer theories of desire and identification offer useful interventions. Deploying notions of dialogism and performativity, I try to recast thinking in terms of cultural signs through which meanings are produced relationally and situationally. I invoke Mikhail Bakhtin's dialogical method (1981) as a productive framework for thinking about the very process through which images and narratives of girls exceed ideological expectations. Queer girls engage critically and creatively with popular culture as an ongoing articulation of fantasies, feelings, and ideas that expands the parameters of what is intelligible. Working from these insights, I elaborate practical research methods that attend to popular discourses alongside experientially inflected languages used by queer girls to interpret mass media.

Fleshing out general ideas to consider the details of a specific popular cultural example, chapter three offers a close textual analysis of Willow Rosenberg's character from the highly popular television show *Buffy the Vampire Slayer*. Willow provides a dynamic and changing representation of a girl whose transformations unfold over the course of the seven-year teen series. Willow gradually comes of age as a queer girl insofar as she refuses clear-cut identity claims while also affirming her desires for girls through words, actions, and choices. Willow's relationship with Tara provides the longest and most drawn-out televisual portrait of love between girls, eliciting intense interest amongst queer girl viewers whose interpretive enthusiasm overflows the boundaries of a single text. I make use of girls' responses to explore specific contours of Willow's fictional character traits and relations with others. Analyzing the narrative twists and turns through which Willow becomes meaningful and adored by a generation of queer girls growing up with so few television images, I raise difficult questions about the dynamics between representation and reception and explore the symbolic status and limitations of queer girls on teen television.

Whereas my analysis of television focuses in on a single character through the insights of devoted queer girl fans, in chapter four, I switch my approach, following and comparing multiple narratives styles and character formations

across a broad range of romantic teen films. I undertake a series of close readings of independent films, exploring the ways desire between girls is visually represented in relation to the responses of queer girl spectators. I argue that not only is the focus of erotic attention between girls a departure from conventional romantic story lines, but these films are also productive cultural texts insofar as they enable new ways of articulating experiences of coming of age and coming out. Constructing visually complex spaces of silence, ambiguity, and excess, these films frame volatile moments of sexual longing and questioning in the lives of girls. Drawing upon conventions of teen drama in the films *Show Me Love*, *All Over Me*, and *The Incredibly True Adventure of Two Girls in Love*, I explore everyday worlds of romance and friendships, as well as school and family contexts, though which youth negotiate homophobia and heterosexism. I pay special visual attention to the intensely charged yet unspoken longings of queer girls falling in love and exploring erotic desires. Whereas most teen romances are structured in terms of realist narratives, *But I'm a Cheerleader* uses elements of queer camp parody through which to position girl-on-girl eroticism in a mode of self-conscious exaggeration. Addressing cultural stereotypes through playfully performative reiterations of visual and verbal codes of sexual and gender difference, this film becomes a key text in the lives of many queer girls using humor to show up and resignify the heteronormalizing predicaments of culture.

Not only are queer girls appearing more and more as protagonists within independent films, but their visible presence in commercial print media provides an important realm for thinking about the commodification of youth sexualities within magazines. Chapter five analyzes the content and reception of four lesbian glossies, including *DIVA*, *Curve*, *Girlfriends*, and *On Our Backs*, paying close attention to the ways older teens and young women are portrayed within advertisements, columns, and editorials. On one level, magazines construct idealizing images of young beautiful lesbians, privileging consumer lifestyles, and transparent notions of sexual and gender identity. As such, queer subjects are precluded or else positioned as "other" or "different" to commercially popularized content and form. At the same time, magazines also provide girls with rare glimpses of public representations of same-sex desire, relationships, and community. There is also a growing genre of queer porn that includes youth within visual cultures of gender role playing and sexual experimentation. Lesbian magazines contain highly contradictory messages, sometimes reproducing closed static images and at other times using self-reflexive and campy languages to trouble the unified and marketable terms of their success. Queer girls approach magazines with skepticism; they are wary of glamorous surfaces without forgoing

enjoyment, expressing frustration at idealized and narrow representations, while showing interest in the ways lesbian magazines circulate shared cultural information, icons, and stories beyond heterosexist conventions of mainstream print media. Explicit discussions and visual explorations of sexuality within magazines become open, and at times subversive, sites of erotic exploration for girls denied access to diverse sexual discourses. Chapter five explores the ambivalence girls feel in relation to lesbian magazines, the ways they struggle with glossy images and commercial formats while using critical perceptions and imaginative desires to open dialogues and gesture toward alternatives.

Queer girls continually express the need for modes of representation responsive to their changing and specific experiences. Whereas mass media depictions of queer girls are made and developed by adults, Internet communications enable more interactive self-representational practices by, for, and about youth. Queer youth express needs for anonymity along with longings for connection and shared intimacy provided by online groups that help them overcome feelings of alienation, isolation, and detachment. Creating and participating within a growing number of online communities, young people forge interactive virtual spaces in which they are able to talk about experiences away from the regulatory and commercialized gaze of adult authorities and media producers. Examining how girls, transyouth and *birls*[17] talk together within distinct queer youth forums, chapter six traces some of the ways they articulate gender and sexuality by deploying mobile languages that resist unification and closures. Online communities are unique spatial and temporal realms fostering informal and convivial communications in which girls reveal personal information, exchange photographs, discuss films and music, show off fashions and body modifications, chat about real life experiences, generate fictions and elicit support and understanding. Experimenting with a process of naming and interpreting themselves in relation with their peers, queer youth use online communities as tools for overcoming cultural devaluation and marginalization, situating themselves as active media producers.

Providing girls with a collectively shaped popular cultural realm of meanings and connections, online communities allow for a more do-it-yourself process of media engagement through which they make images and stories. As Mary Celeste Kearney argues in her analysis of girl zine making, "many female adolescents employ practices of *detournement* (appropriating and reconfiguring mass produced cultural artifacts into personalized and politicized creations) in the subversion and resistance of privileged notions of gender, generation, race, class and sexuality"(1998, 298). Thinking about queer girl music cultures

follows this line of thinking further, addressing those in-between spaces in which mass media productions and grassroots cultural interventions converge in dynamic ways. A broad range of queer girl artists and bands are strikingly forthright in voicing queer differences through expressions of rebellious anger, gender diversity, and kinky sexuality in the face of institutional heteronormativity. Tuning into defiant messages of young queer music artists, chapter seven shows how girls embrace genderqueer possibilities in the content and form of multiple genres from rock to hip hop. Music provides girls with opportunities to transform sexual and gender representation. Not only do girls talk about lyrics, rhythms, and visual presentations of these artists, but they also speak about performances and events, turning attention onto live cultural arenas of engagement. Because of its accessibility and prolific circulations across media, music becomes a privileged site through which to explore critical consciousness and resistance of queer girl cultural identifications and pleasures. On the border between alternative and popular mass media, queer girls creatively play with hybrid combinations of words, signs, and sounds of music within their everyday worlds of experience.

While this book moves from mainstream areas of popular culture towards increasingly alternative and diverse realms of queer girl cultural representation and practice, there is no fixed logic guiding the reader from beginning to end. The chapters are designed to have their own integrity and can be read alone, while also being interconnected conceptually and thematically. Because this book looks at such an expansive and diverse range of media and textual examples, I have tried to adjust ideas and methods so as to make them relevant within specific fields of analysis without losing touch of the shared stakes of theorizing queer girls and popular culture as a shifting and multidisciplinary process. The loose structure of this book takes its cue from the uneven and heterogeneous ways queer girls negotiate mass media. The point is not to create a coherent narrative that would tie together fractious cultural engagements, but rather to create points of entry and allow for moments of rupture and contradiction in which girls come to signify more than can ever be captured once and for all.

Due to the fact that so little has been written from an academic perspective about the cultural practices of queer girl cultures or their subjectivities, it becomes important to proceed cautiously, leaving room for silences, doubts, and hesitations. I have a hunch that the persistent ambivalences, detours, and tensions in the ways queer girls position and talk about themselves in relation to popular culture need to be taken seriously as a survival strategy of knowing

something at an intimate level, while acknowledging the limits of what can and should be grasped as institutional knowledge. Rather than see ambivalence as a lack or a fault of queer girls' immaturity, I prefer to embrace it as a key methodological insight. As hard as it is for rigorously trained scholars to admit, when it comes to thinking about marginalized youth, leaving conceptual maps as tentative, rough, and partially drawn as possible may be the only way to ensure an ethical rapport. Yet because there is not yet systematic work completed on the cultural practices of queer girls, it is tempting to rush in and stake out what remains undertheorized and impose a conceptual schema onto what appears to be an academically unmarked terrain. This danger of colonizing queer girls is seductive and foreboding, an ever present risk of interpreting and making public their suggestive words. At the same time, thinking about queer girls is not merely a process of encroachment and prescription, but also an occasion for opening up conversations that work to question taken-for-granted ways of understanding girls. At its best, theorizing and researching queer girls does not secure more and better truths but rather encourages a greater receptivity to what is yet to be understood, leaving room for how girls feel and think beyond the condescending mastery of adult-centered knowledge.

· 2 ·

QUEERING GIRL STUDIES

Dialogical Languages and Performative Desires

Are queer girls, girls? What are the signs and discourses of girlhood and queerness that would be drawn upon to respond to this query? What are the social, theoretical and epistemological issues at stake in asking this queer question? At the outset, the task appears to require an un-coupling of normative meanings of the category of girl.

Marnina Gonick, "Sugar and Spice" (122)

A subject constituted in gender, to be sure, though not by sexual difference alone, but rather across languages and cultural representations; a subject en-gendered in the experiencing of race and class, as well as sexual relations; a subject, therefore, not unified but multiple, and not so much divided as contradicted.

Teresa de Lauretis, *Technologies of Gender* (2)

I would definitely use the word queer to self-identify. Particularly because I have had intimate relationships with FTMs (female to males), so I myself would not identify as a lesbian. I do not (and am not sure why) . . . I don't identify as "two-spirited," as I myself do have gender issues. The term has been described as a newer word to describe a really old feeling. At one point I did identify with the word, but as I learn more about myself, and my own gender issues, I feel most comfortable identifying as queer. Queer, First Nations youth.

Tania, age 19

In the daily communications and cultural rituals of the youth with whom I spoke, referring to oneself as *queer* makes a lot of sense when used as a flexible and strategic mode of identification. Girls offer elaborate explanations as to how and why the word *queer* jibes with their experiences and ways of thinking, suggesting personal and collective desires for more pliable, intersectional, and open modes of self-signification. Tania situates herself as a Queer First Nations youth, openly theorizing a complex process through which she selects, questions, and uses particular terms meaningful to her gender, sexual, and cultural experiences. In a similar spirit of reflexivity, twenty-year-old Louise also uses the term *queer* to begin a dialogue, saying that "when I identify as queer, people usually want to know how I define the term. It gives people a chance to ask me questions without feeling rude about their curiosity." Louise suggests that, by deploying the term *queer* to talk about herself, she is encouraging curiosity and questioning in relation to how others see her. For many girls, the term *queer* provides ways of signaling the contingency of language in relation to their subjectivities. These girls are utilizing dialogical and performative modes of communication to articulate their specific desires while at the same time trying to leave room for ambiguity and uncertainty. The process of naming oneself *queer* is understood as a dynamic response and rearticulation of words and meanings in order to convey departures from heteronormative expectations. As such, *queer* is not a descriptor of fixed qualities but an instigator of a process of engaging with languages and inventing identifications. Connecting their embodied selves with cultural images and narratives through which they signify their desires, queer girls engage in a process of representation that calls for new theoretical and research strategies.

This chapter lays out some methodological directions, mapping out theories through which to interpret the prolific and dissonant voices of queer girls and popular culture. Academic discourses are largely out of touch with the vernacular insights of queer youth. Susan Talburt writes that "in their efforts to counter images of pathological queer youth . . . antihomophobic discourses have constructed queer youth through a logic that creates a binary of (1) narratives of risk and danger and (2) narratives of the well-adjusted, out, and proud gay youth" (18). Yet even such prescribed attention to queer youth often overlooks the unique contours of girls' experiences. Within scholarly discourses, the pairing of the words *queer* and *girl* together remains virtually unthinkable. There is an almost universal tendency within literature on girls to align female sex, feminine gender, and heterosexuality as a foundation for establishing commonality. Even when researchers emphasize contradictions in the struggles of

girls who embody adolescent feminine heterosexuality,[1] binary terms used to measure developmental success or failure in relation to norms of gender and generation remain rigidly adhered to. Countering such tendencies, this study of queer girls de-centers well-worn trajectories of girlhood, calling upon readers to unlearn those traits and languages that have become naturalized as a normal and expected part of what it means to grow up as a girl. There is no doubt that researching *queer girls* risks destabilizing the very frameworks that have enabled sustained thinking about girls within areas of developmental psychology, social policy, and cultural studies. Theory and qualitative research on queer girls that seek to articulate the transience and diversity of gender and sexual experiences demand a rethinking of notions of girlhood sexual "innocence" and cultural uniformity while also questioning how experiences become interpreted, so as to avoid reinscribing queer youth in terms of deviant differences or well-adjusted sameness.

Analyzing protocols that have rendered girls a coherent field of investigation within feminist girl studies is a useful way to begin to analyze how even the most well-intentioned and coherent research falls prey to gender and sexual heteronormativity. Learning how and where this body of literature forecloses and also elicits queer thinking about girls provides insight into how to proceed. At this point, seeking out interpretive practices that encourage the voices and desires of queer girls to enter and challenge academic assumptions also becomes an important part of mobilizing the tools of feminist analysis to access previously marginalized girl cultures. As a researcher, trouble comes when trying to bridge fields of academic work on girls, queers, and popular cultures. There are very few developed points of correspondence through which to launch a theoretical discussion. Knowing this has plagued me throughout the writing of this book, as I try to integrate girl studies and queer theories, both of which have almost nothing explicitly to say about being female, young, and queer. At the same time, there are many implicit connections to be fostered and drawn out. This chapter tries to enjoin feminist and queer discourses in an uneasy, yet productive, collaboration.

Feminist Girl Studies: Straight Conceptions and Missing Desires

Girls whose sexuality is active, who are "unfeminine" in that they are "mouthy" or argumentative at home or at school, are likely to be interpreted as a problem and as "at risk."

LIZ FROST, YOUNG WOMEN AND THE BODY (123)

Feminist theorists and researchers have created an expansive range of texts devoted to the study of girls. For the most part, they have focused attention onto powers constructing and regulating embodiments of young femininity. Accounts of girls who question and act outside of heterogendered lines enter feminist texts as indications of what exceeds and disrupts systems of control. As suggested by Liz Frost's quote above, critical attention is given to the ways sexually active, "unfeminine", "mouthy," and "argumentative" girls are vilified within social knowledges and institutions. At the same time, emphasis is placed on governing relations, vaguely gesturing towards girls who resist without according them the same degree of detailed analysis. When it comes to the active sexual and diversely gendered lives of queer youth, feminist writers are virtually silent. Recent empirical work in girl studies has begun to hone in on how specific girls inhabit and contest social discourses across racial, national, ethnic, and class locations,[2] yet it is difficult to find any discussion, or even mention of, what it means to be a queer girl. Anita Harris opens her recent collection of essays titled *All about the Girl* with the statement: "Good girls, bad girls, school girls, Ophelias, thirdwavers, no wavers, B girls, riot girls, cybergURLs, queen bees, tweenies, Girlies: young women suddenly seem to be everywhere" (xvii). This wide-ranging list includes many categories and identities but poignantly leaves out any mention of queer girls. While multiplying lists of differences within and between girls have become common within feminist academic discourses, they are inscribed over and over again through heterosexist assumptions that refuse to explicitly acknowledge other possibilities. In this way, the desires, fantasies, and pleasures of girls that unsettle expectations and typologies get erased or sidelined.

At the leading theoretical edges of girl studies, feminists have explored the status of girls as a discursive hotspot in the new millennium. In her book *Future Girl*, Anita Harris writes that "young women today stand in for possibilities and anxieties about new identities more generally" (2), positioning what she calls a "can-do" girl as an ideal construction of selfhood through the convergence of popularized feminist and neoliberal discourses within advanced capitalist societies. A "can-do" girl is cast as the penultimate image of a market-based individualist notion of success through self-invention, resilience, competitive ambition, and continual transformation. Girls are seen as particularly suited to the demands of an economy built on mobility and adaptability, implicating the desires of girls through slogans of empowerment and freedom to excel in meeting the demands of transnational corporations. According to Harris, "can-do" girls are idealized projections that work to discipline girls, pressuring them to quest after impossible standards of individual perfection, compelling

privileged educated girls to pursue corporatized dreams of achievement. At the same time, the dominance of this ideal negatively sets apart those girls who fall outside its domain, othering and devaluing girls who are deemed to be "at risk," those who seem to lack ambition and appear angry, indifferent, or lazy, those who fail to perform and play the game. Within this ideological schema, girls are either subsumed by idealizing media abstractions or subjected to demonizing categories, split off into either an unrealizable abstraction or lumped together as victimized failures. Poor, uneducated, non-white, non-Western, and disabled girls get left behind to do the dirty work of global capitalism. Yet even those girls who are deemed most successful in their achievements and independence are subject to increasing disciplinary powers of surveillance and management. Harris frames this in terms of a Foucauldian incitement to discourses, promising freedom while delimiting and regulating the very terms of possibility.

Most of Harris's references to the performative enactments of girls driven by "can-do" ambitions center on conventionally heterosexualized subjects. Similarly, those categorized as "at risk" become the reverse side of normative success, defined within a closed dichotomy. What is most exciting about Harris's interpretive framework is her consideration of those girls who remain unintelligible within the binary terms laid out, especially those who trouble the very systems that continue to generalize girls as either good or bad, "can-do" or "at risk." According to Harris, it is in the marginal spaces and networks of girl activist and cultural practices that resistance can be found. While popular media cultures are almost exclusively bound to the "can-do" ethos, grassroots cultural production offers a way to imagine something else. Harris covers an impressive terrain of case studies and cultural arenas as evidence of girls resisting, yet she overlooks how girls might subvert ideological formulations of the "can-do" girl from within everyday popular cultural activities. This is partly because she is paying attention to hegemonic discourses rather than the heterogeneous responses of girls. How culturally idealized and denigrated images of girls are received by girls in ways that might point to their polysemic meanings is not considered. Although Harris points to the association of girls with "new identities," exploring alternative cultural practices of girls who resist corporatized media systems, sexual subjectivities are either normalized or bracketed out of discussion. Harris is extremely conscious of the historical contingencies shaping responses to the question "who is a girl?" while simultaneously eliding representations, identifications, and desires of diverse subjects.

In a similar vein to Anita Harris, Catherine Driscoll places girls at the very core of postmodern social formations in her book *Girls: Feminine Adolescence In*

Popular Culture and Cultural Theory. Driscoll makes bold theoretical claims that popular figures of girlhood have come to signify the crux of a crises of subjectivity throughout the twentieth century, "mostly as a marker of immature and malleable identity, and as a publicly preeminent image of desirability" (2). Within this account, young femininity comes to symbolize the unstable edges of post/modern selfhood, in ways that both valorize and delimit girls' social status. Girls have become privileged symbolic sites of cultural analysis insofar as they represent a self in flux, in-between, impossible to hold still and pin down. In some ways, Driscoll bypasses Harris's ideological framework of dividing girls into can-do/at risk, controlled/uncontrolled, and ideal/vilified types by honing in on the discursive indeterminacy of girl subjectivity. Yet it is highly significant that fluid and capricious qualities remain linked to a feminine difference and continue to mark girls out as desirable rather than as actively desiring in Driscoll's account. Even when girls are seen as disruptive cultural figures, hetero-feminine contours of subjectivity continue to ground analysis of the symbolic and experiential meanings of girls. Speculations about the fractious mobility of girls, as cultural markers of a postmodern condition, remain burdened by a blind spot that keeps them from recognizing social and embodied queer contours of girls selves.[3]

I want to argue here that a key problem within even the most daring feminist analysis has to do with ambivalence about the status of girls who are sexually desiring subjects, especially desiring of other girls, and those girls whose identifications may or may not be feminine. While there is an increasing recognition of what Michelle Fine calls "the missing discourse of desire," when it comes to feminist ways of thinking about girls, it has been much more difficult to elaborate how girls desire otherwise. When girl sexuality enters into media analysis, it is commonly to highlight the projective ideals and fantasies of adult viewers. In this way, Hartley and Lumby write that "voyeurism shadows the anxious scrutiny of teenage girls in popular discourse. This is something about which teenage girls themselves can hardly fail to be aware—and the pervasive denial of such desire is surely the flipside of the need to attribute an exaggerated 'innocence' to its object" (54). Framing girls as helpless victims of adult perversion suggests a patronizing concern for girls that deflects attention away from their own responses and constructs them as objects to be watched over. The desires of girls are an intensive cultural site of protective anxiety that often conceals erotic fascination and complexity. On the one hand, media are blamed as a key source of objectification, and, on the other hand, when girls are approached to speak about their sexual feelings, unmediated

experiential narratives are privileged as authentic truth against the distortions of popular cultural representations. Feminist researchers have tended to split off a nuanced analysis of media reception from experiential narratives of girls talking about their gender and sexual embodiments. This has a consequence of constricting sex/gender/sexual cultural languages through which girls' experiences are shaped and interpreted. I want to trace out some significant examples of feminist qualitative research focused on girls, media, and sexuality to show how and why they exclude queer girls and their cultural desires, while also suggesting directions through which to develop inclusive understanding.

There is no doubt that feminist cultural researchers have gone a long way to understand and value girls as active cultural consumers and producers. Interest in listening to girls in relation to popular media has mobilized detailed accounts of how representations impact upon the thoughts, feelings, and imaginations of girls. At the heart of this body of work is an attempt to analyze the perspectives of girls traditionally marginalized within research on youth culture, while developing critiques of the ways media construct and engender girlhood. Those working in this field combine critical analysis of gendered cultural institutions with close-up investigations of the ways girls themselves approach media within overlapping microcontexts of family, friendships, and school. At their most comprehensive, feminist cultural studies have called attention to the creative negotiations of girls in relation to popular media, following the sophisticated ways girls read and utilize media representations within their daily enactments of identity.

Angela McRobbie's groundbreaking studies of how girl magazines work to regulate and prescribe girls' self-perceptions has opened the way for ethnographic work that balances analysis of material conditions, texts, identity formations, and everyday phenomenological experiences. Redressing the male orientation of cultural studies of youth that historically focus on the public dimensions of boys' subcultural activities and styles, McRobbie turns attention onto the domestic worlds and intimate pleasures of girls' popular cultures, taking place in the private realms of the home and bedroom rather than in the visually evident public sphere of the street. Her early work draws attention to the gender specificity of the cultural spaces and texts of girls' cultural participation, and she later explores the material dimensions of girls' cultural productivity. It is precisely her attention to how girls use and make meaning out of popular culture as an interactive dynamic between self and social relations that provides a crucial starting point. McRobbie forges a uniquely girl-oriented field of popular culture analysis focused on gendered spaces, tastes, habits, and identities. At the same time, her persistence

in aligning girls together has resulted in a tendency to overgeneralize qualities shared between girls, de-emphasizing heterogeneous selves, interpretations, and strategies of resistance. While interpreting meaning from within the lifeworlds of girls, McRobbie underplays differences and uncertainties. Trouble arises when the very assumptions of who girls are, where girls play, what girls watch, and how girls desire are elaborated through empirically grounded knowledges that leave unquestioned unifying claims about what girls share in common. McRobbie does begin to think about a "new habitus of gender relations" in her more recent research on changing modes of femininity within rave dance sub-cultures. In her essay "Shut Up and Dance," McRobbie investigates postmodern influences on girls as they become "unhinged from their traditional gender position" (68), exploring an increasing fluidity of feminine embodiments and interactions. But while McRobbie questions the gender fixity of her previous analysis, specifically queer dimensions of such a new habitus of girl cultures remain a silent and undeveloped aspect of her work. The playful excess and frenzy of media pleasures characteristic of girl experiences at the end of the twentieth century remain cast in generalizing terms oblivious to those features that contest feminine and heterosexual logics of girlhood studies.

While some feminists have theorized the gendered contours of girlhood through racialized and classed dimensions of historical experience in ways that complicate universal norms of femininity, binary differentiations between feminine girls and masculine boys continue to be inscribed across much of the literature. In this sense, the feminist turn towards girl cultures has enabled legitimization of previously ignored and devalued subjects while also constituting them in ways that reinforce naturalizing assumptions about girls and popular culture. Such reifying tendencies often take for granted heterosexual feminine norms as the ideological foundation of girls' media participation. For the most part, the heterogendered foundations of girlhood are embedded within feminist theories, even when the powers constituting these foundations are a target of critique. When they are considered, the normalizing powers of mass media and educational discourses take precedence over the variable desires of girls in complex relation with them. In her book *Young Women and the Body*, Liz Frost touches on a tension in the lives of girls between idealized surface appearances and muted desiring voices, suggesting a disjuncture between mass-mediated images and embodied narratives. She writes,

> Schooled by almost all available sources that it is their prime duty to be as visually attractive as possible—the currently fashionable idea of "girl power" being one more

inducement to girls to package their bodies to maximize sexual allure—girls are apportioned the responsibility for controlling a male sexual "drive" which they have been warned is threatening, if not actively dangerous. "Look sexy," "act sexy" . . . "but don't be sexy." (121)

Liz Frost pinpoints contradictions that underlie girls' sexual lives today, the imperative to both perform and evaluate themselves as sexy bodies and to discipline themselves according to ideals of good moral feminine conduct. According to this analysis, consumer cultures and entertainment media incite girls towards hyper-hetero-sexualized display, while regulatory regimes continue to proscribe desire, producing a gap between looking sexy and enacting desire as a girl. Frost's interpretation reveals a critical problem while overlooking how girls might act out and speak about desires at odds with dominant interpellations of consumer culture.

Whereas sociologically oriented approaches tend to fixate on the controlling aspects of media discourses, feminists using psychoanalysis to interpret the role of fantasy in relation to representations of girls have called attention to the ways desire is configured interactively between media texts and subjectivities. In her book *Daddy's Girl: Young Girls and Popular Culture*, Valerie Walkerdine combines a historical materialist approach with a psychoanalytic account of the fantasy worlds of working class girls in ways that explore "the ambivalent eroticism of the positioning of little girls in popular culture" (165). Walkerdine analyzes the pervasive media fetishization of girls, going beyond a focus on exploitation to understand its implication in, and transformation through, the psychic lives of young girls. She thinks about the dynamic ways representations become part of a "psychology of survival" (29) through which girls dream within and beyond class-bound social conditions as well as predatory adult gazes. The sexuality of girls is approached through a class-inflected oedipal fantasy, aligning girls as objects of the desire of daddy figures. Girls are not passively situated but are seen to actively invest in such oedipal narratives with desires for transgressing the material constraints of working class life. Within this perspective, girls use popular culture to elaborate defenses, to fulfill wishes, to unfold desires, and to forge identifications in ways that reproduce and also push against the limitations of their socioeconomic worlds.

Walkerdine regards popular culture as a deeply contradictory space mobilizing collective and individual fantasies about girl sexuality both as naturally innocent and pure and as dangerously alluring. Differences between good girls and bad girls are inextricably bound to hierarchies of sex, race, and class that

not only subjugate girls but also provide the conditions for imagining escape and transcendence. Walkerdine writes,

> I have tried to demonstrate how particular girls live those contradictions and how they operate in the limited terrain of self-production which is open to them. These practices are practices of survival, because they are about managing to survive and even to prosper in difficult circumstances. It is not the case that there are no choices, but those choices are heavily circumscribed and shot through with conscious and unconscious emotions, fantasies, defenses. It is the complexity of the production of the intersection of subject and subjectivity that I have been exploring. (171)

Walkerdine's analysis of mass media portrayals of young girl sexuality blends theory and empirical observation as she listens to and watches girls as they talk about celebrities and sing and dance to their favorite songs. Her research becomes attuned to the prolific and volatile ways girls invest in gendered and sexualized images and stories of popular culture. What is so unique about Walkerdine's methodology is that the sexuality of girls is not treated as abstractly structural or directly accessible but as always mediated by cultural signifiers that are themselves part of a reflexive research process. She does not rely on the direct voices of girls or on semiotic analysis of media texts but tries to read how girls hook into popular culture through fantasy investments that constitute permeable relations between self and social meanings. Paying attention to how girls perform popular songs, what they say about their favorite icons, and which glamorous stars they choose to emulate, Walkerdine interprets how girls use and alter media messages.

But while girls are seen to play an active desiring role in utilizing and disrupting media projections within Walkerdine's study, the structure of the sexualized scenarios engaging girls remain unquestionably centered on femininity and heterosexuality. Theoretically and methodologically, girl sexuality is unhinged from static ideals, while, at the same time, modes of desire and identification that exceed heteronormative trajectories are never explicitly acknowledged. Walkerdine's approach seems to offer flexibility in terms of how girls might reimagine and reenact cultural constructions of girls' sexuality, yet their heteronormative psycho-symbolic patterns remain constant. It is very hard to wedge even the slightest possibility of girls desiring girls or girls identifying in non-feminine ways within Walkerdine's reading. The partial and subjectively filtered slant of her interpretations is recognized throughout her book, yet ideological contradictions valorizing either a pure desexualized girl or demonizing an unruly sexual temptress contain the ways in which girls might negotiate their own sexual curiosities. I wonder how the psychological survival of working class queer girls might work its way into the popular oedipal stories told by

Walkerdine, supplementing and interrupting this paternally structured fantasy in the direction of the early "perverse" longings of adolescence?

Walkerdine is concerned with young girls who are not at a stage of articulating a conscious sense of sexual identity in any comprehensive way. Because her subjects are preadolescent girls, she is cautious when reading the sexual contours of girls' popular cultural pleasures and attachments, centering her analysis on the force of adult fantasy projections and mediations. At the same time, what remains so compelling is her interest in the tensions and interconnections between girl self-images and enjoyments in popular culture and hegemonic expectations and meanings. Psychoanalytic readings become useful in elaborating the gaps and slips of girls' unconscious desires and identifications in relation to the dominant codes of popular cultural texts. In contrast to the subtle interweaving of psychic, symbolic, and social dimensions of experience within Walkerdine's research, most research on girls' sexuality turns to the empirical evidence of girls talking about their sexual behaviors and feelings. There seems to be a division between cultural studies approaches that attend to mediated dimensions of girl subjectivity and feminist social scientific focus on the embodied authenticity of experiential voices.

Whereas media analysis of girls tends to emphasize the power of representations to shape the languages and even the fantasies through which girls desire, empirical studies of sexuality have turned directly to ask girls how they feel and behave. The experiential emphasis of feminist research attends to the sexual specificity of girls through practices of self-representation. This process overcomes the lack of attention to the diverse and desiring subjectivities of girls within cultural studies texts. At the same time, the very status of experience is left without much theorization, privileged as a source of data close to the sensual embodiments of girls. Listening to what girls have to say, or not say, about their sexual embodiments has become a goal of feminist scholars, such as psychologist Deborah Tolman, whose book *Dilemmas of Desire* offers a detailed examination of how girls express their desires through experiential narratives. The erotic lives of girls are approached by asking direct questions about when, where, how, and why sex matters to them. Tolman develops a phenomenology of the sexual desire of girls through in-depth interviews using feminist voice-based analysis. While Tolman frames her analysis of personal stories around an understanding of the social and cultural regimentation of girls' sexuality, her interest is on how girls live and talk about desires within social regimes that enforce contradictory ideals. What is striking about this study is its treatment of desiring embodied voices of girls in almost complete abstraction from popular cultural representation and participation. Although influences of

the broader social world are broadly referred to, languages of desires are valued in terms of their direct relation to embodied experiences. Tolman's phenomenological work on older adolescent girls' sexuality explores the self-descriptions of their most intimate sensations, fears, pleasures, and traumas, addressing the missing desire of girls by asking questions and soliciting experiential perspectives. The responses from girls are heterogeneous and richly detailed, providing insights into their sexual imaginations and also their silences.

Tolman's methodology makes it clear that the ways girls are addressed—communicative languages, styles, formats, contexts—become a key process shaping their social status and self-perceptions as sexual subjects. Communicative dynamics are taken seriously by Deborah Tolman when she argues that "asking these girls to speak about sexual desires, and listening and responding to their answers and also to their questions, proved to be an effective way to interrupt the standard 'dire consequences' discourse adults usually employ when speaking at all to girls about their sexuality" (1994, 340). What is remarkable about this approach is its candid and flexible method of following the confessional responses of girls who are rarely given opportunities to talk about the sexual intricacies of their lives. Most of the girls interviewed in Deborah Tolman's study say that they are used to keeping their fantasies and memories quietly to themselves. Being given the opportunity to name and share sexual experiences enables girls to consider and to construct their own identities while getting feedback and support.

Feminist research on girls' sexuality points to the importance of reflecting on the very assumptions through which youthful sexuality is deemed legitimate and intelligible within scholarship. Much of the present work on girls that focuses on self-esteem, negative body images, and sexuality fails to grapple with those features of girls' desires that do not fit into heteronormative models of sexual health, beauty, and happiness. In other words, it becomes important to think beyond the taken-for-granted languages of sexual development in order to learn how to listen for the desires of queer girls. While the conscientious aim of feminist ethnographic work on girls' sexuality is to remain responsive to the ideas presented by girls, the research models tend to be limited to semi-structured interview forms that call for transparent and direct naming of empirical experiences. Providing some room for unpredictable fantasies, and loose narrative lines of dialogue, feminist social science texts tend to be rigidly marked by the authoritative inquiry of an adult positioned as the knower-interpreter who decides and guides who, what, and how representations become institutionally relevant and valid.

Within most social science research, when a girl is asked "what do you desire?" and responds with silence, anger, doubt, ambivalence and caution or

with dizzy enthusiasm, answers tend to be oriented to fit into a linear academic text. What strikes me is the tendency to discount or devalue elusive detours, fictional mediations or interruptions to a coherent narrative of desire. It seems that this is the crux of heteronormative discursive power that renders ambiguous, indirect, and unstable ways of signifying desire invisible to the social analyst. What needs to be theorized are the means through which contested desires of youth become noticeable and meaningful to researchers. This seems especially important with regards to queer subjects whose embodied and psychic differences trouble conventional discourses. Provocative questions emerge: What means of signifying desire might allow for queer girls to convey their experiences beyond the "straight" codes? Does this undermine the fixity of the category *girls* and the conventions of social science? What about the ephemeral, embodied, or ironic articulations of sexual subjectivity that are not easily transcribed into interview models? Would taking them seriously shift not only dominant mass media formulas of feminine heterosexuality but also academic protocols of rational coherence? What is the best way of eliciting and reading queer girl desires? How might it be possible to read these experiential desires through popular culture texts without reducing or simplifying the tensions between them?

To begin to answer these questions, feminist research needs to integrate queer theoretical perspectives that broach ways of conceptualizing the languages and selfhood of girls beyond normalizing structures of knowledge. Bridging queer and feminist approaches enables culturally situated ways of reading queer girls that do not generalize media texts or reproduce transparent accounts of experience but enable what Teresa de Lauretis calls a "semiosis of experience." I use queer theories as tools guiding the elaboration of my own research methodology into queer girls and popular culture. Starting with the self-representations of queer girls, I gesture towards performative enactments and dialogical relations of language in the elaboration of their subjective differences.

Queer Girls Messing with Language

Rather than containing youth in adult narratives, how might we avoid repeating identities? How can we encourage practices that do not depend on the intelligibility that dominant adult narratives presume to be necessary? How might adults come to see the identities we and youth adopt as creative rather than as evolving copies?

Susan Talburt, "Intelligibility and Narrating Youth" (35)

Being queer has gotten me used to not needing to conform exactly to the norm, so my style, identity, and pretty much my life in general, is like this odd combination of things

that are completely unrelated to each other except by the fact that I like them. At the moment I'm not even close to following any standard style, or well-known path, or anything. I'd describe my life in general as kind of hodge-podge or seemingly random, but comfortable.

Pat, age 16

Queer girls continue to be a blind spot within feminist research. Their subordinate status within academic theorizing reiterates ideological tendencies to ignore and delimit the dissonant desires of girls. At the same time, the social and cultural emergence of queer girl selves pushes up against adult theorizing, compelling new ways of seeing and hearing from girls who insist on an expansion of references, words, images, and concepts through which to tell their stories. Pat insists that using the term *queer* does not reflect any preexisting identity but rather enables her to generate a "hodge-podge" of styles and relations that elude normative ascription. Theorizing and researching queer girls is an inherently hybrid exercise, one that calls for integrated ways of knowing tuned into popular texts and girl talk. Staying close to how girls approach the texts they enjoy and use to make sense of their world, my emphasis is on self-reflexive interpretations. I show that queer girls are already theorizing within their daily cultural activities, and while I am not privileging their ideas as transparent and authentic as opposed to discourse analysis, I am suggesting that theory is already woven within the tellings of these youth. In the process of naming themselves along with the kinds of texts to which they relate, queer girls defiantly cross the boundaries imposed by official discourses as an inextricable part of their quirky and provisional experiences of the media world that surrounds them. I introduce queer girls identifying themselves in this section to highlight some of the ways they mess with languages, troubling prescriptive codes of identity.

Learning from queer girls requires a willingness to broach the difficulties and pleasures of girls' erotic desires for other girls, girls identifying as boys, and young people desiring and being desired in ways that exceed the comfort of expected categories. The horizons of queer girls are in flux and ambiguous. While my focus is on the engagements of queer girls with popular culture, it is crucial to begin theorizing out of the self-identifications girls use to position themselves as subjects. Queer girls continually grapple with how to represent themselves to others. They are very conscious of the difficulty of naming how they feel and think in relation to social norms. Many youth qualify a chosen category by saying that they use it "for society's sake," realizing that it doesn't quite fit all of who they are. Others are insistent upon shaking up expectations. Sixteen-year-old Sal talks

about the tensions inherent in her choices of "she" and "Mr.," claiming that "pronouns and titles are a bit funny with me—I prefer both 'she' as a pronoun, and 'Mr.' as a title. I couldn't tell you why these two seemingly contradictory identifiers seem right, but they do." The contradictions between these terms are reconciled in the ways Sal uses them to signify different aspects of a changing self. Kerry tells me that "queer kids have a whole different language, it's like a jargon that only we understand and it's great and really interesting." She is keenly aware of the complicities between language and queer identification, while refusing to remain passively interpolated. As a researcher, I am conscious that queer girls are not a unified group, nor do I have direct access or immediate comprehension of their desires and identifications. In many ways, their queerness challenges, baffles, and fascinates me. I am compelled to reflect upon my own ignorance in terms of the constitutive cultural negations through which queer girlhood seems oxymoronic, almost impossible to conceptualize. Redressing the force of regulative and normalizing knowledges about girls, I learn to listen to how girls articulate their emotions and ideas through the mediations of popular texts. Using e-mail surveys, interviews, and focus groups, I asked self-identified queer youth between the ages of sixteen and twenty-three to define their gender and sexual identity, and, while I anticipated a range of answers, I was offered an amazing breadth of responses that defy codification.[4] When it comes to gender, the following is a small sample of the ways queer girls describe themselves:

"I dress butch, but i'm told my personality is really femme"

"Homoflexible"

"Girlie feminine"

"Transgender FTM"

"Uncertain more feminine"

"Unlabelled in this category, all over the place"

"In the middle of fem and butch"

"Is tomboy an option? If not, then I suppose masculine"

"A tom boy with a princess stuck in side of me"

"I feel that I am a nerd-butch dyke"

"Andro"

"Fem-androgynous, sometimes soft butch"

"Feminine I suppose, though not dramatically so"

"Usually feminine, masculine on occasion, but never really both at the same time"

"I'm not overly feminine and i'm not straight up butch"

"Butch girl who likes being girly"

"In-between"

"Sexy, cute, preppy, punk type fem."

"Neutral"

"I'm a girl. I do not attempt to categorize myself any further"

"Girl, fag"

It is striking how often the girls I interviewed refused familiar and straightforward categorizations. Many statements purposefully defy binary gender coding, mixing and confounding normative terminologies. While these youth commonly make use of subcultural identifications, such as butch and femme, they use them in idiosyncratic ways. An insistence that they not be pegged down leads many to talk and write about themselves through irony ("girl, fag"), playful indirection ("all over the place"), and contradiction ("fem-androgynous"). Whether they use gender-specific words ("girlie feminine") or vague terms ("neutral"), their responses provide evidence of shrewdly honed self-representations. For several youth, active refusals of labels and roles were repeated over and over again as when Joy asserts: "no I am not butch, no I am not feminine, no I am not confused, no I am not what you want me to be . . ." I gathered that the very act of being researched compelled some girls to emphasize the impossibility of standardized definitions, pushing me to question the very intent and form of my question about gender identification. A multiplicity of gendered positions, words, and paradoxes began to circulate at the heart of my research project, deterring me from making any generalizable claims about queer girl identities.

Not only are queer youth gender signifiers impossible to stabilize, but the ways they position and name their sexualities also avert regimentation. Girls identified as "bisexual," "polyamorous," "lesbian," "kinky," "slut," "curious," "questioning," "homo," "open," "queer," "gay," and "perverse," and some also refused to attach themselves to any single appellation. Naming desire becomes an equally fraught practice for many youth who actively challenge neat and discrete titles. I wonder at bold assertions of sexual desires resisting prescriptions of shame and moralistic valuation. Conceptions of sexual selves and relations fracture paradigms conventionally used to study either "gay" or "lesbian" youth, complicating the terrain of personal attractions and collective affiliations. In an attempt to create a

provisional yet imperfect way of naming sexualities throughout this book, I refer loosely to "girls who desire girls." The members of my focus group really liked this way of talking about a particular aspect of queer girl sexuality without foreclosing other possibilities. These youth seem more comfortable referring to provisional movements of their desires than entrenching identities once and for all. While I needed some focus on sexual affinity to guide my popular cultural readings, I try hard to render ideas about sexual identifications flexible, tentative and open.

Across profuse anecdotes, narratives, words, and images, queer girls challenge sanitized ideals of female innocence and reticence, while also gesturing towards uncertain and unfinished modes of representation. The languages through which they name, or work to unname, their queerness makes social scientific coherence futile from the start. Perhaps the most difficult and poignant part of my research has been learning to respect ambiguity and leave identifications pliable. At the same time, many of these youth felt comfortable using the word queer as an overarching reference. In one teen's words, "Queer is such an umbrella term. I like how it doesn't pin-point one specific sexuality or preference. Because although I am certain I like girls, it's nice to have options :)." Another teen insists that "other terms make me feel trapped, like I have to exactly fit the term I've chosen, but to me, all 'queer' means is not straight, and I know I'm not straight, so it feels like a safe way to describe myself." At the same time some girls deploy "queer" as a way to trouble distinctions between heterosexual and homosexual types, to open the field of questioning beyond isolating fixations on sexual minority youth. *Queer* as a strategically chosen term works against the foreclosure of desires and the imposition of controlling assumptions; it is deployed by girls as a way of enabling possibilities rather than guaranteeing identity or knowledge about identity.

There is something wonderfully "precocious" about the self-fashioning of queer girls. Deborah Britzman reclaims the term "precocious" in order to consider queer sexualities in a much more expansive way that incorporates bodily, intellectual, emotional, and creative styles of living and learning that exceed institutionally reified discourses. Britzman writes "of questioning the curious combinations made from psychical and symbolic apparatuses, and of encountering the uncertainty, the curiosity, the alterity, and the strange relations sexuality also presses into form" (37). Britzman elaborates a rethinking of sexuality through a Freudian psychoanalytic model of sexual drives in childhood linked to dynamic corporeal formations of self, social interactions, and quests for knowledge. Sexuality emerges out of an infantile polymorphous perversity which has no set aim or object but is rather a diffuse impulse for pleasure that increasingly

becomes channeled in the formation of relationships, languages, embodiment, and learning.[5] Holding onto a sense of the inventive dimensions of sexuality, Britzman uses the term "precocious" to open up passages between somatic drives and cultural practices of meaning making, identifications, and sexualities in nonlinear, non-teleological ways. Framing queer girls as precocious sexual subjects provides a way of gesturing towards productively overflowing desires giving rise to the creative cultural talk of queer girls. This allows the sexualities of girls to become meaningful within cultural analysis through a dynamic process of questioning, as a site of curiosity and learning rather than a prescribed set of characteristics.

As a queer researcher, I am wonderfully surprised by how deft young people are at articulating themselves without disavowing ambiguity and doubt as they speak about desires and acknowledge contradictions. The challenge becomes figuring out how to forge a way of theorizing and researching that does not box in the daily gender and sexual explorations of girls through authoritative methods and truths. Is it possible to address the specific inclinations of those young people who call themselves queer without at the same time reinforcing divisions between heterosexual and non-heterosexual youth? How do I engage queer girls according to their precocious desires without stopping the flow of their changing selves? Where and how should queer girls be approached? What methods work best to elicit queer girl perspectives with the least amount of invasive control? Is it possible to study queer girl desires without focusing directly on a narrow set of sexual attributes and behaviors? What textual and research strategies enable the expansion of girls' desires in language? How does talk of popular culture both elicit and mediate queer girl subjectivity? To begin to answer these questions, I try to elaborate a queer methodology that draws upon both queer theories and the practical dilemmas and contexts of my research. There are intriguing points of connection and tension between the self-articulations of queer girls and the speculations of queer theorists. Rather than apply theory to data, I interweave theoretical insights as a tool of practical engagement and textual interpretation.

Thinking Dialogically:
In-between Queer Theories, Texts, and Experiences

> I have found it useful to read queer theory not as a set of contents to be applied but as offering a set of methodological rules and dynamics useful for reading, thinking and engaging with the psychical and social of everyday life.
>
> Deborah Britzman, "Precocious Education" (54)

The point of my research is not to narrowly define queer girls, nor is it to create neat and logical correspondences between sex/gender/sexual identities and popular culture texts. Instead, I try to listen to and interpret the unsettled ways girls mark out their identities as they talk about cultural texts. My goal is to read queer girl desires as a process interconnecting cultural texts, interpretations, and investments without reducing their heterogeneity. I try to mark out distinct patterns of media representation without entrenching truth claims about why or how a specific example, subject, or theme has value. Tensions between trying to focus attention on queer girl texts and responses while simultaneously refusing to generalize their significance pervade my analysis. In my attempt to deheteronormalize feminist work on girls and girl cultures, I am forced to confront tensions between deploying and questioning languages of identity and desire. And it is precisely the re/constitutive work of language that is at stake throughout this book. The methodological crux of my project hones in on exchanges between cultural signs and queer girl selves, adopting dialogical and performative frameworks of analysis to guide my conceptual and writing practices.

I borrow from Bakhtin's concept of the dialogical in order to think through the relational status of subjectivity, sociality, and language. Language comes alive at a concrete level of an utterance, spoken in context, in dynamic interactions: "Each utterance refutes, affirms, supplements, and relies on others" (1986, 91). In this sense, general linguistic structures are meaningless without individually crafted mobilizations of images and words. At the same time, personalized speech is always already enabled and shaped through the words of others, spoken out of the past and projected into the future. Without subjectivizing or dehistoricizing language, a dialogical approach considers signs refracted through emotionally and socially embodied experiences of youth. Meanings are created on the border between self and others, body and language, desires and media systems, activated through an event of communicative interchange that is never static or finalized. For Bakhtin, language flourishes on the threshold between intimate and collective articulations. A dialogical reading of queer girls avoids the pitfalls of psychologism and the abstractions of discourse analysis, focusing on individual utterances as instances through which culture is activated and transformed. This way of understanding selves and language makes it possible to think about queer girls' desires and engagements with popular culture without pegging them as isolated individual choices or ideologically determined responses.

Conjunctions between queer girls and popular culture texts throughout this book are framed dialogically such that voices converge and diverge in discussions of media representations. Meaning does not lie in a single text or individual reading

but is propelled along the multiple lines of communication linking discourses and subjects. Specific and situated voices of queer girls are connected through the image-word-story texts of popular culture, activating interactions irreducible to singular perspectives or totalizing social systems. A dialogical approach becomes crucial for attending to the ways queer girls mess with language: selecting, combining, and playing with media signs as personal and collectively relevant. This approach both calls upon and alters feminist research, which has tended to analyze girls in terms of dominant media messages in ways that miss out on the slippages and ambiguities of queer girl talk. Feminism comes up short when considering the desires of girls not merely because diverse sexual subjects are not included in their projects, but perhaps more importantly because of how language is used to secure knowledge. The monological tendencies (which are mixed with dialogically rich elements) within feminist research on girls make it very difficult to hear expressions of queer desire that ripple outward, away from any centralized interpretive position. In contrast, I try to foreground centrifugal aspects of dialogue propelling readings in several directions with no easily finalized outcome.[6]

A dialogical approach to queer girls and popular culture is usefully aligned with a queer performative emphasis on speech acts that destabilize heteronormativity. While a dialogical framework provides a relational setting and intermingling of utterances within a social field of power, performative ways of thinking turn attention away from preexisting or guaranteed differences of identity and knowledge onto new configurations, which are, as Diana Fuss claims, "less a matter of final discovery than perpetual invention."(7) Performative notions of identity and desire become very useful in this project, helping to unhinge the study of girls from preconceived norms of gender and sexuality, turning attention onto the constitutive talk and happenings of queer cultural practices. Queer girls speak their desires performatively, engaging with characters, narratives, images, and songs as a creative process, deriving value and pleasures from them by reiterating and reversing signs and meanings in ways relevant to their lives.

Within literary elaborations of queer theory, it becomes important to connect linguistic and emotional struggles that propel performativity out of childhood experiences of exclusion and devaluation. Eve Sedgwick's essay "Queer Performativity" presents a reading of the ways in which sexuality emerges through performative utterances such as "shame on you." Using shame as exemplary of the communicative struggles of queer subjects, Sedgwick avoids collapsing queerness into prescribed narratives of homosexual depravity, while at the same time unfolding the subjective impact of painful words of abuse.

It is precisely because of psycho-social-cultural interactive processes that subjects are able to performatively transform their identities into queer affirmations of difference out of interpellations of "shame." Sedgwick writes, "If queer is a politically potent term, which it is, that's because, far from being capable of being detached from the childhood scene of shame, it cleaves to that scene as a near-inexhaustible source of transformational energy" ("Queer Performativity", 4). Sedgwick refers to processes of shaming as an exemplary instance of queer performativity, which enables her to avoid imputing any substantive content to queer identity while theorizing it as "a strategy for the production of meaning and being" ("Queer Performativity," 11).

By tracing signifiers of suffering, social withdrawal, and communicative struggles for recognition in response to shame, Sedgwick renders queerness a dialogical process: "The emergence of the first person, of the singular, of the present, of the active, and of the indicative are all questions, rather than presumptions, for queer performativity" (4). Of course, there are many other affective states through which queer youth remember, construct, and enact their queer singularities. Using popular culture examples that frame and tell stories about sexual confusion, loneliness, violence, or the erotic delight of falling in love with a girl for the first time, I show how they mediate emotionally charged feelings and memories from the past, eliciting girls to converse about themselves and their interests. The very process of telling anecdotes and reframing experiences with references to shared cultural stories enables queer girls to locate themselves within the terms of a fractured yet common culture and to represent their own subjective lives within and against discursive ideals and powers.

When queer girls talk about themselves in relation to popular culture, they mobilize languages through which to constitute meaning about themselves and others. It is the unsettling reiterative activity of signifying sexual subjectivity without closure that shifts attention away from a heterosexual teleology of girls' development and identity onto the dynamics through which popular images and narratives configure profuse desires in specific social contexts. Confounding ontological divisions between original and copy by suggesting the imitative status of all sexuality, Judith Butler analyzes performativity as an active and modifying formation of subjectivity rather than an essence or truth. Butler writes,

> Performativity is thus not a singular "act," for it is always a reiteration of a norm or set of norms, and to the extent that it acquires an act-like status in the present, it conceals or dissimulates the conventions of which it is a repetition. . . . Within speech act theory, a performative is that discursive practice that enacts or produces that which it names (*Bodies that Matter*, 12–13).

Performative approaches to language suggest the impossibility of knowing identity and desire prior to communicative exchanges, directing attention onto citational acts that both repeat and displace historically sedimented sex/gender/sexual dichotomies. This calls for a shift away from definitive accounts of identities, such as homo/hetero or boy/girl, towards a consideration of "identity as practice, as a signifying practice . . . language refers to an open system of signs by which intelligibility is insistently created and contested" (Gender Trouble, 145). Tracing girls' desires in performative gestures of talking about popular culture, I shift attention away from pinning down an ontological origin or the qualities of a preconstituted or sexual self, unfolding languages of young desiring selves shaped over and over again in and through everyday cultural encounters.

Queer performative theories provide dynamic psycho-sexual and linguistic frameworks through which to consider the variant and erotically charged voices of girls. At the same time, the status of particular social experiences and contexts are left hanging, making it important to supplement Butler's approach with Teresa de Lauretis's elaboration of a "semiosis of experience" as a way of accounting for a passage between languages of desire, psychic engagements, and materially situated experiences. Teresa de Lauretis elaborates Charles Peirce's notion of semiosis to "account for the subjective and social aspects of meaning production . . . mapping the relations of meaning to what I have proposed to call experience" (Alice Doesn't, 168). Within this theory of "experience," sign activity becomes interwoven through lived material social relations, such that both subject and object are seen to be mutually transitive, entwining signifying activities and affective relational experiences. De Lauretis highlights "the weight of the object in semiosis, an overdetermination wrought into the work of the sign by the real, or what we take as reality, even if it is itself already an interpretant" (Technologies of Gender 41–2). She reclaims the status of "the object" not as a pregiven factual reality but as a "dynamic object" which engages physical bodies, emotive responses, and symbolic organizations.[7] This engages multiple dimensions of experiential relations of subjectivity in ways that Butler's performative model skims over. Connecting reiterative speech activity to the dense psycho-social webs of meaning within which they are spoken and received by others, de Lauretis writes of a "process by which a representation in the external world is subjectively assumed, reworked through fantasy, in the internal world and then returned to the external world resignified, rearticulated discursively and/or performatively in the subject's self-representation—in speech, gesture, costume, body, stance, and so forth" (The Practice of Love, 308).[8]

Elaborating a concept of experience alongside a performative notion of desire becomes crucial when considering how girls approach popular culture. Linking images to a concrete event that happened in their lives, or referring back to an embodied occasion that resonates with a fictional character's story, girls negotiate meanings back and forth between texts and contexts through which they interpret culture. Desires and identifications are articulated in between real and fictional relations, providing spaces for reflection and speculation. In this way, engagements within popular culture are best understood as an ongoing series of shifting personal, social, and discursive convergences that are never static or reducible. Following the desires of queer girls becomes possible as a "semiosis of experience" always already mediated by, yet not limited to, the evanescent formations of popular cultures. Queerness emerges here as a simultaneous practice of cultural reception and subjective inscription, a naming that remains open to the contestation, wonder, and futurity of queer girlhood.

Through performatively enacted and dialogically connected experiences, becoming a queer girl can be traced in a persistent reiterative process through which words, silences, and stories are spoken to constitute desires and identifications that cannot be fixed beforehand or at the point of articulation. The ephemeral and experientially refracted quality of such utterances becomes valued in terms of their potential to spur new readings of girls as desiring subjects. Queer theories provide analytical tools through which to rethink the normative status of girls as sexual and gendered subjects that pervades feminist research. While queer theory has little explicitly to say about girls, it offers a heuristic method of interpreting desires without foreclosing their contradictions and mutability. A crucial insight afforded by the dialogical and performative directions of queer theories is a refusal to clearly separate cultural texts and desiring subjectivities. The challenge becomes reading them together without collapsing or severing their connections. Working to integrate queer theories into a feminist methodological practice attentive to girl selves, my goal is to mobilize dialogical encounters between popular cultures and queer girl receptions.

Strategies of Researching Queer Girls

Truth, like queerness, irreducibly linked to the "aberrant or atypical," to what chafes against "normalization," finds its value not in a good susceptible to generalization, but only in the stubborn particularity that voids every notion of a general good.

Lee Edelman, *No Future* (6)

I started this chapter with some critical thoughts about feminist studies of girls, focusing on the lack of attention to queer dimensions of discourse and experience. What was missing was not merely inclusion of queer girls as research subjects but perhaps more importantly a means of questioning common sense notions of feminine heterosexuality in relation to media and girls' speech acts. This problem leads back into the very method of approaching girls, of addressing gender and sexuality, without imposing assumptions or expecting unified results. This is the ethical heart of queer girl research and theory. The point of trying to bridge feminist empirical work on girls and queer theoretical approaches is to learn ways of rendering the voices of queer girls relevant and meaningful in the aberrant richness of their particularities. Translating such goals into a research and writing practice is a key challenge of this book. I try to bring media and interview textual analysis into an integrated dialogue, shifting away from positivistic concerns with the transmission of empirical data, attentive to interactive dynamics of data collection and interpretation. The point is not to read either popular texts or queer girl voices as clear and distinct sources of primary research, but to unfold them coextensively, allowing for what becomes unthinkable within generalizations about girls and cultural ideologies, catching glimpse of an elsewhere.

Critiquing the ways in which conventional representations of interviews reveal a desire for presence, which is symptomatic of dominant logocentric rationalities, Patti Lather promotes a dialogical facilitation of multivoiced texts and participatory engagements in rewriting interview data such that "attention turns away from efforts to represent what is 'really' there and shifts, instead, toward the productivity of language within what Bakhtin has termed 'the framing authorial context' " (112). Lather refers to this as a "postpositivist praxis" in which research is undertaken as an interactive and participatory project that does not aim to pin down a definitive truth, but pushes for change and revision. Research is thought of as a productive enactment of desire and power among various subjects that needs to be interrogated in a direction of democratic inclusion and social transformation rather than used to inscribe single authorial truths. Within a moving field of social relations in which gender, race, class, nationality, ethnicity, and sexuality simultaneously constitute subjective desires, multiple versions provide partial representations of shifting social encounters, effecting exclusions that need to be addressed as part of a persistent reflexivity. Lather highlights performative dimensions of research texts that displace the exactitude of social facts through ongoing signifying relations. Data becomes a basis for telling stories that might disturb and alter people's consciousness and provoke actions. Lather writes,

Data might be better conceived as the material for telling a story where the challenge becomes to generate a polyvalent data base that is used to vivify interpretation as opposed to "support" or "prove" . . . turning the text into a display and interaction among perspectives and presenting material rich enough to bear re-analysis in different ways bringing the reader into the analysis via a discursive impulse which fragments univocal authority. (91)

Lather reconstructs data as socially meaningful stories, offering several versions and reading them against each other. Research data are used "demonstrably, performatively . . . to condense, exemplify, evoke, to embellish theoretical argument rather than to collapse it into an empirical instance where data function as a 'certificate of presence', a buttressing facticity" (150).

Following Lather's cue, my goal is not to pin down and decipher the essence of queer girls or to analyze exactly what a particular representation means, but rather to open up a space in which to listen for culturally mediated and imaginatively embellished communications. I am an active part of the dialogical movement of ideas without laying claim to any grand gesture of theoretical synthesis. Involved as a key cultural participant, as a desiring queer researcher, I engage with both media texts and queer girls, spurring conversations in-between while listening for momentary confluences and disjunctions of meaning. I seek out queer girls to talk to on websites, make choices about certain media over others, compare and organize issues and examples, and design an open set of questions to ask girls as a way to elicit their stories and ideas. The goal is to open up passages through which queer girls can be understood as desiring cultural subjects while paying attention to how popular cultures become invigorated through them. I do this without forgetting that I am an integral part of what Lather calls "vivifying interpretation." I try to show how queer girls themselves are continually theorizing identity and power as they struggle to recognize and speak of themselves through collective discourses. In this sense, I conjoin my theorizations with the ongoing theory talk of girls rather than imposing metaconcepts onto what often gets belittled as unformulated empirical data. This is not to discount my power and limitations as a researcher but to complicate the ties between myself as an adult theorist and youth participants. One of the most challenging facets of researching queer girls is learning to respect the ways in which young people name who they are and what they like in nonlinear and informal dialogues.

Because I am less interested in an in-depth study of any single girl, identity, or media text than in the relational emergence of contradictions, patterns, and questions arising between them, my methodology is avowedly de-centered, and

so are my methods of data collection. Such methods resonate with the theoretical guiding principles I have laid out above, insofar as the emphasis is on performative speech acts and dialogical encounters rather than producing transparent or unified knowledge. There are also very practical reasons for connecting with queer girls in several realms using diverse and loosely formulated approaches. I talk to girls within several contexts and in qualitatively different ways so as to elicit responses that emerge out of the unique places where they live and intermingle. I wanted to find subjects in the process of speaking about themselves, taking to others, and interpreting cultural representations. My hope was to be able to engage with queer girls in ways that did not seem detached from the media environments in which they use, read, and chat about popular culture. This leads me to enter already existing realms where queer girls inhabit culture and congregate in online communities. Worrying about being invasive and out of place, I always introduced myself from the start as a queer professor writing a book on queer girls before proceeding to ask questions or even lurk around. Because I was on their turf, it is my hunch that many of the girls so willingly and enthusiastically agreed to converse to me because I gave them room to answer on their own time and in more casual and flexible ways. Although I asked all girls to answer a general survey to start with, they were able to continue with more detailed questions and also set the limits as to how to respond and how much or little to say, with some girls even questioning my questions and posing new ones.

Giving girls a chance to participate in ways and degrees that matter to them was especially possible using e-mail, since it allows for a greater adaptability in terms of time and length of response and can accommodate variable kinds of back-and-forth interchange, ranging from a decision to leave a question blank to refusing to send back questions altogether. E-mail also helps facilitate extensive and prolonged correspondence. Not only was I able to bridge geographical distances, but I was also able to utilize a medium in which this generation of girls feels a relative sense of "safety," comfort, and control, which is especially important when it comes to taking about sexuality.[9] Researchers have begun to explore the ways in which girls use computer-mediated communication to express themselves in dynamic and alternative ways.[10] Shayla Marie Theil writes that "Online identity construction and manipulation appears to be an enormous consideration in this communication process among adolescents" (185). Providing unique spaces of dialogue between public and private spheres, girls are able to perform and textually play with languages without the conventional pressures and restraints of interpersonal communication between youth and researchers. While few studies have looked at the implications of

adopting tools such as e-mail for qualitative research on girls, my use of e-mail to ask queer girls questions about themselves and their cultural practices has proved to be extremely productive. Spurring dialogues mediated by language and physical distance, girls were able to share bits of information and reveal intimate stories at their own pace and through diverse textual styles. Many girls took the opportunity to use e-mail in creative and personalized ways. They sent back responses with varied time-lines, relaying anecdotes, fleshing out personal narratives, compiling lists of favorite cultural texts, offering me quotes and sending me links. My sense is that they were less worried about giving me a coherent, rational and linear account of themselves via the internet than they would have been face-to-face. Pressures toward normalization and intimidation implicit within youth-adult communication, especially in contexts of academic research, without being eliminated were noticeably diminished through the use of online modes of inquiry. E-mail provides a medium in which to leave room for partial, unfinished, and often ambiguous thoughts on a range of subjects. Using a combination of carefully crafted statements, broken grammatical forms, lots of ellipses, question marks and long stream of consciousness passages, girls often treated my e-mail interview in similar ways to other nonstructured forms of online writing. Because e-mail offers girls a flexible realm in which to write about themselves in uninterrupted and solitary ways (similar to diary style entries but directed toward others), it facilitates opportunities for slow experiential reflection and interpretive risk taking inhibited by face-to-face conversations and focus groups.

Using the Internet to communicate with queer girls also opens up interactive possibilities. When introducing myself, I was able instantaneously to direct girls to my institutional Web site for information about my role, address, and credentials as a professor. The girls in response often shared information about e-mail addresses as well as Web site, e-zine, and blog links. E-mail enabled queer girls to pass on my e-mail address to friends in a spirit of networking, generating a snowball effect. Although e-mail does not eliminate discomfort and power differentials, it provides a unique situation in which boundaries between researcher and researched are uniquely pliable and negotiable. There are also many limitations to using the Internet and talking to girls via e-mail, which include a lack of contextual understanding of their situations and also a one-sided focus on written text. At the same time, I was amazed by the richness of responses and the enthusiastic engagement with which girls participated in my research via Internet communication. I realized that, for many young people who are still unsure about their identity and may not be out to

family and friends, the Internet is a lifeline through which to connect with other queer youth and adults, explore ideas, and represent themselves publicly. Within the textual realm of computer-mediated communication, queer girls creatively perform gender and sexual selves while simultaneously embedding their individual narratives within a dialogical process.

For girls, the Internet also provides a productive space in which popular cultural icons, celebrities, and story lines are inventively appropriated, sampled and recirculated. Some of the most exciting research focused on girls has called attention to the productive cultural activities of girl fan sites.[11] As a personalized medium through which mass media can be talked about, disseminated and referenced in hypertextual ways, the Internet is a rich source of cultural production, references, and reinterpretations. I discovered that many personal and collective queer girl Web sites are directly focused on popular culture, providing me with a way of reaching communities of girls watching particular television shows, such as *Buffy the Vampire Slayer*. Finding girls on Web sites, listserves, blogging communities, and message boards run by Willow and Tara fans provided me with a context in which to engage with issues and ideas already being talked about in active forums. These sites not only instigated discussions about plots, characters, and media production, but, by providing e-mail addresses, they also gave me a chance to talk to individual girls about particular ideas in greater depth. An interesting feature of online discussions about popular culture is the way they foreground a collective process of passionate receptions and fictional reconstructions. As such, my theoretical focus on dialogical dimensions of queer girls utterances was organically unfolding within the practical operations of girls' online communications centered on popular culture texts.

While e-mail and the Web were my main research tools, I supplemented e-mail interviews with a focus group and one-on-one interviews with queer girls. The focus group involved five girls meeting for several hours once a month over the course of four months to watch videos and skim through magazines, offering a casual and convivial setting in which to have informal conversations about popular culture. It was here that I learned so much about the practical dilemmas and obstacles faced by high school girls attempting to access and enjoy queer media texts. Because of the continuity and local context of this group, discussions often focused on concrete issues of finding, sharing, and understanding media texts. I was able to observe some of the covert and tricky methods girls use to find and evaluate materials with queer content. Talk between the girls often roamed away from specific texts onto personal experiences of

confronting homophobia, dealing with parental denial, being out in school, becoming politically active, finding a date, or attending community events. The group was a social gathering in which queer teen girls were asked a few questions by me but then took liberty to expand discussions in several directions. While I tried to keep the group focused on popular culture, I realized how permeable boundaries are for girls, shifting between talk about texts and ruminations on lived experiences with cavalier ease.

In both my online and offline interviews, where, how, and what kinds of questions I asked girls became a very complex process in which I allowed for a great deal of flexibility and contingency. I was faced with a challenge of asking questions along with interpreting answers by girls without proscribing what and how they name, mediate, refuse, and embellish their desires. While I started the project with some sketchy ideas and points of references, my hope was to be receptive to what is unexpected, unforeseen, and even unintelligible within the terms of formal knowledge. This called for a research process that allowed for uncertainty at every stage of interviewing and writing. Even when I asked more structured questions, the way girls chose to answer differed wildly in terms of the extent to which personal experience and intimate feeling were included and elaborated. While some girls answered back once, others participated over the course of several months, responding to multiple sets of questions about specific areas of popular culture and texts. This led to vastly different degrees of involvement, conditional upon how interested the girls were in continuing. I tried to adjust and modify the kinds of questions depending on subjects and responses, such that I paid close attention to how they named themselves and how they located themselves within popular culture. Because of the variable way questions and answers unfolded, responses were not compiled and compared for similarities and differences so much as they were treated in terms of how they facilitated lines of dialogue. I often went off on tangents with girls, following their words and asking for elaboration. I allowed this to happen in part because my goal was never to create a controlled research setting. I did not want to predetermine the borders and scope of queer girl talk. This meant that I was offered so many more insights than I can ever render in the pages of a book, but this excess accords with the impossibility of defining or delimiting the terrain of queer girls and popular culture. Such a free-flow style of questioning allowed for a less aggressive and rushed sense of having to ask all the "right" questions to all the girls in order to achieve an impossible ideal of inclusiveness and rigor. I have no illusions that what I have managed to gather and interpret can ever represent queer girls as a whole, but rather I articulate

haphazard and momentary convergences between experiences, speech acts, and media representations.

Performative and dialogical theories of language inform not only methods of listening and talking to queer girls but also styles of interpretive writing and argumentation. My job as a reader is to try to mobilize disparately located and loosely spoken words into essays that are readable and connected, while conveying the multiplicity of selves and textual threads interwoven throughout. In this way, I try to engage with a broad range of ideas spoken about texts, linking and analyzing specific points without synthesizing them. The outcome is not a smooth summary or logical closure of an argument but rather a series of interpretive parts joined together in provisionally structured essay form. Grappling with diverse media and prolific responses, I am compelled to highlight key parts around which interviewees were especially animated and involved. I try to follow their passionate investments and identifications with popular texts through a critical analysis of discursive meanings without imposing a theoretical style that might overwhelm the often ephemeral and playful perceptions of girls. While I try to maintain a balanced attentiveness to academic concepts, cultural debates, and vernacular speech, it is difficult to accomplish, and I sometimes sway awkwardly back and forth. Perhaps such imperfections are an inevitable sign of the gaps, tensions, and evasions that arise when working between the unexpected and wildly intelligent desires of girls on the margins of media culture? My process of understanding involves letting go of the smooth, controlled rhetoric sustaining heteronormative ideals, embracing the inordinate contradictions and pleasures of contemporary queer girl engagements with popular culture.

· 3 ·

WILLOW'S QUEER TRANSFORMATIONS ON *BUFFY THE VAMPIRE SLAYER*[1]

Coming of Age, Coming Out, Becoming Powerful

If it weren't for queer girls on TV, so many teenage lesbians would have killed themselves in the struggle to find themselves. And with each and every episode, people's eyes begin to open and they see love and a sense of right instead of just lesbians. It becomes part of people's daily lives and gradually they become more open to the thought of us being here for good.

Kerry, age 16

Vamp Willow in Dopplegangland? "OH MY GOD! HOT!" It was the very first time (seeing as I was younger when the episode first aired) that I was really turned on by another woman.

Tracy, age 16

Watching queer girls on TV is not a trivial pursuit for youth struggling to find some semblance of public representation through which to make sense of their lives. Yet television as an institutionalized medium is a tricky place to begin to consider queer girls in popular culture. Many critics have noted that TV is not conducive to signifying queerness in terms of the "difficulty of making same-sex

desire uneventful, serial, everyday" (McCarthy 609). While narratives of gay adolescent boys coming out on TV have emerged within teen dramas, they are often developed in terms of a "special" coming out story that highlights a brief moment of visible difference with very little time in which to expand and contextualize experiences of being young and gay beyond dramatic scenes of revelation.[2] Integrating same-sex desire is even more tenuous when it comes to representations of female youth. Lesbian, bisexual, transgender, and questioning girls remain very hard to find on the television dial; even short dramatic coming out scenes focusing on girls are rarely included within the repetitive formats of heterosexist teen TV.

In the face of pervasive invisibility, most researchers and fans watching television for signs of lesbian desires have resorted to elusive subtextual analysis and fan-fictional reconstructions, elaborating even the smallest glimpses of attraction between women into full-fledged fantasy figures and scenarios. Shows from *Star Trek* to *Xena* have compelled fans and critics to queer the straight edges of televised fictions, reimagining subversive alternatives in silent glimpses and furtive body languages. Faint traces of desires between women are elaborated into nuanced ways of seeing and talking about a lesbian presence on TV. With recent developments of cable series, such as *The L Word* and *Queer as Folk*, focusing on out lesbians within queer communities, stories and characters become more readily available for viewer identification and enjoyment. Yet even with increasing visibility on mainstream TV, it is adult lesbian women that have come to embody sexuality and elicit erotic fascination. In this way, the very conditions of visibility are prescribed by class, race, gender, and age norms according to which viewers come to see and recognize what a "lesbian" looks and acts like. Not only are queer identities and sexual relations between girls largely absent from the central dramas of texts, but subtextual engagements become even more convoluted and peripheral to explicit story lines. Young queer girls embodying sexual and gender ambiguities and flux challenge stable, "positive," "out" constructions of sexual minorities within liberal mass media frameworks. On rare occasions when girls are portrayed, they become reduced to an immature phase of bisexual indecision or a clear-cut transition toward adult identity. In such scenarios, the cultural stakes and limits of representing complex and questioning girl characters in love and lust with other girls are formidable. To profile a visibly queer girl self on television not only gives rise to intense controversy, excitement, and interest, it also raises disturbing questions about how to see, read, identify, and name such girls. With few public languages to receive and address girls who exceed heteronormative expectations, their appearances and meanings

on TV become unclear and fraught with tensions. How do we come to see and understand queer girls on television when their very appearance is so often denied, obscured, and unpopular from the start? What emerges is a type of girl that is not so easily defined and marketed, a gap in television representation that renders her almost unintelligible within its terms of reference.

With so few characters and shows to list, compare, and contrast when it comes to examples of girl characters engaging in sexual and romantic relations with other girls on TV, my interpretation is driven as much by an awareness of what does not exist as by what does. Without a corpus of media texts to work with or a systematic body of academic literature, work must begin in the subjectively limited yet emotionally intense spaces of viewer response and resistance. I take my cue throughout this chapter from the energetic attachments and insights fostered between girl fans and popular entertainment fictions. As the opening quote suggests, queer girls are highly receptive and invested in the emergence of stories and images of girls on TV who perform desires and romantic longing for other girls. Rather than reading against the grain of ostensibly heterosexual images of girls, many queer girls engage creatively with a select group of characters they can find on TV. The fervor of fan participation in relation to queer youth television characters speaks to the personal and social importance of popular cultural representations in the lives of GLBTQ (gay, lesbian, bisexual, transgender, and questioning) youth. Indeed, connecting with a TV character who is confronting violence, falling in love, and finding community may provide a young person with more than merely a positive image or role model, enabling hope and imagination through and beyond the specific conditions of their everyday lives. The meanings televised characters and their actions hold for fans go beyond the text into expansive dialogues hooked into the life worlds of queer girls themselves. In this sense, a TV show or character is not a self-contained text but a series of narratives and visual signs that seep into the daily praxis of queer youth subjectivity and culture. Following the lead of queer girl viewers, I am interested not only in the formal structures of specific story images, but also in how they signify queer girls in a reflexive process of watching, talking, and thinking about characters and their relationships.

I approach interactions between television texts and girls as an adult queer researcher, at a distance from the fray of teen girl crushes and passionate opinions shared between youth. But while age and education separate me, memories, fantasies, and longings bring me closer. I also watch TV with a desire to see and identify with young queer love, wishing for something else beyond heterosexist story lines. Like young curious readers, my attention turns to whatever signs

of affection, desire, shame, friendship, lust, suffering, and pleasure I pick up on as proof of a queer connection. At the same time, I am plagued with doubts about both the need and possibility of finding such proof and being able to translate its meanings. Undoubtedly, this is not a quest for traditional forms of textual evidence: Does a lesbian kiss offer a transparent sign of evidence? Do I look for a gesture, a gaze, a narrative structure that constitutes the key to queer girl subjectivity? Does nostalgia distort and idealize my reading of young sexuality? Do queer adolescent fans seek out more than is really there to begin with? Such questions are unavoidable when it comes to focusing on a field of representations so small within the televisual universe and yet so affectively loaded for young girls who crave and dream about so much more than mass media texts deliver. In such a situation, there can be no objective exegesis or detached analysis; the only way forward is to reflect on how specific representations become meaningful simultaneously inside and outside the heterosexual parameters of teen TV. Perhaps the point is not to ask "How is a girl character queer?" but rather "In what ways does a specific televisual representation of a girl queer popular assumptions and elicit alternative responses in diverse audiences?"

At the same time that a dynamic process of reception is valued over fixed textual content, the voices and actions of specific characters, such as Willow on *Buffy the Vampire Slayer* (*BtVS*), have emerged at the turn of the millennium to inspire a process of thinking about queer girls throughout this chapter. A slow but notable development of fictional subjects coming of age in ways that trouble linear trajectories of feminine identity, girl-boy romance, and sexual maturation is inspiring a wave of girl fan discussions, websites, and fan clubs. It has been noted that new teen series, such as *BtVS*, "seem to embody great promise for bringing to the screen lives, desires and issues that are often ignored, stymied or cursorily treated by television. One key element here is longevity: the sheer length of a long-running series allows for the development of characterization, and substantive narrative depth and complexity" (Davis 131). This is a productive place to begin a discussion of girl characters who desire differently, providing a fictional convergence point for talking, fantasizing, and arguing about what televised queer girls look and act like. Fleshing out narratives of girls on TV, my goal is not to prescribe qualities but to elaborate the dilemmas and becomings of desiring selfhood. Along these lines, I pivot my analysis around the fictional character Willow Rosenberg. As the best friend of Buffy, Willow is an integral driving force of this girl hero action story, functioning as neither a marginal sidekick nor a competitive rival, neither the same as Buffy nor completely different. Through her looks, actions, words, and

relations within the show's dynamic plots, Willow becomes a productive and open text. Willow is represented within *Buffy the Vampire Slayer* as an intellectually, sexually, and socially complex character who inspires identifications and commentary among young viewers. I want to turn attention directly onto the ways Willow becomes meaningful as a fictional character in dialogue with others. In this sense, rather than exult a queer version of an individual heroic self or an isolated role model, I engage with Willow as a way to create a conversation that situates constructions of a girlhood within queer theoretical frameworks, popular discourses, and informal interviews. Willow provides a take-off point for considering how a girl growing up, coming out, forging friendships, having sex, expressing love, enduring heartbreak, and struggling to embody power becomes represented, received, and conceptualized in queer terms.[3]

Ambiguous Desires and Identifications: A Girl on the Verge of Becoming Something Else

I can honestly say that no other television program has, or has had, a character as interesting and deep as Willow Rosenberg.

Linda, age 16

Willow went from innocent and geeky and adorable to confident and intelligent, and then to frighteningly evil but still sexy, and then to unsure . . .

Helen, age 21

Focusing on Willow Rosenberg as an example through which to analyze queer girl self transformations on television makes sense on many levels. There are several highly popular fan Internet sites devoted to Willow, including The Kitten, the Witches and the Bad Wardrobe (Kitten Board), Extra Flamey, and My Always, along with many Willow communities on LiveJournal.com that actively involve self-identified queer girls as members. A defining thread throughout these sites is nuanced attention to Willow's relations and subjectivity. Girls chatting online as well as those I interviewed express a decisive need for queer young individuals on television that they can relate to, identify with, and desire. The attention and status accorded to singular characters goes beyond cults of celebrity, opening up spaces in which youth actively situate themselves in relation to the personal and social contours of fictional characters. Queer teens speak about the deep importance of watching and connecting with the experiences of out lesbian and bisexual characters at a time when they are growing up, trying to figure

out their sexuality, and negotiating their identities within heterosexist worlds. They focus on specific characters such as Willow in depth and with an extremely detailed and analytical knowledge precisely because the feeling, thinking and erotic layers of queer youth subjectivities are so rarely represented in the simplified formats of teen popular cultures. The dynamics of character transformations matter to queer girls in a media world that overlooks and others sexual minority teens. In this sense, engagement with individual characters on TV is a contradictory site for marginalized youth investment and longing. The quest for characters that resemble their lives seems oriented towards messy, fallible, and changing features of selfhood, rather than neat, sanitized, "positive" images; twenty-one-year-old Helen writes that she prefers characters that are not perfect and "exotic" media creations but girls "like me":

> I work at Taco Time. I don't have a girlfriend, and haven't in over three years. I wear normal, boring clothing and dirty shoes. I listen to Broadway musicals and obsess over TV shows. I love my friends but don't fall in love with them. Every person I'd like to be with doesn't necessarily want me back, and vice versa. I have an accepting family where there is no drama whatsoever related to being gay. I'm not a sex object used to please the male viewers. I am a real person who happens to like girls.

Helen indicates her need for identificatory figures that jibe with the mundane contours of her life world. But although many girls assert the desire for "ordinary" depictions, they also seem to want imaginative fictional alternatives that do not unify and fix what it means to grow up gay. It is not that youth want naïve realist texts that are assumed to reflect their lives, but they are interested in modes of representation that do not reify abstract ideals. Even when they favor fantasy shows such as *BtVS*, they hone in on story elements that address ambivalence and contradictions across Willow's relationships and choices. The girls I interviewed indicate that compelling, fleshed-out characterizations of queer youth on TV must include heterogeneous elements that help them identify and situate themselves.

Willow Rosenberg is undoubtedly the most complexly represented girl in love and lust with other girls to be developed within a mainstream network television series. She survives as a main character for the entire seven years of the show in which she undergoes tremendous changes, falling in love with a boy, exploring her bisexual feelings, and eventually forming a committed relationship with another girl for more than two years. Never before has a queer girl been given so much space to grow, hesitate, struggle, and assert her powers across a broad range of teen and young adult experiences. Rather than create

a "special" episode in which to package a queer teen story, the emerging signs of Willow's desires are interwoven across many story arcs. Unlike many attempts to represent gay or lesbian adolescence in terms of a crisis or a problem that is staged in relation to the normality of the rest of the show, Willow's queer inclinations take shape as part of the everyday banal, as well as spectacular, occurrences in the fictional dramas of Sunnydale. She comes of age over an expansive range of events and relationships and is given time to live out ambiguities without the pressure of a quick revelation or narrative resolution. It is not in isolated episodic acts or in static images that Willow's queer tendencies are framed or contained. It is not in a brief image of a kiss or the flash of a seductive exchange that I focus my analysis of Willow. *BtVS* provides a very unique framework that unfolds Willow's character over time, to become "gay" slowly and patiently, beyond the certainty of linear progression and finality. The young fans I interviewed engage in ongoing readings of Willow's character, attending to various aspects of her looks, words, and actions, trying to figure out her subjective uniqueness. And so any reading attuned to Willow's transformations must situate small character details, social relations, and narrative segments in an always incomplete picture of Willow's self-formations over time. Willow's character becomes a changing text, fractured by events and interactions, as well as surrounding conversations, that make any single description impossible.

Beginning with a discussion of Willow's ambiguous and flexible embodiments and transitions of subjectivity orients discussion towards the broader implications of a poststructuralist performative mode of signifying identity. Honing in on representations of identities of youth on television, Rob Cover makes a very strong argument for the ways "*Buffy the Vampire Slayer* in particular has portrayed an awareness of language as performative, as that which brings into being what it names as an effect of the act of naming" (9). Against ideological attempts to naturalize and categorize types of youth on teen television shows, Cover recognizes the intricate strategies of representation at work throughout the series that allow for reflexivity and open readings of character development and transgression: "showing up the ways in which the foundational relationships and subsequent patterns of identity performatively are unstable and open to re-interpretation" (12). Drawing upon Judith Butler's performative theory, Cover focuses on a mobility of self and meaning within the discursive limits of institutional powers and cultural modes of signification. Cover writes that "Performativity, then, is the understanding of subjecthood as the non-voluntary citation of the culturally-given signifier in a reiterative process that is never stable or guaranteed, and that always risks its own undoing

by the necessity . . . of reiteration" (4). Instability and reinvention are always already constituted while exceeding the terms of normative social identities. Reading the characters of *BtVS* through Butler's notion of performativity is useful insofar as representations of selves are continually at risk of becoming something else, while at the same time being contained by the dominant race, class, gender, and sexual discursive contexts and codes of teen TV.

Cover writes that all characters in *BtVS* enact tensions between a humanist ideal of a unified rational self and a fractured self marked by social conflicts, divisions, and abjection. In this way, Cover situates the constitution of differences within and between characters within general problematics of the postmodern condition. Centering on the universalizing tendencies of performative conceptualizations of identity becomes both useful and limiting for thinking specifically about queer sexual subjects in *BtVS*. Clover's approach emphasizes the uncertainty of all forms of identity on the series, rendering subjectivities on *BtVS* vulnerable to transformations, and provides close readings of how all the characters are at risk of becoming someone/something different from what they once were. On one level, framing everyone's identity as performatively constituted helps to avoid the othering of different characters, situating all transformations in a relational dynamic between desiring selves and discourses. This jibes with Sedgwick's "universalizing" approach that mutually implicates homosexual and heterosexual subjects. A limitation of this approach, however, is that it overlooks the specific and distinct ways Willow's performative embodiment of girlhood disrupts heterosexual norms on the show. Noticeably, when Willow's transformations are brought into Clover's discussion, it is her encounters with the powers of magic and witchcraft that get highlighted. It is striking that, although Butler's analysis of the constitution of "lesbian" identity is referenced by Cover as exemplary of performative repetition, Willow's sexual transformations as a young girl are completely left out of his interpretation. Unwittingly, the psychic and cultural contours of Willow's queer self get bracketed out of Cover's detailed interpretive work.

In contrast to such erasure, I want to read the specific contours of queer performativity through a distinct process of representing Willow's sexualized, racialized, and gendered desires and identities. I argue that a performative framework is especially useful for thinking through Willow's ambiguous enactments as a queer girl, which position her as different without necessarily positioning her as other. A key question becomes, is there something in the signifying practices of Willow's character that can be understood as queer or at odds with heteronormative assumptions of what it means to be a girl? How exactly is Willow's self

transformed? Willow undergoes profound changes in terms of her physical appearance, interactions, and verbal style. The Willow we meet in the first seasons is coded as a quiet, shy, geeky, hesitant, and book-smart girl, and yet, even within the contours of this portrait, we begin to discover her contradictions and excess. Both childish and mature beyond her years, sexually curious yet inhibited, ditzy and intensely focused, hyperrational and magically gifted, she fashions herself a cutesy little girl at times and asserts an aggressive boyish pose at others. Willow's knowledge, interest, and behavior are difficult to define from the start. Willow grows more and more enigmatic as the series evolves, becoming socially confident and supremely powerful as a witch while retaining elements of her teen girl self. Even before Willow shows signs of desire and love for girls, her character disrupts heterosexual feminine norms at the same time as she negotiates and struggles with them. Willow continues to be represented through her dynamic changes as a girl who is positioned as different yet similar, simultaneously negotiating and resisting cultural and social forces that marginalize her. Ambivalence pervades Willow's outsiderness as she both craves and refuses to be a "normal" girl.

Even in season three, while Willow is an ostensibly straight high school girl romantically involved with a boy, she embodies and verbalizes an ambiguously desiring self. I want to focus on Willow's own uneasy questioning of herself in "Dopplegangland,"[4] spurred by an uncanny queer naming of her leather dominatrix vampire self: "That's me as a vampire? I'm so evil, and skanky. And I think I'm kinda gay!".[5] This statement dynamically constitutes a queerness as both integral to Willow's self from another dimension and as repulsive. In this episode, Willow lives out a doubleness in which the notion of a single original self is momentarily confounded by the appearance of a strange yet an almost perfect copy. The distinctions between homely shy girl Willow and red lipstick–wearing, bad, bisexual, vampire girl Willow are simultaneously blurred and marked as they collide. In fictional terms, these oppositional versions of Willow are separated by a cosmic dimension, but, in terms of performance, they are played by one and the same girl, belying the very certainty of who she really is. Both Willows are enactments of a discursive type of girl, and both are vulnerable to variation and change in the practice of signifying them together. It becomes useful to return to Judith Butler's notion of performativity in which gender is not "a singular 'act,' for it is always a reiteration of a norm or set of norms . . . it acquires an act-like status in the present, it conceals or dissimulates the conventions of which it is a repetition" (*Bodies That Matter* 12–3). "Dopplegandland" disconcerts and provokes young fans of Willow to guess what this other self means. Many see Vamp Willow as deeply connected to good

straight Willow, as a side as yet unexplored or actualized. And some see the queer sexual desire embodied by Vamp Willow as a sign of Willow's unconscious desires for girls and power, foreshadowing who she will become in future seasons.

Willow's queer encounter with her own otherness can be understood through Butler's use of psychoanalysis to theorize the ways unconscious drives and fantasy propel performative processes of repetition to produce differences both within the self and in relation to symbolic norms. Understanding gender and sexuality in between psychic and sociocultural spaces, Butler foregrounds slippage and ambiguity over unity and sameness. This is a crucial move that destabilizes normative expectations of what is familiar, recognizable, and representable. Interweaving performative theories of language and psychoanalytic readings of desire, it is precisely through a "variation on that repetition" ("Gender Trouble" 145) that Butler locates the potential for subjective agency without relying on a self-contained notion of rational consciousness. This confounds divisions between original and copy by suggesting the imitative status of all sexuality. Butler uses psychoanalytic insights throughout her texts to account for sex/sexuality/gender as a culturally mediated fantasy that facilitates bodily materializations of desire. She writes that "identification is never simply mimetic but involves a strategy of wish fulfillment . . . we take up identifications in order to facilitate or prohibit our own desires" ("Gender Trouble, Feminist Theory, and Psychoanalytic Discourse" 333). Her attempts to theorize corporeality in terms of a performative inscription of words, acts, gestures, and desire on the surface of the body as psychic effects of incorporation alongside regulative discourses call into question categorical distinctions between internal and external dimensions of subjectivity. Butler writes that

> the unconscious is this excess that enables and contests every performance, and which never fully appears within the performance itself. The psyche is not "in" the body, but in the very signifying process through which the body comes to appear; in the lapse in repetition as well as its compulsion, precisely what the performance seeks to deny, and that which compels it from the start. (*Bodies That Matter* 28)

Challenging Lacanian notions of a monolithic law of desire as well as object relational paradigms which posit an origin of relational patterns, Butler uses a Foucauldian account of productive discursive incitements of desire and the embodiments they unfold. Combining Foucault's historical analytics with a psychoanalytic account of the "psychic which exceeds the domain of the conscious subject" ("Imitation" 24), Butler hypothesizes psychical relations sustaining cultural abjections of queer desire. A key idea here centers on the desire to become

and have what we most fear and reject. And it is Willow's simultaneous fascination and abjection that reveal the psychic resonance that Vamp Willow's queer differences have on Willow. Willow makes use of popular discursive insults to repel and devalue Vamp Willow's status as "skanky," "evil," and "gay," and yet her interest in watching, mimicking, and protecting her identical yet opposite twin is keenly felt. Willow experiences profound discomfort in the eroticized physical touch of Vamp Willow as she licks the neck of her human copy. Willow's visceral repulsion captures the uncanny desires evoked not merely by the lesbian overtones of this gesture but also the narcissistic pleasures it suggests: unconscious desire to become what she both already is and is not, in excess of her conscious will.

Willow's bisexual Vamp self is both a fictional and psychic construction; she can be understood in terms of a supernatural occurrence within the story line and as an imaginary figure that haunts Willow's self-perception. Bound up within her unconscious fantasies, Vamp Willow influences Willow in uncertain and uncanny ways. And it is precisely such ambiguous moments of contact between reality/fiction, conscious/unconscious, human/supernatural, self/other, and straight/queer that spur intense dialogues among viewers. While psychoanalytic and poststructuralist theories may seem an abstract way to approach Willow's character, the powers of fantasy and discourse are recognized within queer teen girl talk about Vamp Willow's status and meanings. Young fans on sites devoted to Willow labor to make sense of her desire and identity in terms of a process of performative repetition, in the sameness and strangeness through which Willow becomes hard to interpret. While some young fans draw very clear boundaries between the "normal" Willow and "evil" Willow, others complicate such divisions by affirming the aggressive erotic sexiness of Vamp Willow,[6] articulating their own desire for a more aggressive "bad-ass" Willow self:

> Hmmmm. The leather was yummy and the licking ☺ I think that explains it. Also the "I'm a big bad-ass" tude helped emphasize that. And it made it WAYYYYYY more fun to watch. "Bored now" In any other circumstance we would have looked at that and said "Damn she's just lazy." But because she gave off the bad-ass vibe it came off as chilling and just plain cool. But hey what do I know? I just use her name.
>
> (VampWillow, Kitten Board)

On the Kitten Board, dozens of responses to Vamp Willow affirm her "hot," sexually dominant and queer presence as a way to expand the parameters of Willow's feminine self. Youth use this fantasy image to think beyond the limits of Willow's good girl persona, while at the same time articulating their own desire for unruly and daring scenarios.

The girls I interviewed all expressed fascination with Willow's "other" self in "Dopplegangland," yet their interpretations differed widely. Some fans embrace Vamp Willow's sexual power while they also disavow her "evil" dimensions. Seventeen-year-old Judy suggests that the two Willows are connected: "Not in the area of being evil, but in the area of being able to express her love freely." Other girl fans reject the dangerous erotic bad-ass femme image as they disassociate the dangerous hypersexual aspects of Willow's double from the nice girl they assume she really is. What is remarkable are the ways many fans use this episode to think through the relation between Willow's shy, gentle, controlled, teenage self and her future transformations into a powerful queer witch. Alison, a sixteen-year-old, comments that "looking back on that episode was fun because there was so much foreshadowing (intentional?)." Willow is seen by these fans to embody more than what she represents at any one time as a "normal" high school girl. In this way, notions of a static, contained and knowable self are contested by the youth reading Willow, as they argue and explore the implications of her erotic and supernatural girl alterity.

A few critics have called attention to the ways Willow's unstable self reaches the limits of textual sense and coherence. Willow is, as Jess Battis writes, "a hybrid identity that deforms the texts of Buffy itself " (13). A key element of this hybridity, according to Battis, is the very illegibility of Willow's corporeal self. It is at the very point of the indeterminacy of her identity that Battis claims that Willow signifies a "lack of em(bodiment)" (paragraph 16). Referring to the episode "Restless,"[7] which enacts Willow's dream of being a character in a play that she does not know or understand, Battis writes that "her corporeality is as fluid as a dream" (20). Yet this dream can also be interpreted as containing one of the most sensual scenes in the show, a scene in which Willow inscribes a Greek love poem by Sappho on the body of her lover Tara. Fluid yet flesh bound, this corporeally luscious scene is remarkable for the ways in which it connotes the wildly passionate certainties of her desire in relation to a girl lover and her social anxieties about fitting in, feeling safe, and belonging. Rather than lacking embodiment, Willow suggests a performative movement of corporeality without social or symbolic guarantees.

It is very interesting that Willow's dream in "Restless" is structured by fear and anxiety about acting in a theatrical performance. Willow is faced with the pressure of performing without knowing the words or plot; she is unsure about what her role is and becomes confused as to why everyone else seems to know what's going on except for her. The very literal staging of a dramatic performance underscores the more vulnerable psychic elements of Willow's self as a signifying

process of identification that requires the social recognition of others. Willow's dream signifies her uneasy transition not only as a queer girl but as a "geeky" intellectual teen looked down upon and ignored by her classmates. Willow's dream explores the gaps and slippages between inner self and outer appearances, the "truth" and the public show. And it is precisely Willow's awareness of the imperfect interplay between them that is so terrifying. In many ways, Willow's outsider position as a smart loner girl in high school has left her with a hypersensitivity to being socially judged and scorned and also a recognition that it is in the effectiveness of public presentations of self that popularity and acceptance is won. As she begins to come out as queer, this knowledge becomes especially relevant to her as subjective desires come up against the scrutiny of peer responses. Willow's dream provides a representational figuration in which to signify the psychic pain and conflicts of being marked out as different and the pervasive anxiety that underlies Willow's seemingly controlled rational self.

Fans offer interesting dream interpretations that suggest personal awareness of the very fears this text unfolds. Christina, an eighteen-year-old girl, argues that "it obviously has to do with how conflicted Willow was at the time about her feelings for both Oz (her ex-boyfriend) and Tara, and the fear of her coming out. Each person has many different aspects to their personality and I guess the play kind of showed that she was conflicted about which role she should take at that time." Perceptively attuned to the ways this dream signifies Willow's unconscious ambivalence in relation to coming out, Christina talks about multiple sides of queer girls selves. Yet Willow's dream touches not only confusion and her fear of rejection and humiliation, but also her attachments to Tara as a safe, protective, nurturing girl with whom she is falling in love. Sixteen-year-old Kerry focuses on the symbolic ways in which Willow's desire becomes represented: "When you really break it down, you can find SO much symbolism in it. Everything from the use of curtains as security, or 'real names' as sexuality, to leaving the boys at her locker as if she's trading them for her life with Tara." "Restless" is an extremely productive text through which to consider the ways Willow's psychic life is inflected by her sexual and social circumstances as a girl on the verge of publicly performing and declaring her queerness. The point is not to finalize a reading of this dream text but to appreciate the ways it elicits discussion amongst girl viewers about the instabilities through which identity and desire are crisscrossed by the contingency of psychic fantasy in and through the regulations of symbolic norms. The irrational flow of Willow's dream is deeply embedded in the world of social judgment constituting internal fears of rejection that Willow so vividly feels and imagines.

It is important that Willow, who is on one level the most consistent pre-dictable teen character on the show in the first four seasons, also becomes represented in terms of the indeterminacy of her embodied desires and fears. Yet, unlike Battis, I do not regard her body as illegible in these moments, but rather, following the interpretive insights of queer girl fans, I regard them as chances to pause and consider how a young queer girl might dream in a context where smart girls are routinely belittled and where heteronormative assumptions and values structure the everyday worlds of youth. Willow's dream provides a glimpse not only into the pleasures of inscribing love letters on the naked body of another girl, but also the extreme terror of not belonging, of being ignored and violently attacked if the truth of one's difference is discovered. In this way, Willow provides queer girls with a cautionary tale of transformations, a tale of growth and knowledge constituted through an ambiguous desire to become more than who one already is with trepidation and persistence.

The subtle psychosocial contours of Willow's character unfold through a performative process of becoming open yet uncertain and vulnerable in encounters with others. Such a mode of representing a teen in transition pushes up against the very limits of heteronormative ways of conceiving of girl-hood. Willow's character is about temporal flux, spatial movment, alternation between binary oppositions, and unpredictable passages. *Buffy the Vampire Slayer* is a show in which all characters are explored through boundary cross-ings, oscillations between human and supernatural, good and evil, normality and the grotesque. Yet it is Willow's character that lives most precariously in the liminal spaces in between, incomplete yet present. Jess Battis writes that Willow's "growing pains are of particular importance, for they identify her as a hybrid site upon which several of the show's most resounding ambivalences converge, overlap and shadow each other" (2). Willow is a deeply unsettling character, eliciting and shaking up viewer comfort in continuity and sameness, shifting from a reliable kind intelligent girl character into a powerfully willed witch and lesbian lover. The transformative aspects of Willow's character contain and exceed her sexual desires and relationships, yet it is the multi-layered picture of performative selfhood developed on *BtVS* that provides a unique framework for representing queer girl feelings, fantasies, identities, and actions. When she finally declares her love for Tara, it is neither the founda-tion nor the end of her "gay" self, rather, it becomes interwoven through her changing experiences as a girl growing into a powerful young woman on the verge of becoming something else.

Willow's Desires: Reading Contradictory Signs of Young Queer Sexuality beyond a Single Kiss or Cliché

Our gay youth, and all viewers of *BVS*, had for the past three years, the rare opportunity to see two women, openly express their love for each other as main characters in a television program. A devoted loving couple, who were trusting, unselfish and protective of each other, reflected the many lesbian and gay long term relationships existing in the real world, but, seldom acknowledged.

R. Zeke Fread (Cited on the Kitten Message Board)

Willow's a total sado-masochist in the sack. Plus, she's definitely fond of girls!

Kerry, age 16

These two quotes reveal substantively different ways of appreciating Willow's sexual and romantic relations as a queer girl on TV. Fread focuses on long-term stability framed in terms of the romantic love and care that Willow and Tara represent as a "devoted" monogamous lesbian couple. As a community organizer focusing on the efficacy of positive role models on TV, Fread places emphasis on a reflective model of representation in which fictional relations of love between girls are understood as mirroring real life examples. Such sentiments are also common on fan sites and in my interviews where youth affirm the "healthy," "functional," and "normal" qualities of Willow and Tara's relationship. Yet fan interest does not stop here. Girl viewers also imagine Willow's sexuality beyond the confines of such normatively "positive" images, pushing towards the limits of the text to imagine the intricate details of Willow's erotic fantasy and "perverse" inclinations and fan fictional reconstructions. Youth push Willow's sexuality in several directions, sometimes using it to shore up normalizing liberal readings of Willow's sexual propriety and romantic reliability and at other times using it to transgress the boundaries of what is representable on mainstream television. Such contradictory uses of Willow's amorous relations are my focus as a way of both analyzing and troubling the very terms used by critics and queer girl viewers to make sense of queer girl sexuality.

I argue that just as Willow's character is represented in terms of complex psychic and social transformations of self, her sexual identity and relations on the show are in flux and open to many interpretations. As a teen growing up, developing crushes, and falling in love with boys and girls, and eventually coming out in university, Willow's desires are represented across temporally shifting yet continuous story arcs that allow for more dynamic understandings

of teen sexuality as something that changes. A season after Willow confronts her Vamp Willow double, she begins to fall in love with Tara. In the process, revulsion at the prospect of her queerness turns to personal awareness of her own desire for another girl. Willow reconstitutes herself as a "gay" girl in the silences as well as in the visual and verbal languages and relations through which her relations with Tara intensify. Coming out is not dramatized as a sudden awakening or climactic social drama but is interwoven into the script as an unfolding intimate experience that eventually becomes common knowledge amongst her group of friends. As a transition rather than a single event, coming out is represented through slow gradual movements of recognition. The episode "New Moon Rising" marks a key coming out scene evocative of the awkward indirect and convoluted ways in which queer youth attempt to tell straight friends about their sexual and romantic interests. Communication between Willow and her best friend Buffy in this scene is played out in hesitantly comical ways:

BUFFY	Okay, I'm all with the whoo-hoo, here, and you're not.
WILLOW	No, there's "whoo," and "hoo." But there's "uh-oh" and "why now?" And it's complicated.
BUFFY	Why complicated?
WILLOW	It's complicated . . . because of Tara.
BUFFY	You mean Tara has a crush on Oz? No, you . . . Oh! Oh.

Excerpt from 'Buffy the Vampire Slayer' (episode New Moon Rising) copyright 2000 courtesy of Twentieth Century Fox Telivision. Written by Marti Noxon.

Buffy up until this point had no idea about Willow's romantic involvement with Tara and is verbally and visibly in shock. Her response is deeply ambivalent as she struggles to hide her feelings of surprise and discomfort. At the same time, Buffy immediately reassures Willow that she is totally supportive; she works hard to convey a stable appearance that suggests nothing has changed and that her love and care for her friend remain strong. Fans hook into both the continuity along with a sense of disruption evoked by Willow's coming out as she remains central within the Scooby gang[8] while learning to reposition herself as an emerging "gay" girl within a heteronormative context. Linda writes, "It took a lot of thought and personal debate but in this episode, Willow finally came to terms with her own sexuality and had the guts to tell someone; she took another step toward being open about it (something I can personally relate to)."

It is significant that, in her exchange with Buffy, and in other coming out moments, Willow does not use the "L word" to name her desire for Tara. She is

Still from "Once More, With Feeling," *Buffy the Vampire Slayer,* copyright 2002 Twentieth Century Fox. All rights reserved

never portrayed transparently or definitely as a "lesbian," and, while she makes scattered references to being "gay," Willow shirks categorizing herself even as she very clearly claims her love of Tara. Whether such avoidance of clear identity markers is a result of WB's hesitation to depict lesbian sexuality or a linguistic rendering of her queer fluidity, it marks an area of ambiguity triggering much debate on fan sites surrounding how to name and talk about Willow's sexuality.[9] Writers such as Rebecca Beirne have understood such ambiguity as a sign of Willow's lack of confidence and strength, claiming that "the lack of any clear definition between the straight Willow and the lesbian Willow, lends a high level of inauthenticity to her sexuality" (3). Yet many girl fans regard Willow's refusal of a clear-cut label as a sign of the contingency of her sexuality and her emotional uneasiness as her desire shifts from Oz to Tara. Calling attention to the specificity of Willow's love for Tara, fans insist that it is not gender or same-sex qualities that fully define their love. Christina says, "I also think that Willow wasn't in love with Tara because Tara was a woman, but because Tara was Tara," refusing to reduce the singularities of their connection in terms of the abstractions of a lesbian identity ascription. Christina also insists that Willow not be boxed in by an exclusive focus on her sexual identity: "She was Willow before you knew she was gay so she wasn't defined by her sexuality. After she came out, she was still just Willow. She wasn't GAY! Willow right from the start. It was a process." This generation of viewers seems to approach identity categories with suspicion that crosses over into their own lives and modes of self-identification, as many position themselves as queer, bisexual, lesbian or "lesbian with straight tendencies." For them, Willow remains uncertain and open in her sexual orientation and this is a predicament that is accepted without judgment or explanation. In Alison's words, "I think queer is a good word to describe Willow because she is quite sexually ambiguous."

Girl fans connect with the vulnerable feelings, hesitations, and risks of coming out explored through Willow's character. For teens in the process of naming themselves as gay, lesbian, bisexual, queer, and questioning, Willow offers cultural relief from pressures to adopt a coherent transparent identity, offering room to explore the troublesome fit between social categories and subjectivities. Connecting to a fictional world in which another teen is shown going through the convoluted motions of coming out and surviving, youth forge a transitional space between self and text. Jackie claims, "I came out when i was 16 and the show was a comfort blanket for me." A few girls cite the show as their first glimpse of a erotic relations between girls. Alison, a sixteen-year-old girl, says that "Willow and Tara were the first lesbian couple I had ever seen, and that helped me in many ways in learning to accept myself." The show has

unique value for girls who are on the brink of discovering how to articulate their desires, especially for those living in small towns without access to a range of queer public figures, spaces, and events. Just as Willow eschews sexual classification, her queer fans refute a simple static positive image of Willow as a lesbian girl, more interested in her ironic, relational, and provisional approach, captured in her wry comment in the face of denial: "Hello, gay now!" ("Triangle"). Willow is appealing as a girl who is given a chance to come out without being totally defined and categorized by that event once and for all.

The serial continuity of *BtVS* works against treating Willow as a "special" girl or fixating on her sexual difference as definitive of who she is. This has led some critics to argue that Willow's queerness is normalized, integrated within the show so as to be assimilated with the rest of the romantic story lines and character developments. Yet the process of normalizing queer girls on TV is complicated both within the specific elements of this text and across the discussions of girl fans. For many fans, the very chance to see a sustained ordinary relationship develop slowly between girls over time is key to their identification and enjoyment. Alison values Willow and Tara's relationship as "normal" because "they got along. sure they had a few arguments but they managed to stay together for two and a bit seasons. TV shows tend to depict lesbian relationships as a quick fling, and then straight back to men (which is definitely not normal) which is why I liked the Willow and Tara storyline." Appreciating the ways Willow and Tara are represented in a committed romance with ups and downs, fans speak about how rare it is to see seemingly banal qualities in the context of two girls in love. For the most part, queer girls locate the uniqueness and power of this show in its portrayal of an uneventful tender relationship between girls.

Although sexual identity categories are shied away from, Willow's emotional and erotic investments in her first girl lover Tara are not. *BtVS* provides a drawn-out narrative framework in which Willow and Tara's romance becomes acknowledged and integrated into the broader community. Yet acceptance and belonging are neither smooth nor complete as Tara struggles to find her place within the Scooby circle, grappling with subtle signs of homophobic exclusion. The most striking sentiment shared by fans is their awe and respect for the caring romantic bond between Willow and Tara. The intensity of their communication as both friends and lovers gets talked about a lot. A deep intersubjective mutuality of affection and understanding between the girls is the almost unanimous focus of the fans I interviewed. Karen writes, "I liked that it was more about love and connections rather than labels and an excuse to show girl on girl action." In sharp contrast to the aggressively physical

eroticism between Buffy and her lovers, Willow and Tara represent comforting love portrayed through soft touches, gentle embraces, and light kisses. While these gestures may seem conservative and sentimental, the impact they have on queer teen fans is remarkable. In social and media contexts where trusting, open affection between girls is scorned, the supportive and sustained passions of even the most reserved desires between Tara and Willow are valued by youth far beyond their more formal textual meanings.

While fans overwhelmingly praise the caring, unspectacular, everyday qualities of Willow and Tara's relationship, academics are more apt to view the romantic normalization of this pair with suspicion. Farah Mendlesohn argues that a "heterosocial model" (49) predominates with *BtVS*, resulting not only in an emphasis on Buffy's heterosexual romances but also in a desexualization of Willow. While Mendlesohn is writing at the beginning stages of Willow's relationship with Tara, her attention to the heterosexism of the show raises some important issues. Referring to Willow and Tara, Mendlesohn writes that "On the one hand this is lesbianism for the male gaze; on the other hand, there is a clear sense that the producers were attempting to avoid this route, but its very openness and innocence desexualizes and removes the erotic tension crucial to a queer reading of the text" (58). Mendlesohn does not explore how or exactly what this "erotic tension" means in terms of a queer reading, but she suggests that Willow and Tara represent a couple who are similarly gendered (referring to feminine narcissism) and lack the antagonism of desire based on differences. This leads her to argue that Willow and Tara's relationship "undercuts a queer reading" (59) of Willow and neutralizes her sexuality in "a safe direction." This resonates with what Rebecca Beirne calls a monotonously "safe" and "normalized" relationship with Tara that delimits Willow's queer potential. Mendlesohn and Beirne also focus on a desexualization of Willow through language, dress, and behavior, arguing that the cuddly soft pink attire, along with Willow's reserved sweet attitude, lacks an aggressive risky seductive edge culturally associated with sexual girls. Such analysis is premised on a very limited criteria for defining what a queerly sexual girl looks and acts like. The erotic tensions of queer sexuality that Mendlesohn and Beirne briefly mention make implicit assumptions about the qualitative differentiation between romantic love and queer desire that I would argue girl fans refuse to make. For young viewers, Willow's romantic devotion to Tara is not so much about desexualization but rather about affectionate and nurturant eroticism. On the other hand, some fans are openly frustrated with the ways explicit sex scenes between Willow and Tara are obscured or denied explicit representation, pushing them to imagine and rewrite what is left out of view.

Providing a more specific analysis of sex scenes between Willow and Tara, Edwina Bartlem writes that lesbian sex is depicted through the conventions of fantasy not realism on the show. Associated with magical rituals, lesbian sex is portrayed as a supernatural and mysterious event. Throughout Willow and Tara's relationship, sex is metaphorically eluded to in the blowing out of a candle, a levitation ritual, or in the ecstatic climax of a magic spell that sensually suffuses them with orgasmic pleasure. Bartlem writes that this "depiction of lesbian sex as a form of magic, situates it as being beyond the material world, outside the physical body and beyond reality. It is constructed as disembodied, supernatural and spiritual" (9), implying that lesbian sex is abnormal, deviant, and unnatural "beyond representation on mainstream television and beyond the understanding of most viewers" (10). Such ideas poignantly reveal the influence of hegemonic discourses to marginalize and deflect open representations of physical sexual love between young women. There is little doubt that the use of metaphors of magic to signify lesbian desire constitutes conscious attempts to work around institutional censorship, since WB was adamant from the start that lesbian kisses and physical intimacy be minimized, imposing strict rules about what could and could not be shown.[10] Due to network regulations, Willow and Tara were never given the chance to be full-fledged physical lovers on the television screen. It is strikingly obvious that, although Willow and Tara come out as lesbian lovers, their sexual relations are continually deflected and muted in terms of visual representation. Many girls I interviewed expressed their appreciation of Willow and Tara's relationship and yet were disturbed by the relative lack of explicit sexual interaction between them. Eighteen-year-old Christina writes,

> I think the idea that lesbians can have healthy, loving relationships was portrayed well, but I don't think their relationship was ever taken as seriously as any of Buffy's relationships with men. Tara and Willow were the "cute" couple but there was rarely anything sexual revealed about them.

In the face of such visual concealment, fan responses are often more nuanced and imaginative than the detached rationalizations of academic critics and television executives. Acknowledging yet superseding the limits imposed by network codes, queer girls' readings range from tame elaborations to wildly "perverse" projections. Such accounts actively rework the most intimate features of Willow's queer girl self. A thread on the Kitten Message Board titled "Willow the Sexual Aggressor" unravels scores of possibilities. One girl writes, "I love the idea of Willow the active woman lover. It's one thing for people to think hey, Willow likes girls . . . its quite another to see Willow take pleasure

from loving a woman. If that doesn't like cement the whole thing, I don't know what would." Dialogues between fans create a bridge between media representations and detailed fantasy scenarios that address what is absent within the text. The lack of visible erotic exchanges between girls gets supplemented by a proliferation of playful sex talk, putting into words what is left unmarked in network television. Another Kitten Board thread called "Naked W/T Sex" involves girl fans writing about precise sex acts they would like to see Willow and Tara engaged in. Willowlicious writes,

> So, what do I want? Everything I can get. Tongues, saliva, open mouths, panting, sweat, Tara on Willow, Willow on Tara, hands disappearing beneath the sheet (damn sheet!), looks of pure bliss, pleasure and naughtiness, moaning and groaning, and, yes, the ever-popular Orgasm Face! In other words, we've had 2 1/2 years of sweetness. We know how much they love each other. I want the PASSION now!

These lusty online speculations are merely the tip of embellished constructions of Willow's adventurous sexual escapades in fan fiction and fan art, providing insight into the ways girls use TV to invent and explore their sexual subjectivities. Such visual and verbal conversations about queer girl sex reveal highly interactive dynamics of TV watching and revising. When youth are asked to talk about Willow's sexual relations, they provide a range of ideas that both recognize the formal limits of the show and reread them in and out of con/text. Talking about Willow's sexuality gives youth a chance to dialogue about queer sex, invoking their fantasies to fill in the gaps of network television, posing questions and thinking through the precise practices and scenarios that turn them on. Willow's transformations[11] at the end of season six become the site of frenzied dialogues between fans. For many who are fixated on the tragic "clichéd" ending of Willow and Tara's love story, this turning point marks an abrupt end to their viewing pleasure and their erotic and emotional engagement with the story line. For others geared toward fabricating Willow's character in new ways, her embodiment of rage and ruthless force opens up new possibilities for envisioning queer girl powers.

Willow's Revenge: The Unspeakable Pleasures of Queer Girl Rage and Power

> I loved EvilWillow because she was sure of herself . . . and confidence is infinitely sexy. She frightened some people, but I loved every second that she was on screen. The power made her strong, and the strength made her sure. There was a bounce in

her step and a wonderfully sarcastic tone to her voice. And yet there was still vulnerability beneath the confidence that I just found adorable. She was hurting, and the pain made her angry, and the anger gave her strength, but underneath it, she was still just Willow.

Helen, age 21

DAMN LESBIAN CLICHE! DAMN YOU JOSS WHEDON! I don't really watch TV since "Seeing Red."

Judy, age 17

Willow and Tara's relationship ends in a horrific mishap of male violence in the episode "Seeing Red." A bullet intended for Buffy hits Tara in the heart, and she dies instantly. Willow is sprayed with Tara's blood shortly after the lovers are shown for the very first time in bed together. The tragic dimensions of this convergence of amorous sex between girl lovers and violent death are undeniable, yet the implications are uncertain. Queer girl fan responses are torn between extreme anger at the abrupt killing of Tara at the moment of their reconciliation to excited fascination at the unleashing of Willow's fury and ruthlessness. Willow's grief and rage in the face of Tara's murder spontaneously drive her to enact unprecedented powers as one of the strongest witches on earth, and it is the contours and responses to this representation of girl power that I want to hone in on. Just as we rarely glimpse young lesbian relationships on television with the continuity of love evinced by Willow and Tara as a couple, we hardly ever get to see a powerful queer girl in action. While Willow's force is configured in terms of villainous cruelty, it is also remarkably compelling in its omnipotence and willful emotional force. Key questions become: How are Willow's powers represented and intelligible within popular culture? Is a lesbian lover's rage meaningful beyond lesbian/death/evil clichés? In what ways do young queer fans of Willow respond to such disturbingly vivid images of power?

Strikingly, Willow becomes more powerful than the show's hero Buffy, born of feelings that are utterly human, along with magical powers spurred by deep emotional suffering at the core of Willow's being. As she enacts revenge on the boys responsible for murdering Tara, her supernatural powers are wildly unleashed, marking a transformation of her character from a "good," polite, controlled girl into an unyielding self who uses limitless psychic, mystical, and physical energy in pursuit of retribution. The change is visually stunning as Willow's hair turns from strawberry red to black, her skin becomes aged and covered with dark veins, and her body becomes aggressively aware and confident. Similarly, Willow's words turn from tentative to exact, she is commanding and

Still from "Grave," *Buffy the Vampire Slayer*, copyright 2002 Twentieth Century Fox. All rights reserved

masterful in her whip-sharp rebuttals, sarcastic quips, and determined demands. Undoubtedly, Willow is dramatically altered, and yet she emerges in this striking form out of the history of her experiences, talents, and emotional investments. This is not some freak event but a response to senseless murder that takes the form of mystical yet humanly motivated power. During the final episodes of season six, which include "Seeing Red," "Villain," and "Grave," an extraordinarily intense visual and verbal spectacle of excess power embodied by a young woman propels the plot forward into scenes of escalating violence.

In the end, Willow returns to her gentle vulnerable self, yet she is changed forever, and so are girl fans so engaged in the traumatic movements of her loss. Willow's dangerous desires and powers are safely contained as she deviates from the expectations that continue to constitute her as good smart girl on the brink of becoming something else. Willow's power as a witch and her queer sexuality are pushed to extremes, represented in terms of addiction and obsession at several points on the show only to be reigned in through the suffering of guilt and remorse. Moderation, understood as normative use of physical force, intelligence, and desire, becomes redirected in the service of Buffy and friends as a moral tale ensuring Willow's sanity and belonging. At the same time that Willow's use of physical and emotional excess is ultimately tamed, it becomes crucial to recognize that never before in a teen series has raw fury been so vividly explored through a young queer girl responding to the sudden death of her lover. Willow's embodiment of rage and power expresses the universality of human emotional pain, the specificity of a lesbian girl's desire for revenge, and the supernatural wonder of a witch's strength and knowledge. Each component of this power is vital for understanding the actions Willow takes and the ambivalent reactions they provoke in viewers. At one level, Willow is given space to explore the depths of love and loss, to show the world her feelings without constraint, to live out full-fledged direct anger for all to witness. Such emotionally and physically vivid expressions are highly unique in the context of television images that tame or occlude the affective dramas of lesbian characters. The intense visual spectacle of Willow's emotional struggle becomes identified by youth as a key site of her growth and heroic status as a girl who overcomes inordinate obstacles to achieve ethical and sexual maturity. At another level, cultural stereotypes of lesbian excess and evil make this portrayal highly suspect. Willow's assertion of her Wiccan powers can be understood as reiterations of negative and irresponsible representations that frame lesbians' anger and actions as irrational, nonhuman, mystical—as irreparably other to Buffy's moral role as a heroic savior of humankind.

Many fans online lament stereotypical connections between lesbians, death, and evil in the final episodes of season six. Debates about the homophobic implications of the fatal attack of Tara, and the emergence of violent Willow, center on the long history of portrayals of lesbians as witches and vampires as dangerous, addicted, murderous, crazy, suicidal, and depressed. So rarely is a lesbian depicted as happy and sane that to reiterate a drama of murder and furious revenge in relation to the first and only romantic teen relationship between girls on television confirms a legacy that dooms lesbians to inevitable unhappiness and madness. While writers and producers of the show have argued that it was not homophobia that shaped this story line but the necessities of the season's story arc of moving Willow into a villainous position of a girl in maniacal possession of magical power, many fans see this as an irresponsible repetition of the lesbian cliché.[12] On the Kitten Message Board, discussion inspires analysis of the inescapable symbolic and ideological implications of killing a lesbian at the very moment of her erotic happiness, pushing her girlfriend to the brink of violent madness. The historical baggage of this plot seems unforgivable to many girl fans whose belief in the longevity of Willow and Tara's relationship goes beyond the fictional expediency of TV ratings. Such charged criticism provides insight into television viewer/writer relations, with many fans calling for a more responsible and accountable process of screen writing that begins with the needs and interests of the fans.[13] But, of course, fan identities, needs, and interests are neither unified nor certain. It is the discord produced in between text, context, and viewer response that is up for grabs in interpretations of what and how Willow's power is culturally and subjectively meaningful. Some interpretations indicate a less oppositional reading of the text, seeing this narrative ending as a tragic event in which Willow becomes even more complex and layered. Stephanie Zacharek writes that "Willow, far from being a cut-out angry lesbian is more fleshed out, and more terrifyingly alive, than she has ever been before" (1). Similarly, eighteen-year-old Lana asserts that "once the cat is out of the bag Willow becomes more powerful more free and sexy because she is true to herself and is being who she really is." Such readings turn attention to the contrast between the rule-bound, reserved Willow who is rarely "naughty" and the manifestations of her power as wildly aggressive and defiant of normative codes and limitations.

Tensions between criticism and revaluation of Willow's villainous incarnation generate exchanges in which to consider queer girl powers, pleasures, and desires. Emerging insights reveal more about the contested cultural significance of Willow's actions and words than an abstract repetition of an evil lesbian stereotype. When developing readings of Willow's queer girl power, it

becomes crucial to consider how, why, and when it unfolds not only within the larger story arc but also from the perspective of the dynamic life worlds of queer youth audiences. Many fans were furious at the termination of Willow and Tara's relationship, and it is interesting to note an overlap between the extra-textual anger expressed by fans due to the loss of Tara and the intratextual expressions of Willow's rage. Yet even girls who are adamant that the way Tara died is "horrible" and "wrong" offer less clear-cut opinions when it comes to interpreting Willow's transfiguration. The ambivalent discord provoked by the emergence of "evil" Willow reveals the uneasy intrigue that surrounds the embodiment of rage and anger by a queer girl witch who no longer cares what others think, who says and acts how she feels in the immediacy of rage, while at the same time harnessing the power to defy natural laws and destroy the world.

Representing unbound anger is unique within TV representations of girls. Elyce Rae Helford argues that anger is mediated by race and class differences within *BtVS*, such that the white middle-class hero uses anger in acceptable ways while marginalized characters are punished for their transgressions. Buffy's normatively contained and deflected anger is contrasted with inappropriate expressions of anger by the other slayers on the show, such as Kendra, a slayer of color, and Faith, a hypersexualized working-class slayer. With the development of Willow's character, her embodiment of anger is also a striking marker of her difference from normative ideals of femininity. Although she is both white and middle class, Willow's "perverse" desires for girls along with her Wiccan powers set her apart and code her as threatening to the point of becoming monstrous. Yet it is not only the ideologically charged race/class/sexual hierarchies that matter in terms of a critical reading of representations of Willow's angry self, but also how fans engage with these hierarchies. Queer girl reception of Willow's anger reveals a conscious awareness and suspicion of cultural legacies demonizing lesbians as violently dangerous. This mediates how far girls go in identifying with this narrative turn, at once eliciting excitement at the chance to witness the unleashing of anger and grief and a fear that open displays of anger will once again be used to devalue and punish queer girls. Such tensions show how difficult it is for queer girls to shape and utilize the meanings of "bad" Willow beyond heteronormative narrative closures. Throughout season seven, Willow ends up disciplining herself to become more emotionally controlled, and fans, in turn, enact equally controlled responses that pull back from too much enjoyment or guilty pleasure in watching the excesses of Willow's queer girl rage.

Willow's dramatically unfettered affect and energy resonates strongly, if ambivalently, in a world where girls who desire girls are under constant pressure

to obey norms and rules, to keep quiet and conceal physical affections, to tame emotional responses, to repress and censor desires, and to accommodate themselves to hetero-feminine ideals and privileges. It is against the general backdrop of such restrictions, as well as their specific embodiment in "good girl" Willow, that the relevance of Willow's raw indignation, revenge, and magical power emerges. Willow's powers come to signify so much more than a cliché such as lesbian = death = evil, as youth engage with Willow's self as a text open to retellings and interpretive rememberings of her contradictory developments, strengths, and imperfections. To reduce the text of "evil" Willow to static clichés is to read it narrowly through the lens of hegemonic ideologies and assumptions rather than through the interpretive contradictions of queer girl feelings and ideas. In this sense, the very activities through which youth address the limits of lesbian clichés undermine any singular influence, comprising innovative ways of approaching the dilemmas of a good girl self turned wickedly bad. Responsive accounts by queer girls provide important counter-discursive moments through which fans imagine alternative realms of queer girl power connected, yet not reducible, to the binary categories that split good and bad, natural and unnatural, moral and evil.

Willow's powers trouble safe, easily recognizable, and commodified images of *girl power* in popular media. In her climatic crisis of force, Willow does not embody a pretty sexy ideal of young femininity; she is, as Xander[14] states, "scary veiny."[15] Willow both looks and acts outside the parameters of the lusty glamorous action girl, and, as such, her power is not completely unrecognizable within its commodified terms. Willow shows up the very limits of what makes girls culturally valuble, while remaining socially and affectively bound to those same references and meanings. It is precisely Willow's connection to Buffy as part of the Scooby gang that renders her differences integral yet resistant. As a girl who is intimately part of the story lines centered on Buffy's looks, actions, and moral perspectives, Willow provides an alternative that engages with and disrupts heteronormative ideals of girlhood. She breaks the mold of being merely a marginal sidekick, giving rise to a close friendship between a straight and a queer girl hero who mutually learn from each other while embodying and performing desire and power in qualitatively different ways.

On one level, Willow acts alongside Buffy as part of a concerted mission to fight evil that seems to transcend the particular qualities of her embodied desires. At another level, Willow's heroic quests center around her will to articulate her differences as she strives for personal fulfillment and recognition from others. Coming into her power as an autonomous subject depends upon

both an assertion of her desires and powers and a responsiveness of her friends to see and love her back for who she wants to be. Willow's development as a character reworks generalizing contours of girl power to include elements of her quirky, smart, techie mind, her ambiguous and changing sexuality, her angry force as a witch, and her cautious return to magic in the service of saving the world. It is impossible to sever Willow's power from her heterogeneity, which both enables her to transform and be flexible but also compels Buffy and the Scooby gang to open up to the differences she represents. There is no doubt that her powers grow and are transformed through magic as she comes out and actualizes her desire for Tara. Willow's heroic powers are inextricably marked by her sexual desire for girls, yet she is never reducible to this part of her self. In this way, Willow's heroism and sexuality are ambiguously linked. Some fans read them together and some separate these elements of power and sexuality as incommensurable. Twenty-year-old Janet writes that, while she considers Willow a hero in terms of her use of her witch powers to save lives and help people, "her sexuality makes her real, not a hero." Janet sees heroism in terms of supernatural capacities and sexuality in terms of "real," sensual, mortal human relations. Yet, for other fans, the crux of Willow's status as a hero revolves around the ways she deals with desire and loss to become a more confident and knowledgeable young woman within the context of her friendship with Buffy. Nineteen-year-old Karen writes that "Willow gave the message that you don't need to be super strong, you can have brains and other powers." Without either collapsing or dichotomizing Willow's sexual and heroic self, it becomes possible to create a flexible and open conception of girl power that integrates them. What stands out for many fans are the ways both Buffy's and Willow's powers in *BtVS* involve a complex mix of human and superhuman, sexual and caring, physical and emotional, and intuitive and rational traits.

Racial and Class Privileges of Girl Heroes

In the Buffy realm, I don't think that someone's color or social background really has as much influence as the person themselves. Willow, who is homosexual and Jewish, was treated just as anyone else. The same goes for characters like Kendra; they were never discriminated against. Although, I guess the abundance of white middle class characters would leave the other races feeling not so influencing or taken into account.

Linda, age 16

I don't know if Buffy would have done as well if they had more diversity but then again that is almost racist that they didn't. I never realized it until now . . . wow

Lana, age 18

It is the relational strength of Willow's and Buffy's heroic powers that provides a unique representation not only of girls working together but also of mutual support and understanding across sexual differences. What becomes significant are the dynamic bonds between a queer and a straight girl who use their powers in alliance together. But while some boundaries are redrawn to include socially diverse relations between girls, other boundaries are reinscribed to devalue and exclude other girls. It becomes important to ask precisely what types of girls are being recognized within the social universe of *BtVS*. Although girls interact across a range of racial, sexual, and class differences throughout the series, questions remain as to whether Buffy's white heterosexual middle-class status constructs a privileged ideal and center point of heroic girl power. Are differences within and between girls prescribed and separated in hierarchical ways? How exactly do Willow's class and racial position work to normalize her queer identity on the show and promote specific kinds of identifications at the expense of others?

The idea of being a "normal" girl is continually explored through the *BtVS* series. While Buffy appears to fit all the physical codes of being normal within dominant cultural terms of small town America, her status as "the chosen one" sets her continually apart as inexorably different. Yet her difference from the normal is the result of supernatural gifts, a fate that is neither socially determined nor individually chosen. Buffy's class, race, and sexual position and identities are indicative of her exemplary normativity within mainstream teen television. In other words, Buffy is socially located inside normalizing regimes of power even while she is an outsider as a slayer. It is the tension embodied by Buffy between being normal and different from other girls that configures her heroic struggle on the show. Yet what frames the terms of her individual struggle is the structural normativity of white heterosexual middle-class ideals and values. Similarly, Willow's differences as a smart queer witch are produced and contained within a larger social system into which she fits and in which she exceeds codes of girlhood. The very standards implied in the construction of Buffy's and Willow's apparent normality, as well as their departures from the normal, are taken for granted throughout the show as an invisible foundation of commonality and popularity. They are able to connect across their respective differences in large part because of their shared social stakes as "normal" girls. In this way, girl power is represented in such a way as to highlight and accommodate isolated differences while systematically excluding others within the fold of friendship and community.

Such invisible norms and exclusions are not merely text bound but reach into fan dialogues about the show. Amongst girl fans, there is a striking lack of discussion about what race and/or class means in relation to character relations and story lines. Amongst hundreds of postings on everything from Willow's fashion accessories to the way she kisses and her dealings with homophobia, it is very difficult to find substantive interest in race and/or class as a topic to discuss and argue at length. This is a function of the ideological nature of TV and the fan cultures it produces that tend to focus on visible, individual and depoliticized qualities. In this way, hierarchical structures of value, domination and inequality along with what is unseen and unheard within the frame of *BtVS* are rarely articulated within fan communities. When asked directly, several girls I interviewed skirt issues of race and representation, utilizing liberal discourses of formal equality. Alison writes, "If Willow had been black, I think she would have been just as popular as she is white." Yet such responses deny the importance of racial identity or power differences, invoking the value of individual character qualities abstracted from any particular social markers, institutions, and histories constituting racialized meanings embedded within popular entertainment texts. Whiteness becomes a pervasive dimension of girl power and popularity, constitutive yet erased within the dialogical formations of fan cultures.

At a distance from girl fan perspectives, several critics have focused on the ways in which racial differences are signified to consolidate the normative powers of white girl heroes on *BtVS*. Close textual analysis of Kendra, who represents the first black slayer girl to make an appearance on the show, reveals that she is not only denied equal recognition, but is also isolated, taunted and actively pushed away from the Scooby gang inner circle. Not only does Buffy dismiss and ridicule Kendra for not speaking like everyone else and failing to understand the conventions of American teen culture, but she also constructs and reifies Kendra's characteristics as other to the ideals of what a good slayer should look, talk, and act like. Lynne Edwards argues that Kendra becomes othered on the series as a tragic mulatto figure. She is visually and verbally coded as not only different from white suburban Sunnydale teens but as inferior, an exotic outsider who can never claim the status of heroic slayer. Kendra is marked as other to Buffy, "the more Kendra becomes like Buffy, the more willing Buffy is to accept her. This acceptance, however, accentuates Kendra's otherness" (Edwards 94), revealing how assimilation into the social network of the Scooby gang is premised on white supremacist codes of sameness. The racialized difference represented by Kendra works to reinforce the "normal" social world of belonging and friendship shared by Buffy and Willow and

friends. Within the narrative of *BtVS*, racialized social boundaries have dire consequences for girls of color, resulting not merely in marginalization but more dramatically in violence and death. Kent Ono argues that

> In contrast to blond Buffy, Kendra's presence seems to pose a threat to the uniqueness of Buffy, to her whiteness, and perhaps to her individuality. The fact that Kendra is a woman of color who ultimately has her throat slit is just one more instance of a woman of color who cannot be a hero. (174)

As a text driven by the themes of friendship and empowerment between girls, it becomes crucial to scrutinize *BtVS* in terms of systems of representation that connect some characters while creating oppositions. Race and class differences become dichotomously structured throughout much of the series, ensuring clear divisions between us and them, as well as riffs between good and bad girls. As a working-class Slayer, Faith represents all that Buffy will never be. From the way she performs her rough and messy femininity to her unruly use of violence and resistance to authority, Faith disrupts the controlled moral order of white middle-class girlhood. More specifically, Faith's physically dominant show of sexual desires, seductive skills and bodily pleasures contrasts sharply with both Buffy's and Willow's relatively restrained sexual embodiments. When read up against Faith's public promiscuity, Willow's monogamous relationship with Tara is rendered sweet and innocent, normalized and wholesome, caring and responsible. Desire between girls becomes mediated by class and race assumptions, giving rise to a narrow version of same-sex love that is sharply contrasted with the dangers of illicit lust enacted by Faith. In contrast to the disdain expressed on the series towards Faith's slutty working-class image, the acceptance of Willow's sexual identity within the Scooby gang is contingent on racial and class conformity. It is impossible to separate Willow's character, relations, and meanings as a "gay" girl from how she is positioned in romantically normative terms against girls marked as sexually other. In this way, her queerness is continually recuperated back into the class and racially coded social conventions and values that constitute Willow and Buffy as friends in the first place.

It seems that, although mutual recognition is central to Willow and Buffy's friendship and heroic endeavors, such mutuality is not accorded to all girls. Willow's whiteness and affluence signify an implicit yet disavowed standard of value reinforcing and circumscribing her friendship with Buffy. Although Willow is identified as Jewish, her ethnicity is muted throughout the show, implied in subtextual aspects of her characterization yet obscured within the text. Differences that might complicate the unity of the Scooby gang fade

into the background of narratives centered on commonality and togetherness. Except for the ongoing presence of demons and vampires, very little disrupts the sociocultural homogeneity of Sunnydale. This has implications for how Willow comes to live out her queer desires. Willow remains tightly bound within a small, closed group of heterosexual friends, never developing queer community or involvement that might open her up to alternative modes of social belonging and cultural identity. In this sense, Willow's relationship with Tara is represented in terms of an insular and individualized love story with little opportunity for collective scope and resonance. Girl fans of Willow are quick to concede that sexual identity is forged on the show in terms of couple inter-actions, not social networks. Allison writes, "I think it would have been nice for Willow to meet up with some gay friends but not that important, and also not very likely to be shown in a TV show!" As an amorous dyadic experience between two girls, sexuality is relegated to private spheres of desire and com-mitment, a perspective that gets reinforced within fan discussions. Narratively centered around monogamous long-term romance, Willow's "gay" girl story becomes intelligible and acceptable on and off the series, accommodating her differences within stable terms of reference and codes of value.

Conclusion: Watching Willow with Intensity: A Frenzy of Queer Girl Interpretations

Although BtVS at one level celebrates independence and diversity, hetero-geneity within and between girls is continually introduced and circumscribed by ideals of friendship and romance that project power, conflict, and differences onto threatening forces of evil. This works to stabilize contradictory relations that might disrupt or question the heroic terms of Buffy's status. The exclusive primacy of Buffy as "the chosen one" is up for grabs in the final season, hint-ing at possibilities that go beyond an exclusionary hierarchical logic of heroic girl power. Introducing dozens of potential slayers who represent a broad range of racial, sexual, and class identities and histories, the show breaches boundaries of sameness, while recuperating others. Sixteen-year-old Kerry makes it clear that abstract valorizations of diversity work to reinforce racialized typologies when she states that "Rona in season 7, rarely says anything that doesn't per-tain to her African American decent . . . for instance, Rona vs. Molly in the fight over the car ('The Killer in Me,' season seven). The black girl beats the crap out of the English girl. Stereotypical, but not unbelievable." Kerry's analysis

of season seven reveals ambivalence towards the ways diversity becomes added at the end of the show through caricatured looks and acts of specific girls. As more girls enter the field of vision as potential slayers, increasingly complex representations of differences trouble a linear discourse of inclusion. In the process of expanding the Buffy universe, Willow erotically and romantically falls for Kennedy, an out lesbian Latina potential slayer, who encourages Willow to overcome her fear and guilt and explore her desires and magic once again. Compelled by Kennedy's sex appeal, support, and confidence, Willow unleashes the intensity of her Wiccan strength to empower girls globally. Within the bonds of this interracial queer girl relationship, Willow endows all girls with the choice to take action, enabling a future that proliferates and de-centers girl powers. In the end, a diverse range of girls have the potential of becoming slayers, projecting an unpredictable expanse of heroic experiences and stories. In the grip of a new romance and on the verge of a new world order, Willow's queer self is unhinged from normalizing pressures of moderation and normalization. Willow's excesses are no longer visualized as dark, scary, and dangerous but as bright, pleasurable, and enabling. Willow collapses in ecstatic joy, a queer girl with the force to change the stakes of what it means to be a girl. This marks a chance to overcome binary ways of categorizing and separating girls, queering the very conditions through which transformative powers are enacted.

Willow's significance as a queer girl is not found exclusively either at the level of text or in the creative speculation of viewers, but rather in an unfolding conversation about the changing and relational status of her desires, actions, and words. An intensity of feeling and understanding drives interpretations of Willow by fans and academics. In a televisual environment that has so few images of girls desiring other girls, the impulse to identify and engage with a character such as Willow becomes extraordinarily strong. Fans in dialogue with the texts of *BtVS* frame the very question of adolescent desire and identity in terms of psychic attractions and abjections, ideological blindspots and misrecognitions, spurring questions that refuse the certainty of general truths. As an example that in no way embodies all that queer girls are or can become, Willow is a singular fiction, partial and limited as all television characters and stories are. My point is not to establish or measure her status as queer in any determinate way but to trouble the process of representing and reading girl desire and identifications beyond the coherence of heteronormative fictionalizations.

· 4 ·

SCREENING QUEER GIRLS

Complex Intimacies Within Independent Films

The typical "boy meets girl" type of teen movie has been way overdone, and it almost seems like making the protagonist a queer girl is a new and interesting twist to a simple storyline that has been turned around to seem different so many times. It is definitely easier to relate to because by making the protagonist a queer girl, it takes away the question in my mind of "what if the main character had been a lesbian?"

Trish, age 16

Queer girls have come to represent some of the most transformative subjects within contemporary independent film, giving rise to new forms of youth cinema.[1] The emergence of queer girl characters driving romantic narratives challenges normative ideals of heterosexual adolescent femininity while also opening up new ways of perceiving a desiring girl as active within an intelligent process of becoming sexual. The emergence of diverse forms of visual storytelling that center on girls fantasizing about and pursuing other girls compels new interpretative practices. Unlike more oblique strategies of reading queerly against the grain of heteronormative cultural texts, intimate portrayals of girls' amorous relations with each other draw viewers into vividly sensual worlds, compelling a process of reception that engages directly with the cultural significations of embodied experiences. What I am calling "queer girl romance films" do not merely add sexual minority subjects within an existing

field of youth films, they also offer chances to rethink the very assumptions of gender and sexuality that underpin how we come to make sense of girls. I argue that the emergence of girl-on-girl images of romance exceed and realign our expectations and understandings of coming-of-age film narratives. Not only do these films explore specific relations between youth with psychosexual subtlety, but they also creatively challenge hegemonic ideologies of what it means to be a girl who falls in love, becomes sexually active, and grows up.

In this essay, I trace dynamic languages through which girls become visibly queer within romance film narratives, while simultaneously showing how girls interpret and use such portrayals. Shaking up the cultural foundations of being young, female, and sexual at the turn of the new millennium, queer girls in film (and as film spectators) test the limits of analysis and reception of youth films today. Not only are film texts being produced in ways that allow for new visions of girlhood, but queer girls are themselves watching films, asking critical questions and articulating insights about their cinematic pleasures. Excited by possibilities of identifying with queer protagonists, girls express intensified fascination with details of characterization and plot development. In the opening quote above, Trish talks about "a new and interesting twist to a simple storyline," suggesting both differences and continuity with conventional teen genres. There is a noticeable tension for many young viewers between excited engagement with what uniquely constitutes a queer girl film and frustration with being pegged and reduced to a few qualities that come to define queer girl movies. Wanting to see fictional accounts of queer girls living their lives beyond limited themes of coming out and being victims of homophobia, young queer spectators seek out moments in which subjectivities and relations unfold beyond fixed projections of mainstream culture. Offering critically edged responses to queer girl films, the girls I interviewed expand upon their favorite moments in films alongside their frustrations with their shortcomings. They talk about their dis/identifications, what attracts and bothers them, what makes them curious or angry, as part of a process through which the field of queer girls and film becomes a space of dialogue. A key aspect of this dialogue involves girls talking back to films through their personalized stories of growing up queer. I want to focus on attempts by youth to link and evaluate filmic texts through a range of social experiences that provide an imaginative locus of queer girl spectatorship.

No single storyline or visual representation structures the experiences of queer girls on the screen or as interpreters of screen images. The point is not to secure a definitive image, plot, or characterization, but to enable new ways

of seeing and understanding the desires of girls in cinema. I argue that it is precisely attention to the everyday details of girls' struggles to know and act on their romantic and sexual longings that defines this subgenre as well as interpretive practices capable of following its contours. Like many teen genres, queer girl films involve movement along a boundary that separates childhood from adulthood and that pivots around first sexual experiences. Going beyond conventional mappings of a male heterosexual desiring gaze to consider the specificity of girls as active subjects of the gaze, my readings involve tricky negotiations between named and silent, visible and the invisible, represented and unrepresentable relations. What these films teach us is that there are no transparent approaches to meaning when it comes to understanding young female subjects whose sexual identities are precisely what is in question. Existing in between the categories of adult identification, in a state of flux and transition to sexually aware and contested selfhood, queer youth present unique predicaments to the imaging and conceptualization of desiring subjects on the cinematic screen. The very enactments of girls within films who disrupt heteronormative relations need to be explored in terms of the difficult ways desires appear and disappear, moving in and out of cultural recognition. The crux of queer girl subjectivities is precisely their refusals to fit neatly into ideological frameworks that prescribe identifications and desires. At the level of textual framing, categorization, and interpretation, queer girls mark a crisis in representation. Yet this crisis does not result in an absence of meaning but rather in a rewriting of the scripts of young love to include intelligent sexually passionate girls.

Ambiguous Identifications: Queer Girls Watching Queer Girls in Film

This film will always have a place in my heart because it showed me, for the first time, in glorious color and surround sound, what I wanted in a relationship. Specifically, a girl. That's right, there I was in college, not sure why I never felt hot-and-bothered with my boyfriends, and along comes the movie "True Adventure," and the answer to the million dollar question!

Anonymous teen, PlanetOut.com

Hollywood films, and critical analysis of girls' sexuality in these films, have tended to focus on the normative powers and pleasures of heterosexual romance, centering on fantasy constructions of adolescent boys and idealizing middle-class family moralities.[2] When actively sexual girls appear on the screen and enter

critical debates, they are framed as victims of aggressive male predators, at risk of disease and pregnancy, and/or as dangerous precocious outsiders. Jon Lewis calls attention to the ways "horror films depicting the punishment of promiscuous young women seem only an exaggerated consequence of the paternalistic and patriarchal reaction to the mythology of a sexual revolution" (66). Critics emphasize the abjection of disorderly feminine sexuality as a key element of teen drama development, which predictably ends in the valorization of monogamous heterosexual coupling.³ In a different vein, youth culture scholar Henry Giroux discusses eroticized projections of girlhood innocence on display to serve adult voyeuristic pleasures. According to Giroux, popular culture has come to intensify the sexualization of youth while delimiting their status as citizens (39–44). Whether the issue is unruly hypersexuality or commodified innocence, when it comes to young girls' sexual bodies, emphasis continues to be on an objectifying regulative masculine gaze as the locus of narrative action and cultural meaning. Very rarely are we afforded representations of girls experiencing love and sexuality as a source of their power and knowledge. Mainstream youth films and criticism seem to mutually reinforce heterosexist ways of understanding the predicaments of girls, leaving little room to consider those films and scenarios where girls learn to become instigators of their sexual lives. For many queer girls, Hollywood teen movies are generally disappointing and predictable, as seventeen-year-old Katie states:

> The hero or heroine of the film is virtually never queer. Non-straight characters may or may not receive sympathetic treatment, but their own feelings, emotions and issues of interest are dealt with superficially or not at all. They might be the quirky friend, or the class weirdo. They say something shocking or undignified which does not fit in with the values of the other characters. They might be a passing amusement or a running joke.

Queer girls rarely enter the purview of Hollywood teen movies without being sexually othered and socially vilified. For many girls frustrated with mainstream representation, figuring out ways of reading texts against their heteronormative grain becomes a crucial strategy of visual pleasure. While much has been written about transgressive queer readings of films,⁴ for the most part, these accounts are adult centered and often invoke a theoretically sophisticated interpretive process in which queer desire is traced in the margins and subtexts of dominant narrative cinema. Youth tend to be left out of these formal discussions of film representation and reception. Informally, queer girls are deft at reading themselves into and out of screen depictions; they talk through variable lines of identification and desire

in creative and subtle ways. When it comes to even the most conventional teen romances, many girls imaginatively if awkwardly position themselves in relation to straight characters. Eighteen-year-old Lorna writes, "I do enjoy a good teen film every once in a while. I picture myself as the guy most of the time." Yet this is not merely a reversal or crossing of gender identification in order to psychically identify with a hero, as Laura Mulvey suggests in her work on visual pleasure.[5] Lorna goes on to express discontent at conventional heterosexual narratives, claiming that such portrayals led her to "date guys for a while until it wouldn't work out, I never felt right like they talk about in the movies, it was never an ohhhh this is what it feels like to be kissed . . . until I kissed a girl that was like it was in the movies." Lorna does not simply inhabit a traditionally male romantic role, she grapples with accruing pleasure within the binary terms of mainstream film portrayals, situating herself uneasily as a guy kissing a girl, while remaining aware of the inadequacy of this compromise. She protests that "it is not right that the relationships which I am involved in are not featured in films."

While mainstream teen films remain heteronormatively structured as a popular genre, feminist critics have noted a shift away from heterosexually centered romance narratives within independent films in the 1990s, which move towards narratives that value same-sex friendships.[6] Feminist treatments of these films have called attention to coming-of-age stories, developed around the emotional support of girls bonding together. There is a tendency to link girl friendship and queer girl romance films as evidence of a turn away from male driven plots. Mary Celeste Kearney writes that films such as *Girls Town* and *The Incredibly True Adventure of Two Girls in Love* "portray coming-of-age as a homosocial process, wherein girls gain confidence, assertiveness and self-respect through each other" ("Girlfriends and Girl Power" 133). The problem with this argument is that it focuses on a unified image of girl identity and power in terms of female solidarity at the expense of a closer look at sexual desires between girls. In many ways, this ends up desexualizing girl relationships, focusing instead on images of female friendship and community. It is disturbing that most feminist discussions of girl-centered films ignore desiring gazes and libidinal bonds between girls. What gets lost in many feminist readings is recognition of girls' growing up romantically and sexually interested in other girls as integral to their empowerment and resistance. Eighteen-year-old Sarah asserts that "films with queer girls as protagonists give an empowering feeling. It's nice not to feel like the underdog for once or like our stories are not important enough to make us the main character. It gives the sense that there are enough of us to focus on us."

To begin to take seriously the empowering dimensions of films focusing on girls desiring girls, it becomes important to return to recent films featuring sexually charged relations between girls, paying close attention not only to narrative patterns and characterizations but also to how queer girls react and engage with them. The emergence of independent queer girl romance films in the 1990s can be traced to the release of Rose Troche's *Go Fish* (1994), which offered insider ways of seeing the lives of individuals and communities historically marginalized within mainstream cinema. Affirming this film's creative edge ten years later, Ruby Rich writes that "the closely observed lesbian lives in *Go Fish* have enough dimensions to register as 'lezbionic,' while the film's mix of critique and affection is a perfect tonic for today's lesbian-deprived landscape." Marking a turning point in which young lesbians are positioned at the center of fictional feature films, other texts, such as Cheryl Dunye's *Watermelon Woman* (1997), depict young queer women of color within stories that explore racist and heterosexist conditions of representation. While *Go Fish* and *Watermelon Woman* profile communities of youth in their early twenties, other films emerged that began to explore the nascent queer experiences of teen girls. Across films such as *Heavenly Creatures* (1991), *The Incredibly True Adventure of Two Girls in Love* (1995), *All Over Me* (1997), *Show Me Love* (1999), *But I'm a Cheerleader* (2000), and *Lost and Delirious* (2001), adolescent girls are portrayed as strong central protagonists struggling to deal with social isolation, friendship crushes, coming out, suicide, and homophobia. These films convey troubling and thrilling realms of girls' experiences as they resist conventional relations and identities in school and family environments where attractions between queer youth are precariously lived out. Focusing on adolescent quests to find belonging and fall in love, these films constitute new cinematic territory. They represent girls in transitional spaces between childhood and adulthood who have yet to establish their sexual identities as they learn to express their feelings for girls.

An expanding range of queer girl films grapple with the visual storytelling of girl-on-girl lust and love. Yet tensions pervade the theorization of queer youth in film, between attention to cultural marginalization and the tendency to normalize differences within teen narratives of romance. Timothy Shary writes that recent films, such as Alex Sichel's *All Over Me*, suggest an "integration of homosexual teen characters into plots that further normalize queer lifestyles and depict queerness as one of many qualities that youth may encounter on their path to adulthood" (246). Shary gestures towards an acceptance and integration of queer youth within film narratives in ways that encourage a more holistic

view of their social lives rather than isolating their sexual differences in exclu-sionary ways. This is especially crucial when the class, racial, and ethnic dimen-sions of youth coming-of-age and coming out narratives are fully acknowledged as integral to how youth define their sexuality. Youth are always so much more than any single dimension of experience, and many contemporary films have begun to explore this complexity by constructing layered psychosocial char-acterizations. At the same time, it is important not to skim over the unique status of queer youth within visual media and the uniquely situated signs and shifts in perception through which youth communicate same-sex desires.

To begin a process of interpreting queer girls in film, both feminist and queer interpretive tools of analysis are needed. Yet feminist film theories of gender rep-resentation tend to conflict with queer theories of sexual heterogeneity, and both have been developed to concentrate on the cultural predicaments of adult sub-jects. Feminist approaches focus on women's identifications and pleasures as spec-tators, paying close attention to interactions between woman as textual image and women as historical subjects, exploring formations of and resistance to ideologies of femininity.[7] Queer approaches reveal the slippery and contested ground of all gender/sexual categorization. Queer theories conscientiously pur-sue performative languages of desire in multiple directions, foregrounding and exceeding hetero/homo typologies and structures. I develop a queer feminist interpretation that combines attention to the performative enactments of girls in films and an interest in signifying girls' desires within texts and between texts and audiences. The challenge becomes analyzing the discursive constraints and meanings of growing up girl, while also watching how films disrupt and recon-stitute expectations.

As a tool for reading film texts, feminist queer theories are useful towards exploring youth as subversively desiring subjects. The indeterminacy of young selfhood, in the process of formation, calls forth a theoretical focus on insta-bility and change. Yet there is a risk of using queer theory to generalize the mal-leability of youth identity. This move is both tempting and troubling as it erases the struggles of particular queer youth as they articulate their desires and relations against cultural assumptions of sameness. While vague notions of sexual instability are continually attributed to girls as signs of their immaturity and irrationality, it is much more difficult to find portrayals of strong, intelligent, and willfully desiring girls. I prefer to look specifically at those instances in film where young girls learn to express their queerness through situated and provi-sional words and acts. It is not a general indeterminacy that marks out queer youth in films but precisely their determination to pursue and experience

same-sex love. At the same time, naming the sexual orientations of girls in films must not be taken for granted. It is important to approach queer girls with an awareness of the tentativeness and flux through which they come to inhabit sexual narratives.

The very status of *queer girl films* remains ambiguous and open-ended. Not only is a coherent genre impossible to define, but the central subjects of representation are signified in uncertain ways. Within many recent girl films, desire does not necessarily translate into a clear-cut sexual identity, which is vividly demonstrated when the young protagonist Paulie expresses shock at being called a lesbian in the Canadian film *Lost and Delirious*:

PAULIE You think I'm a lesbian?

MARY You're a girl in love with a girl, aren't you?

PAULIE No, I'm Paulie in love with Tori. And Tori is—she is in love with me, because she is mine and I am hers. And neither of us are lesbians.

This disavowal of "lesbian" identity resonates with youth discomfort with labels that would presumptively categorize their nascent emotional and erotic experiences in general terms. Similarly, as critical spectators, girls hesitate to draw direct connections between their sexuality and their film tastes. Eighteen-year-old Moe insists that "my sexuality doesn't define me, I define my sexuality, so neither does my sexuality define the kinds of films I watch to any great extent." While Moe engages passionately with many films featuring girls who desire girls, she resists delimiting her perspective and interests to her gender and sexual orientation. Such a refusal to align one's interests narrowly with specific film content or themes extends further into criticism of those films that simplify the form and substance of queer girl characters and stories. Many girls express frustration at simplistically represented "lesbian" subjects and issues, insisting upon nuanced ways of interweaving experiences of same-sex erotic relations into narratives without reifying their centrality and meanings.

Addressing the complexities of representing queer girls in film, there is a striking tendency amongst young viewers to read and evaluate films through rich accounts of lived social experiences. Wedging fragments of memory and fantasy into their interpretations, they assess and compare everyday realities to cinematic constructions. Youth commentary is focused around the provisional ways film characters and plots connect or fail to connect with their lives. Girls understand and talk back to films through personalized narratives that resonate with fictional aspects of film texts. At the same time, youth also hone in on

those aspects of personal experience that are left out of view and hoped-for iden-
tifications that are precluded. Speaking about the lack of queer girls of color in
the film *But I'm a Cheerleader*, seventeen-year-old Brenda writes, "most of the
queer girls there didn't represent the other part of myself, that is what is a lit-
tle hard being a person of color and queer trying to find yourself and only to
find half. I think more movies about queer girls should be more conscious of
that." Brenda is frustrated at the failure of films to articulate the intersectional
richness of youth identities across sexual, race and ethnic lines. A critical
recognition of the racialized politics of queering popular culture emerges
through self-reflection, trying to forge identification yet realizing the impossi-
bility of fitting into established frameworks of visibility. This becomes an occa-
sion for thinking about broader issues of inclusion and community for Brenda
as she expresses desires for representations beyond what are available to her:

> I would love to see movies that represented queer girls of color, I think that is some-
> thing that is lacking not only in the lesbian community but also the gay. We should
> have a community that includes not excludes or we will become the mainstream of
> where we are not represented, we should become the example to follow.

Thoughtfully responsive, many queer girls engage with films with an intensi-
ty of desire to see their lives represented on the screen. This is not a naïve wish
for transparent reflections between films and social reality but a process of using
and integrating texts in the lives of marginalized girls who crave meaningful sto-
ries and images that speak to their complex experiences. Such an approach chal-
lenges both producers and interpreters of films to consider the intimate and
social stakes of representation.

Watching and analyzing queer girls in film is a difficult task for me as an
adult queer viewer. Positions and conventions of film reception need to be ques-
tioned with ethical care: What do queer girls look like on the screen? Who is
looking at them? How are they looked at? How do girls look at other girls? In
what ways can these looks be named and compared? By attempting to scruti-
nize and theorize queer girl images and viewers, what kinds of limits do we
impose? These questions trouble me as I watch films in which girls desire other
girls, fearing that my search for knowledge might reify the differences I seek out.
Becoming a responsive viewer involves following the subtle ways a girl's desire
for another girl spurs narrative and visual meaning. From the start, a reflexive
eye/I becomes crucial to a practice of reading across a disparate field of girl-girl
romance films signifying small intimate moments rarely glimpsed in commercial
cinema. In Mallen and Stephens's words, "looking becomes a complex play

between characters and viewers . . . the act of looking that characters undertake also helps to make the viewer aware of the particular quality of their own gaze . . . to position the viewer in ways that focus attention on the specific nature of his/her gaze" (5).

In this way, my readings of queer girl films are emotionally invested and partial, they are shaped through textual analysis combined with my own desire for images of girl desire that gain significance within the broader context of systemic invisibility and devaluation. I have chosen to work on four film texts that I argue provide exemplary strategies for representing queer girls; at the same time, there is no escaping the pleasures these texts offer me as I scope out dialogues. Linking each film with sets of issues and ideas, I focus in on detailed visual and verbal narratives and character formations in specific film texts. Structural patterns tie into subjective responses refracted through the idiosyncrasy of my queer eye for queer girls along with the queer eyes of girls themselves. At times, they conflict, contradict, overlap, and diverge. Whereas I focus on the silent expressions of queer girl crushes in *Show Me Love*, I go on to explore embodied gender-bending performances in *All Over Me*, defiant queer naming in *The Incredibly True Adventure of Two Girls in Love*, and the parodic camp humor of *But I'm a Cheerleader*. These films highlight distinct features of queer girl experience and representation, while also turning back onto attempts to see, question, and understand them. At stake is learning how to read the shared elements across these films while focusing in on textual, imaginary, and contextual details of queer girls in film.

Fucking Amal/Show Me Love: Shaming Words and Visible Desires

> ELIN. Is it true you're a lesbian?
> If it's true, I understand.
> 'Cause guys are so gross.
> I'm also going to be one, I think . . .
>
> Show Me Love

Show Me Love, an independent Swedish film directed by Lukas Moodysson, is a complex tender film about two girls falling in love and coming out. Originally entitled *Fucking Amal*, which refers to the name of a small Swedish town, the film recounts the everyday angst and frustrations of growing up in a rural environment where dreams of escape and excitement coexist alongside mundane

longings for connection. The story follows Agnes, a pensive high school outcast who has lived in Amal for almost two years without being able to make friends or feel a sense of belonging. While Agnes is detached from her peers, she develops an agonizingly intense and shy crush on Elin, a pretty sharp and popular blond girl. Elin is sexy; she is well liked within the "in crowd" and has an extraordinary physical self-confidence: "I'm so beautiful," she says, "I'm going to be Miss Sweden." Yet she is deeply unsatisfied by the world and the people that surround her: The boys are dull and predictable, gender roles are stultifying, adults sink into routine entertainments, and her classmates are caught up in cruel girl gossip. Elin wants more, but she is unsure where and how to find it. Agnes wants Elin but has yet to realize the possibilities of her fantasies. While the surface differences between Agnes and Elin separate them socially, they are both smart and crave meaningful relations. It is their persistent refusal to make easy choices, to give into the expectations of their family and friends, that establishes their bond.

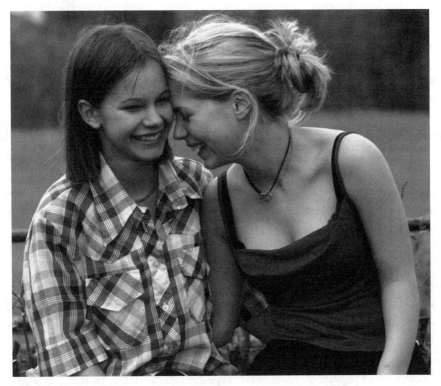

Agnes and Elin in film still from Show Me Love *(Memfis Films. 1998).*

The opening scene of Agnes pouring her heart out over her computer keyboard sets the mood and direction of this romantic story. Agnes is lonely and isolated, she closes the her bedroom door, plays somber music, and writes desperate messages to herself:

My Secret Wish List

1. I don't want to have a party.
2. Elin will see me.
3. Elin will fall in love with me.

I love Elin!!!!!!!

The secret longings of an adolescent wish list constitute the opening lines of *Show Me Love*, inscribed across Agnes's computer screen as she confesses her love of Elin alone, in the privacy of her room. Kerry Mallen and John Stephens argue that this domestic space is conventionally associated with femininity while being transgressed by the active queer desire that Elin explores from within it. This film suggests some ways in which feminist analysis of girls' bedroom culture might intersect with an exploration of the reclusive fantasy spaces utilized by queer youth, such as online personal writing and confession. Private spaces lend themselves multiple meanings for girls who are excluded from boy public cultures and also from the shared intimacies of girlfriend rituals. Agnes's room represents the solitary place of her romantic reveries. What becomes clear is that the enclosed space and silence that surrounds Agnes's awakening erotic attraction is filled with uncertain risk and knowledge. An uneasy space between her inner desires and lack of social recognition renders Agnes a remarkably vulnerable character. It is precisely the tensions between Agnes's longings and her isolation that gets picked up by eighteen-year-old Diane, who exclaims, "I loved Agnes. I loved that she was a huge dork, which is something you don't often see represented realistically and positively in teen movies. I like that even though she hated herself at times, she knows herself really well."

Agnes's awkward secrecy is reinforced within a homophobic context in which her schoolmates label her a "lesbian" in an attempt to shame her. Using shame as exemplary of the performative activity of queer subjects, Eve Sedgwick avoids collapsing queerness into prescribed narratives of homosexual depravity, while at the same time unfolding the bodily and emotional impact of painful words of abuse. Subjects performatively transform their identities into queer affirmations of difference through interpellations of shame. In this way Agnes is outed as a "lesbian" through the harsh words of gossip before she has had

a chance to even kiss a girl. The quick tongues of teen girls making fun of those who are different, designates coming out as a locus of ridicule, stereotyping, and innuendo. Even Agnes's mother invades her privacy to find out the "truth" of the lesbian rumors. Being called a "lesbian" by others works to reify Agnes's subjectivity at a time in her life when being able to explore feelings and impulses is more important than taking on labels imposed by others. When she is taunted with a false kiss by Elin and asked if she is lesbian, she sits without saying a word, refusing to play into hurtful adolescent jokes. Agnes lives on an edge of self-discovery and despair as she tries to take her life after being outed in a humiliating game by the girl she adores. The film explores the difficulty of identity for Agnes as she struggles for self-awareness and expression without ever calling herself a lesbian. There is a protective silence in Agnes's refusal to name herself, revealing how sensitive and simultaneously resilient she is in the face of those seeking to belittle her. Queer girl viewers appreciate the ways Agnes responds to harassment with an emotional strength. Sixteen-year-old Sabrina says how much she "liked how she was able to take the homophobia of her peers with some composure." Without ignoring Agnes's emotional suffering, *Show Me Love* uses subtle signs of perseverance to show how Agnes takes hold of her queer differences through and against the shaming words of others. Girl viewers elaborate identifications with Agnes in ways that allow them to broach personal instances of being picked on and developing painful crushes. Eighteen-year-old Moe claims to "identify quite a lot with her . . . when I was younger I also got bullied and also fancied someone that I never thought I'd get."

If words are weapons of public shame, the gaze becomes a realm of subversive possibility for queer youth. *Show Me Love* allows the contradictions of Agnes's desiring yet vulnerable presence to be represented through images of her watching eyes. From an abject position that places her in the background of school social life, we catch her looking at Elin. The camera pauses, offers a close-up, and stays still for a moment in which to catch visual signs of the aloneness and desire in Agnes's eyes. Seeing and being seen are crucial here—"Elin will see me"—a process that is painfully tentative and slow. While Agnes does not voice her feelings out loud, she communicates with her probing looks, and we watch as she takes pleasure watching and sexualizing Elin's body, coming to terms with who she is and what she wants. Agnes's gaze becomes an active expressive force creating a queer field of looking that fosters the development of a nonheterosexual romantic plot. Rather than simply reversing a patriarchal model of the male fetishization of a passive female object,[8] the gaze of this young girl subverts binary structures, configuring tentative intersubjective relations in

which both looker and looked at are active desiring subjects. *Show Me Love* conveys the desires of a girl for another girl through an oblique glance of fascination; the camera lingers over the tension between wanting and indecision, leaving room for viewers to identify with the emotional charge of Agnes's gaze. A striking feature of this visual narration of the lives of young teenage girls in the early awakenings of their desires for girls is the fullness of the silent details of body language. The status of the visual image over verbal expression becomes meaningful in the context of an adolescent who has not fully come out to herself and others. Queer girls tune into this silent dimension of Agnes's communication, recognizing the value of unspoken desires and recalling memories of their own deep silences growing up. Diane says she "loved how her silent nature was used to further the plot." Agnes has not yet named what she feels, and this film unfolds an inarticulate yearning as unfinished moments when nothing is said in words, but so much is revealed in body language and facial expression. There is a weight to the quiet passion of Agnes's gaze that lets viewers inside the difficult emotional predicaments of queer youth coming of age.

The narrative organization and pace of *Show Me Love* provides room for Agnes to experience ambivalence, to feel hopeless and to find hope again, to lose faith and to begin to trust, to want to die and to affirm life. There is a patient, slow, and tense quality to the shots of Agnes, giving the viewers an emotional sense of her in-between psychic states. This wavering is a common trait of growing up, but it has specific meanings for youth whose sexuality marks them as different, unable to be like everyone else. The film represents how Agnes negotiates the dilemmas of growing up queer with an uncanny stillness that elicits viewers' focused attention and identification. We are privy not only to Agnes's experience of social exclusion but also to her gutsy autonomy. The film allows this outsider stance to mark Agnes as the target of teenage mockery and also to become a site of Elin's fascination and identification:

ELIN You are weird.

AGNES You're also weird.

ELIN Am I?

AGNES Yes.

ELIN I want to be weird.

 Well, not weird but . . .

 I don't want to be like everyone else.

 Though sometimes I'm just the same.

AGNES But you're not.

These little fragments of dialogue are the beginning of a mutual recognition between Agnes and Elin as they share their estrangement from the teenage and adult cultures that surround them. The film foregrounds the power of inter-subjectivity as a basis for coming out and coming of age. The film vividly details the feeling and thinking process that young girls experience as they realize that their differences are the sources of their deepest pleasures and fears of social marginalization. It is the interaction between Agnes's secret wishes to be accepted for who she is and Elin's loud exacerbated cries at being stuck in a small town that forms a connection between them. Agnes sees in Elin a spontaneity and wild desire for an elsewhere, and Elin glimpses an alternative in Agnes's tomboy rebelliousness and intelligent individuality.

Their first real kiss is in the back of a car as they attempt to hitch a ride to Stockholm; it dramatizes a mixture of adventure and eroticism at stake in this coupling and becomes a turning point for Elin, as she realizes the sexual power of her attraction to Agnes. Representing the denial and terror that overcomes Elin as she desperately asserts her heterosexuality with an ordinary local boy, Johan, the film enacts repeated interruptions of normative pressures to be straight in the progression of queer teen romance. Show Me Love does not simplify or glamorize the process through which Elin comes out to herself and others; her fear and confusion are integral to her realization that choosing Agnes will shatter her privileged popularity and transform her life. But unlike many stereotypical narratives that leave gay and lesbian youth alone, scorned, and unhappy, this film offers a joyful and empowering image of togetherness to end the film. Playing with the metaphor of coming out, the girls are literally locked in a bathroom together as they confess their mutual love. This scene evokes another closed interior space in which the girls grapple with their desires. Tensions build as schoolmates and teachers bang on the door trying to get them to come out. When they finally emerge, Elin aggressively calls out, "This is my new girlfriend Agnes. Now if you'll excuse us we're going to go and fuck." They storm past the crowd with smiling faces, moving defiantly outside into the public world. Many girls expressed delight at this ending as an in-your-face show of queer girl desires. Olivia talks about how much she "loved the scene where the girls walk out of the washroom. Elin's confidence is refreshing; her snarky line and the shock of her classmates was hilarious." The film both allows for a dramatic scene of erotic union between the two girls and suggests that struggles for recognition will continue. While enjoying the ending, girls talk about their doubts and unanswered questions. Moe confesses that "the cynic in me wonders how long it's gonna last before Elin gets bored and goes back to guys."

Stories of first love raise difficult personal issues for queer girl viewers who are grappling with their own anxieties and uncertain futures. In this sense, watching such films evokes ambiguous and intense emotional trials of finding love. Coming out is never a single complete act, it is always a slow difficult process that contains multiple events and responses, failures and affirmations, memories and denials. Similarly, filmic representations of coming out are best when they allow for the impossibilities of knowing and the joys of experiencing the unexpected. Queer girls find ways of identifying with these tensions played out in *Show Me Love*, pondering moments of being alone and withdrawn and being swept up in the pull of erotic anticipation and action that drives this teen romance forward.

All Over Me: Public Enactments of Young Queer Girl Bodies

In terms of Claude, I suppose I could relate in some ways. When I first came out to myself, I was in love with my closest friend at the time, so I could relate to the struggle that she was having. But at the same time, I feel rather disconnected from the whole situation, seeing as I've come a long way since then. . . . I don't really care about 14 year olds coming out anymore, even if I once was one.

Diane, age 18

Show Me Love represents Agnes's process of coming out as a movement from interior secret spaces to shared intimacy, from the homophobic bigotry of small-town teen cultures, as well as the socially isolated realm of her bedroom, towards a rebellious public declaration of girl-on-girl romance. Throughout most of the film, Agnes's hidden desires are visually signified by positioning her within closed claustrophobic settings where she exists immobile and alone. It is with the help of Elin's bold act of naming that we see Agnes embracing her differences as a socially viable choice. In contrast, the American film *All Over Me* represents a working-class girl inhabiting city spaces on the brink of self-discovery. This film, directed by Alex Sichel, follows fifteen-year-old Claude as she walks through an inner city New York neighborhood with an unself-conscious sense of independence, making friends with other queer youth, working in a pizza parlor, and eventually going alone to a local lesbian bar. The narrative counters notions of the street as taboo and dangerous for girls that Angela McRobbie argues reinforce gender segregation and associate feminine romance with domestic spaces (*Feminism and Youth Culture*, 41). In contrast,

All Over Me locates many of Claude's coming-of-age experiences within public street contexts. Claude is neither physically isolated within the private space of her bedroom nor emotionally detached; she is engaged and open to her changing environment, dreaming of being a girl rock star in an all-girl band as she practices guitar playing with her best friend Ellen. At the same time, *All Over Me* offers a gritty portrayal of queer bashing, refusing to gloss over the daily risks and traumas that confront queer youth in public spaces. In this film, coming out and growing up mean learning how to find reciprocal queer gazes, make moral and political decisions, and discover subcultural movements to bond with marginalized youth. Several queer girls comment on the fact that this film takes on "so many extreme problems" that it's hard to follow and confusing. Presented as an unfinished series of story fragments, the film tries to mimic the interrupted temporality of teen experiences. But while this form tries to capture the day-to-day environment and experiences of an urban queer girl, teen viewers had trouble following along. Diane complains that there are "too many things going on. With drug addiction, crazed abusive boyfriend, the dead gay boy. . . . I was very sad about that." In this section, I try to elaborate some of the textual elements over which queer girl viewers struggle. Even though this film is not very popular, it engages girls in complex dialogues about what kinds of stories and characters they are attracted to, what features distress and discomfort them, and where their resistance as spectators emerges.

All Over Me captures Claude's direct look of sexual wanting. Viewers get a close-up view of Claude's gaze as Ellen dresses in front of her and teases her with kisses. They play sex together—humping each other in a distorted circus mirror—laughing as they imitate boy and girl roles in exaggerated heterosexual postures:

CLAUDE Hi there.

ELLEN Gee, you're real cute.

CLAUDE So are you.

ELLEN Great, let's fuck, fatso.

CLAUDE All right.

ELLEN I'm going to suck your big juicy cock.

CLAUDE Suck me, suck me.

ELLEN This is stupid.

Ellen cuts off this silly queer spectacle and walks away, leaving Claude in front of the mirror strangely turned on and abandoned. This scene offers a spontaneous

outburst of girl teen mimicry and a glimpse of Claude's delight in playing out sex roles to a point where fiction and reality blur. A little later, Ellen returns late at night to brag about having sex with her new boyfriend Mark. Claude asks her to show her what it feels like, and they passionately kiss. The film signifies Claude's aching pleasure and frustration in these ephemeral moments of erotic touch and talk, which mean much more to her than a friendship crush. These scenes are not flippant fun for Claude but a crucial part of her self-recognition and growth as she comes to terms with her sexual longings for her best friend. They are also instances of gender performativity, reiterating heterosexual acts so as to reveal what Judith Butler claims is the imitative status of all sexuality: "Performativity is thus not a singular 'act,' for it is always a reiteration of a norm, and to the extent that it acquires an act-like status in the present, it conceals or dissimulates the conventions of which it is a repetition" (*Bodies That Matter* 12–3). Butler's theory of a performative process of desire and identification res- onates with the role playing between Claude and Ellen that constructs differ- ences and connections between them and shows up the instability of the sexual conventions they play out. Queer girls talk uneasily about the sexualized inter- actions between Ellen and Claude, wondering how to fit them into common sense understandings. Sabrina calls the irrational play between them a "weird, weird relationship," having trouble making sense of the ambiguous physical encounters between them. Finding it hard to put into words exactly what is going on, Sarah wonders "what the random making out is all about?" to which Diane responds "oh, it happens . . . but not in my circle! [*laughter*]." Girls express a clear discomfort with the awkward erotic exchanges between Claude and Ellen, trou- bling their reliance on the moral parameters of Hollywood love stories.

Performative displays of sexualized role playing are not the only signs of Claude's desire for Ellen. Some of the most tense and vivid representations of Claude's yearnings are drawn out in long silent episodes that leave Claude want- ing, waiting, and hoping for something else. Claude is often left alone looking out at Ellen from her apartment window, watching her walk away towards her boyfriend Mark. Such moments infuriate many girls who view Claude's actions as signs of weakness. The unresolved tensions of unrequited love provoke anger in queer girl spectators who insist that Ellen is just using Claude. They express impatience and a resistance to sympathizing with Claude's desires. Whereas queer teens are quick to judge Claude's misguided romantic pursuit of Ellen, I approached these failed pursuits as part of a contemplative space opening up in the film for Claude to reflect on her desire for belonging and connection beyond expectations of heterosexual adolescent girlhood. The camera turns on Claude's

face—a pensive yearning pervades her visual presence. She is caught on screen with a tenacious, thoughtful, desiring gaze. Claude becomes a caring witness to Ellen's self-destructive obsession with Mark and her drug addiction. She is compelled to make difficult choices, to turn away from Ellen when she finds out about Mark's brutal murder of Luke, a young gay man who lives in her apartment building. *All Over Me* complicates Claude's coming out as more than an individual choice and desire, showing it as a process of complex social and ethical negotiations. This stretches the boundaries of a teen romance genre, directing attention to the expansion of Claude's social consciousness as integral to her sexual agency.

All Over Me is filled with raw agonizing passages following a queer girl coming of age, which makes it very emotionally difficult for queer girls to enjoy. Olivia comments wryly that "teenage angst has been completely overdone," fed up with representations of sexual minority youth in distress. At the same time, this film's moral heaviness is counterpoised with Claude's earnest and daring romantic quests. Claude eventually hooks up with Lucy, who not only reciprocates desire, but also teaches her the importance of showing her affection for girls in public, outside the walls of her bedroom. This shift in Claude's erotic attention elicits excitement in queer girl viewers, offering a chance to identify with this thread of romantic narrative. Sabrina insists that "she should have gone for Lucy," preferring this choice because Lucy is a confident queer girl and offers some possibility for fulfillment. *All Over Me* represents Claude's coming out as gradual, partial, and relational. The film explores her intense vulnerability—framing scenes where she breaks down crying listening to Patti Smith as she reaches an impasse that moves her to name and pursue her desires more openly. A transition occurs that bridges the romantic distance of adolescent crushes and the physical passion of girl-on-girl sex. Claude and Lucy explore their sexual desires—grabbing, kissing, and sucking each other's flesh. We only catch brief moments of this, but they allow us to see the interplay of knowing and not knowing, hesitation and action, and fear and action as Claude begins to let go and experience her desires with Lucy. As she opens up erotically, she must also confront her social marginalization in a heterosexist society and the violence that surrounds her. The crux of Claude's ambivalence that stalls and drives the narrative forward is indicative of the ways queer youth are compelled to ask difficult questions and make tricky judgments in the very midst of adolescent arousal and uncertainty. Coming out emerges through intersubjective acts of mutual recognition that work to bridge Claude's embodied attractions with her social perceptions. Claude finds in Lucy a responsive desire for her desire that confirms and enables her to realize a queer relationship. Refusing to remain stuck adoring a

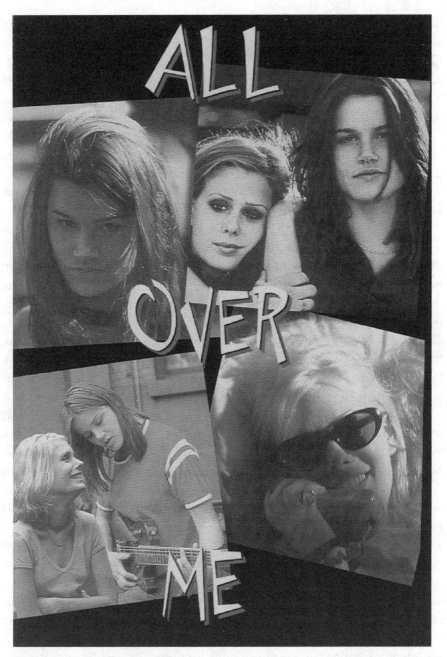

'All Over Me' copyright MCMXCVii, New Line Productions, Inc. All rights reserved.
DVD Cover appears courtesy of New Line Productions.

straight girl who gives her little in return, Claude begins to transform herself through the interplay of another girl's mutually recognizing desire. She makes pivotal decisions about ending friendships and forming new ones.

In *All Over Me*, queer differences are elaborated through the cultural details of speech, body language, dress, and movements. Claude's queer distinctiveness is literally written on her body, which inscribes its social meanings in sharp contrast with Ellen's straight, blond girl persona. Whereas several women in the film, including Ellen and Claude's mother, are on diets, wear skimpy tight clothing, and walk around seductively in high heels trying to attract male attention, Claude becomes a desiring spectator gazing in on the "to-be-looked-at-ness" (Mulvey, "Visual Pleasure" 487)[9] of the straight female characters. Yet Claude's spectator position is not male; it crosses gender boundaries, at times holding a distance of sexual objectification and at other times emotionally engaged as a nurturing friend and daughter. Claude's gender ambiguity is displayed through her active body: the ways she walks down the street with a clumsy teenage masculine stride and takes up space with her roller skates on the sidewalk. Lauren Greenfield writes that "the body has become the primary canvas on which girls express their identities, insecurities, ambitions, and struggles." I would add that it is a culturally mediated sexualized body image of girls that becomes open to queer performances. In the small gestures and habits of her routine, Claude nonchalantly transgresses normative images of girls. This is symbolized vividly in the way she fulfills her hungry appetite, eating food with abandon out in public, an image of a girl that is rare in popular culture. Claude exudes an indifference towards the protocols of feminine appearance and beauty norms, wearing baggy clothes and speaking with a direct boyish verbal style. For queer girls, this image is, as Diane says, "more realistic than lots of other representations of queer girls. She was not quite butchy but whatever . . ." Neither femme nor butch, Claude's gender ambiguity becomes a point of identification. Mary Celeste Kearney refers to the ways such "representations of teenage girls subvert the two-gender system that grounds the ideologies of not only patriarchy and heterosexuality but also liberal and cultural feminism" ("Girlfriends and Girl Power" 140). Yet it is not only the signs of female masculinity evoked in Claude's appearance that represent genderqueerness; when Lucy enters the picture with flaming pink hair, piercings, and riot grrrl punk musical tastes, *All Over Me* offers a more expansive representation of the collective emergence of queer cultural styles that allow for audience recognition. Sabrina tells us how much she loves "Lucy's cute pink hair," responding to everyday performative gestures and nonverbal signs of alternative girl culture. The surface visual details are

important for understanding a process through which girls come out queer as an indirect, layered, and temporal communicative activity.

Using a realist fictional style, *All Over Me* frames how queer girls enact subversive languages of visibility in the face of hegemonic public invisibility. Yet at no point in the film are the words *lesbian* or *queer* ever explicitly spoken. This aporia is both a result of the questioning space of adolescent identity and a context that discourages youth from voicing same-sex love. The film touches directly on the active social exclusion of queer teen relationships in a scene where Luke asks a gay teen, "Do you have a boyfriend?" and the teen responds, "No one ever asked me that . . . no one ever asks me that." It is within a broader framework of denial that Claude's emerging gender identity and sexuality become relayed through telling gestures, looks, music, and actions. There is a play between represented and unrepresentable elements of desire throughout this film, suggesting the impossibility of symbolic transparency theorized by Judith Butler when she writes that "part of what constitutes sexuality is precisely that which does not appear that which, to some degree, can never appear. This is perhaps the most fundamental reason why sexuality is to some degree always closeted, especially to the one who would express it through acts of self-disclosure" ("Imitation and Gender Subordination" 25). Butler does not deny possibilities for signifying sexual identity in the flux of embodied relations but suggests a partial and tentative process through which desire becomes articulated. *All Over Me* explores the uncertainties of coming out without foreclosing the show of affection here and now, as the film ends with Claude and Lucy kissing outside on the street, disclosing to the world their existence as queer girls. This romantic ending takes the idea of queer public presence and acceptance further than *Show Me Love*, insisting on the empowerment of young girls to inhabit city spaces as fully as possible. *All Over Me* not only represents the coupling of amorous girls, but also glimpses a world of queer cultural participation crisscrossing street, work, family and subcultural realms.

In its ambitious attempt to include painful moments of adolescent girl longing, loss, and belongings rarely glimpsed in films, *All Over Me* elicits discomfort and resistance in teen viewers. There is no single reason why this film fails to elicit youth enjoyment and identification, yet the ways it constructs unresolved relations and events in the lives of fictional characters seems to leave young viewers without the clear sense of direction and resolution that they seem to crave. In many ways, this film addresses what is usually unrepresentable within popular culture: the mundane and vulnerable disappointments, as well as the tentative pleasures of coming of age as a queer girl. There are few cultural frameworks in which to appreciate the tenuously open-ended trials and connections unfolded

within this story line. And while an indirect and performative mode of signifying desires in this film appeals to me as a theorist, I also realize how crucial it is to listen to the ways this film troubles girls at a visceral level to the point of repudiation. There is a profound gap between what I consider to be the cultural value of this film and what girls express. Whereas I have a critical interest in representational forms and contents at the limits of what is representable, for queer girls, the stakes of meaning are grounded in more immediate emotional interest in cohesive storytelling. Resolving a plot through romantic fulfillment is not merely an aesthetic ideal for queer girls but a basis for hopeful cultural engagement. It is not simply that teens prefer "positive" images but rather that they are able to situate and imagine themselves and their conceptions of love between girls more easily in the smooth narrative structures of teen romances. In this way, the film *The Incredibly True Adventure of Two Girls in Love* is enthusiastically embraced by queer girls, addressing them at the level of their fantasies for romantic joy.

The Incredibly True Adventure: Narrating Playful Erotic Attractions between Girls

I'd like to see a film in which queer girls live their lives, which don't always revolve around harassment and forbidden love.

Diane, age 18

Show Me Love and *All Over Me* are serious complex romantic dramas, structured by a coming out and coming together of girls on the cusp of sexual awakening. They represent the silence, pain, and solitary emotional struggles for recognition, unfolding long, slow moving images of girls experiencing their desire for girls for the first time. In a different vein, *The Incredibly True Adventure of Two Girls in Love* is a light romantic comedy that plays off the predictable twists and turns of popular teen genres in which opposites fall in love against all odds. Directed by Maria Maggenti, this film breaks ground by refusing to focus on the "problems" of being a young lesbian, instead allowing a working-class tomboy named Randy to exist as an already out, proud, and politicized dyke from the start. Responding with intense recognition, an anonymous teen viewer in a PlanetOut movie forum writes, "being both a young lesbian and a huge fan of Walt Whitman ('I Sing the Body Electric,' anyone?), *Two Girls in Love* was like a dream come for me! The youngster in me cringed at the usual teenage

moments, while the lesbian side laughed at the familiarity and the romantic me grinned and sighed, wishing that would happen to me . . . oh well."

A compelling aspect of this movie for queer youth is the portrayal of the protagonist Randy, who is repeatedly insulted as a "freak" and "diesel dyke" by the kids at school yet creatively resists the status of social outcast. While spending time alone, smoking up, and playing her guitar in her room, she is outgoing and engaged in her relationships within a "normal lesbo family," with her gay friend Frank, and at her job at a gas station. Randy has a buoyant rebellious spirit, eliciting the interest of youth who identify with her defiance throughout this story line. When Randy develops a crush on Evie, a popular straight girl, we watch as she risks opening up her feelings and desires with a bold direct honesty. In many ways, this film replays standard themes of the smart pretty rich girl falling for the working-class outsider, stressing the gulf between them. Yet this theme gets repeated as a queer girl romance across race and class lines, working inside and outside conventional narrative structures, as the film broaches the specificity of girl-on-girl affections within hegemonic contexts of social division. In this way, the film integrates a unique queer youth experience into a more general humorous tale of adolescent love.

The Incredibly True Adventure playfully launches into Randy's sexual explorations from the first scene where she voraciously kisses and grabs an older feminine married woman in the bathroom of the garage where she works. This departs from the very gradual indirect view of young lesbian romance provided by *Show Me Love* and *All Over Me*. Eighteen-year-old Joy enjoys such fast and playful depictions of Randy's sexual lust when she says that "Randy seems so sure of her sexuality and ready to pursue her desire." Joy enjoys the ways these characters break away from images of hesitant, unfulfilled, and often tormented longings between girls in film. Rather than reiterate a distant idealized image of an adolescent crush that conventionally absorbs girls on the screen, the film begins with images of raw physical sexual action. Opening with a frenzied erotic encounter sets up a very distinct view of Randy as impulsively sexual; she is cast as a seventeen-year-old who actively pursues other women and puts her body on the line to feel pleasure. And it is by putting a queer girl's pleasure front and center that *The Incredibly True Adventure* constructs a unique visual framework for representing a female teen experience. While Randy's initial sexual fling is presented with an edge of comic relief as we watch her grope after a mature woman's body with an adolescent boyish awkwardness, her attentions quickly move toward a deeper, more engaging object of affection as she falls in love with Evie. Randy's challenge is to bring her carnal passion into her new friendship with Evie and to allow herself to become in return a sexual object

of a femme girl's desire. Although Randy has some experience as an out lesbian, and Evie is introduced as a straight girl, they are both new to the intense and engrossing qualities of queer girl romance. Desire becomes a more fluid communicative act as the narrative progresses, and Randy and Evie stake out their mutual longings. In this way, the film develops romance between teen girls as both an exciting adventure of shared laughter, understanding, and erotic touch, which enables a fuller relationship than either Evie or Randy have ever experienced before. While friendship is key to this budding relationship, sexual allure remains a driving force of attraction between these girls. In this film, love and sex converge in a gradual process of discovery through which these two girls in love are transformed.

Randy's and Evie's desire for each other is gender, race, and class inflected. The film plays with butch/femme dynamics with a humorous edge when Evie acts out the distressed girl afraid to put air in her expensive car's tires, and Randy the mechanic comes to the rescue. Their roles become complicated as Evie's sharp rational intelligence emerges alongside Randy's self-deprecating academic insecurity. These differences are culturally elaborated and provide a basis for learning and exchange as Evie's love of opera and literature is shared with Randy as a romantic gesture of giving. In turn, Randy's youthful enjoyment of cigarettes, pot, and rock and roll provide Evie a way to let loose from the more rigid confines of upper-middle-class culture. Evie comes from a wealthy, educated, black family with a strong legacy of kinship ties and knowledge, whereas Randy was raised within a poor, white, nonbiologically constituted lesbian family dislocated from her maternal kin. They come to know each other through the contrasting details of their personal histories. Intense attractions run between these girls, crosscutting gender, class, and racial identities, expanding the parameters through which their desires and identifications are forged. In many ways, Randy and Evie are exploring new forms of cultural understanding in and through their erotic connections with each other, which remain vital to their mutual fascinations.

The Incredibly True Adventure elaborates Randy's socialization as a queer girl by situating her within a lesbian household. This pushes beyond a romance-centered teen narrative to include family and community formations of queer culture as integral to Randy's sense of self and belonging. Dialogue about coming out is spoken with personal recognition within her family:

RANDY I came out to a girl at school today.
AUNT'S
GIRLFRIEND How'd it go?

AUNT	Well, she didn't run for the hills or anything.
RANDY	She's like this totally cute popular girl in my school.
AUNT	Well, be careful, you know how people can be, but it's good to come out. I'm proud of you.
RANDY	Why do you have to make everything into a federal discrimination case!

We witness a volatile back and forth conversation across generations of queer women, a rare scene in contemporary films. This presents a unique set of family supports to deal with the daily realities of being harassed for coming out in a heteronormative society. Whereas *Show Me Love* and *All Over Me* represent an impasse between girls and their straight parents, *The Incredibly True Adventure* offers an alternative dynamic of queer family connections and resistance. What stands out in Randy's family are the caring bonds of community that include friends, ex-lovers, and lesbian partners. The qualities of this context are vividly shown when Evie comes over to Randy's home for dinner and is taken aback by the vivacious, messy, noisy, and chaotic ritual of food preparation in a working-class lesbian household. This sharply contrasts with the sophisticated, neat, and controlled family environment in which Evie and her mother live, where we watch them eat an elegant sushi meal over intellectualized discussions of parent-child separation. Communication across these class lines is mediated by race as Evie assumes that Randy's aunt does not like her because she is black, which Randy reinterprets as a discomfort with Evie's heterosexual class privilege. Coming up against social inequalities that divide their families, these girls help guide each other through their respective worlds of experience in ways that are integral to forging their romance.

While Randy and Evie are from strikingly separate worlds, they are drawn together in a fictional narrative of teen sexual exploration and independence. Both defy the rules imposed by peers and adult authorities to follow their desires, and both risk social rejection along the way. Evie is completely abandoned by her friends at the point of coming out to them and sends her mother angrily screaming "it's a girl!" when she discovers the two young lovers in her bed. Randy is confronted by continual harassment and name calling and must contend with the strict protectiveness of her aunt. Yet both girls learn to struggle for their autonomy, driven by their fierce romantic longings. What stands out in *The Incredibly True Adventure* is the girls' power to defy those prohibiting their union. It is their refusal to limit their erotic imaginations and actions to accommodate adults and peers that underlies the film's significance. It is

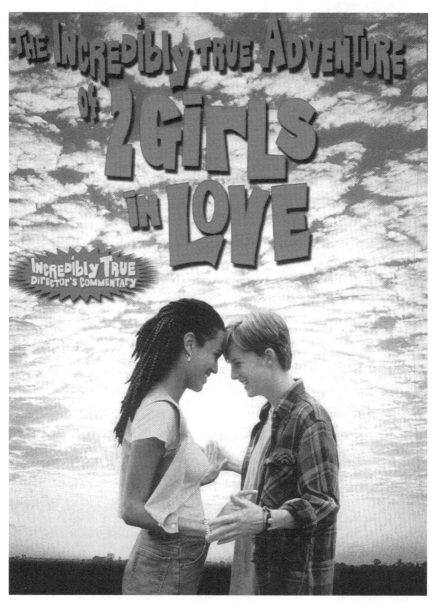

"The Incredibly True Adventures fo 2 Girls in Love" Copyright MCMXCV, New Line Productions, Inc. All rights reserved. DVD Cover appears courtesy of New Line Productions.

precisely the rebellious and risk-taking actions represented in the film that excites eighteen year old Joy who exclaims: "these girls follow their hearts, they go for what attracts them, ignoring adult fears and the threats of high school bigots." This film's innovative elements pivot around the development of girls' desires for each other, visualized as a mise-en-scène that foregrounds their amorous pleasures and sensual explorations. Constructing a fantasy space of queer girl erotic intimacy, the film sets up dreamy flowing images of them listening to music while touching, lying in the grass, collapsing ecstatically together on the floor, caressing and kissing each other's naked bodies with abandon. In these moments, *The Incredibly True Adventure* visually presents mobile and shifting carnal embodiments of two girls in love. But while it offers a different twist to an established theme of romance, it remains bound to a dualistic structure of teen pleasures, eliciting sentimental identifications without challenging generic terms of action, conflict, and narrative closure. In sharp contrast, the film *But I'm a Cheerleader* makes use of queer camp representational strategies to reflexively call attention to cultural codes of romance and sexuality. By far the most popular film amongst the girls I interviewed, *But I'm a Cheerleader* parodically sends up not only heterosexual dramas but also earnest characterizations of lesbian love This film stands out in the ways it turns back upon gender and sexual frames of reference, teasing out myths of heterosexual normality while belying social pressures to categorize gay and lesbian subjects as stable, uniform, and knowable.

Campy Pleasures: Queer Girls Reading
But I'm a Cheerleader

Camp taste identifies with what it is enjoying. People who share this sensibility are not laughing at the thing they label as "a camp," they're enjoying it. Camp is a tender feeling.

Susan Sontag, "Notes on Camp"

I personally think, that if you're a queer girl, you better have a damn good sense of humor, otherwise you're gonna get shit on a lot more.

Marnie, age 17

Most of the queer girl romantic films discussed so far develop positive character representations using realist narrative forms. This has the effect of constructing and eliciting identifications and desires without calling attention to the very conventions and assumptions of meaning-making. And while *The Incredibly True*

Adventure uses humor to convey coming-of-age experiences, the focal point of laughter is delivered through portrayals of distinct types of heterosexual and lesbian subjects reproduced in naturalizing ways, with the goal of normalizing their distinctions in the process of moving the plot forward. In contrast, the 1999 movie *But I'm a Cheerleader* directed by Jamie Babbit uses social stereotypes to produce instability and irony in the performance and reception of gender and sexual identities. *But I'm a Cheerleader* uses queer representational strategies of camp to play with and recontextualize norms. Twenty-three-year-old Cher affirms that this movie offers a unique style of representation, "not just of the typical queer girls' films where everything is dramatic and usually a sad ending, but a satire on the typical romance film as well." In this way, *But I'm a Cheerleader* intervenes in the process of representing and narrating subjectivity and romance, self-consciously reenacting taken-for-granted elements of teen romance genres to mock and disrupt the very quest for authenticity.[10]

But I'm a Cheerleader focuses on Megan, a sweet, feminine, beautiful, blond cheerleader living in a small town and growing up in a "hallmark greeting card family." While Megan appears "normal," she is pegged a lesbian by friends and family who label her according to clichéd attributes, such as eating tofu, looking at pictures of girls, and liking objects with vaginal motifs and gay iconography. She is sent off to a camp to cure gays of homosexuality, which is called True Directions, where she undergoes a five-step plan to overcome her - lesbianism and embrace heterosexuality. Initially, Megan resists, screaming out,

I'm not perverted!

I get good grades!

I go to church!

I'm a cheerleader!

I'm not like all of you!

Eventually, she becomes convinced that her erotic fantasies of girls (visualized in short, fragmented memory flashbacks of girls' breasts and legs) are not "normal," proving that she is definitely a homosexual in need of treatment. The film follows Megan moving through rituals of conformity: She is taught how to name and categorize her sexuality, identify its root cause, rediscover her gender identity, and adopt appropriate domestic and sexual roles as a woman. This film is a visual spectacle of oppositional signifiers: pink for girls and blue for boys and excessively gendered spaces, behavioral codes, and fashions. The very artificiality and control of this environment is literalized with plastic pink flowers that surround the house.

Constant reiterations of the naturalness of heterosexual lifestyles take place within a world that is undeniably fake, undercutting any possibility of truth. This movie is vividly framed as a fantasy text, redeploying hyper-heterosexist images, tracing out surface details of style, etiquette, and slogans bereft of any substantive ground.

While Megan participates in "reorienting exercises" with an earnest will to change, she becomes attracted to Graham, a rebellious and cynical girl, who sees through the illusive ploys of rehabilitation. Graham's character refuses the fantasy of heterosexual normality, maintaining a distance even as she plays along. Seventeen-year-old Katie relates to Graham's "solitary otherness. She is an outsider and she knows it. I identify very closely with her rejection of indoctrination." Not only does Graham get in the way of Megan's training to become straight, but she also tempts Megan to explore and talk about her feelings for girls. Graham educates Megan in queer girl desire: "You are who you are; the only trick is not getting caught." Megan's naivety contrasts sharply with Graham's shrewd awareness of the power of homophobic regulation and punishment. Not only does Megan begin to change from passive innocence to become an actively desiring girl, but she also falls in love with Graham in a gesture of willed eroticism. She gets kicked out of the program for having sex with Graham and becomes heroic in asserting her sexual autonomy, risking everything to pursue the subject of her affections. Megan eventually wins Graham's heart, convincing her to defy her parents' wishes, as they both leave True Directions in a climactic and flamboyant finale. In the midst of a graduation ceremony, Megan chants in her cheerleading uniform:

1, 2, 3, 4, I won't take no anymore.

5, 6, 7, 8, I want you to be my mate.

1, 2, 3, 4, you're the one that I adore.

5, 6, 7, 8, don't run from me cause this is fate.

Ending with a mixed message of passionate outlaw sexuality and acceptance of fate, the film both contests and reiterates conventions of teen romance narratives.

On one level, this film can be analyzed in terms of the ways it standardizes a coming out narrative insofar as Megan ends up naming herself a lesbian, moving from a state of confusion to a position of positive self-certainty about who she is and who she desires. Susan Talburt uses this film as an example of the discursive production of youth sexual identity through which Megan "crafts a lesbian subjectivity based on what is available to her, which are essentially

essentialist emancipatory discourses that would limit her choices of 'being who she is' "(21). In the end, becoming a lesbian is marked as good and inevitable for Megan through her achievement of happiness and independence to become who she really is. According to Talburt, while *But I'm a Cheerleader* offers a view of gender as culturally mediated, such that "signifiers are everything," (26) the narrative ends up opposing heterosexuality and homosexuality in ways that foreclose ambiguities and reinscribe binary ways of thinking. By valorizing a lesbian subject in such a determinate way, Talburt argues that the movie prescribes a narrow view of sexual selfhood and reproduces disciplinary effects of power in the guise of sexual freedom.

My approach to this text differs from Talburt's emphasis on the ways *But I'm a Cheerleader* ends up containing and reifying young lesbian subjects. While this reading is compelling, it does not quite jibe with how queer girls make sense of this film. I want to unfold several interpretive possibilities that need to be opened up by way of queer girl responses. Many girls express contradictory feelings and ideas in relation to *But I'm a Cheerleader* that allow for a much more dynamic take on the way subjects are constituted within the film. The uneasy and selective status of identities in *But I'm a Cheerleader* is broached repeatedly by girls such as seventeen-year-old Celina, who insists that

> Because the movie is so satirical and humourous, I don't think it's taken as representing the queer female population. There's so many types of lesbians, and while some of us fit into stereotypes, others don't. I'm an athlete, I'm a student, I'm a book worm, I'm dykish sometimes, femmy others, you can't classify that.

For girl viewers, the film provokes a crisis of representation rather than a confirmation of a cohesive and knowable lesbian subject. It is significant that Celina notes the importance of satire to disrupt totalizing notions of representability. Attentive to the campy aspects of *But I'm a Cheerleader*, queer girls gain pleasure from the denaturalization of gender ideals. Using exaggeration to show up cultural artifice and contingency, camp becomes a strategy that both uses and mocks realist narrative and visual elements. As a parodic performative method of representation, Susan Sontag writes that "camp sees everything in quotation marks," and it is precisely the conscious and skeptical sensibility of camp that appeals to queer girls as spectators of *But I'm a Cheerleader*. While camp is an important style produced at the level of textual production, it is also a mode of cultural participation and reception. Many girls engage with the film through irony that allows for an emotionally rich and playful process of understanding rather than dismissive sarcasm. What is

striking is their tendency to weave together responses that address issues, such as heteronormalizing camps, in terms of serious personal and social relevance, while also attending to their ridiculousness. Katie writes, "I loved the way it managed to laugh in the face of what is, if truth be told, a really scary group of people and mindset." In a similar vein, Marney exclaims, "for once someone had the balls to make fun of heteros! Well maybe not make fun of them persay, but just make people aware that there are schools and people out there that honestly believe that they can change someone's sexuality, you know, like make them 'normal' again."

For these girls, the representational mode of camp both reveals social forces of control and deflates their centrality and power from the perspectives of those marginalized. Humor arises in the gap between projected ideals and their incongruities that pervade the visual and verbal signs of *But I'm a Cheerleader*. Some girls awkwardly try to match their own experiences to this text with outcomes that trouble straightforward assumptions. Seventeen-year-old Brenda situates herself in between "Megan/Graham because I can be a rebel then also an all American girl that at the end of the day isn't so all American." Identification in this case does not fixate on lesbian sameness but undermines seamless knowledge of identities by both positing and questioning them. Undermining heteronormative uniformity in the constitution of an "all American girl" opens up a space of ambiguity in which boundaries between normal and queer girls are troubled. Eighteen-year-old Lorna claims that this film "shows that a queer girl many not just be the one sitting in the corner but may be the head cheerleader who is dating the captain of the team." For Lorna, it is the very depiction of a hyperfeminine popular girl representing queer girl desires that provides a basis for challenging viewer preconceptions. Other girls talk about how Jan's character, the only butch girl in the True Directions program, confronts assumptions that masculine girls are necessarily lesbians. Terra says she "also liked the bit with Jan saying that she wasn't gay, people just assumed she was because of her hair and clothes and love of sports. I think things like that do a lot to combat stereotyping." In this sense, queer girls find meaning in precisely those parts of the text that are least predictable and formulaic but that nevertheless hinge on resignifying mainstream popular cultures. Enjoyment of this movie revolves around self-conscious performances of gender and sexual types, addressing how straight culture both imagines and misrecognizes queer subjects.

Queer girls don't seem to read *But I'm a Cheerleader* for how it represents identity but for how it complicates the need to seek out a single image or story

capable of including everything. Marcia critically comments that "they missed out a lot on the stone butches, the hippies, the feminists and the bisexual girls. They only revealed a few stereotypes, but then again they only had an hour and a half to do so." Marcia points to the fact that the types of girls represented in this film are purposefully drawn as "stereotypes," suggesting that what is being signified is not a "real" lesbian but rather a consciously selective and simplified image of what a lesbian is expected to be. These viewers are receptive to the limitations of these fictions, engaging in critical discussions of the dominance of white characters and racialized norms that constitute the kinds of sexual stereotypes deployed. Seventeen-year-old Olivia states that "I think they could have been more representative (e.g., more black, Middle Eastern, Asian characters), although that may be because I live in a particularly diverse city and I'm not used to the 'all-American white suburbia' stereotype employed in the film." Olivia draws from her own experience as an urban Asian girl to interpret the racialized content and frames of representation that give rise to images of what is presumed to be "normal."

While maintaining a critical and ironic distance, queer girls negotiate their pleasures watching *But I'm a Cheerleader* as fictional entertainment, enthusiastically citing "cute girls" and a "really hot sex scene." It is precisely this oscillation between emotional immersion in the love story between Graham and Megan and awareness of its campy contextualization that unfolds an ambivalent process of queer girl spectatorship. In many ways, the film texts offer a chance to view queer girl love simultaneously inside and outside the heteronormative frameworks that structure popular films. The very status of lesbian sexuality is up for grabs as Megan asks her gay mentors Larry and Lloyd how to become a lesbian: "I thought you could teach me how to be a lesbian, what they wear and where they live?" She is told that there is no one way, and she must continue to be who she is. Megan asks this question from an abstract sense that she must become and conform to the standards of what a real "lesbian" is. Yet it is precisely such abstractions of sexual identity that the film undermines through campy performative reiterations. Desires between girls are set out in a world in which True Directions cannot be guaranteed, they hinge on the specificity and variability of embodied attractions and fantasies. It is the erotic passions exchanged between Megan and Graham, rather than any definite claim about their identities, that constitute *But I'm a Cheerleader's* happy ending. Rather than regard the film's conclusion in terms of a normalizing and closed structure, most girls read it as a playful affirmation, a happy ending with an ironic wink.

Conclusion: Watching Girls Loving Girls

It is impossible to escape the fact that the textual analysis outlined in this essay is imbued not only with the subjective insights of queer girls but also with my own desire to see cinematic images of teen girls desiring girls. Queer girl films thrill and provoke me! Coming to them as a cultural theorist, I try to be conscious of how my feelings and fantasies inform my ideas. These films are important to me as a queer adult craving stories through which to make sense of my adolescent past. I also feel strongly that they are crucial to younger generations of film viewers looking for a broad range of possibilities for identification and imaginative projection. By making the claim that these films are culturally transformative, I have selected and highlighted certain parts that help build an argument centered on the representational specificity of queer girl experiences. I am deeply aware of how little cultural attention is paid to queer youth and how dominant heterosexual ideologies pervade popular and critical interest in youth. This leads me to argue that reading queer girl films for their nuanced differences is a reflexive and critical interpretive activity. In this sense, the personal edges of my reading are also political, an approach that consciously values subjects that have been historically erased and marginalized from public view. As Jean Bruce writes, "a queer reading against the grain, to steal pleasure is also an implicit politics of interpretation. This is one place where the politics of identity and the aesthetics of resistance coincide in textual analysis" (288). Films constituting the lives of queer girls in fictional narratives are politically meaningful insofar as they enable ways of seeing and imagining young romance beyond a heteronormative gaze and narrative structures while borrowing and resignifying elements from teen film genres. The point is not to formalize a new subgenre but to open up dialogue about the representational practices that enable viewers to identify and interpret these stories in multiple ways, to develop languages through which queer girls are engaged as culturally visible and viable subjects.

The rich variety of stories and images constructed within these films attests to a creative field of queer girl cinema emerging today, calling forth reflexively engaged viewer responses. The significance of these specific romance films lies in their detailed perspectives centered on the psychic, intersubjective, and cultural work involved in queerly coming of age as girls. *Show Me Love, All Over Me, The Incredibly True Adventure of Two Girls in Love,* and *But I'm a Cheerleader* help viewers see that becoming queer as an adolescent involves self-knowledge

and the ability to communicate and act in the face of widespread denial and hostility. In other words, queerness is portrayed as an active verb, a doing, a growing, and a maturing into selfhood. The strength of these films lies in their willingness to profile the emergence of queer girl subjectivity in diverse relational contexts. It is not a rational progression toward moral normative maturity that structures these films, but rather a dynamic interplay of self and other, body and mind, silence and language. Performative contours of girls' identities and desires are elaborated through daily enactments, what they say and wear, how they move and gesture, the music they enjoy, and how they interact with those around them. The characters are visually and verbally produced as queer girls in and through their embodied and culturally mediated relations. By framing the sexual identifications of girls as an ongoing accomplishment that is contingent and mobile, while also being grounded in their specific stories, these films overcome the closure of heterosexist endings. While each film demonstrates that the path towards the self and social recognition of queer adolescence is not reducible to a static formula, they trace difficult challenges as each character comes to terms with her sexual difference. Coming out and coming of age are represented as a creative process involving deep feeling, emotional intelligence, and social insight.

The transformative crux of the films profiled in this chapter is the chance they offer to see smart girls who are determined to find love and become sexually active with other girls. This offers another take on "girl power" premised on the strength of girls to defy gender and sexual norms of beauty and desirability and seek out alternatives. Their power is portrayed as vulnerable and situated, breaking with the commodified presentations of the hyperglamorous sexuality of heterosexual girl power icons. Images of ordinary girls embracing, kissing, and fucking girls provide key visual moments through which we glimpse desires, getting a close-up view of queer girl physical and psychic pleasures. The protagonists' desires are also the driving impetus of narrative development, making things happen and moving the story along. Through the force of their desires, these girls are compelled to make choices and act in ways that change the course of their social lives, forgoing conformity for risky pursuits. Yet there is no causal or predictable outcome to the plots of these films. While, in some sense, the girls become heroic individuals overcoming obstacles to get the girls they want, they are also shown hesitating in the ambiguity of adolescent doubts and uncertainties. There is a striking persistence underlying these girls' erotic longings that combines quiet caution and visible determination. Yet all these films provide narrative endings

that involve amorous interactions between girls; they come together if only briefly to affirm the possibility of fulfillment. This transforms conventional hetero-endings of teen romances, as we are left to imagine the futures of these girls as queer subjects. It is not the guarantee of a type of self or romance that matters here but contingent and relational images of love actualized between girls that provide hope and promote change.[11]

· 5 ·

UNEASY PLEASURES

Reading and Resisting Lesbian Magazines

I was 18 when I bought my first lesbian magazine. I knew about them for years, because of my gay uncle. He would always have a copy of the *Freshman* in his bathroom. So I knew about gay mags since I was around 13.

Betty, age 19

Try reading *DIVA* on a bus without worrying that somebody old and conservative is going to look over your shoulder and either have a heart attack or throw a bible at you.

Katie, age 17

Queer girls read lesbian magazines with an uneasy sense of pleasure and belonging. At first glance there appear to be very few magazines geared to youth who identify beyond heterosexist ideals of beauty, fashion and entertainment. Most corner stores and large chain bookstores carry dozens of teen magazines for and about conventionally feminine girls centering on glamorous images and tales of love between the sexes. It seems paradoxical to try to find traces of queer girl culture within a medium that continues to construct some of the most trenchant fantasy consumer cultures of straight girl etiquette and appearance.[1] Up against the limitations of mass media circulations addressing and reaching young queers, it becomes necessary to pay attention to a growing niche of magazines emerging over the past two decades in which girls who desire girls are

directly addressed within the broader lesbian lifestyle focus of editorials, feature articles, news stories, gossip columns, fashion spreads, and advertisements. Although there are no specifically queer girl magazines, many lesbian magazines are unique in their attempts to cross generational boundaries within the style and content of their representations. Because lesbian magazines are not exclusively focused on girls, the very process through which young readers are addressed and constructed is qualitatively distinct from other popular and alternative teen media. Youth are addressed within the larger sphere of commercialized lesbian culture. While this opens up interesting possibilities in terms of less rigid age boundaries and more possibilities for dialogues across generational experiences and differences, it also restricts articulations of queer youth experiences and identities. Teens and young adult women become framed within a cultural context of commercial mass media portrayals of lesbian consumption, sexuality, politics, and community. Positioned within the generalizing commercial ideologies of mass media publications, the queerness of youth often becomes muted for the sake of promoting normalizing ideals of lesbian identity.

Lesbian magazines are a contradictory cultural site for studying queer girls. On one level, youth increasingly have a strong visual presence within commercial magazines owned and written by, for, and about lesbians, such as *Girlfriends*, *DIVA*, and *Curve*, yet, on another level, this presence is circumscribed within commercial media formats focused on consumerism and the cultural branding of identities. In this way, a young lesbian self becomes prescribed as a media creation, a projected commodity image based on race, class, gender, and sexual hierarchies of value and intelligibility. Larry Gross points out how gay commercial representations do not reflect existing ways of life but fabricate social ideals and individualities to be emulated and longed for. While I consider lesbian magazines as a realm of communication that both constructs and complicates what it means to be a lesbian, I discuss the ways such a commercially segmented media niche narrowly and normatively frames young sexuality and selfhood. Glossy lesbian lifestyle magazines are characterized by deep tensions between representing socially marginalized subjects and advertising differences in ways that reify consumer identities. They package and sell images of lesbians in terms of race, class, and gender norms, while also calling attention to the cultural contingency and political stakes of minority representation. Enabling public visibility while at the same time circumscribing its terms of value, lesbian magazines shape notions of identity, desire, and community, simultaneously reiterating and disrupting the centrality of heteronormative consumer cultures. More than any other mass media, magazines reveal their commercial connections

by interweaving ads and content. A process of selling readers to advertisers for beer, car, sex toy, clothing, and vacation companies is central to the production of lesbian magazines, yet this process has specific implications when the target market is young lesbians and the readers are teen girls in the process of shaping and questioning their queer subjectivities.

This chapter positions queer girls as readers who are invested yet frustrated with their status within lesbian magazines. I explore how youth are represented in these publications and also how young readers interact with them. What emerges are insights into how queer youth negotiate their pleasures and engagements within the limitations of commercial media available while developing strong visions of the kinds of magazines they would prefer to see. In Katie's words, "In a perfect world I would be able to walk into a newsagent and be faced with a choice of different magazines aimed at queer women, each with a separate focus and audience." Katie knows that her choices are limited to a small range of very general magazines that she avidly reads while allowing herself to wish for something more, hoping that her queer girl interests might one day become represented with a sharper focus and greater diversity. While I try to stay close to the specific responses of girls to what is available and accessible to them, I also elicit their insights into what is missing and what kinds of magazines they imagine would speak to them more directly. This chapter follows the ambivalence and compromise expressed by the girls I interviewed, following their skeptical enjoyments while listening to their desires for alternatives to what is available in the here and now.

Deheteronormalizing
Girl Magazine Research

Beauty magazines disillusioned me towards magazines as a whole when I was young.

Mel, age 18

Mainstream girl's magazines mostly talk about makeup tips, how to do your hair, and how to get boys to like you with a light touch on serious interests. I read magazines like Seventeen when I was twelve and had grown tired of them by age 14.

Cindy, age 17

Feminist analysis of girl cultures has focused on mainstream fashion, celebrity, and lifestyle teen magazines as distinct girl genres that work to prescribe beauty and romantic idealizations.[2] More pointedly, feminists researching the common cultures of girls have noted that magazines work as an intense site for shaping normative investments in heterosexual femininity. In almost all cases, what gets

taken for granted in studies done on adolescent girls and magazines are both the types of mainstream magazines consumed along with the sexual and gender identities and desires of girl readers. Not only does this "leave unwritten, a heterosexual context for the subject" (Case 56), but it also limits the very field of empirical and textual research through which to understand a diversity of girl cultures today. Trying to shift attention onto magazine circulations that might address queer youth, it becomes important to begin to ask questions that rarely get asked in feminist research on girls: Where do youth look for print images of girls who are in a process of questioning their sexuality and gender? What about girls who desire girls? Girls who desire female boys? Girls who see themselves as masculine, butch, androgynous, and/or male? Femme girls with tomboy fantasies? Sporty young dykes in search of popular icons? Where and how do queer girls find images and stories that speak in some way to their experiences and fantasies in popular magazines?

Many queer girls that I interviewed approach mainstream teen's and women's magazines with a great deal of skepticism and critical insight. They are keenly aware of the limited personal appeal of consumer culture ideals of heterosexual femininity promoted within the glossy pages of magazines focused around lifestyle images. Twenty-year-old Virginia exclaims that "teen magazines give detailed sex and relationship advice but only to straight teens!" At the same time, interest and enjoyment of beauty magazines is not completely discounted by queer girls. When I put a pile of magazines, including *CosmoGIRL!*, *Seventeen*, *Teen People*, and *ELLEgirl*, in front of a group of queer teen girls, they grabbed for them with sly delight, making ironic playful comments about cover girl images and contents, experiencing popular textual pleasures while queering them along the way. Eighteen-year-old Sarah states that "fashion and beauty magazines can be amusing to prod through for eye candy or ridiculously girly bits but nothing substantial." Prodding for eye candy, giggling at celebrity gossip, rolling their eyes at clichéd portrayals of hyperfemininity, queer girls evince subtle responses. Asserting their own creative agency in response to passively posed sexualized models, these girls derive pleasure from the very act of altering the "how to get your dream guy" theme of teen magazines to accommodate their own fantasy constructions of dream girls. Responding to the pervasive "in-your-face" media presence of heterosexualized youth culture, queer girls learn the codes and are well versed in their visual and narrative conventions, while at the same time twisting their relevance, meanings, and influences.

Most research on girls and magazines has overlooked potentials for the resistant perspectives of queer girls, focusing on normalizing reproductions of gender

and sexuality. Even critical approaches to mass media representations of girlhood continue to fixate on hegemonic constructions of femininity and foreclose alternative ways youth might read and challenge them. Dawn Currie writes that "as a social text that mediates discourses surrounding femininity, women's magazines are part of the process of signification through which the female body, as a signifier is invested with characteristics which are culturally read as feminine" (16). While Currie provides a layered analysis of the interaction between media texts and the lived, embodied experiences of girls, there is little room to consider girls whose self-perceptions collide with normative signifiers of femininity. Currie calls attention to the gap between ideal beauty images and embodied experiences of girls, but she ends up stressing the ways magazines produce desires to emulate girl models in magazines. Currie goes on to write that "what the gap between the cultural Ideal and experienced Self creates is desire; a desire by women to be thinner, more beautiful, more accomplished in their femininity" (17). Emphasis is given to girl readers who desire to become like the hyperfeminine models in the glossies. Yet the girls I spoke with actively turn self-serious representations of makeovers, beauty tips, fashion spreads, and celebrity obsession into an occasion to talk back ironically, articulating disillusionment and disbelief in gendered beauty ideals rather than being interpellated as longing subjects. Seventeen-year-old Cindy confesses that "sometimes I try but I just don't think I can pull off mainstream femininity. I end up looking like a butch in a dress." Tensions between idealized representations of girls and queer youth self-perceptions call for methods that appreciate dissonance between norms and selves, pictures and experiences. When it comes to beauty and body images, queer youth develop reflexive dialogues between magazine texts and their social embodiments that are not resolved into desires to conform with or reject normalizing ideals. Accommodating the changes and ambiguities of their gender and sexuality, queer youth call for new ways of thinking through relations between dominant representations and subjectivity. It becomes important to leave room to consider youth whose differences provide a basis for media analysis and self-recognition that are not oriented towards assimilation or sameness.

Beauty is not the only realm in which queer girls' engagements with magazines are critical and complicated. I was repeatedly told how "sick and tired" they are of the constant message to find, date, and obsess over boys. Feminist researchers have focused on romance and sexuality within teen magazines as a key site of the enculturation of girls into heterosexuality. Elaine Kaplan and Leslie Cole interview girls about teen magazines and claim that, regardless of race and class locations, girls tended to displace talk about themselves with talk

about boys, and "the girls' focus on boys was often accompanied by criticism of female models in magazines" (147). While they are concerned with girls' pre-occupations with boys and conclude that girls are "not very knowledgeable about their sexuality" (156), the entire focus and design of the study leaves no room to question the heterosexist assumptions not only of magazines but also of their empirical approach and interpretive framework. In a similar vein, Laura Carpenter's analysis of cultural scripts of sexuality across twenty years of *Seventeen* magazine reveals dominant patterns through which "young women's visions of themselves as sexual" (166) become constituted. Carpenter writes,

> *Seventeen's* editors direct readers to particular scripts and subjects positions by dis-
> regarding some sexual scripts (e.g., cunnilingus), by denigrating other scripts (e.g.,
> homosexuality), and by resolving discrepancies among scripts in relatively conserva-
> tive ways (e.g., promoting protection over pleasure). (166)

Recognizing the ways in which sexual scripts are historically contingent and changing within teen magazines, Carpenter continues to focus exclusively on hegemonic binary representations and meanings of sexual identities and prac-tices, leaving little room for queer subjects or readings. In this way, queer girls are left out of the picture not only as media content but also as potential inter-locutors capable of altering the preferred meanings of advertisers and editors.

Understanding the uses and values of mainstream and alternative magazines for queer girls calls for nuanced methods. It seems that queer girls engage in readings that promote skepticism and dis/identifications with beauty and teen magazines without eliminating opportunities for cultural pleasure and desire. It is precisely these volatile reading positions that get bracketed out of feminist analysis of girls as magazine readers. In order to take into account the hetero-geneity of queer youth cultural engagements, methods attentive to the inter-pretive power of ambivalent desires and dis/identifications in relation to mainstream media need to be considered alongside uneasy engagements with alternative media. The process of trying to find out what kinds of magazines speak to queer girls' interests and experiences is complicated by the fact that there are no magazines that directly address queer girls. In this way, even though lesbian magazines offer alternative cultural discourses for queer youth, they are always already part of a genre that does not quite fit queer girl subjects. A difficult predicament faced by queer girls is an almost complete lack of mainstream visual culture geared towards them specifically. So even when the research focus is de-centered away from mainstream teen's and women's mag-azines towards an alternative lesbian niche, it becomes necessary to follow the

ways queer girls develop reading strategies that enable them to negotiate the ongoing tensions of their queer desires.

The point here is that, in researching queer girls and magazines, there are no clear-cut texts or set of representations constituting them as subjects. Neither is there a reliable population of queer youth that reads lesbian magazines. On the contrary, the representational sphere of magazines, as well as the process of queer youth interaction, is wildly indeterminate. Many queer girls have never heard of lesbian magazines, some want them but can't find them, and others are terrified of being caught with them, worrying as twenty-year-old Dana does, that "if I bought these magazines it would make my sexual orientation highly visible." The fear of being caught with a lesbian magazine is a continuous problem raised throughout my interviews, and it is not an abstract worry but a concrete obstacle to consumption and enjoyment. Sally writes, "I live at home and would be kicked out without my college paid for if lesbian magazines were found in my house." The stakes are high for girls risking exposure by reading queer magazines. And while some girls are willing and able to take such risks, the knowledge that many youth are unwilling and unable to read lesbian magazines remains a backdrop to my analysis throughout this chapter.

The terrain being studied here is risky and uncertain; queer girls approach lesbian magazines with hesitations, doubts, and disappointments. At the same time, many youth also express joy and relief at having something else to which they can turn. Sixteen-year-old Wanda says she turns to lesbian magazines "when I get sick of those 'How do you know if he likes you or not?' articles that are usually in *Teen People* or *YM* or those other typical teen girl magazines." Some youth are vividly excited by the chance to see images and read stories about young queer women. Sixteen-year-old Trish writes,

> I was immediately surprised that the articles and images in a lesbian magazine are so different from those in mainstream magazines. They are far more interesting, as I can relate to them. I feel more compelled to read the magazine when I know I can relate to the topics, and the magazine will hold my attention.

While remaining sensitive to the difficulties girls have in accessing and participating in commercial lesbian media, it is important not to underestimate the significance of magazines in providing girls with images, stories, advice, and information about lesbian culture. Nineteen-year-old Betty says that magazines are where "I find out about 50% of new info pertaining to lesbian culture." Sarah comments that lesbian magazines "can be a great tool in allowing girls to know that people of this type exist and that it is not a 'weird' idea to be

queer." Normalizing images of lesbian identity, relations, and sexuality in glossy magazines may seem like a limited avenue of cultural identifications and desires for queer girls to explore, but they should not be easily dismissed, as they may be the only public text a teen can read in which pictures of girls kissing are openly portrayed and valued. Of course, queer girls want more than kisses; they want much more. As I will explore throughout this chapter, girls approach lesbian magazines with a longing to find representations that jibe with their queerness and with a realization that they have to look beyond what commercial culture offers. Yet queer girl interest in these magazines is often spurred by longings for popular representational affirmation, leading them to invest in some elements and poignantly question others.

Consuming Lifestyles and Branding Queer Youth

It feels like *Cosmopolitan*-Lesbianized. And really, that kind of annoys me, because *Girlfriends* tends to leave out a lot of what makes Lesbians so different: The set of struggles we've had to face that are completely different than straight women. Don't get me wrong, we've all had to face the same crap for being women, but at the same time, straight women can't even imagine some of the things lesbians have had to go through.

Charmaine, age 17

At the core of this chapter is a concern with the commodification of queer youth in an era when commercial media is increasingly focusing on young gays and lesbians as consumer culture icons and participants. With the development of gay- and lesbian-produced mass culture, youth are increasingly being used to market events, products, and ideals while also being positioned as target audiences. While this is part of a general cultural obsession with youth, who are used to sell idealized notions of health, beauty, and sexuality, little attention has been paid to how queer youth are depicted and how they in turn negotiate hegemonic images of themselves. The ways teen girls and young women are signified and situated within lesbian media calls for close attention to various influences tied to broader commercial and cultural formations. Although my focus is on the ways queer girls are framed and commodified within magazines, the meanings of such representations are not homogeneous or static. I trace dialogues surrounding these texts signifying desire, identity, and community in order to explore how youth make sense of themselves within such media contexts.

In his article, "Image-Based Culture—Advertising and Popular Culture," Sut Jhally argues that mass media representations are regulated within a commodity image system in which diverse social identities are instrumental to corporate advertising and branding. Within this system, visual appearances are simplified and tweaked as media spectacles that are easy to categorize and quick to consume. Fast, abstract, and seductive, this visual economy trades on the surplus value of youthful sexualized bodies. Commodity images speak to unconscious dreams of instant happiness and desirability, and, in this way, they work against socio-historical-political understandings of selfhood. Individualized lifestyles and surface appearances ritualize the discursive terms through which cultural ideals are circulated. Yet, as Jhally stresses, their power lies in the transference of media abstractions into emotionally gripping experiences and longings. Ad images respond to desires for social belonging and romantic love, and, in this sense, they are not false or superficial but rather a displacement of deep psychic and social needs onto the fantasy texts of consumer culture. Operating within this expansive commodity image system, how do lesbian magazines construct images of happiness for young queer subjects, and how do youth engage with such a representational system?

Towards answering this question, it becomes important to rethink the ways in which sexually marginalized people have become visible and culturally meaningful by actively using and transforming commercial media formats and commodity images. In this sense, there is no absolute way of separating out "authentic" subjects from commodified modes of visibility, but, rather, as queer theorist Diana Fuss suggests, the very possibility of recognition lies on the border inside/out such discursive regimes. Many lesbian magazines self-consciously engage with the conventions of advertising and fashion media so as to reiterate, play with, and complicate binary sexual identities. Girls also approach these magazines with an edge of reflexive questioning and identity investment. Coming to dominant media forms with savvy ambivalence, they are aware of their commercial interests and mainstream biases, while also enjoying and using them for pleasure and knowledge. In this way, the very process of commodification comprises regulative and creative potentials. As Steven Miles argues, youth consumption is not simply a mode of self-expression or escape, but rather "young people's experience as consumers may indeed give youth researchers a unique insight into what it actually means to be a young person at a time of apparently rapid social change" (170). To be both young and queer complicates the ways consumption shapes experiences. I want to argue that consumption of lesbian magazines by queer girls is much more than a trivial pastime,

revealing the challenges of buying into, while exceeding, the economic and symbolic terms of exchange.

Much of the work done on the commodification of lesbian culture analyzes the subtextual dimensions of imagery used to address lesbians while accommodating dominant heterosexual audiences. Danae Clark writes in 1994 that "lesbians have not been targeted as consumers by the advertising industry" (485), leading her to discuss the ambiguities and dual meanings of "gay window advertising" in which gay and lesbian consumers read implicit codes of same-sex desire against the grain of heteronormative imperatives. Clark hones in on increasing tendencies of mainstream commercial media to appropriate lesbian cultural elements as individual style and consumer choice, positioning lesbian visibility as part of capitalism's colonizing powers. This rise in lesbian commercial presence is not merely about domination; it has also spurred the very process through which lesbian identities are constituted and proliferated within and against dominant texts in unstable ways. She writes that "lesbians are accustomed to playing out multiple styles and sexual roles as a tactic of survival and thus have learned the artifice of invention in defeating heterosexual codes of naturalism" (491). In response to invisibility and reified visibility, lesbians have become deft interpreters, seeking pleasures in the process of eliciting subcultural meanings out of commercially driven representations.

While Clark's interpretation continues to be relevant, doing research today calls for different strategies and theories through which to interpret a proliferation of lesbian-specific consumer cultures over the past decade. Lesbian magazines are now filled with ads centering on youthful sexualized lesbian bodies. Ambiguous images with dual meanings for hetero/homo readers give way to full-fledged attempts to capitalize on a lesbian gaze, which is itself a projected ideal of sexual identity and desire that fits neatly within consumer cultural models of selfhood. In terms of the visual power of advertising, young white feminine subjects come to embody lesbian ideals of self and culture. A racialized economy of lesbian looks becomes inscribed within white supremacist logics valorizing an exclusionary range of representations of lesbian love and lifestyles. In this sense while sexual minority subjects enter commercial spheres of marketing, they reproduce race and class homogeneity while entrenching lines of division, occluding intersections of social identities within lesbian mass media niches. Several queer girls of color call attention to a failure to represent anything other than what twenty year old Marcia calls the "typical white mold of popularity and sex appeal." Along these lines of criticism, Iris writes that "seeing girls kissing on the pages of magazines is not enough if they always look the same, act the same and make lesbians appear without diversity."

In the hierarchal fabrication of lesbian images within commercial magazines, boundaries reinforce what gets seen and valued and what gets erased from view. Some critics have commented that a generation gap has become intensified between lesbian feminist subjects and young fashionable lesbians. Sue O'Sullivan writes that

> Two images of lesbianism exist at the same time, one young and proactively attractive and fashionable the second older, dowdy, prescriptive and overtly political. Both images are fantastical; neither image corresponds any more to the multilayered realities of lesbians' lives than other media caricatures of women do. (92)

A key age division between young and older lesbians occurs alongside the intensification of consumer marketing and visibility. Young lesbians are being constructed as fun, hip, media savvy, and assimilated, leaving others out of the media loop. Yet commodified hierarchy divisions are not merely constructed across generations, they are also being intensified between young queer subjects, separating ideals of white feminine affluent and "straight-looking" girls from queer youth who fail or refuse to conform to normalized ideals. When gender variant and ethnically diverse youth are included, their differences are marked out and simplified as currency in a youth market that thrives on transgressive differences as surface styles and sellable trends.

Commodification reaches a point at which age, sexuality, race, and class differences become stripped of social and political substance and resignified as alluring corporate concepts. Naomi Klein calls this a "new branded world" (3), in which youth are the primary targets of corporate identity building. In the case of young lesbians, branding operates not through duplicity or sly concealment but rather as an attempt to render a specific version of sexual identity transparent and self-evident. The branding of lesbian youth within corporate media milieu builds itself on immediately identifiable concepts, relying on emotional resonance that comes with pushing the boundaries of a historically invisible sexualized subject to reveal its real raw truth: "This is what a lesbian looks like!" In one sense, branding uses the metaphor of coming out in popular culture to construct and capture the essence of an out, proud, and liberated lesbian. Converging with an increasing emphasis on celebrity culture, portrayals of out, beautiful, lesbian stars become branded in terms of definable, so-called special qualities and personalities. In the repetition of lesbian star profiles and cover stories, lesbian magazines become key sites of brand promotion and circulation. Branding capitalizes on revelations of authentic unified lesbian selves as a difference assimilated within the sameness of consumer culture norms of individuality and choice. This extends and intensifies the shift noted by Arlene

Stein toward lifestyle lesbianism and against a more anti-style, politicized lesbian feminism. In Stein's words, "A 'new lesbian' face peeking through today's mass culture is young, white, and alluring, fiercely independent, and nearly free of the anger that typed her predecessors as shrill and humorless" (477). Yet the very generational and cultural binary analyzed by Stein makes less and less sense when the branding of lesbian style works to incorporate resistance as variations of consumer choice. In Clark's words, "style as resistance becomes commodifiable as chic when it leaves the political realm and enters the fashion world. This simultaneously diffuses the political edge of style" (494). Both Stein and Clark focus on the marginalization of lesbian feminist politics with increasing commodification. Queer youth also question media projections of a stable, visible, transparent lesbian figure at the expense of intersectional identities, mobile desires and engaging politics. Many girls I interviewed were bewildered by commercial interpellations to become a lesbian. Eighteen-year-old Joy asks, "what on earth is this obsession with lesbians all about anyway!"

While there is no single brand of images that captures what a lesbian looks like, the focus of most corporate marketing is to show up the obviousness of girls who desire girls. A Bud Light ad in *Curve* magazine inscribes ". . . be yourself . . ." on a close-up illustration of a tattooed young beautiful woman, beer in hand, being touched erotically by another voluptuous femme. The interpellation here is direct and blunt: Be who you are, become who you want to be, desire and touch other women, and don't be shy or hesitant. Lesbian sex is rendered into seemingly visually transparent statements within such branding formats. An ad for Prowler clothing stores in DIVA magazine displays the body of a young woman with her low rise jean shorts undone, bikini briefs exposed, polishing a Rolls-Royce above a caption that states: "not just for boys." Queer girls read such ads with mixed and ambivalent reactions. Seeing the Prowler ad for the first time, eighteen-year-old Diane smiles with an admission that the image is "deliciously hot," which she immediately qualifies by commenting that it is also disturbing in the ways it leads her to fall prey to the seductions of sexist media techniques. Diane reflects on the uneasy feelings she has about her enjoyment consuming sexualized images of girls within a commodity image system. She articulates critical awareness about the implication of her erotic gaze within this system while simultaneously deriving queer pleasures from it. Some youth are thrilled with increasingly bold, out public images that suggest a unified positive cultural identity produced within corporate advertising. Charmaine exclaims, "I love seeing ads for things like Pride-shirts, Queer-orientated cruises, 'sex toys', etc. I mean, we're not everybody else. Queers do have their own culture,

and with that comes our own world of advertising. I absolutely love lesbian ori-entated advertising!" Such excitement is often interrupted by cynicism; youth interest in the public display of lesbian desire becomes tampered by conscious-ness of the crude money-making motivations of corporate advertisers.

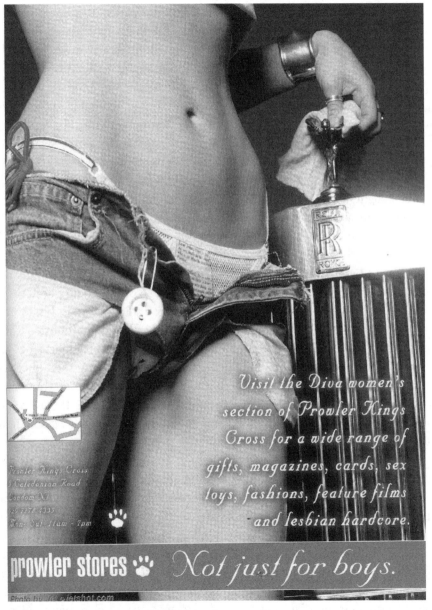

Prowler advertisement by photographer Jet of www.jetshot.com

Commodification calls upon readers to come out, strike a sexy pose, be part of a cool, sexy culture of gorgeous young gals. Of course, being out in advertising is premised on a narrow set of criteria. Not only are most models young, white, affluent, and thin, but they are almost exclusively feminine. Many writers have commented upon the emergence within mainstream media during the 1990s of lesbian chic, which has tended to valorize hyperfeminine images of lesbians as ideals to emulate. The lipstick lesbian becomes branded within media culture as a safe crossover figure of identification and desire. Normalized within heteronormative regimes of beauty, age, and sexuality, lesbian chic has mass appeal, leaving the gender and sexual status quo in tact. Meg Moritz argues that images of lesbian chic need to be theorized in terms of economic exploitation and cultural homogenization (136). While critics such as Moritz have focused on the professional urban ideal of white femme chic, idealized qualities of youth are increasingly incorporated within this image. The preferred model of lesbian advertising appears to straddle the teen / young adult border, can easily pass as straight, and conforms to the class, racial, and sexual codes of mainstream consumer culture. In this way, hegemonic feminine looks are valorized while the complex queer dimensions of femme desire become muted and contained, ". . . be yourself . . ." but make sure that you fit into dominant race and class modes of individuality, make sure you don't look, act, and dress too gender ambiguous or sexually flamboyant, and don't even consider being or desiring a butch! In this way, queer elements of queer subjectivities that resist binary categorizations are excluded from the branded realm of lesbian authenticity and consumer choice. Eighteen-year-old Victoria says, "most lesbian magazines are geared towards lipstick lesbians and queer femmes, leaving trannies, butches, andros, fag bois, Daddies/girls, and others out of the picture." Even those girls who enjoy normative feminine ideals are conscious of what gets left out. In seventeen-year-old Olivia's words, "I don't mind the femmes . . . but I guess there could be more androgyny and trans folk."

Normalized visual representations enter through lifestyle branding and advertisements rather than through content that provides the substance and mandate of these publications. There is no doubt that the youthful, white, affluent feminine body is visibly commodified in lesbian magazines, especially within advertising content. While many ads actively celebrate and promote the existence of lesbian cultures beyond the text, they construct social ideals and boundaries through their public representations. Even though lesbian cultural ads are less directed at making over the physical contours of individual bodies, they nevertheless inscribe types of girls and women according to hierarchies of

value. Yet the branding of a feminized lesbian chic is not quite the equivalent of the pervasiveness of hyperfeminine beauty ideals in teen fashion magazines, such as *CosmoGIRL!* and *Teen Vogue*. What is striking across *Curve*, *Girlfriends*, *and DIVA* magazines is the absence of cosmetic and beauty product ads and beauty columns. Most ads focus on lesbian-specific events, clubs, festivals, and services and provide glimpses of cultural communities and the social subjects who are associated as belonging within them. Looking beyond advertisements, visuals and stories are not only more diverse, but, at times, they also disrupt unifying commodity images of lesbians. There is a productive tension opened up in these magazines between tendencies to brand lesbian desire and articles and profiles that challenge and mock these tendencies. Lesbian magazines seem to play up the very contradictions of their own commercialization, creating a discursive space in which to question the conditions of mass media acceptance. I am interested not only in critiquing the commodified ways in which girls are represented within lesbian magazines, but also in thinking about what exceeds the branded ideal and identity of lesbian desire. Young lesbian, queer, and questioning subjects become articulated within this commodity image system in ambiguous and, at times, disruptive ways. As readers, queer girls respond to these contradictions with a keen recognition of the impossibility of corporations to ever fully assimilate their marginal status, deriving pleasure from the attempts and failures of advertisers to include them as part of their brand.

Lesbian Camp for a Genderqueer Generation

Queer girls are known for having styles that are all over the map. Often it's not what's portrayed in *Vogue* and the like (and, we can't afford them either)!

Celina, age 17

While commodification works to privilege and normalize a limited range of representations, it is not definitive of what these magazines offer readers. Interwoven into the content of interviews, articles, and photo essays, lesbian identity and culture become a complex and politically engaging process of representation. In the "100th Souvenir Issue of *DIVA*," a project called "Looks Lesbian" asks designers to devise advertisements that address lesbian invisibility and commodification. In this piece, marketing is used as a site for ironic representation that engages with readers to "imagine a world where everyone you see purrs 'lesbian' at you" (Roberts 25), a world in which butch dykes sell products on TV and queers dominate the visual landscape. Deploying the

skills of advertising designers, *DIVA* requisitions ads that talk back, rebranding lesbians through a self-conscious awareness of the importance and pitfalls of commercial visibility. A mock ad titled "Instant Visibility" uses retro style graphics to parody the process of public recognition by selling a forehead tattoo that reads "Dyke." Below the image, an explanation reads, "Skewed representations of the female body in the media have ramifications—but 'you don't look like a lesbian!' It is demanded that we come out continually and verbally when people assume that we're heterosexual" (Roberts 32). This example plays with cultural conventions through which an image is assumed to "look lesbian," reflecting on the discursive parameters through which seeing and being seen are negotiated. Pushing this process to absurd extremes, in the corner of this ad is a message that reads, "DYKE hair stencils, simply place on head and shave around!" The mock ads in this series speak to a young generation in which branding is increasingly inscribed on bodies, worn as identity logos on the flesh of youth to become identifiable as lived embodiment. Another ad features the words "*BUT C HER*" tattooed across the bare back of a model wearing a butcher's apron, gesturing toward the lack of visibility of butch bodies in popular media. Yet even here a coy feminized model is used to stylize the butch subject, revealing the threshold of what is representable as a commodity image, even when the intention is ironic reflection on media stereotypes.

Using camp as a strategy to both show up, exaggerate, and recontextualize dominant cultural meanings, lesbian magazines can be seen to mobilize ambiguity that calls into question the naturalizing effects of gender and sexual ideologies. Larry Gross argues that camp "is the quintessential gay strategy for undermining the hegemony of mainstream media images," (19) propelled by strategies of distancing and recontextualization. Sue Ellen Case theorizes camp in specific relation to a butch/femme aesthetic, focusing on the specific contexts and rituals of gender expression within lesbian relations and cultural contexts. Both Gross and Case focus on individualized subversive approaches that counter hegemonic discourses. Extending Case's cultural focus to include a broader range of lesbian public commercial cultural texts, it becomes important to consider how magazine producers and queer youth readers mobilize camp cultural strategies within commodity-saturated fields of representation. Clark writes that "many lesbians, particularly younger, urban lesbians, are . . . exposing the constructedness of 'natural' fashion, and finding a great deal of pleasure in playing with the possibilities of fashion and beauty" (487). Strategic use of camp has become a common element through which lesbian style and fashion is self-consciously performed and showcased in lesbian magazines. For the fifteenth

anniversary issue of *Curve*, an article by Katie Liederman titled "15 Years, 15 lesbians" plays around with "types" using tongue-and-cheek humor: "Every sociable lesbian knows that there are roughly 15 personalities that run rampant in our diverse dyke communities" (51). Elaborating each stereotypical lesbian self through details of surface style and cliché, a list of images and definitions becomes absurdly resonant:

> The student Dyke: She's stoked about being out, boning every lesbian in sight and quenching a lifetime's worth of pent up sexual thirst while contextualizing her dyke-dom in academia. It just doesn't get any gayer than this. (51)

Flirtatious portrayals of young "dykes" provide moments of cultural (mis)recognition, teasing out common languages of experience and interpretation that elicit and refuse certainty. Youth pervade the list from "the pretty-boi dyke" to "the sprightly elfin femme"; such campy categorizations work to queer lesbian selfhood. What is interesting about this short article is its appeal to the accuracy of types that are "generally dead on," while revealing their ironic ambiguity. Binaries get redeployed in the context of hyperbole and witty rearticulation, suggesting a proliferation of styles and meanings.

Campy gender restylization also gets highlighted in many fashion spreads. On the "Queer as Life" page of a the April 2005 issue of *Girlfriends*, Becca McCharen, a twenty-year-old architecture undergraduate "notes that fusing conventionally masculine pieces and feminine pieces (for example the skirt she wears here, made by sewing several ties together) makes her feel unattached to any particular category of gender or identity" (Wortham 26). Becca's youth cultural style is portrayed in terms of queer pastiche and performativity; she is adorned with fuchsia hair, fishnets, big sporty boots, silk long gloves, and long fake diamond earrings. In this youth fashion profile, queer femme appearances stand out in sharp contrast to static codes of femininity that figure within three lesbian vacation ads positioned on the opposite page. Becca's style becomes an unruly site for creatively unbranding lesbian selfhood, a do-it-yourself mash-up that actively confuses identity concepts while affirming a queer process of stylization.

Fashion is commonly an opportunity for satire in lesbian magazines, actively confronting heteronormative assumptions implied within fashion photography and writing. A *DIVA* fashion spread in the July 2004 issue "Too Cool for School" turns to girls' gym wear as a site of young lesbian desire: "The last time you were a PE hit, you were probably harbouring a suspect borderline crush on your PE teacher—or at least one of your classmates. But that that doesn't mean that the look can't be revived." Appealing to the nostalgia of older

lesbians as well as resonating with younger generations, this fashion spread is less about selling clothes and more about visually staging fantasies of sporty girls on the field and in the locker room. At the end of a roll of action shots with girls fighting over a soccer ball, one girl finds the words "Kelly is a Lezza" written on the wall. Fashion becomes an occasion to explore stories of lust and homophobia, replaying erotically loaded events with a collective wink. Fashion retells stories of girl desire and conflict that allow for pleasure in the mediated distance of magazine imagery. The final image shows Kelly looking provocatively at the camera just before she is about to remove her shirt, asserting her own desire in the face of insults. Queer girls approach the parodic elements of these fashion spreads with caution, wary of the ways magazines turn social experiences into seductive visuals. Seventeen-year-old Charmaine asserts, "alright, alright, alright! Enough about my clothes! There are more important things in life than what I put on my ass!"

Fashion spreads in lesbian magazines foreground the ways in which visual images and cultural styles become important realms through which to recontextualize dominant gender and sexual scenarios of girl-on-girl desire while also constructing subcultural alternatives. At the same time, most identities and styles featured in lesbian magazines are circumscribed according to normalizing gender and beauty ideals. While fashion images do include some androgynous- and boyish-looking girls, feminine girls and women remain the privileged fashion spectacles. Masculine, genderqueer, and transgender subjects remain on the margins of what gets seen and discussed, except in scattered articles and profiles of artists, athletes, activists, and musicians. It is in the content of specific columns, news, and interviews that queer cultures and subjects are given some representational space, pushing the boundaries of "lesbian" magazines to include subjects otherwise left out of view. Yet the question of how young queers fit into the overall framework of lesbian lifestyle circulations calls for critical reading not only of where they appear but also of how they are situated in relation to the dominant lesbian story images produced in advertising, editorials, and regular columns. Whereas feminine girls are visually pervasive, butches and transgender people are included as "special" topics of discussion or else positioned as the adult expert–giving guidance. From the love advice columnist "Fairy Butch" in *Curve* magazine to the transgender sex educator and therapist Patrick Califia's sex and relationship page in *Girlfriends*, older masculine subjects are given authority as relationship and sex experts rather than as sexy bodies and cultural icons on display to be desired.

Subjects that destabilize the unity of lesbian identity such as bisexuals, transpeople, and genderqueer youth are introduced as topics of investigative reporting,

represented in a serious news format distinct from the entertainment, fashion, and advertising sections. Queerness becomes othered in ways that separate visual fixations on young feminine lesbians from those whose body image, gender, sexual, race, and age differ from this commodified ideal. One of the few exceptions to the pattern of positioning masculine subjects inside lesbian magazines as experts or news topics rather than models and icons is the August 2001 cover story of *Curve* magazine by Pam Huwig, featuring alternative rock group the Butchies[3]. Framed through a close-up photo of the members of the band wearing white shirts and ties, this cover stands out as a rare exception to the glamorous celebrities who reign as lesbian cover girls, turning to queer youth subculture celebrities as a site of lesbian identification and desire. The Butchies are portrayed as cute boy performers with a parodic edge, adorned as schoolboy/girls with an inside full-page image of a band member looking masculine while wearing a skirt. Eighteen-year-old Diane, whose favorite band is the Butchies, was thrilled at this cover and story while remaining conscious about how rare such images are. Queerness seems to have cache as a hip subcultural youth style enacted by artists for the music issue, remaining distinct from commercially valorized images of lesbian girls and women that grace the cover and advertisements on a regular basis.

Queer subcultural images enter lesbian magazines in association with particular types of activities, scenes, and tastes. Along with musicians, athletes are also represented as a distinct category of youth in which queer looks enter the picture in the form of masculinized body images and styles. In the 2003 "SPORTS EXTRAVAGANZA" issue of *Girlfriends*, professional mountain biker Missy Giove graces the front cover in a strikingly provocative pose. Topless and tattooed, this sports star is shot from below, making her look large and powerful, and she is positioned as a glorified figure within the "out lesbian athlete hall of fame" (Daggett 18). Muscular, tough, and sexy, Missy Giove's youthful masculine athletic body presents a striking contrast to the femme glamour girl. Yet as queer youth point out, this is just another way in which magazines like to focus on spectacular examples. Youth seem frustrated by what they refer to as "extremes" that suggest binary opposition and leave little room for in-between and shifting identifications. Joy says that butches tend to be "over-sexualized" and limited to hypermasculine styles when they make rare appearances. Several girls in the focus group were excited and disturbed by Missy's sexualized jock cover image, asking "why does she have to be topless?" or exclaiming "I think she's hot!" At a more practical level, these youth felt that visible sexuality and partial nudity not only made it difficult for them to walk around in public with the magazine in hand, but also seemed to trivialize the lives of gender-variant youth. Although young feminine

lesbians are the primary commodity image being marketed, queer girls are also commodifiable as simplified "extreme" or spectacular icons of gender and sexual transgression. Queerness becomes contained in the process. Situated as style, celebrity coolness, or parodic play, girls who exceed binary norms of gender are at once included and othered. The tendency to include elements of queerness as a supplement to a normative standard of lesbian identity is even more noticeable when it comes to representations of sexuality.

Circulating Sex: Personals, Pictures, and Confessions of Young Lesbians

As the naughties progress, women of all genders and ages know what they want when they get into bed, and how and where to get it.

"The Truth about Lesbian Sex," *DIVA* magazine

I do think that, for younger, questioning females, the constant barrage of sex toy photographs is somewhat embarrassing and off-putting—and could well give an unhelpful impression that sex is the absolute focus of queer culture, at the exclusion of all else.

Katie, age 17

Lesbian magazines are caught in a bind between signifying sex and romance as a defining feature of their promotion and success, while being limited by commercial and heteronormative terms of representation. As Victoria Brownworth states in an article called "De-sexing the Cherry" for *Curve* magazine, "lesbianism has always fallen between the sexual cracks so to speak." Obscured within mainstream media, lesbian sex circulates ambiguously within lesbian magazines. Focusing on sexually desiring and desirable girls across cover pages, editorials, feature articles, sex toy ads, fashion spreads, gossip columns, and personals, lesbian sexuality gets portrayed in provocative yet regulated ways. *DIVA, Curve,* and *Girlfriends* share a common preoccupation with love and sexual topics, providing an important media realm through which teens and young women are encouraged to read, think, talk, and act out sexual information, fantasies, and experiences. But while sexual images made by, for, and about lesbians expand the scope of public visual presence, the status of lesbian sex raises difficult questions about representational content and reception, especially when it comes to queer girl readers. While more and more images interpellate lesbian desire and love, Katherine Sender notes that nonnormative elements of queer sex get sacrificed for commercial viability and mainstream assimilation.

She asks, "what are the consequences of being interpellated—'Hey, you're gay!'—by media vehicles in which sexuality is emptied of the open, lusty, joyous acknowledgement of queer desire?" (360). For queer youth, sexuality is a hotspot of fascination and discontent when it comes to magazine reading, with queer youth expressing the desire for open queer representations yet feeling uncomfortable with the formats through which lesbian sex becomes visible and marketable.

As central dynamics through which the bodies of youth are used to advertise products, services, ideals, and lifestyles, sexual representation and commodification are closely connected in lesbian magazines. Young readers are both intrigued and bothered by the emphasis on lesbian sexuality and identity. While romantic and sexual content pervades all the magazines discussed so far in this chapter, queerness is muted in the production of commercially viable images of coupled, monogamous, feminine, "innocent," affectionate eroticism between young women. Signifying diverse sexualities in magazines is very risky business, best left ambiguous and indirect, available to interested readers yet away from the prying eyes of conservative critics and moral censors. Sender makes it clear that there are strong economic pressures from advertisers to limit the amount and kinds of sexual representation in gay and lesbian publications. The mass marketing of lesbian sex has implications not only in terms of what gets shown but also in how sex gets framed and communicated to readers. Questions of where girls and young women fit into this process of sexual commodification and representation rarely get asked. Erotically signifying images and texts within magazines that include youth are easy to find, but discussions about their cultural significance are muted and feared. Difficult questions emerge surrounding what ideals of lesbian sex are being sold to youth "as the naughties progress," and how desires are constructed and contained along the way?

Magazines provide youth with rare glimpses of girl-on-girl sexual intimacy that include images of kissing. passionate gazing, and physical touching. Whereas televised kisses are difficult to find due to the pressures of network censorship, lesbian-owned and-edited magazines celebrate embodied signs of physical desire. Even in advertising for non–sex-specific products and services, young women are shown holding hands and embracing each other. While showing light caresses is usually as far as advertising in these magazines goes, it gets noticed and talked about as important to youth. Signs of public affection are deeply meaningful to young people growing up in contexts where erotic touch between girls is pervasively appropriated, shunned, and demeaned. There is no doubt that displays of physical intimacy are very important to girls

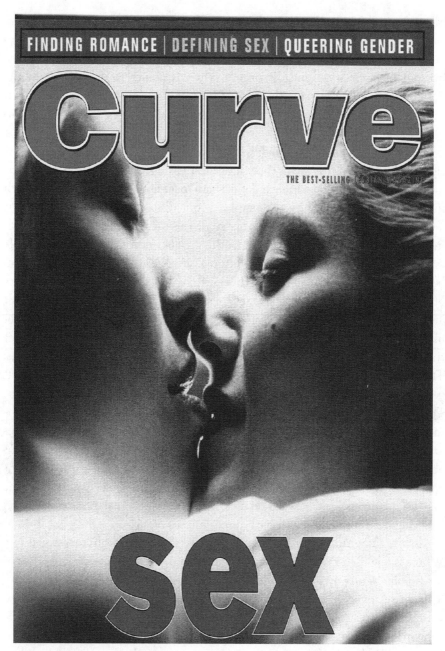

February 2003 cover of Curve Magazine.

and that magazines presenting these affections as normal provide girls with visual pleasure. Expressing an urgent need to see images of girls together, some youth will go out of their way to read magazines that are much more difficult to attain than teen magazines. There is a sense of illicit enjoyment of images otherwise excluded from their cultural environments. The visibility of lesbian sensuality both lures and repels girl readers, often forcing them to hide the magazines from friends and parents. Sixteen-year-old Trish was deeply embarrassed when another classmate passed a lesbian magazine to her during class, as she was worried that others might see the bold image of two lovers on the front cover. Although many youth read these magazines in secret because of their lesbian content, sexual imagery is talked about as being an obstacle to their public enjoyment.

The normalization of erotic touch between girls both enables and contains how lesbian sex is constituted within magazines. Systemic patterns of representation desexualizing lesbians within mass media have worked to create idealizing notions of lesbian affection that exclude lustful, passionate, "perverse" sex. Gayle Rubin argues that sex is organized within stratified intersections of power that privilege "sexuality that is 'good,' 'normal' and 'natural' . . . it should be coupled, relational, within the same generation and occur at home. It should not be pornography, fetish objects, sex toys of any sort, or roles other than male or female. Any sex that violates these rules is 'bad,' 'abnormal,' or 'unnatural' " (13). Such hierarchical systems of sexual value are inscribed within magazines, centering on gentle, affectionate embraces between young, slender, feminine, attractive women. The invisibility of butch dykes, trannyboys, high femmes, or queer punk youth as sexual subjects is an effect of foreclosures of queer desire within commercial gay media. According to the visual codes of mainstream lesbian magazines, lesbian sex does not seem connected to penetrative sex, bisexuality, or role playing, nor does it involve those who look masculine or kinky. If sex toys are shown, they are bright colorful objects detached from bodies, except when they appear in the classified section at the back of magazines, where more explicit sexual images are located. Although lesbian sex is a continual preoccupation within the main pages, it is sanitized and homogenized for the sake of national advertisers and mass consumption.

The stakes of a stratified sexual system of representations in magazines need to be considered from the perspectives of girls coming of age who use these magazines as a source of sexual information and exploration. Lesbian magazines actively assume the role of sex educators, lending advice, giving sex tips, and offering so-called expert knowledge about relationships. In a 2005 feature article in *Curve* magazine titled "What Do Lesbians Do in Bed," Gina Daggett

addresses youth when she writes, "what if you're coming out and you know very little? You've finally got the other girl—now what do you do with her?" (27). Daggett goes on to tell her own story of coming out in high school, before elaborating her insights into lesbian sex as a "seasoned dyke" for a younger generation of readers. Lesbian sex articles actively include and solicit the interest of young people as part of a dialogue that includes the voices of older teens as well as middle-aged women. Age boundaries are crossed not only within individual stories about sex, but also as part of the ways lesbian magazines organize topics dealing with sex. Older lesbians become positioned as teachers of youth, through which girls are directly interpellated within a pedagogical process of learning about lesbian sex. It is here that magazines become more flexible and open to alternative scenarios and relational connections, exceeding the more rigid sexual divisions and hierarchies inscribed at the level of images. Daggett goes on to explain the malleability and contingency of lesbian sex, listing diverse acts, feelings, and situations, and revealing the impossibility of a general definition. As an open-ended pedagogical text, magazines help girls to imagine sexual possibilities within the format of commercial entertainment. While many of the youth I interviewed are bothered by the visual emphasis on lesbian sexuality, they are also deeply interested in the information and educational articles and columns about sex and relationships. Olivia admits to having "an odd fixation with reading relationship columns, which are all the more interesting when they're queer."

It is not only as readers that youth are engaged within lesbian magazines. They are also included as narrators of experience, telling stories and confessing desires. Youth sexuality becomes part of the content of written texts. Sensual touch between girls once again stands out as a key aspect of representation, this time translated into words rather than images. In the April 2005 issue of *DIVA*, twenty-one-year-old "Czech Lady lover" Alexandra says, "I love it when my girl is lying on her belly and I can follow the line of her neck, back and hips" (Von Holleben 11). Several other youth stay close to the body when recounting what they love most about women. Later on in this issue, eighteen-year-old Sally confesses that her "favorite thing is having her lick my neck and talking dirty into my ear as she licks it, then feeling her work her way down my body. I'm too shy to talk dirty myself but I love it when a girl does it to me; its seems so grown-up, and I like the idea of having sex with older women" (25). Corporeal descriptions and "dirty talk" get enacted by youth as sites of longing. Lesbian magazines provide a rare cultural space in which youth actively participate in the construction of erotic discourses. Creating a sense of authenticity, confessional sex talk bridges the more abstract commodified ideals and celebrity icons with the intimate lives

of so-called ordinary lesbians. Magazines make use of experiential narratives to create personalized languages that elicit identifications from readers and link the representational realm with the so-called real, everyday life worlds of lesbians. While such experiential links are culturally produced within a commercial media system, they create an illusion of immediacy and intimacy, mediating between text and lesbian subjects in ways that provide a sense of shared experiences.

Most lesbian magazines focus on "lesbian sexuality" as a stable locus of desire, yet, within alternative porn genres, depictions of sexuality work to queer the very premises of visual pleasure and identification. In light of the increasing popularity of queer girl porn media, it becomes crucial to include a discussion of its transformations in an era in which sexually explicit imagery is no longer considered a discrete and secretive cultural realm but has become shamelessly appealing to young generations of girls as central to their viewing experiences.

Porn for a Genderqueer Girl: *On Our Backs*

Where would pop culture be without queer eroticism and vice versa?

Marissa Pareles "Media-Whore," *On Our Backs* (June 2004)

Lesbian sexual representation runs throughout all the magazines discussed so far in this chapter. In feature articles, sex toy ads, fashion spreads, and gossip columns, attention to the sexually desiring and desirable self becomes a complex part of contemporary lesbian popular print cultures. This emphasis on public visual presence can be understood as a response to the pervasive desexualization and hypercommodification of lesbians in mass media. Access to sexual images made by, for, and about lesbians has been a crucial part of a struggle over representation. Erotically signifying images and texts from print and online magazines that include youth are easy to find. But while most mainstream lesbian magazines are very careful about regulating the kinds and degrees of sexualized content they publish, others have actively pushed against the very limits of what is recognizable and acceptable within mainstream media. Here I want to investigate soft pornographic images of queer girl desire that go beyond safe and neat conventions into the popular cultural texts that speak to a generation of kinky queer youth.

Whereas lesbian lifestyle magazines constitute ideals of sexuality within safely depicted parameters of girl-on-girl affections, a magazine genre of queer porn is increasingly targeting and including older teens and young adults between its pages. One of the most visually daring and accessible magazines to

explore representational boundaries of lesbian and queer sexuality, *On Our Backs* markets itself as "The Best of Lesbian Sex," a media savvy and sex-positive publication. While *On Our Backs* centers on "lesbian women" as a general community and demographic, the gender, sexual, and age ranges of readers, writers, and models defy neat categorization, troubling the very terms of identity around which this magazine coheres. Colleen Lamos argues that "*On Our Backs* is not just a lesbian version to straight male pornography, acceptable to liberal sensibilities as, perhaps, 'different strokes for different folks.' Instead, the magazine makes it all the more difficult to distinguish between 'different strokes' and 'different folks' or between heterosexuality and homosexuality" (90). Theorizing *On Our Backs* in terms of a postmodern lesbian text, Lamos focuses on women "taking on the phallus" (90), strapping on dildos and playing out multiple relations of power and identity. In this way, *On Our Backs* paradoxically invokes and challenges the very terms of sexual identity around which it markets itself. Whereas mainstream lesbian magazines work to consolidate a clear-cut sense of lesbian identity and desire, *On Our Backs* unsettles its very status through multiple sexual fictions that engage young queer viewers as interlocutors.

In my discussions with girls, I began to hear scattered stories about their interest and participation in a variety of queer porn media such as *On Our Backs*. Porn in this context is not privatized and marginal but is increasingly recognized as a collectively legitimized facet of queer girl culture. In this way, pornographic languages shift away from notions of obscenity (being off scene, out of sight, or away from the public view) to what Linda Williams refers to as "on-scene pornographic discourses," positioned and circulated as central within the imaginations and practices of a culture, unsettling rigid distinctions between popular and pornographic texts. Williams writes,

> If obscenity is the term given to those sexually explicit acts that once seemed unspeakable, and were thus permanently kept off-scene, on/scenity is the more conflicted term with which we can mark the tension between the speakable and the unspeakable which animates so many of our contemporary discourses. (4)

For queer girls, tensions between the speakable and the unspeakable, the visible and the invisible, are pronounced, unsettling portrayals of girls as naturally feminine and heterosexually desirable. Sexual representations of queer girls in alternative lesbian queer porn magazines evoke heterogeneous and precocious dimensions of young sexual desire.

While gender is a key term around which to talk about the subversions of a coherent lesbian subject, age and generational differences also give rise to

interesting questions about the status of desire and identification in On Our Backs. Although mature content suggests an adult audience, youthful bodies have increasingly become the primary visual subjects around which personal confessions and fictional narration unfold. Officially keeping On Our Backs within legal age limits is crucial to its survival; the front cover inscribes clear restrictions: "Not to Be Sold to Persons under the Age of 18." At the same time, teens on the border, those barely legal, can be found both within its covers and as avid readers. Several girls with whom I spoke referred excitedly to On Our Backs as a resource for accessing sexually explicit queer girl talk. In the words of seventeen-year-old Charmaine,

> On Our Backs is really specific in what kind of content it delivers. It's all sexual and relationship involved. . . . And it delivers to the max. On Our Backs gets into the nitty-gritty. If you go to their website, there are pictures of women in-the-act, short erotic stories, etc. And it's nice to have that. I mean, straight women can swap sex stories and it's the norm. Not all queer women have the luxury of being able to babble about their sex lives. And On Our Backs is definitely the answer to that.

This magazine actively speaks to girls on a number of levels, but perhaps the most intriguing aspect of queer youth presence is constructed within the visual portraits and scenes of desire. Models in their late teens and early twenties are commonly found in ads, articles, and centerfolds. On Our Backs encourages older adolescents and young adults to become active, shameless, and intelligent sexual explorers, confounding hierarchical divisions between the knowing older woman and the naïve and inexperienced girl. Girls both show and tell their desires in defiance of social regulations and moral condemnations so prevalent in media treatments of girls. In the process of affirming sexual fantasies and conversations, the magazine is by no means neutral or transparent. Girls are constructed and framed in terms of the values and symbolic references of sex-positive lesbian and queer cultures, centering on those girls who are willing to risk exposure and talk "dirty." The magazine offers a sexual education of queer girlhood that is rarely glimpsed publicly. What gets represented are not straightforward lesbian versions of sex but contradictory visions of how, what, and where girls perform their sexual identifications and desires.

My analysis calls attention to the complex ways young queer subjects are constituted and elicited in the pages of this magazine. Unlike formulaic depictions of girls in mainstream porn magazines, the body images, poses, stories, perspectives, and contexts through which young models enact their sexualities in On Our Backs are remarkably interactive and self-reflexive. Models in this magazine are either amateur volunteers or independent culture celebrities.

Displaying a broad range of body styles and sexual combinations and acts, this magazine disrupts the uniformity of mainstream heterosexual pornography. Most of the photo spreads have an unpolished homemade appeal, with rough black-and-white production values and a parodic sense of artifice and recontextualization. Youthful scenarios of sexual transgression are often replayed with an ironic wink toward heterosexual stereotypes, inscribing queer erotic differences with humor. Performative reiterations of clichéd depictions of heterosexual complementarity recast visual pleasures on thresholds inside and outside mainstream pornographic regimes. In a series of photos from the September 1999 issue titled "ooooh, team," popular high school icons of jock and cheerleader are queerly profiled with the following statement: "After winning the final game of the season, Alex the most valuable player this year, feels like celebrating. So does Lisbeth, the head cheerleader. Lisbeth is such a tease, she drives Alex crazy . . . teasing and tantalizing turn into a serious make out session. Don't you wish you had a high school experience like this?" The photographs consciously reference and replay hyperheterosexual roles and teenage myths with a trans-butch and femme twist. This series of photos situated within a school baseball field explores social territories that conventionally exclude queer lust, fleshing out high school environments with public queer sex. It is precisely the public sexual display of ambiguous bodies and pleasures, a disregard for social propriety and control, that opens up this fantasy image text.

Not only are public spaces regulating queer youth reconfigured in queer ways within the visual frameworks of On Our Backs, but the contours of feminine and masculine erotic embodiment also become transformed. This is vividly shown on the cover of the June 2003 issue, where Beth Ditto, singer with the band the Gossip turns back at readers with a confident naughty stare. Inside the magazine, Ditto is interviewed and visually portrayed kissing her drag king boyfriend Freddie, sucking his cock, and getting penetrated with a strap on over a bathroom sink. As a fat activist and youth culture icon, she erotically affirms her body size and calls out to other fat girls to embrace their sexual beauty and power. When asked, "What is sexy about being fat?" Ditto answers, "Sexy? Everything! It's something to hold onto. You know love handles? It's so true. It's something to hold onto and squeeze, and it feels good, and it's warm, and it's totally kissable. It's wonderful. Everyone should touch it" (Herbitterm, 31) Corporeal pleasures become affirmed from the standpoint of a fat girl artist enjoying her sexy curves, calling upon others to touch, show off, and explore physical sensuality. Interlacing a discussion of her feelings about her identity as a dyke, reflections about body size, queer sexuality, and punk art movements

alongside porn imagery, this spread provides a multilayered personal and politicized perspective on queer girl eroticism.

Given the capacity to talk about themselves and their desires, models, who are often readers of the magazine, are framed in terms of involvement and interaction. Positioned as producers and consumers, doers and viewers, voyeurs and performers, queer girls are shown to crisscross cultural boundaries. A quirky documentary style works to depict and describe the sexual tastes of models. Meredith, nineteen, defines herself as a "Submissive dyke slut girl" for a photo shoot by Janet Ryan in which she is given room to name her sexual "type," favorite sex toy, favorite sex act, and also talk about her experience of the photo shoot. Meredith candidly confesses to readers that "I've recently discovered the joys of vaginal fisting. It's such an unbelievable experience for me on a number of levels" (15). Meredith is fashioned as both a porn star and as an ordinary girl confessing desires in the mediated intimacy of On Our Backs. Yet the confessional mode here is strikingly self-aware in terms of its staging and mimicry of submissive girl innocence. The magazine constructs a gaze that looks back at readers, breaking down barriers between objects and subjects of desire and confusing the lines between sexual voyeur and spectacle. In this photo, Meredith is reading a girl porn magazine as she sits on the toilet while also looking back at the magazine reader. She is positioned as a girl in the process of exploring her sexual pleasures, including the pleasures of being looked at by others. In this way, a young, queer, sexualized, knowing gaze is signified so as to displace the hegemony of a male-centered economy of desire, without denying or repudiating the complex gratifications of submissive femininity.

Analyzing erotic representations of a self-defined nineteen-year-old "Submissive dyke slut girl" raises lots of difficult questions. In an era in which girls' sexuality has been viewed as either commodified and exploited or protected and idealized, it is difficult to wedge a space in which to discuss possibilities of erotic agency and power. The public sexual presence and knowledge of queer girls is even more restricted and obscure. Tendencies to exclude queer youth from public representations of adult gay and lesbian sexual cultures are overdetermined by moral panics around gay predators and pedophiles and the fear that adults might be blamed for luring youth into the "lifestyle," often leaving youth out of representational spheres altogether, especially those dealing with kinky sexualities. In an article "Beyond Child's Play," written in October 2000 in On Our Backs, Jill Nagal tackles the lack of social recognition of queer youth sexual fantasies and practices including S/M and role playing. She writes that this "effectively creates an abyss called adolescence, in which power games no longer count

as mere child's play, but neither are their young proponents deemed mature enough to know what they are doing" (42). The article references groups and advocates working to open up dialogues that respectfully listen and respond to the sexual desires of young people. While this article addresses the subject of youth in journalistic form, the content and visual style of On Our Backs reach out to older teens and young women on a regular basis. There is a tacit recognition throughout On Our Backs that girls are sexually inventive and active.

The importance of role playing and sadomasochistic explorations of power dynamics becomes a locus around which gender, sex, sexuality, and age are queered in On Our Backs. Reconfigurations of butch-femme, femme-femme, butch-butch, girl-boy, daddy-girl/boy, mommy-girl/boy, top/bottom, domi-nant/submissive, and many other relations of desire are displayed in ways that throw into question the intelligibility of unified sexual identities, turning attention to variable enactments of fantasy. There is a complex ambiguity between erotic scenarios and the youthful looks of the models who are presented not merely as performing to gratify other people's sexual desire, but as actively positioning themselves within erotic visual dramas being played out. In a 2002 photo spread titled "Scout's Honor" by Shawn Tamaribuchi, two young mod-els dressed up as boy scouts engage in adolescent male erotic sex play. Moving from shy flirtatious poses to boy-on-boy acts of penetration, oral sex, and light bondage, this spread evokes a very queer sense of a sexual coming of age of female masculinity. The boy subjects profiled here are shown having fun, smil-ing as they tease each other and play-fight with an almost gleeful indifference to onlookers. This spread represents a taboo realm of adolescent boy scout homoeroticism from the perspective of older transgender youth. This version of adolescent male desire embodied by young adult females is not trivialized in relation to "real" lesbian sex but becomes part of its shifting gendered and generational parameters.

Transgender desire enters the pages of On Our Backs in terms of sexual role playing and also in terms of changing autoerotic embodiments of youth, visually profiling biologically female youth who identify and/or perform their sexualities as boys or men. In the June 2003 issue, Chris LaBite, a twenty-one-year-old self-defined "genderqueer," is shot, at one moment, wearing a dildo and, at another, masturbating with a dildo. Adorned with a goatee and Elvis sideburns, LaBite complicates readings of the body as either masculine or fem-inine, phallic or receptive. Pleasure in self-penetration and pussy stimulation is conveyed along with masculine pleasures of wearing and showing off a cock. Queer autoerotism is represented here in ways that defy expectations of either

masculine or feminine sexual bodies and pleasures. Representing gender switching and variability within and between selves becomes a unique feature of *On Our Backs'* content and form.

Gender subversion is an integral part of the representational process within a range of images of sex play not only focusing on transboys but also on femme girls pursuing each other. In a series of photos titled "Femmes on Film" by Aaron Kovalchik, from a 2003 issue, the layout describes how "film students Zoe and Chloe were alone in the editing room working on the their final project, a stylish and pornographic lesbian romance" (22), which becomes the take-off point for seduction between students making movies. A photo showing Chloe being caned over film editing equipment dramatizes the blurring of lines between art and life, imaging and living out pornographic desires. Youthful femininity becomes the site of mutual attractions in this layout; not only are they female students, but they also are in the process of making their own erotic film. Makers and performers of porn are blended into a fictional account that constructs femininity as aggressively desiring. What gets visualized here is a relation between learning and doing, making images and touching bodies, girls engaged in the formation of cultural texts which in turn spur on their longings to make physical contact.

Focusing on cultural performances, sexual images and narrative texts as integral to the real lives of queer girl readers, *On Our Backs* offers a productive site of on-scenity. Within a broader commercial realm of porn that fetishizes youth sexuality for adult enjoyment or denies the very possibilities of youth sex play, *On Our Backs* provides a space in which girls are enjoined to create and enjoy kinky representations. Such queer porn transformations within a popular commercial magazine are contingent on the ways young adult writers, models, editors, and readers have sought to address their queer erotic lives beyond the heteronormative mandates of mainstream media. I would argue that *On Our Backs* provides rich opportunities for understanding the erotic curiosities of queer girls.

Queer Girl Personals: Between Mediations and Connections

The realm of magazine sexuality offers more than static images to look passively at, soliciting readers to live out their desires beyond the printed page. Contemporary lesbian magazines contain a unique component that works to bridge text and social relations. Personals are a pronounced feature of all the magazines profiled throughout this chapter, tailored according to specific

marketing styles and imagined readers. *On Our Backs* provides a passage between cultural fantasy and real-life sexual adventures with its online personals, which are advertised to encourage readers to chat and hook up with each other. In one example of a advertisement for a personals service, the scenario of meeting someone online is portrayed as a gritty make-out scene in a city back alley. This ad enacts a realistically framed fiction of a sexual encounter between strangers as a way of inviting reader participation to do more than merely look. Including a few side profiles of online members, this *On Our Backs* advertisement holds out the promise of linking readers together in an adventurous and porn-loving community.

Magazines can provide a sense of cultural belonging in circumstances where lived connections to other queers are practically inhibited. Used as a means for meeting other lesbians, magazines also provide a tangible way of overcoming physical separation and isolation. What is striking about advertisements for personals is the pervasiveness of youth-centered images. A Diva Mobile[4] ad features two girls causally lying in the grass sunbathing, with the headline "GIRL MEETS GIRL." The image depicts flirtation, evoking nostalgic charms of girlhood crushes in an era of mobile tech dating. Another ad from the Diva Mobile girl-meets-girl series focuses in on two girls romantically dancing, staring deeply into each other's smiling eyes. These ads promise happiness through instant connections, focusing on bodily touch and closeness while selling disembodied communications systems: "Just dial up and find your soul mate." Here magazines utilize various media technologies to enable girls to hook up as friends or lovers, to flirt at a casual distance or to meet for a date in person. At the back of the magazine, a section called "Dial-a-Diva" provides another avenue for youth to advertise themselves in an effort to meet others:

> Fun-loving F, 19, interests are musicals, sport, television and making people happy. Seeks considerate F, 18–35, for relationship.

> Butch F, 18, loves socializing, music, conversations, pubs, bars, quiet nights and soaps.

Such profiles include a list of self-descriptors, identifications, likes, and interests. Within this process, girls construct themselves as desiring subjects in words and phrases. They become actively involved in playing out romantic fantasies in the quest to find a girlfriend. In this way, the media text influences more than the imaginations of readers, activating their erotic subjectivities, compelling girls to do something: Write an ad; dial up a girl; send an online message to someone special. The commodities and pedagogies of lesbian romance

promoted throughout theses magazines encourage the search for real-life con-
nections through personals.

While youth are not the only users of personals in magazines, they are mar-
keted in ads as the primary users and are becoming more and more engaged in
dating through a variety of new media services. Seventeen-year-old Olivia
thinks it is "odd that the advertisements would use youth as models if they're
trying to reach an older target market. It seems exploitative if they're overtly
sexual or if the models are far too young (e.g., hypothetically, 15-year-olds for
a dating service)." While the ads suggest that youth are the primary users of the
services, queer girls question the ways they are portrayed in such ads to attract
older women. Youth seem hesitant to admit they use personals, dismissing
them while also acknowledging that they have tried them out when they were
younger and in the early stages of coming out. Several youth spoke about using
personals to talk to other youth for support and casual conversations online
rather than for real-life sex or romance. Personals extend the commercial rep-
resentational industry of magazines into interactive and community services in
which youth are increasingly involved as participants.

Within *Girlfriends* magazine, advertisements for *Girlfriends* online personals
reveal a cross-promotional enterprise. The ads feature a full-page sexy provoca-
tive image of a desirable woman with three smaller photos of young women
along with their profiles in small print. While the ages are not included in the
ad, it is clear that the girls profiled are in their teens and early twenties, elic-
iting the interest of girl readers. Such advertisements for personals include web-
site addresses, leading readers directly to the website where a quick search of
girls between the ages of eighteen and twenty-four reveals over one thousand
profiles from across North America. For a twenty-four dollar package of cred-
its, users can send a limited amount of messages or smiles to as many girls as
desired. Communication can be completely anonymous and controlled or
boldly revelatory and vulnerable, focused on a brief encounter or continuous
exchanges. Services such as *Girlfriends* online personals facilitate a relatively
safe and cheap way to reach out to other young queers on the Web searching
for romance, spurring connections with others beyond the static representations
of print mass media. For queer youth, online personals offer useful ways of over-
coming social obstacles to meeting other queer girls without the risk of humil-
iation. The difficulty of finding and identifying queer girls locally is bypassed
within these forums where listing who you are and what you want becomes part
of an open process of online dialogue. How queer girls use and engage with per-
sonals is flexible, as there is no single approach or outcome to signing up as a

member. Many girls use these services to test out possibilities for meeting others and representing themselves as queer and questioning without necessarily wanting to make the leap to actual dating or face-to-face contact. Mass-mediated personals open up new means of forging girl-meets-girl friendships and romances with varying degrees of concealment and revelation, contact and distance. Girls can participate at their own pace and can set clearly defined limits on interactions. Personals offer a spatially and temporally controlled process that calls for a qualitatively distinct approach to understanding queer youth sexuality and romance.

Personals are one aspect of lesbian magazines that speaks to readers' desires for interpersonal bonds with a focus on romantic encounters. On a more general level, lesbian magazines also provide youth with a sense of community created through an exchange of images and stories. Many queer girls use magazines to feel broadly connected through shared news, icons, texts, and events. At the same time, youth struggle with the gap between their local experiences and the more urban, commercial, lesbian, cultural ideals represented. Queer girls are compelled to be creative in the ways they make use of mass media representations to meet their emotional and imaginative needs for community belonging.

Imagined Community and Mediated Belonging

> I love that I can say "did you read the latest copy of *Curve?*" to someone in New York and discuss the new artist from Iowa who's making a new album. I love the connection among the small community. I love what these magazines are covering as well . . . music, literature, celebrities, just queer pop culture in general. I like learning all the latest gossip inside our little world. I feel a lot more informed about my community through magazines alone.
>
> Betty, age 19

> I live in the countryside, and it may be a cliché, but there really isn't much of a scene out here. *DIVA* gives me a sense of company which I would not otherwise have.
>
> Katie, age 17

Lesbian magazines build community through the use of popular images, news, and narratives that construct and celebrate shared cultural networks. Twenty-year-old Tammy claims that "they made me feel very much a part of a community when I was younger." Such a mode of community is, in many ways, an imagined ideal, signified through fragments of texts rather than embodied in material social relations. Drawing upon Benedict Anderson's notion of a nation as an imagined community in which members "will never know most of their

fellow-members, meet them, or even hear of them, yet in the minds of each lives the image of their communion" (6), it becomes possible to conceptualize how readers of lesbian magazines might feel themselves part of a broad community that remains disembodied, anonymous, and abstract, while at the same time generating "a deep, horizontal comradeship" (7). My point is not to draw an analogy between nations and lesbian magazines but to understand a vital, and ephemeral, sense of cohesion and belonging felt by young readers. Even without physical contacts or specific ties linking magazine readers, the feeling of community is no less real for many of the young readers I interviewed. In Katie's words, magazines "provide some much-needed solace to the closeted or questioning who may otherwise feel alone and scared." Affective responses are produced as an ongoing reading process in which stories circulated and interpreted by youth give rise to belief and trust in a collective realm of belonging. Against mainstream invisibility, isolation, and marginalization of girls desiring girls, these magazines assert lesbian life as a valued social experience, with unique cultural markers and meanings generated and shared between members. Through mass media portrayals of lesbian culture, youth are given a chance to realize that they are not alone and that a social world exists where girls can love girls out in the open and without shame. The very existence of public cultures that extends beyond the private world of the self becomes a basis for hope and future projections of a common culture. Eighteen-year-old Lorna writes that the "babydyke" online section of *Curve* magazine "shows that there are queer girls all around the country and world." Extending Anderson's ideas to consider the effects of commercial print-capitalism on minority subjects such as queer youth at the turn of the millennium, it becomes important to recognize how important mass circulation texts are in developing national and even international community consciousness for those who may have no physical access to local queer community formations. Eighteen-year-old Verna says that even though they are second best to what a local supportive community can provide, magazines help to make "young queers feel a part of the community, rather than shut out of the loop."

One of the primary ways in which lesbian magazines elaborate a sense of belonging within a wider sociocultural sphere that extends beyond the written page is by advertising social events and promoting queer gatherings. It is striking how many ads are focused on pride celebrations, music festivals, bars, nightclubs, and lesbian resorts. Yet, for most girl readers, the representational bridge between event and magazine image is vague and out of reach insofar as they are rarely able to participate in events that are often geographically distant

from where they live, too expensive, and geared to older crowds. It is here that youth wonder and are puzzled about how exactly they fit into magazine references to the lesbian community. The adult-centered world of expensive vacations and fertility clinics are regarded as oddly irrelevant to their young lives. Youth don't necessarily identify with the hegemonic images of the lesbian community, yet they are still able to take elements that matter to them and feel connected or excited about the possibility of one day hooking up with "tons of other dykes." Imagined community is not so much given to youth as a ready-made package as it is creatively devised by youth in relation to magazine texts that suit their needs. It seems that youth are more interested in the ways cultural community coheres around icons, artists, cultural texts, and entertainments. Selecting scattered stories, gossip, and pictures that speak to their age-specific interests, youth forge their imagined community niches in partial and provisional ways. In other words, youth are able to hook into the shared dimensions of popular culture as an accessible means through which to define their community identifications. As Betty stresses in the opening quote of this section, her community engagements occur through dialogue about queer artists, celebrity trivia, and events that are constitutive of the "small community" where she locates herself. In this way, community becomes a media-simulated process that involves girls in an active dynamic of textual selection and circulation. Not only is community devised through magazine reading open-ended, in terms of who and how belonging is imagined, it is also deeply contradictory, or, as Verna says, "iffy," an intangible horizon of cultural possibility rather than a substantive realm of inclusion. Community becomes important for youth not as an entity produced by advertisers or editors, but as a process through which they take segments of news, advice, fashion, book and music reviews, and artist profiles to create their own lines of affiliation and identification. In Cindy's words, "there is always something I can take away from every issue and put it to good use." For Cindy, "good use" is linked to a continual effort to imagine and foster her ideas and life as a queer girl in relation to a wider realm of cultural production. This suggests a dynamic mode of using pieces of magazine text in the work of making identity and community. Reading magazines in this way is not a passive mode of individualized consumption but a creative interpretive activity through which to feel connected with and influenced by others. Even if these ties are fictional and provisional, they provide a vision of relating with others.

Although community is neither prescribed nor closed, the community most often articulated through magazines by girl readers is one centered on entertainment media cultures at the expense of alternative cultures and politics.

While soft news items and current interest stories introduce political information within these publications, they tend to focus on liberal rights agendas and legislative issues directed towards equality and inclusion rather than social change. Political citizenship and community are almost entirely framed in terms of normalizing assimilation into dominant institutional discourses and structures. Queer politics that seeks to challenge power relations and cultural norms does not fit into lifestyle magazines, and, when activism is introduced, it is usually to celebrate individual leaders and accomplishments detached from any attempt to elaborate or advocate social movements. At the same time, there are some exceptions when queer youth political projects are featured, as in Gina de Vries' article "Ten Dyke Activists to Watch" in the April 2005 issue of *Curve*, which focuses on anti-racism, trans rights, fat-positive, and anti-poverty struggles led by activists under the age of twenty-five. While the article compiles brief quotes by youth and glosses over diverse issues, it gestures towards the richness of real-life political community work by youth beyond its pages. It is interesting that the most complex political stories in these magazines grapple with marginal and intersecting social identities articulated by and for queer youth. Many girls I interviewed crave political knowledge and inspiration and are animated about wanting to read more political articles. Charmaine asserts that "things like activism are hard for teens to get their hands into, but many Queer Youth are dying to get that chance. It'd be great to have a magazine that talked about 'Getting Into' Queer politics, activism, and volunteer work." For many youth, magazines are a primary source of political news while also delimiting what, when, and how politics comes to matter. Safe liberal rights perspectives seem to collide with more grassroots politicized subcultural youth elements that resist those very categorizations. While lesbian magazines attempt to create a cohesive unity across generations and social locations, the outcome is often an awkward attempt to smooth over deeper political tensions. Queer youth readers are sensitive to these divisions as a sign of conflicting interests between commercial media representations and the life worlds of queer youth.

As an ephemeral and contradictory form of textual community, lesbian magazines promise so much more than they can ever deliver within a commodity-image system. They provide brief glimpses into community involvement by youth, representing individualized examples rather than facilitating social networks of communication and dialogue between youth. In this sense, magazines help to construct imagined communities that remain at an abstract distance to young readers' social circumstances. Magazine emphasis on celebrity gossip and consumerism frustrates many girls looking for more alternative

cultural and political content. Troubled by slick media versions of lesbian desire and identity, youth express desires for a different kind of magazine in which multiple facets of queer experiences might be explored in more interactive ways. I turn in the conclusion toward youth speculations about magazines they would like to read. Although there are no alternative queer girl magazines to turn to as empirical examples, youth provide lots of insight into what they might look like if queer youth themselves were given creative powers to make their own magazine.

"If I Could Design a Queer Girl Magazine I Would . . ."

I would definitely include fashion, DIY crafts, sewing, politics, sexuality, performance reviews & interviews with influential queer people, DIY divas, fat fashionistas, girl bands, etcetera. It would be designed like a teen magazine (like, oh, SASSY?) but it would be very subversive and geared towards being for the other teenage girls, the ones who don't buy into the whole YM thing. I am seriously considering doing this someday, I have thought about it so much.

Anne Marie, age 22

Articles would include shedding light on lesser-known subcultures (taking a look at things usually not thought or known of). . . . I think that would be my main one. There would definitely be a place where the readers could write articles or stories/ poems to have them published, and a talk-back section to discuss articles in other editions.

Tammi, age 20

Many queer girls speak directly about what is not available to them in mainstream girl and lesbian magazines, what is lacking within lifestyle publications when it comes to queer youth. At the same time, they vividly imagine what they would like to see while pausing to tell me that they realize that the magazine of their dreams would probably not make a profit or have wide enough appeal to compete in the marketplace. This dual recognition has lead many queer youth to make their own alternative media. Queer girls are adept at creating do-it-yourself print media, such as zines, in order to bypass hypercommodified youth cultures. But rather than completely reject mass media, several girls with whom I spoke would like to see wide-distribution magazines provide tools for more local cultural practices. Katie would "like to have some practical articles giving pointers on how to do things like setting up one's own website, printing zines, making electronic music, or even just engaging in some political activism, to encourage DIY spirit." In this way, queer girls are trying to figure out

how to move back and forth between commercial and grassroots alternatives. Against the construction of girls as passive consumers, these youth want to be interpellated as cultural participants who make use of representations of queer youth to mediate their own choice of actions. They do not see this process as antithetical to mass media production but as filled with creative potential for queer girl culture.

Towards imagining what a queer girl magazine might look like, young feminist magazines such as *Bitch* and *Shameless* provide common reference points to talk about ways of combining popular cultural focus and political mobilization. What they like about these alternative youth magazines is their attempt to include queer subjects within a broader discourse of youth culture. *Bitch* magazine often addresses the problem of media heterosexism within its articles and also profiles queer artists, cultural events and activists. Canadian magazine *Shameless* targets a younger reader, including queer youth on its teen advisory board and reaching out through relevant stories and perspectives. In this sense, a few existing youth positive feminist magazines are talked about as being, in many ways, more engaging than lesbian-specific texts. There is a tension between wanting texts that speak more directly to girls who desire girls and desiring a more flexible and inclusive genre that does not stake out a single identity through which to market itself. Making use of current alternative forms of magazines, youth expectations are not utopian whims but are guided by knowledge of what exists as well as desires for new genres of print media for marginalized youth.

While interested in magazines that articulate queer perspectives beyond a narrow "lesbian" focal point, many of the girls I interviewed crave magazines geared to specific issues and perspectives of their age group. Cindy says that she "would ideally like to see a queer magazine with a focus group of 13–18. I think it would help a lot of queer youth deal with issues that plague them right now: high school, parents, first relationships, what to do when you live in a small town, things like that." Rather than have to rely on either straight teen magazines or adult-centered queer culture, teens want access to publications that include and address them directly. The point is to design a magazine that is responsive to the material and symbolic lives of queer youth rather than projecting commercialized norms. Taking elements from mainstream magazines, such as dating and sexual advice columns, youth suggest ways of reworking them to consider experiences in which romance is not merely a personal problem but is inseparable from political and community involvements. The daily negotiations of coming out, warding off homophobic violence, and trying to meet

other queer youth not only call for different magazine issues and sections but also call for new ways of representing popular teen discourses.

As recreated by queer girls, magazines would become practical resources for self-empowerment and community dialogues rather than focus on idealized models. Although fashion is still regarded as an important area, the focus would be on exchanging pictures and ideas about how queer youth are stylizing themselves. Tammi suggests that it would "be interesting to have a body modification section. So many people are interested in that these days and it would be cool to share information and pictures of new mods." Fashion by, for, and about queer youth becomes conjured as a site to exchange images that articulate hybrid modes of self-representation. Suggesting open-ended show-and-tell forums of subcultural style, queer girls are less interested in prefabricated looks and much more excited about hearing how other youth craft their visual expressions. Following a do-it-yourself ethos of marking and fabricating queer bodily identifications, youth wonder about the possibility of more dynamic forms of fashion representation that might disrupt the corporatization of youth. Overcoming media presentation of slick brand concepts, these girls are interested in innovative and politicized embodiments. Queer girls desire politically oriented magazines that provide information that would tell them what's going on and enable them to hook into alternative cultural scenes and activism.

I end this chapter with an unfinished projection of future possibilities for queer girl magazines. In many ways, this chapter has been about partial and ambivalent representations and engagements by young people in adult-centered lesbian media. While youth are more and more included within commercial magazines, their social experiences and diversity are often simplified and integrated into a commodity-image system of branding that celebrates queer youth as a sexy, fun entertainment segment. This is not to discount the ways many girls are able to read and enjoy these texts for signs of visibility and community otherwise denied. But it raises critical questions about the shortcomings of what lesbian magazines can offer to enrich queer girl cultural production and involvement. In the wake of prolific do-it-yourself print, video, and online zine cultures by, for, and about queer girls, the very status of mass media publications is uncertain for a generation frustrated by the normalizing commercial protocols of magazines. Yet one of the most interesting outcomes of this critical impulse is not a refusal of mainstream texts for alternative cultural texts but a desire to transform the very mode of representations that might enlist, circulate, and address queer girls. It is in the whimsical elaboration of visions of hybrid media texts that would be age- and gender- specific while also fluid and expansive,

locally relevant yet globally connected, stylish without becoming corporately controlled, entertaining and political that the ambitious dreams of a gen-derqueer generation emerge. The very ability of these girls to see beyond what is available says a lot about where they are and where they want to go. When I was a teen, twenty years ago, the very idea of a popular queer girl magazine would have been unthinkable. Today, the wildly intelligent desires of girls become articulated not only in relation to commercially successful media texts but also in their explicit longings for alternatives.

· 6 ·

PERFORMING COMMUNITIES ONLINE

Creative Spaces of Self-Representation

The birl community is very important to me. We, as birls, and other groups that break the gender barriers of the world, hold a very special place in my heart and in my mind. They are a constant reminder that age-old gender stereotypes are, to be frank, a load of crap and nobody has to act or look a certain way merely because of their gender. That not everything is as it seems, and that not everything follows the same pattern and routine. Diversity is something that is many times attempted to be stifled, and communities such as that of birls keep diversity alive.

Jan, age 18

Queer youth are actively creating and participating in a wide range of online communities. Whereas in the mid-nineties Addison and Comstock wrote that "tellingly our search thus far has not turned up any exclusive lesbian and/or female bisexual youth sites" (376), today there are dozens of lesbian, bisexual, gay, and trans Internet sites and communities offering youth chances to produce self-expressions as mass media. Many queer kids grow up in contexts where their gender and sexual embodiments as gay, lesbian, bisexual, transgendered, queer, two spirited, and questioning are shunned, devalued, or ignored, and they are compelled to actively seek out alternative means of making connections, asking questions and seeking out advice from others sharing similar experiences. The Internet is uniquely suited to the predicaments of youth who are often

geographically separated, culturally isolated, and socially threatened. It is not only for the sake of communication that queer youth turn to cyberspace, but also to fashion sex/gender/sexual embodiments and cultural styles. In other words, youth make use of the Internet as a realm to try out, play with, and perform their identities and desires through provisional combinations of images, words, and narratives.

Within cyberspace, queer youth challenge fixed notions of girl/boy, male/female, and heterosexual/homosexual prescribing desire and identifications. Across a broad range of cyber-communities, self-presentation is often an unstable and changing process. This affirmation of a self in flux lines up with Sherry Turkle's idea that "the culture of simulation may help us achieve a vision of a multiple but integrated identity whose flexibility, resilience, and capacity for joy comes from having access to our many selves" (249). The contingent and arbitrary relations of Internet media link up with the transitional self-formations of queer youth in ways that are mutually reinforcing. While I set out to research queer girls online, I discovered very soon that "not everything is as it seems, and not everything follows the same pattern and routine." Through interactive social environments, youth are complicating the very terms through which they name their sexual and gender identities. And it is precisely in these collective spaces of dialogue that the queerest signs of youth resistance to fixed binary categories emerge. Even as I tried to remain focused on tracking exchanges of girls desiring girls, the specificity of my Internet search turned in several directions. What about those "girls" who are boy identified? How about the genderqueer possibilities of boy-girls desiring girly girls or transboy fags desiring each other? In what ways do transgender youth name themselves online? Can I give up the "girl" and still stay true to my queer girl project? Maybe my fixation on "girl" is getting in the way of a queer reading? My sense is that it is time to follow the words of youth more closely. On the Internet, young people are daring to name, question, connect, and imagine their individual differences and collective bonds in new ways.

There has emerged such an expansive range of communities for/by/about queer youth that it would be impossible to cover even a fraction in a single chapter; they range from large politically driven national groups like Queer Youth Alliance and Gingerbeer in the United Kingdom and Youth Resources in the United States to more specific groups like the Transproud online community and the TransYouth WebRing. There are several youth positive lesbian dating forums, such as Superdyke, Lesbotronic, Gaydar, and Pink Sofa, as well as digitally savvy sites, such as Technodyke, and creative forums for young

lesbians of color, such as Pheline.[1] Not only is there a proliferation of community forums, but within them the modes of communication include message boards, e-zines, chat rooms, live discussions, community blogs, webrings, and listserves. The time has come when there is virtually a group to suit the needs of most young queers in cyberspace. Online communities help to provide multilayered spaces of self-representation, support, and belonging for youth who are marginalized on the basis of their gender and sexual differences. Designing, moderating, and joining groups in which to talk with others, queer youth are at the forefront of do-it-yourself digital media. Cyber-communities are expanding the very terrain of social interaction and identification for young people coming out and growing up within geographically scattered and culturally distinct contexts. Yet the questions remain: What is the form and content of these community spaces? How do youth construct and participate in online communities? In what ways is community queered? How are community boundaries drawn? Who is included/excluded? Do these virtual communities have a connection to the real worlds of queer youth? What do youth say about them? How do I study youth online communities as an adult without being an unwanted lurker?

Theorizing Queer Youth Communities: Connections of Care, Hope, and Conviviality

Girls talk to each other and listen to each other; they share concerns, encourage each other, console each other, and let each other know that no one of them is going through her issues or feelings alone. Moreover, the community is constructed dialogically, as are the girls' individual identities, in a forum that is generally safe.

Ashley Grisso and David Weiss, "What Are gURLs Talking About?" (46)

Feminist researchers have begun to explore the unique ways girls participate in online communities, emphasizing empowering collaborative practices engaging girls talking to girls beyond male-dominated forums. At the same time, it is important not to romanticize the unity and sameness of online girl participants as they establish provisional community identities and relations. Rhiannon Bury emphasizes the tendency of online communities to create "an insider/outsider binary wherein exclusion necessarily goes hand in hand with inclusion" (15). Maintaining a cautious appreciation of how the boundaries of virtual girl communities both construct togetherness and create lines of division becomes especially vital when considering particular stakes of online participation for

sexually marginalized youth. Not only are queer youth often devalued and marginalized within many girl-centered communities, but their needs and uses of queer online groups also call for more specific attention. Drawing upon ideas about girl-centered Internet activity and community to think through the particular conditions of queer girl belonging becomes an important first step towards more empirically detailed insights. Anita Harris writes that cyberspace "existing between public and the private, works well for young women seeking to combine a desire to organize and communicate with others with a need to avoid surveillance and appropriation of their cultures and politics" (61). This dual need for public voice and protection from regulation and surveillance is especially crucial for marginalized youth. Queer girls make use of the relative safety of the Internet as a realm in which to talk to others while having control over where, with whom, and how much to reveal about personal experiences and sexual identifications. Moving back and forth between anonymity and self-disclosure, online communities and home pages create flexible spaces for young people to explore the very process of representing themselves as queer, unfolding the layers of their emerging identities with varying degrees of distance and closeness, fiction and reality, self-reflection and social dialogue. In this way, online groups provide queer girls with mediated forms of community through which to disclose changing and variable aspects of selfhood as a mobile process of exchange with other queer and questioning youth.

Community is not a given for queer youth; it is lost, taken away, refused, and recreated at a very vulnerable time of life when articulating a sense of self and belonging becomes intensely urgent and uncertain. In a recent report studying queer youth in rural Canadian towns, a girl comments on the pain of being left alone and socially stranded: "It's the isolation, being the minority, losing a whole bunch of friends. All the harassment from students and their parents and teachers" (Morton 27). For many youth, coming out as GLBTQ (gay, lesbian, bisexual, transgender, and questioning) results in a traumatic loss of community and family acceptance. The high suicide rates of queer youth are intimately tied to a desperate hopelessness of feeling socially excluded, unloved, and misunderstood. In this respect, it is important not to underestimate the hurt experienced by a youth who feels a crisis of community affiliation. The challenge for youth becomes how to avert or meet this crisis through a constructive search for alternatives. Queer youth communities provide a complex tool of self-reparation, a way of working through and overcoming the pain and loneliness of being left out, treated as unworthy, or even punished for nonconformity. Connecting up with other queer youth is important because, as many writers

have noted, the chance to have queer mentors, friends, and acquaintances deeply matters. Robert Owens writes in his book *Queer Kids* that "within a support network, especially one consisting of other teens, individual internal conflicts can subside and a youth can begin to heal. Self-esteem can be rebuilt" (149–50). In this way, communities for, by, and about queer youth may help to rebuild or strengthen social trust and hope. This is not to say that queer youth communities are shaped solely out of reactionary experiences of suffering; indeed, there are many examples of playful and creatively oriented groups centered on the "here-and-now" pleasures of collective engagement.

While queer youth may be isolated and individualized within their everyday life worlds, they are also cunning community builders learning to use new media to create innovative social networks. According to Addison and Comstock, "as a result of their isolation and increasing access to the internet and the WWW, it seems that more and more les-bi-gay youth have begun to employ technology in order to understand and express their experiences and demand that they be considered culturally significant members of society" (368). Facing an especially hard time getting social recognition within their families, neighborhoods, or schools, many youth are compelled to actively pursue new community forms and practices. I would argue that queer youth develop critical consciousness about the difficulties, conflicts, and compromises of partaking in communities as part of their coming of age and survival. There is a strong degree of intentionality in the making and sustaining of queer youth groups as they are forged out of a crisis of not fitting into the norms of traditional community frameworks. This converges with the requirements of Internet communities that demand a high level of intentionality that is very different from the concrete bonds of physically situated communities. Online communities are such that "symbolic boundaries and resources are all fodder for the imagination of what a given community consists of and can be, as well as the kinds of interaction that this new type of engagement reflects" (Renninger and Shumar 6). Queer youth are socially and culturally positioned to take advantage of these transformative dimensions of online communities, staking out new terms and territories of identification and belonging. Renninger and Shumar write that "the Internet has altered our sense of boundaries, participation and identity. It allows for the recasting of both self and community, meaning that through the Internet a person or group can revise his or her sense of possibilities" (14). Allowing for flexible spatial and temporal boundaries of community participation, online community offers youth who are dispersed chances to align themselves through multiple and shifting interests, ideas, sentiments, and values.

While the turn to online communities may seem like a poor substitute for face-to-face interactions, it becomes crucial to rethink simple divisions between real and virtual sociality. Mary Chayko argues in her book *Connecting* that some of the strongest emotional bonds can exist in the sociomental realm, in which getting together and establishing a social bond with others is based on the mental, perceptual, and imaginative interchange between people who may never physically meet. Chayko writes that this is "an absolutely genuine and often deeply felt sense that despite physical separation, a closeness among people, a nearness, exists; that while the physical distance separating people may be great, the social distance between them may be very small indeed. They represent an experience of communion" (2). She further suggests that, while these non-physical connections are often belittled as inauthentic, false, or inconsequential, they are in fact the basis of very subtle and meaningful forms of hidden social relationships. I would stretch Chayko's ideas further to help frame the importance of online communities for marginalized youth, which are inconspicuous and ephemeral on the surface yet are invaluable as a locus through which youth come together and support each other. Many youth express intense feelings of connectedness and understanding shared with others they will never see face to face. The trick is to learn how to trace and theorize some of the unique contours of these intangible social bonds.

Unlike embodied social ties, online interactions are based on personalized exchanges of text and images mediating community formations. The identities and desires of members are known and interpreted through an interplay of words, symbols, and pictures. In this way, online community is lived and studied at the level of textual dialogue. At their most general, these communities facilitate the circulation of stories, pictures, and comments that move back and forth between self and others. Following Bakhtin's notion of dialogism, the languages that comprise queer youth community relations, are ongoing, open-ended, and value-laden conversations into which words become recontextualized from many perspectives. Although they are textually bound, they are deeply social and embodied as words are spoken from particular subject positions reaching out towards other located selves. Words exchanged online not only pass through the experiential histories of youth across temporal and spatial boundaries, they are transformed in the process of being heard and answered through the varied interpretive stances of youth. Bakhtin's notion of heteroglossia becomes important here insofar as there is a diverse interplay of voices to be found within online communities. No single unitary voice prevails or

stabilizes subject positions within collective dialogues. Coming from distant social contexts, cultural backgrounds, class locations, and racial identifications, queer youth dialogues in cyberspace are extraordinarily dynamic. As talk shifts across time, places, and people, community relations become realigned and redefined. In this way, there is no way to pin down these communities, as that is not the point; rather, they are best approached through particular moments of their dialogical formation, as contingent textual relations between individuals talking together as community.

Queer youth communities online are distinct social, symbolic, psychic, and political spaces of dialogue. These communities range from formal service and educational sites to more casual gatherings. And it is precisely those places where young people meet to enjoy and create what Oldenburg refers to as conviviality, places of casual talk and intimate banter, that are the focus of this essay. In-between the public spaces of school and work and the private spaces of family, environments are being created that resemble cafes, clubs, pubs, and community centers as spontaneous arenas for meeting, hanging out, and chatting. Oldenburg argues that, in the face of shrinking real-life public spaces facilitating easygoing social interactions, the Internet provides an alternative sphere of conviviality where people meet to connect in spontaneous and unregulated ways. For queer youth, informal public modes of community are especially valuable in the face of a lack of social recognition and support within both formal public institutions and private realms family. Queer youth are often in a predicament of having literally nowhere to go in order to physically experience the pleasure of feeling at home with others. And it is precisely those improvised, casual, and open forms of sociality to which young people turn for a sense of laid back, spontaneous belonging. Providing moments of intense intimacy and connection, these communities also allow for safe distance and anonymity. "Gone are the fears of discovery by the librarian, the operator, or the accidental meeting with your sister at the entrance of a meeting. With anonymity, lesbian, gay and bisexual youths can gain information about sexuality . . . and resources, swap coming out stories, discuss feelings, and seek advice" (Owens 153). Youth are able to mediate their own participation online, controlling the degree to which they give their time, disclose personal information, or share their fantasies.

While on the surface such communities may seem to be trivial places of private leisure, their social value and importance to queer youth need to be understood from within their life worlds. In the words of young people, these

groups take on deep social meanings that have been traditionally associated with family and close friendships. A teen responds,

> In reference to this specific community of birls . . . they are like a second family for me. I can't talk to people in my own family about my sexuality and the idea of being a birl, so I turn to them when I have questions and concerns. They are the sweetest, most caring group of people I think I have ever met and it makes me feel better about myself and who I am to know that there are people out there just like me and to have contact with them.

What characterizes this community are caring relations that go beyond the physical immediacy and conventions of traditional family ties. At its most basic and stirring emotional level, it is the nurturing responses of online strangers that comprise community by and for queer youth. And it is precisely an ability to give and receive care through a mutual recognition of the queer differences of youth that makes these communities so vital. Even when ties are temporary and short lived, consisting of only a few words of comfort, praise, or advice to someone, the impact seems much greater for individual youth than they may appear to outsiders. In this sense, acts of care are symbolic and imaginative gestures that tie young people together through informal yet common social and ethical bonds.

Extending Kath Weston's argument in *Families We Choose* that gays and lesbians often build strong networks of friends as innovative forms of kinship, youth use the Internet to reinvent family/community ties geared to their specific interests. Youth are uneasily situated within adult gay and lesbian kinship relations because they may not clearly identify either way, they may be exploring multiple identities, they may not be ready to come out, and/or they may be dependent on their families of origin. For those who may not have access to social events or the desire to join gay and lesbian organizations geared to adult interests, the Internet provides a medium to search for, try out, and experiment with their identities and social alliances. Young people are often left out of or else assimilated into more general community frameworks without room to explore their diverse needs or styles of communication. Shaped through the dialogues of young people talking together on the basis of shared experiences or imagined commonalities, they are able to build their own innovative social forums that borrow from, redefine, and challenge heteronormative parameters of community ideals and practices.

Run by and for youth, most online communities are able to bypass unwanted adult control. In the user info headlines of a transyouth group, it states, "If you don't want to get eaten alive by the adults for saying the wrong thing when you post about something, then here is a good place to post and ask questions." This suggests that what youth want to talk about may be unwelcome or harshly judged

within adult online communities. The need for youth-centered cyberspaces is partly due to the exclusions and hierarchies within mainstream communities online and off-line that work to regulate youth perspectives. In Renninger's and Shumar's words, "the ability to circumvent hierarchical positioning might be very important for an individual's ability to learn and grow. It might also help the individual to find other like-minded individuals who want to escape such interactions" (13). Many queer youth communities express a desire to circumvent adult authority, seeking social ties and knowledges that are not adult initiated, mediated or evaluated. Reacting to unequal systems of power, age boundaries constructing queer youth community meanings and membership work to ensure that it is young people who direct and participate in their own collectivities. While the exact age cut-off point is left purposely vague in most of these groups, being a youth can range anywhere from thirteen to twenty-seven years of age, yet self-identifying as youth, girl, or boy, rather than adult, becomes an important marker of belonging. These groups are fiercely driven by a youth ethos of self-determination, seeking to overcome dominant forces that belittle the agency of youth by interacting and working together.

The Internet enables informal grassroots types of communities that are suited to the needs and circumstances of queer youth insofar as there is a great deal of room for experimentation and improvising with visual and verbal styles. While some youth speak directly about themselves, others use popular culture or fiction to introduce themselves or represent an idea. Using personalized handles and icons, it is possible to join discussions without ever disclosing a self, mingling with others through a concealed or possibly invented identity. At various stages of coming out publicly, youth make use of this self-representational flexibility to show themselves at their own time and in their own specific and often quirky ways. A nineteen-year-old is quoted by Kelly Huegl in her GLBTQ survival guide as admitting, "I've come out to people online, in large groups in chat room, which is much easier than in person or one-on-one" (Huegl 82). Entering community through a poem or song lyrics, an oblique Webcam shot, images of pets, or a drag self-portrait, youth are able to manipulate the signs through which they are read within the group. There is a striking diversity of modes of representation that not only leave room for youth to explore how they will present themselves but also enable diversely queer selves to join in. As such, community is not based on the transparency or stability of the identity of all members but on the personal and collective work of signifying the details and transitional signs of queer youth experiences. And while deception is possible, misrepresenting a self in a completely false guise is rarely a problem in these

groups, as the point is not to tell the truth but rather to respond to others with understanding, care, and reciprocity. Queer youth instigate performative dialogues online, encouraging creative practices of self-representation in relation to participation in community.

Lurking Methods:
Reading Community Conversations

Now it's time for me to get specific. After surfing online for a couple of months, checking out and comparing dozens of queer youth homepages and wandering through prolific and fascinating threads of discussion groups, I decided to focus on a close content analysis of daily dialogues within two communities that are part of the larger blogging site called LiveJournal.com. I selected the ikissgirls and birls communities because they are extremely active and popular open forums with a continuous and diverse flow of talk by youth about gender and sexuality. They are also useful because they are linked to the individual blogs of individual members, giving other members, and me as a researcher, access to personal and contact information. In this way, there were multiple possibilities for interaction between individuals, one on one and collectively, expanding the means through which youth communicate and connect with each other. These groups are also fully archived and contain a very flexible range of topics as well as a mix of textual and visual forms of communication. What also interested me were their distinct yet overlapping modes of address to "girls who kiss girls" and to "girls who identify as boys." There is an oddly wonderful tension within and between these communities. They are sometimes connected through dual memberships of individuals, yet they are also distinct in terms of the sexual and gender boundaries they construct. While ikissgirls focuses on lesbian sexuality, and birls converges around masculine identifications, in practice, these communities also share some of the same members, topics, and conversational styles. Both birls and ikissgirls are driven by a casual pleasure in idle talk, a collective sense of conviviality and performative playfulness balanced with support, advice, and nurturance. They are loosely organized around identity categories that become points of departure for a broad range of personal and politically themed discussions. Their members range loosely from fourteen to twenty-four years of age, and they include several hundred members with varying degrees of participation.

I closely followed and took notes on the textual contents and forms shaping these communities for several weeks during July and August 2004, and I also undertook a close and detailed interpretive analysis of a single week's worth of

archived discussions.[2] In this way, I analyze online discourses for rich multilayered conversational elements. Steven Thomsen et al. argue for the effectiveness of an ethnographical method of "thick description" (Geertz) of Internet communication. While I work with digital texts, I try to trace out specific embodied lives and contexts, while embracing their discursive mobility. Drawing heavily upon the detailed words and dialogues developed by youth, I decided to use as many direct quotes as possible to convey living dynamic voices within these communities. My work links and organizes fragments of texts into coherent themes, reading isolated passages for how they articulate broader social problems. The trick becomes learning how to convey a sense of individual spontaneity and differences with collective patterns of identification and meaning.

As I became intensely focused in my observations and analysis, I began to feel uncomfortable, unsure about my status as a researcher. I was utterly enjoying the queer youth talk I was studying. It spurred my personal memories of being young, challenged my assumptions about contemporary queer "girl" communities, and stretched my perceptions of online social relations. Yet as a middle-aged queer woman, I was an obvious outsider to these communities. While I could enter cautiously, reflexively, and empathically as an ally, I could not pretend or force my belonging. I wondered if my presence would be considered invasive, prying, or prurient. Was I an unproductive lurker taking information without giving anything back in return? I decided to randomly ask some of the youth if they minded me studying their community dialogues. Although ikissgirls and birls are open public sites, and I decided to maintain the anonymity of the youth, I approached each person I quoted for permission to use his or her words. I was amazed by their unanimously affirmative responses:

Question:

Hello, I'm a queer prof doing research on queer youth and online communities. Do you mind if I quote your words anonymously from the birls/ikissgirls community for a paper I am writing?

Responses:

Feel free to. In fact, I'd be honoured if you did so.

That would be a-ok with me, and thank you for thinking that what I have to say has some sort of impact or significance, it means a lot to me.

i would be happy for you to use my quote!!!!!

Thank you for showing interest in what I have to say.

I'd be thrilled if you quoted me in your essay!

it's flattering to want to be quoted, and i hope that your research proves to be successful!

Queer youth want to be heard, understood, and respected. They want their words to have broader social significance, to be part of a bigger picture in which their experiences and perspectives are taken seriously. In many informal conversations I had with these youth through e-mail, I discovered that, while youth enjoy spontaneous self-directed exchanges with other youth online, they are more than willing to have their words used to support an expansion of knowledges about their lives. In the face of social invisibility and silence, after years of being dismissed as strange, immature, deviant, and confused, many youth are pleased to have their words recognized as valuable and publicly meaningful. They want their words carefully contextualized, left open for contradictions and changes, treated as intelligent and creative, and protected from negative moral judgments. And these are the burden of responsibility and the gift of recognition that need to be fostered within research about queer youth online. It is not an exact science but a caring engagement that acknowledges failure, partiality, and emotional investment. Hopefully, my readings that follow offer a glimpse of the rich dialogues shaping queer youth communities, sharing intimate words for the sake of expanding public awareness of complex identities, desires, and social relations enacted by, for, and about youth online.

I Kiss Girls: By, for, and about Queer Girls

I started up this site after many unsuccessful attempts to find a friendly online community for young females who are attracted to other females, simple as that. All the sites I found were aimed at all genders and/or sexual orientations, seemed threatening in some way, or were specifically for older women. I was looking for something personal, something I could easily relate to, something non-commercial and created by someone like me. As for the age thing, I myself realised at the age of ten that I was attracted to girls. Discovering one's sexuality should never be restricted to adults.

Bonnie, Ikissgirls.com originator

As one of the most active youth forums in LiveJournal.com, the ikissgirls community is an extension of a youth-owned and-operated Web site named I KISS GIRLS that includes a kisses gallery of pictures, a webring, a message board, storytelling pages, and an advice column. This elaborate Internet site emerged out of a simple idea of creating "a friendly community for girls who kiss girls." Hailed as a "resource for young lesbian, bisexual and bi-curious women," this community draws its boundaries according to specific age, gender, and sexual identities. It is unabashedly queer girl centered and is designed to encourage the

showings and tellings of girl-on-girl erotic desires and relations. The Web site is visually slick and seductive, with a bold red background and a glamorous image of two girls kissing as part of the heading logo. With clear sections marked as "interact," "communicate," and "support," this homepage provides a framework for involving girls in cyberspace social interactions. The LiveJournal community ikissgirls is an offshoot of the I KISS GIRLS Web site and extends its interactive possibilities through ongoing threads of discussion and hypertextual links to the individual blogs of each member. Started up in 2003, it already lists over a thousand members and produces up to thirty-five threads of conversation a day. It is here that the interests, meanings, and purposes of this community rebound across a wide range of subjects from girl crushes to homophobia in schools to coming out and sexual adventures. Dealing with much more than personal lifestyle issues, this community has developed to provide members with a place to talk about vulnerable experiences that take on broader social significance as youth speak to each other with insight, care, and humor.

Ikissgirls provides a relaxing virtual community to casually talk with, listen to, and look at images of girls desiring girls. There are very few rules governing membership, and minimal guidelines shaping content and form of discussions. While there are no age restrictions, during the week of my study, the average age was eighteen, and the oldest girl was twenty-four. Relaying minute details of a date, seeking out hair or fashion advice, exhibiting revealing pictures of oneself, telling of heartbreak, showing off a new tattoo, sharing a poem or song, passing along a comic, introducing a pet, debating about gay marriage, asking questions about sex toys—these are all engaging topics carried forth by members of ikissgirls. This community is not bound by a single interest; rather, it coheres in providing a space to talk openly. Just being able to follow or participate in a relaxed spirit of openness provides a liberating space where sexual preference does not define all aspects of these girls' lives, while being an important part of their sense of belonging. As such, this virtual community's purpose and meaning is as fluid as a group of young people hanging out, gossiping, and laughing together. Yet such simple activities are often harder for queer youth to access and thus are especially valued online as an supplement to real-life community. A sixteen-year-old self-identified lesbian member writes,

> I do have a fairly large amount of GLBT friends, and I love them. But ikissgirls is different. It gives people a place to open up and share things. You can talk about personal subjects and issues that you wouldn't be able to address with close friends. People in the ikg community are of all ages and from all over. You can get an honest outside opinion on something, which is what I really enjoy. You can also get all kinds of support

and advice. GLBT teen communities have helped many people I know become famil-
iar with their sexuality and come out. It is a wonderful thing.

The idea of being about to talk more freely about personal subjects within the
community is especially relevant when it comes to topics of sex and dating. It
is here that the physical distance and anonymity of a virtual community become
useful for eliciting emotionally risky talk about falling in love. At times, the
agony of teen romance comes across through the loneliness of silence. When a
girl talks about falling in love with her best friend or confessing that a girlfriend
has cheated on her by sleeping with a boy, it is often expressed for the first time
online, out of reach of those who might scorn her. Many secrets about love are
told precisely because they are addressed to other lesbian or bisexual girls who
can relate and share feelings. These youth go to great lengths in providing
details and analysis as they try to communicate their romantic predicaments and
receive detailed accounts in return. After comforting someone who was dumped
by a girlfriend, a member thoughtfully reflects on a similar event and reaches out:
"If you want to talk, I'm usually always signed onto AIM. . . . I know I'm a
complete stranger, but sometimes talking to a stranger, who doesn't have any
bias, is better than talking to a friend who knows you. =) *hugs*." The offer-
ing of unbiased support gets reiterated often within this community, especially
when it comes to intimate struggles of love and loss. Yet an even more creative
interplay of confession and assistance emerges as girls take on the imaginary role
of lover. Here is an example as a bisexual girl responds, "im sorry she's cheating
on you. . . . your such a great person and if you were here . . . i would never cheat
on you.. . . well i would have a boyfriend too . . . but no cheating on you with
another girl :) i love you." Wounded from real life romance, girls are met with
the promise of a better kind of romance fictionalized online. Community as heal-
ing and hope emerges through brief passionate exchanges online through which
these girls help each other feel better and move on.

While some youth articulate a secure sense of sexual identity and desire for
girls, others use ikissgirls to talk about their doubts and fears. Some as young
as fourteen seek out advice from older members, asking "what is gaydar"? "how
to know if a girl is straight or queer?" and "what is the best way to make the first
move?" At the beginning stages of their sexual explorations, many of these girls
use the forum to get information and learn through their shared experiences.
As a form of self-help dialogue, they teach each other conventions of lesbian
culture. A twenty-year-old writes that this community "is a good place for the
younger generations that are going through tough times because of their alter-
nate lifestyles, to converge and gain support and guidance from the older

generations that have already mustered their ways through." It is interesting that a twenty-year-old is considered part of the older generation! While this is a sign of the age lines implicitly drawn by members, it does not mean that age determines sexual confidence or experience. Seeking out sexual help and admitting vulnerability are common elements of many posts, almost requisites of belonging to ikissgirls insofar as they create a common sense of needing to hear back from others with similar frustrations and curiosities.

A remarkable feature of this community is its fluid sexual boundaries. Even though the focus is on girls who kiss or want to kiss girls, many participants are openly and proudly bisexual. The very status of sexuality gets articulated as bisexual girls speak up about their need to be understood and respected, telling stories of not being taken seriously in either straight or queer communities. Several girls refuse to identify in clear-cut terms, leaving their sexuality open to multiple interpretations. A seventeen-year-old comments that she is "a lesbian with heterosexual tendencies," remaining coyly ambiguous and eliciting positive feedback. There is a remarkable openness towards bisexual and questioning youth in this community that gives them permission to ask questions without being shot down or ignored. A sixteen-year-old girl writes, "I find it weird that being more straight than bi, that I enjoy lesbian porn more than straight porn. . . . why is that? *shrugs*." Not only does this question offer a rare chance to hear about youth enjoyment of porn, but it also calls for responses from girls to exchange ideas about its pleasures.

The visual identity icons selected by members are frequently highly eroticized images of girly porn stars or celebrities. I was struck by the prevalence of bold sexual visuals. Of course, these icons are their personal tags that circulate amongst many communities, but they have special queer significance in this site, providing conversation pieces about how hot they are as figures of girl desire. Explicit sexual dialogues take place about buying sex toys, wearing dildos, and making do-it-yourself harnesses. Mixed in with practical comments about where to purchase and how to use toys, these youth talk about their fantasies and inhibitions. Ikissgirls incorporates sex as part of this community of queer girls in ways that overcome the regulative, taboo, illicit, and shameful tenor of discourses within the dominant culture where girls are framed as either sexual prey or innocent and unknowing kids.

While the ikissgirls community is largely devoted to personal talk about self-image, leisure, romance, and sex and is not ostensibly a political forum, even its most intimate exchanges touch on issues of invisibility, power, and exclusion. I came to this community expecting light friendly chats, but I was very

moved by expressions of loneliness and fear, as well as resistances interwoven into the dialogues. Sharing experiences of coming out is very common amongst the members of this community. They have a chance to talk about the process of coming out with other young girls, without judgment or adult scrutiny. Over the course of a week's entries, I counted more than a dozen in which the issue of coming out was talked about. And it was in the context of family relations and fear of rejection that the girls expressed the most worry, driving them to seek out advice. One girl writes, "Speaking of coming out to my mom . . . ANYONE HAVE ANY ADVICE??? She's really anti-gay and very Christian, so she's going to kill me." She is offered sympathetic diverse pieces of advice. From short quips that advise her to keep quiet and get away from her mom as soon as possible to longer analysis of right-wing Christian attacks on gays and lesbians, a responsive context is developed to place individual experiences in social perspective. Some recount their own struggles with intolerant parents, focusing on the dangers of coming out without a safe degree of independence and outside support. Other girls tell of strengthened bonds with their mothers and fathers and possibilities of shared learning across generations. Many come forward with their struggles to understand and name their own feelings, suggesting the ways coming out to oneself may be a drawn-out difficult process. Girls also speak out about the empowerment of refusing to live in secrecy and shame by making their lesbian or bisexual identities public. Wildly diverse stories of coming out intermingle uneasily in this community, encouraging the youth to figure out their choices in relation to others. This community frames coming out as an ongoing social process, helping queer girls to see themselves as less isolated and alone in claiming their sexual identities.

Talking about coming out includes talk of the risks of losing social recognition and love, broaching larger issues of oppression. Although issues of homophobia and heterosexism are not explicit topics of discussion, they enter fragments of narratives as these youth admit to losing friends, being excluded at school, or having their rights denied. The more abstract aspects of gay rights are brought home when a girl desperately appeals for feedback on her decision to join the military. Raising doubts about the "don't ask, don't tell" policy, and worrying that her career aspirations may force her to sacrifice her desire for girls, she asks, "would any of you go out with a lesbian serving in the military?" While she is greeted with support and confirmation that there are girls who would still want to date her, this thread marks an important glimpse of the fear provoked by institutional barriers facing queer youth today. Acknowledging that problems of injustice reach into the religious heart of American culture, this community

grapples with the power of anti-GLBTQ forces. After watching a story about a gay bishop on the TV news magazine *60 Minutes*, a girl questions the ignorance that surrounds her inside and outside her immediate family. In response, a fifteen-year-old girl asserts the need for political action and a movement when she comments, "it would be so cool if there was a gay type of Martin Luther King who can stand up for us." This seemingly apolitical youth community does not skirt more substantive issues of injustice that are raised out of the urgency of power inequalities and conflicts in the material world of the here and now. In this way, the personal desires and identities of these girls emerge as inextricably political as they are grounded in the daily realities of the heterosexist social worlds they have grown up in and continue to survive in as young queer people.

The ikissgirls community is an informal realm of social engagement that challenges us to think beyond the binaries of private subjective spaces and public political spheres. They don't draw lines separating sexuality from issues of family, work, or school, as these issues are interwoven in their embodied and symbolic experiences. The banal details of fashion are not outside deep questions of belonging, sex is not only about bodies and pleasures but also the limits of social acceptance, talk of tattoos is not a purely subjective issue of adornment but also a mode of communication, and coming out is not merely a psychic process but a painful confrontation with heterosexist culture. The performative work of self-definition and social analysis is enacted in many combinations. These girls know the complexities they bring to bear on this community, and they also seem confident that it is capable of including them. I would argue that this glimpse of a queer girl cyber-community points to new ways of understanding youth and community. As I turn to the birls community, this challenge is pushed further by throwing into question the gender parameters through which I have been referring to queer girls. What about girls who identify with masculinity? What about genderqueers who desire boys? Where do boyish girls go to hang out, chat together, and enjoy conviviality? What about queer girl-boy online dialogues? For those born female whose identity does not fit into "girl" terms or ideals, virtual communities are emerging to provide alternative spaces of social bonding.

"Boyish Girls Unite" in the Birls Community

see i'm just a little girl boy,

trying to make my way in a man's world

"Best Cock on the Block," Bitch and Animal

In my search to understand the range and specific community practices of queer girls online, I realized that the very concept of being a girl is being transformed by those who define themselves and seek out others who identify outside the clear-cut lines of being girl/boy, straight/queer, female/male. Many youth-activated virtual communities are creatively resisting normative identities. Whereas ikissgirls takes for granted the gendered status of being and desiring girls, other groups purposely defy them. Some communities adopt a more generalizing approach that embraces all who refuse gender binary categories: "This community is for those of us who don't feel we fit the binary gender system in use by most of society. Ungendered, many gendered, a gender other than the one society thinks you should be?" (Genderqueer community user info). In an attempt to overcome rigid identity-based community forums, this community defines itself through open-ended gender ambiguity and inclusivity. What is shared in common is a desire by many young people for movement across the gender spectrum without the compulsion to fit into or self-identify with a predetermined single spot. Genderqueer communities are actively structured through disinvestment and disidentification with normalizing categories of difference, linking individuals through shared interests in flexible gender systems. In many ways, such virtual genderqueer spaces of dialogue and belonging mark new frontiers of community that disrupt a more specific focus on queer girl online connections.

Transgender youth groups often elicit and produce a provocative flux of identity: "new . . . girl . . . boi . . . ME! . . . I'm 16. . . . I dont identify with a gender . . . or a sexual orientation/preference. I'm just me" (transyouth LiveJournal community). Transgender communities can also work to challenge heteronormative gender ideals while embracing specific sex/gender identities as a new basis for community. In this way, transgender FTM (female to male) youth groups embrace male and masculine aspects of their transitioning or transitioned selfhood. For youth who join these communities, talk is of becoming boy, of progressing towards the achievement and status of becoming a man. The passage is conceived as unidirectional away from being a girl or having been seen as a girl. A seventeen-year-old on an FTM open community writes,

> And ever since I was little I've always felt I belonged in the so-called "male world." All my best friends growing up were guys, and I've always acted far more "boyish" than my (few) female friends. I've only just recently begun to look into things; mostly because I'm finally beginning to get disgusted with the body and social role I seem to be trapped in. I'm looking into someday (when I have money and am away from my mother) making the trip across the spectrum.

Support and advice pivots around the desire for male masculinity. While many participants grew up as girls, they recognize themselves in the present as boys and communicate with each other as such. FTM transgender youth communities tend to be build on shared and diverse self-identifications with masculinity uprooted from girlhood histories and origins. However, it is interesting that, while the community is male identified, queer girls enter these community sites indirectly, as friends, lovers, allies, or threats to FTM individuals and their communities. Girls are peripheral figures here, haunting reminders of a painful social imposition of growing up biologically female that must be overcome with the help of other transboys. At the same time, queer girls that accept and love these boys are sources of community understanding, witness, and support. Many FTM youth are also members or guests of femme girl communities in LiveJournal.com. While FTM communities are not themselves queer girl subjects, they raise complex questions about the relational boundaries of queer girl communities.

I came across a few sites that combine transgender and girl identities, simultaneously using and transforming their meanings as a basis for community formation. One of the most interesting and popular communities called birls, "a community dedicated to boyish/androgynous girls" with open borders such that "all people who don't define themselves as birls are welcome as well, including femmes, bio-boys, androgynes, and transguys . . . or you could just make up your own label for who you are." Birls draws together many boyish girls who gather to talk in detail about their self-images, romance, family, hobbies, and social struggles to be accepted. As an open and flexible community, members and friends come and go, altering the composition of members and conversations. Listing over eight hundred active and inactive members and up to thirty new and distinct threads of discussion everyday, this community stood out as attracting and maintaining the interest of a large group of youth. Naming oneself a birl is a celebrated act that encourages others to join in and get involved in the inventive development of self-presentation and interaction between birls. It is precisely the made-up and playful qualities of this identity that provides the virtual community with a unique space for connecting girls who look, act, and feel like boys without delimiting who this includes.

Community amongst birls in this LiveJournal forum begins with a mutual appreciation of the value of being a birl in the face of widespread misunderstanding: "Some folks can't grasp that just because some girls are butch/boyish/androgynous/birly doesn't mean that they aren't female under their clothes . . . there's something insanely sexy about being able to look at someone

and not be totally sure what sex they are, just that they're insanely hot."
Affirmation of the desirability of birls is a key element throughout this online
site even when complex issues of gender and sexual positioning are being
worked through. There are many threads of discussion engaged in a process of
defining birls and, more specifically, of trying to answer the question "why am
I a birl?" In this sense, the community provides a collective place to dialogue
publicly about identity, to share with others alternative ways of inhabiting in-
between genders. A youth introduces himself in the following ways: "I am a boy-
ish girl (and a girlish boy) because I fluctuate between feminine and masculine.
My gender identification is different all the time. I love to wear skirts, but I also
love to bind, pack and wear ties. I am comfortable being called she most of the
time, but other times I prefer he." Expressing a creative ability to live in the
world as both boy and girl, this birl invites responses. In return, the commu-
nity offers warm praise—"you are a doll"—and encouragement— "I'd love to
see you post more!" Gender ambiguity becomes a source of pleasure and bond-
ing between these youth, taken as a sign of being interesting and worth know-
ing. At times, the very concept of gender is up for grabs, boldly theorized by
youth beyond heterogendered frameworks. A nineteen-year-old writes,

> I was born a girl and I can be pretty femme, but I no longer claim gender. I only ID as
> queer. . . . I really HATE gender labels, and all the million new labels seem to cram
> people into even smaller boxes. The thing that bothers me so much about labels are
> the stereotypes that go with them. Girls are supposed to be fragile and nurturing, and
> boys are supposed to be feelingless and tough. Majority of the time my general persona
> is equivalant to that of the stereotypical gay man. It seems as though the only way to
> defy gender is to be a butch girl or a flamboyant man.

Young people in the birl community learn about differences from each other,
exchanging stories and insights about their gender experiences. In one week,
I tracked several comments about the discovery of being a birl emerging from
the daily interactions of members online and off-line. Birls bring their real-life
relations of being perceived as a boy into play as they redefine themselves
together as a virtual community.

Visual presentations of self are a vital way through which birls represent
themselves. Images are an integral part not only of the introduction of a new
birl to the community but also to the maintenance of contact and connection.
Showing off a new haircut or eyeglasses, asking for fashion advice, posing
seductively for a Webcam photo, revealing friends and pets—these make up the
content of frequent posts. Photos provide a visual immediacy that helps birls

come to know each other in more intimate ways. But even more importantly, these photos are the basis for demonstrating and talking about birl embodiment. Here, visual evidence of clothes, gestures, tattoos, accessories, and movements works to characterize the individual enactment of birliness. Personalized snap shots become a dynamic locus of birl talk, much of which is centered around praising and complimenting a person's looks—"mmmm very cute!" Valuing physical appearances works to reverse and displace the negative perceptions and invisibility of masculine girls in mass media, creating an empowering social realm in which to re-envision oneself as beautiful, attractive, and sexy, precisely for being a boyish girl. All those who reveal themselves are received with embracing compliments, a remarkably effective way to encourage even the shyest to make themselves visible. A pervasive tendency of members is to flaunt their physical image, to assert themselves as "camera whores," and to pose for the community over and over again.

Talk surrounding the physical details of looking boyish goes beyond a playful narcissism. It is also a site for sharing stories about social degradation and restriction. Barriers to birl self-expressions, such as parental disapproval, are shared for feedback and support: "Does anyone else have the problem of your mom telling you to be more feminine? If so, what do you say?" This person calls out to other birls to offer insight and strategies for dealing with pressure within families to conform to feminine ideals. The responses are generous and revealing of diverse perspectives and practical advice. While some dismiss the parents as ignorant and not worth the effort, others raise questions and begin an analysis of the dilemmas they face: "I mean I can understand their desire to have their daughter look more like their daughter than their son, but seeing as I was that daughter who wanted to look like a son I understand that side too." Several older members recount the history of their conflicts with moms and dads, holding onto their masculinity and sometimes finding acceptance. Narratives of resistance against parental judgments provide a powerful collective cultural system through which youth can draw encouragement and knowledge to deal with potentially devastating family rejection.

While much talk revolves around the physical presentation of birls and the social reactions based on surface looks, many members, in their attempt to define who birls are, stress that appearances are not everything, claiming that no prescribed look constitutes a birl since it has "everything to do with personality." The very question of looking masculine or feminine versus being masculine or feminine is at stake, as members seek to include girls who look girly into the birls community. Defending her place in this forum, a member writes, "for those of you who

don't think I'm a birl, you're under no obligation to click this link. So don't . . . a dress only makes me feel girly for a few moments, anyway." Simple assumptions of gender identity are rejected as more subtle elements of embodied conscious-ness enter discussions. There is an outpouring of support to include girly birls, as members speak out passionately about this girl's right to belong:

> Being a birl has as much to do with your inside as it does with your outside, and I think one of the biggest points of this community is to be who you are. You're an artist, a girlie girl and a birl . . . and I for one love the fact that you share that with all of us. You're awesome and beautiful, so don't let it get to you.

Talking about who belongs to the birl community provides an opportunity for questioning common sense notions of boyish girls, exploring the emotional, mental, physical, and social variability of this subject position. Rather than sim-ply defining birls through a static set of attributes, this community creates coherence through an ability to dialogue, interpret, and personalize meanings.

While gender identity, not sexual preference, is the focus of this commu-nity, many of the discussion threads address birls lusting after girls, desiring other birls, loving queer femmes, or exploring their bisexuality. Desire pervades birl talk. Being lesbian, gay, or bisexual is not a prerequisite of this community, yet much of the friendly banter takes on an erotic charge of queer attractions. Commenting on the sexual allure of birls becomes a daily ritual of birl mem-bers, reinforcing self-confidence and collective bonding. It is remarkable that virtually everyone posting pictures is told that they are "cute," "hot," "sexy," and "adorable." Such affirmation unites this community as a place to find sexual acceptance. Their mutual belonging rests on a mutual appreciation of their appeal as birls. Much of the exchange is light and flirty, filled with playful dia-logues that teasingly suggest possibilities of encounters:

A. I've got some ties you can have . . . for a small fee

B. And what fee would that be, pray tel? ;)

A. Yeah ust umm . . . stop by my house. lol

B. I'll be right over . . .

The birls online community is scattered with imaginary promises of real-life con-nections, many of which are sexually driven. These moments are often brief and ephemeral within the public realm of the community. They are important to sus-taining interest and openness between birls and the girls who love them. It seems that erotic recognition is an ongoing dynamic of community involvement, acting in performative ways to create a shared sense of their desirability as birls.

Beyond the enactment of sexual flirtations and seductions online, this community asks questions, shares frustrations and pleasures, and tells stories about sexual relations occurring in members' real-life experiences. A recurring theme is the problem of lusting after and dating straight girls. A member of the birls community writes:

I am hopelessly in love with a straight girl

completely head over heels

I love everything about her

except when she talks about boys

and how they hurt her

Birls express how risky it is to pursue straight girls who use them to try something new and experiment with their sexual identities. It is in relation to straight girls that members talk about wanting to be boys: "I wish I was born a guy, everything would be simpler." Positioning straight girls as deeply desirable, they are also represented as elusive and deceptive; they provoke vulnerability, fear, and anger amongst this community. This ambivalence creates a division between birls and straight girls. In the process, these youth reinforce boundaries marking those inside/outside the birl community. Sympathizing and relating to the dilemmas of desiring straight girls become a common means of bonding as birls. While not all birls are interested in straight girls, this experience signifies more general difficulties of being a boyish girl in a society that favors bio boys or feminine girls. In a disturbing way, straight girls mark the other to this community, sometimes longed for and sometimes loathed as reminders of gender normalizing powers.

This online community of birls is complex and shifting in the ways it marks its boundaries, identities, and interests. It builds its collective momentum through the affirmation of the physical, social, and personal qualities of boyish girls, which are left open to continual performances, representations, and interpretations. As a symbolic space of community interaction and belonging, these youth express joy and a sense of belonging in their masculine differences as girls. What is at stake is a sharing of experiential stories and visual images that become the basis of a virtual interconnectivity and empathy. In this way, the content of most community discussion is grounded in the material worlds of these youth. Individual fragments of this material get taken up, reworked, questioned, exchanged, and mediated within an online sphere to become the basis of a collective discourse. Crossing between real and virtual is the crux of

the birl forum, leading some to fantasize about their coming together: "I want a big abandoned house right off the beach, filled with birls." "Well you know what kid, birls stick together dammit!!" Some birls dream of actualizing this community in time and space. While this may be impossible, this imaginary projection of community is empowering in the ways it compels these youth to envision gender alternatives. Such imaginative work is potentially transformative according to Renninger and Shumar, who write that "the fluidity of boundaries and flexibility of how community is defined make it possible for participants to enact forms of community in the virtual world and extend the definition of community as a function of social imagination" (9). These youth are continually learning how to construct a community based on an acceptance of differences. In the process, they come up against the challenges of sustaining an inclusive environment. This is cautiously commented on by a birl who gets right to the tenuous heart of the matter: "I think once we start excluding people, that will be our downfall."

Virtually Real-Life Communities: Textually Embodied Queer Youth Experiences

In emerging online communities, queer youth are active makers and facilitators of provisional and fluid spaces of dialogue, sharing specific experiences from their life worlds and creating imagined social worlds. Queer youth cyber-communities challenge simplistic divisions between the virtual and the real, the imaginary and the physical, the textual and the embodied, and the experiential and the fictional. They provide insights into the in-between spaces where youth work out the unique contours of their sexualities and genders as they perform their identifications and desires in words and images told to others. It is online that young people find ways to safely and creatively explore their queer differences as lesbian and bisexual girls, transyouth, genderqueers, and birls. Reaching beyond binary sex/gender systems, the youth quoted throughout this chapter are at the forefront of elaborating virtual community forms and practices that transform the public voices of youth today. These voices have made me question my own fixation on queer "girl" cultures, calling for more nuanced ways of naming their identities. Putting their bodies, fantasies, and experiences on the line, queer youth refuse to tame or censor themselves in fear of adult predators or moral panic. Desire becomes a language negotiated and owned by

these youth, turned towards the detailed dilemmas they face day by day. In this way, the erotic lives of youth are explored by, for, about, and towards those who are also willing to talk about sex as young people resisting heteronormativity. At the same time, intimate acts of care are exchanged back and forth within informal public spheres, inviting a relaxed flow of chat, gossip, jokes, and flirtation. Integrating intersubjective bonds of emotional care, pleasurable connections, and politicized talk of oppression and exclusion, youth are in the process of devising flexible and multidimensional collective spaces shaped according to the whims and needs of queer youth themselves.

· 7 ·

"YOUR MUSIC CHANGED MY LIFE. I NEEDED SOMETHING QUEER"[1]

Musical Passion, Politics, and Communities

> Kiss your fashion goodbye
> We're for queer youth
> We're "go union."
> We are pro-choice.
> We are not scared by you.
>
> The Butchies, "More Rock, More Talk"

I think music does offer a lot more queer diversity for youth. There is a greater range of queer artists playing music now who seem to not be as afraid about talking about being queer. They're more up-front about it and you can seek out different kinds of queer artists whether you're into more quiet folk artists or into punk queer bands or into rock, not just having to go to a gay bar and listening to the mainstream music they're playing there. I think that queer youth are becoming more interested in finding queer musicians who they associate with the way that they feel.

Kelly, age 23

The lyrics to the Butchies' song "More Rock, More Talk" directly challenge commodified forms of fashion and popular music, articulating young political queer feminist ideas that spur fans to become creative and critical participants.

Queer girls quote and talk about the Butchies with a passionate recognition of the power of music to inspire them and mediate their desires, instigating expansive personal and political connections. Groups such as the Butchies are part of a growing field of music attracting the attention of young people interested in queer alternative musical texts, performances, and spaces.[2] This music provides a socio-symbolic realm in which questioning and countering normative ideals and authorities become integral to the pleasures and excitements of youth cultural engagement. In the quote above, Kelly insists that, unlike more circumscribed media forms, music provides possibilities for queer inclusivity and diversity, referring not only to a range of artists and styles but also to how musicians are "talking about being queer." When asked to reflect on their musical interests, fans provide detailed insights into the specific ways listening to lesbian, bisexual, and transgender artists influences their everyday worlds. Music becomes a vital tool in shaping queer youth self-perceptions, imaginative longings, and political commitments. Girls not only reference and discuss music with explicitly queer messages, they also offer interpretations of visual, verbal, and sonorous languages exceeding heteronormative codes, used as part of their ongoing identity work. Personalized engagements with queer music incite awareness and resistance, while also helping girls to feel comfortable, connected, and in tune with others.

In previous chapters, I focused my interpretations on close readings of a few exemplary media texts. In this final chapter, I purposefully expand my approach to consider a much broader and interactive terrain of cultural practices. Rather than merely celebrate a few isolated songs or singers, I listen as girls speak about music in prolific and libratory ways. Perhaps more than any other area of popular media culture, music defies narrow textual analysis, entering into the experiential narrations and collective representations of youth. Queer girls talk avidly about being part of musical scenes, of becoming transformed in their social lives through the musical worlds they inhabit. Not only is music complex at social and semiotic levels of appreciation, combining visual, kinetic, verbal, and nonverbal modes of signification, it is also highly accessible and flexible, unbound by centralized modes of production, distribution, and reception. As a cultural realm to which youth feel aligned as makers, players, interpreters, listeners, and disseminators, they are able to position themselves more fully as knowers and doers. Music is also regarded by youth as a cultural tool that exceeds hierarchical institutional powers of regulation and formalization. Because of these tendencies, marginalized youth are interested in music as a subversive medium, using it in their daily routines to challenge dominant media,

transgress cultural boundaries, and create grassroots do-it-yourself projects. In this way, queer girls have been able to forge alternative musical discourses, reworking media technologies and ideologies in new directions. It is precisely this process of innovative and participatory engagement that I want to explore in this chapter, turning attention onto subjectively and collectively nuanced aspects of queer girl music by using a broad array of media and interview texts. Analyzing the political edges of queer girl music along with intimate accounts of emotional healing and belonging, I emphasize processes through which queer girls engage with music as an empowering dialogical activity.

Queer Girl Musical Dialogues

Its kinda like a chain reaction. . . . I started listening to Tori Amos and then I met a friend who was totally obsessed with Tori Amos and she said you should listen to Ani DiFranco so I listened and from there it was like "I got to find more girls who like playing guitar," and from there I listened to Tegan and Sara and I just started talking to more and more girls.

Lorissa, age 20

Queer girls privilege music as an accessible, flexible, and socially dynamic cultural practice.[3] Jenna tells me that "I think music is one of the easier parts of queer culture to get access to; especially when I was living with my parents, for instance, I usually didn't feel free to rent a lesbian movie, but I could go to the library and rent Le Tigre's *Feminist Sweepstakes* album." Music, unlike television, magazines, and film, is not as tightly bound to centralized corporate industries, allowing for smaller and more diverse distribution networks and performance venues. With increasing access to music through circuits of digital file sharing and online message boards, girls are able to download music from the Internet, exchange recordings, and pass on information about new songs and band tours. Music becomes a focal point of online exchanges between female queer youth. A great deal of Web content and group discussion by these girls involves the circulation of information and commentary about alternative music. Although communication technologies contribute to popular knowledge and access, word of mouth is also a key mode of information gathering in the daily conversation of queer youth. As Lorissa claims, talking to other girls about music is like a "chain reaction" that propels the desire to talk to even more girls, learn more, and pursue knowledge by seeking out other fans with whom to converse. Similarly, girls talk about the power of live performances to bring fans together as active participants listening, singing along, and dancing together. The status

of popular music culture is recast to consider a broad range of cultural texts, acts, events, and practices. Twenty-two-year-old Alice says "it's an interactive experience, three dimensional instead of two. When I'm watching the L Word, sure it's hot, but when I'm dancing my ass off at a concert I feel like I'm contributing to queer culture. I don't feel like I'm contributing when I'm sitting at home watching two girls fuck on the L Word." A profoundly embodied sense of interaction through music is conveyed by girls who crave engagements beyond the consumption of manufactured entertainment images. This dialogical mobility and urgency enables girls to more easily join in as fans and musicians, blurring the line between cultural production and consumption.

Many girls interviewed stressed how music infuses their lives. Eighteen-year-old Joy tells me, "a day does not pass when I don't listen to queer girl artists. . . . I listen to music almost all day long . . . I am never without my ipod!" Music becomes a pervasive presence in their everyday lives from home to school to work to nightclubs to cyberspace, it crisscrosses private and public spheres of experience, traveling with marginalized young people across multiple physical and imaginary spaces. This temporal and spatial flow marks a unique quality of musical enjoyment. Being able to have access to queer music through online musical dialogues, friendship networks, and live events helps queer youth to counter the heteronormative ethos of their social environments. Music's ability to cross boundaries, to be a potential source of personal pleasure and subversion, even in the most restrictive and hostile of locations, is especially useful for fostering counter-public queer cultures that validate and nurture youth. Not only does music provide an embodied and interactive medium, it is also open-ended and ambiguous, generating complex expressions of queer identity and politics. Echoing the sentiments of many girls interviewed for this chapter, twenty-one-year-old Randy argues that "music is more queer in a less popular way," which, for her, means that, rather than catering to a generalized mass audience, queer girl music is more finely tuned to tastes and sensibilities. Girls crave bold looks and words as they seek out music capable of addressing their emotional, bodily, and social nonconformity. Appreciating the refusal of queer girl musicians to mold their images around corporate ideals of feminine sexualized sameness, fans map out an expansive field of artists and texts shaping their queer sensibilities and communities. Not only are most queer music artists located outside corporate music industries, produced and distributed by smaller artist owned and operated companies, but they are also appreciated by youth for their ability to foster creative integrity and autonomy. Girls focus in on political ways of describing and referencing queer female artists who seventeen-year-old Celina says "write about gender identity, embracing bodies,

embracing races, cultures, lifestyles, women's rights, gay rights, abortion rights. Queer artists tend to be more political." Even those artists who have relatively broad popular appeal, such as Le Tigre, are respected by youth for the ways they integrate conscious messages with fun and danceable tunes, bridging audiences without compromising their creative differences for the sake of marketability. Katie is thrilled with the ways contemporary musicians communicate critical ideas without forgoing playful styles of entertainment. She embraces

> A mixture of political awareness, queer sensibility, sexiness and fun. Sometimes this
> is best found in the subversion of mainstream pop culture, but I think it can be built
> by individuals too, and I would say that Le Tigre is an example of this: Kathleen
> Hanna's later project is more lighthearted and better suited to a soundtrack of a fun
> evening out than an angry stomp around, and in my opinion that's definitely a good
> thing.

Le Tigre.

While loose and quirky descriptions are commonly used to affirm queer bands, unifying qualities are much harder to pin down and conceptualize. Distinguishing, locating, and naming queer girl musicians and genres is a difficult process that raises interesting questions as to whether it makes sense to lump diverse musical styles together under a single "queer" rubric. Twenty-two-year-old Lucinda claims that there are vast differences between what she calls the "crunchy lesbian" style of Ani DiFranco and the riot grrrl punk-influenced music of a band such as the Gossip. At the same time that Lucinda stakes out differences, she questions the relevance and certainty of such boundary marking. For many girls, clear divisions and categories are impossible to formulate, and they prefer to list queer artists in heterogeneous ways, jumping between folkie singers Tegan and Sara, diasporic Asian electro artist MIA, raunchy pop star Peaches, soul-inspired Meshell Ndegeocello, transgender rapper Catastrophe, heavy metal black feminist vibes of Skin in Skunk Anansie, queer hip hop innovations of Deep Dickollective, upbeat party mixes of Lesbians on Ecstasy, and the hardcore sounds of Tribe 8. Defying containment within single genres, girls select and talk about queer girl music in hybrid combinations. While this chapter focuses on musical influences that directly address same-sex desires and gender variance, many girls are also attuned to the queer dimensions of music by "straight" artists, defying the very notion of a separate queer musical scene. Several youth spoke about queer positive dimensions within mainstream music publicity, pointing to hip hop artist Kanye West's recent statement on MTV denouncing gay bashing and homophobia.[4] Youth take such opportunities to establish connections with a broader terrain of musical artists and texts, going beyond a narrow discussion of queer music per se to trouble divisions between straight/queer realms. As a researcher, I am astonished by the breadth of the music and media examples girls draw upon to articulate queer readings. I am also very aware of how important it is not to make broad assumptions about the musical tastes of queer girls as a group. Twenty-three-year-old Winnie insists that "just because the music is queer doesn't mean that I'll listen to it. I like music and artists because of the sound, lyrics and beat . . . not because it is written/performed by a queer person." Such qualifications are important reminders that, although rich connections are being forged between queer girls and music, the lines between them are not reducible to simplistic assumptions of identity.

In this sense there is not a single field comprising queer music, but many scattered sites where young people forge multiple investments. Gayatri Gopinath refers to a concept of "queer audiotopias"[5] (58) which helps to

elucidate desiring subjective engagements within transnational movements that exceed corporate commodification, offering a useful way of thinking through localized yet mobile negotiations of musical meaning and enjoyment within global systems of commercial exchange and dissemination. I began research on this chapter thinking that I would be able to hone in on a specific musical subculture, such as *queercore* (sometimes referred to as *homocore* or *dykecore*), as a center around which to analyze queer girls' musical investments. What I discovered was that, while there is definite interest in exploring independent music scenes, interest and participation are less focused on any single subcultural identification than on eclectic modes of selection and reception across stylistic and social boundaries. Very few girls that I interviewed had heard of *queercore* and most were not very interested in limiting themselves to any particular "core." Queer girl music troubles insular notions of subculture while also providing a basis for an eclectic cultural commonality through songs, artists, and social scenes. Engaging with a broad range of musical genres, including pop, folk, electro, hip hop, world music, rock, and punk, girls articulate queer elements in the visuals, rhythms, performances, and words of diverse individual artists and groups. While some girls are sharply focused on a favorite artist or style, I also interviewed many whose interests and curiosity spread out over a wide terrain of musical styles. Expressing delight with various forms of music, Kelly exclaims,

> I LOVE dykey grrl music like: the Butchies, Tegan & Sara, Ani DiFranco, Placebo, Le Tigre, Kaia, Melissa Ferrick, Sleater-Kinney, Cadallaca, Hole, Alix Olson, Chicks on Speed, Anika Moa, Mirah, the Be Good Tanyas, Sarah Dougher, Peaches, Bikini Kill, the Gossip, Veruca Salt, The Need, Neko Case, Bitch and Animal, Sini Anderson, Missy Higgins, Peaches, Team Dresch, the Murmurs, Juliana Hatfield and Tori Amos. What appeals me to them is their sound and their lyrics. As well as things they get involved in i.e. politics etc.

Given this diverse list of artists, it becomes almost impossible to neatly categorize the kinds of music Kelly regards as indicative of "dykey girl music."

The examples scattered throughout this chapter reveal a breadth of texts and artists that is striking, indicating an era in which female youth have increasing access to heterogeneous music by, for, and about young women crisscrossing commercialized and independent and local and global markets. Fans provide lists and commentaries about artists that complicate the construction of a generic or subcultural type of music, and so it seems much more productive to follow the fluid ways in which queer girls talk about and use a

range of musical forms and examples rather than try to examine a single case. Interested in alternative artists and scenes, marked out as unique yet not antithetical to "straight" pop, hip hop, electronic and rock genres, the engagements of queer girls are not fixated on mutually exclusive classifications. What is also intriguing are musical references that span more than two decades of women's music, crisscrossing generational lines as well as genres and degrees of commercial success. Such tendencies defy stable classifications, displacing corporatized branding and global marketing strategies targeting and constituting girl consumer tastes. Decentralized investments in local grassroots and independent music coincide with reappropriations of mainstream music media that foreground contradictions of commodification. Combining underground and hyperpublicized examples, the sounds, spaces and archives of queer youth music are complex and dispersed, calling attention to prolific and fleeting modes of music production and appreciation by girls often invisible within dominant narratives.

Yet even instances of more centralized and industry-manufactured lesbian girl pop creations, such as t.A.T.u.,[6] evoke complex responses from teens grappling with surface images to articulate their own subjectivities. While many girls dismissed t.A.T.u. as evidence of a commercially driven inauthentic mass media product, sixteen-year-old Julianna talks about first seeing t.A.T.u. on television,

> I was mesmerized and stunned. I thought people would hate them, I thought only queer girls would listen to that and I didn't want people to know I was lesbian, so I didn't buy their CD. It took me a while to understand that their images didn't really matter to other people, if they liked the songs, they'd still buy the damn CD! So I did. And I didn't regret it at all, even though I felt a little embarrassed. I thought everyone would know I was queer because of that.

Julianna's response to t.A.T.u. grapples with tensions evoked by manufactured images of girl-on-girl desire, her uneasy longings to listen to this band, and her expectations of homophobic backlash. Julianna is both mesmerized by representations of lesbian desire and terrified at the thought of being publicly identified as queer. The memory of her engagement goes beyond simplistic mass-marketing effects of passive consumption, unfolding an ambivalent process of coming to terms with liking music while feeling shame and fear. The vulnerability of Julianna's response is suggestive of emotional hesitation and excitement at the prospect of showing interest in queer music. While many girls quoted in this chapter are more assertive and savvy in their affirmations and interpretations of queer music by so-called real, alternative queer musicians, Julianna's emotional negotiations with the queerness of mainstream pop provide a vivid reminder that the stakes and status of queer authenticity are not clear cut or guaranteed.

Coming to music at different ages, from diverse contexts, and through specific experiences, queer girls engage reflexively with a multiplicity of styles, gesturing alternately towards mass-marketed images, polemical messages, confrontational expressions of genderqueerness, lusty displays of same-sex desire, and sentimental love songs. While there is no defining quality linking texts, artists, and fans, many girls acknowledge that what signifies queer music is a willingness to grapple with issues and feelings relevant to young queer women. Of course, what counts as relevant is variable and undecided. Seventeen-year-old Katie claims that "queer music can be particularly interesting in addressing subjects which are underexplored in music or in the media—for example 'Viz' by Le Tigre takes butch visibility as its subject. Other artists—Ani DiFranco in particular—are talented at expressing some of the emotions experienced particularly by queer women." Many girls speak about the value of music attuned to their specific predicaments of social marginalization that voices defiance and queer affirmation. It is precisely because their experiences are contingent upon material circumstances, relations, and representations that queer musical discourses are best thought of in terms of an assemblage[7] of embodied and textual practices. Amongst queer girls, there is no consensus about what constitutes *queer girl music*. Loose clusters of performers, songs, styles, attitudes, communities, and events emerge as meaningful sites around which girls engage with music. Yet it is important to acknowledge that the emergence of such a field of music openly articulated by, for, and about queer female youth is a relatively recent occurrence propelled by globalized media and localized community formations. While it is tempting to pin down a subcultural type of music, give it a catchy name, and impose definitions, it is much more useful to follow dynamic assemblages as an expansive process through which girls engage with music cultures. What seems important to these youth is an ability to connect to music that fosters expressions of queer desires beyond the limitations of formulaic and centralized media. Queer girl music is a loose constellation of cultural texts and practices, offering creative possibilities for dialogues without forgoing differences.

Heterogendering Girls in Music Subcultures and Music Studies

Youth research has demonstrated that music is one of the most powerful cultural forces through which young people express emotions, shape their identities, and generate ties with others. Twenty-year-old Dana writes that "music is a big part

of my life. In fact, I would say that music is my life. . . . I think it has had quite a big impact on my youth identity. It might sound really superficial to say this, but somehow it seems like you are what you listen to." Engaging with music written and performed by queer female artists with an intense sense of personal knowledge and emotional investment, Dana suggests that music exceeds attempts to neatly reduce this area of youth culture to a narrow set of textual meanings, genres, and media effects. Unlike the more contained uses and effects of other forms of mass media, music is regarded as spatially and temporally pervasive within the lives of youth across public and private spaces, shifting back and forth between social terrains from bedrooms to street life to dance clubs and live performances. Researching the impact of music on teens, Christenson and Roberts write that

> music alters and intensifies their moods, furnishes much of their slang, dominates their conversations, and provides the ambiance at their social gatherings. Music styles inflect the crowds and cliques they run in. Music personalities provide models for how they act and dress. Given the pivotal role of music in adolescent life, it seems obvious that oversimplified, formulaic thinking about it will not do. (8)

Accordingly, music plays an intensely important role in the lives of adolescents, calling for complex interdisciplinary methods of analysis. But while Christenson and Roberts gesture towards the layered emotional and social stakes of music, their research universalizes its effects. Who exactly "they" are is often taken for granted or implies a generalized male teen subject as a representative norm of research. Research on youth and music tends to either overlook gender and sexual specificity or else focus rigidly on oppositional distinctions between boys and girls.

Sociological analysis of girls and rock has tended to work within essentializing frameworks of gender and sexuality, such that girls are positioned as domestic consumers rather than culturally productive subjects. Simon Frith writes in his book *Sound Effects* that boys are more interested in the quality of sounds along with the performative aspects of rock, whereas girls are focused on words and images. He claims that

> it is boys who are interested in rock music, want to be musicians, technicians, experts . . . form the core of the rock audience, become rock critics and collectors (girl rock fanatics become, by contrast, photographers). The rock 'n' roll discourse constructs its listeners in sexually differentiated terms—boys as public performers, girls as private consumers. (228)

According to Frith, differentiation occurs not only in terms of the process of reception but also in terms of genre, connecting boys to the edgy rebellions of

"hard rock" and girls to soft "teeny-bopper" ballads. The gendered divisions reproduced within Frith's study emphasize the phallic sexual dimension of rock, arguing that " 'hard rock' is a masturbatory celebration of penis power: girls are structurally excluded from this rock experience" (227). While Frith's study was written in the early 1980s during the preliminary stages of youth music studies, it points to a pervasive problem of inscribing gender differences within empirical research in ways that leave little room to listen to the resistant voices of girls or to deconstruct gendered forms of participation and appreciation. Responding to the sexist orientation of research on subcultures, feminist youth culture approaches have often reified gender parameters in their attempts to promote female alternatives. Although girls' musical tastes become the focus of feminist analysis, conceptual frameworks remain structured in binary gender terms. Angela McRobbie responds by acknowledging masculinist assumptions structuring subcultural discourses and turning attention onto specific girl subcultural practices. At the same time, she leaves little room to consider girls who defy heterosexual expectations and feminine norms, excluding consideration of those girls who take up masculinity as a site of identification. In McRobbie's words, "the possibility of escaping oppressive aspects of adolescent heterosexuality in youth culture . . . remains more or less unavailable to girls" (*Feminism and Youth Culture: From 'Jackie' to "Just Seventeen'* 36). In this way, it becomes impossible to consider queer youth subcultural participation. Fixated on narrowly gendered subcultural relations, youth research tends to lose touch with specificity, variability, and instability.[8]

While there are very few studies focused on queer youth musical cultures, feminist researchers have turned attention onto women's music and lesbian subcultures, approaching relations between young women and music with a more critical understanding of the gendered and sexualized parameters of the popular music industries, artists, and fandoms. Mavis Bayton stresses the normative reproduction of gendered subjects in her book *Frock Rock*, writing that "young women and men learn how to be feminine, masculine, and heterosexual through listening to rock music, and observing the clothes, bodily gestures, and general performance of rock musicians as they simultaneously perform gender, sexuality and music" (1). In a similar vein to other feminist studies on women and music, initial emphasis is placed on the male-dominated institutions of popular music through which girls and women are marginalized and trivialized in their musical talents and judgments. Even though Bayton does examine the conditions under which female music cultures develop, her book stresses the exclusionary and hierarchical structures of mainstream music along with their

gendered ideological effects. Women's musical movements are situated in relation to the phallocentric norms of men in rock. In this way, discussions of women's rock tend to reproduce assumptions about rock as a conventionally masculine preserve that ends up ghettoizing women's talents and tastes. Women's differences stand out as exceptions to the systematic dominance of male-produced popular music. Not only does this end up reifying sexual differences between men and women as the primary focus of analysis, but it offers little attention to racial and class tensions and divisions within homogenous categorizations of women's music. More recently, ethnographic research on female fan communities has opened up spaces to consider specific and diverse feminist contours of music production and consumption. Ann Savage writes, "I wanted to talk with women who listened to artists who challenge gender roles and seek equality, justice and choice for women—artists that are critical of women's subordination and dedicated to political and/or feminist issues" (14). Paying close attention to the ideas, feelings, and inspirations generated by women's music, Savage listens carefully to young feminist responses. There is no doubt that analysis of feminist potentials within women's music has worked to overcome tendencies to center on male-dominated traditions, shifting focus onto adult women's cultural production and reception.[9] This body of work tends to emphasize adult creativity and consumption. Those feminist accounts focusing on folk music situate "womyn's" musical content and festivals in relation to second-wave feminist movements and lesbian feminist cultures, making it difficult to consider more contemporary female youth music. These texts exploring the transformative power of women's music at the level of grassroots production, distribution, marketing, and consumption call attention to non-commercial, politicized, and separatist elements against the sway of patriarchal and heterosexist popular musical trends. Whereas lesbian feminist approaches tend to unify the category of women, the emergence of third-wave feminist discourses has expanded the terms and frameworks through which to talk about women's music based on class, racial, and ethnic histories. Such accounts have also thrown into question sharp divisions between commercial and non-commercial, heterosexual and lesbian forms of music.[10]

Third-wave feminist approaches represent music as integral to the cultural and political expressions of girls.[11] Critics have begun to hone in on intersectional social relations conditioning music creation and appreciation. Yet, even here, very few links between the legacies of popular women's music and contemporary female youth cultures have been explicitly discussed.[12] This failure to build connections between earlier generations of women's music and girl

cultures creates a gap in the literature, overlooking changing yet continuous feminist and queer possibilities across various musical cultures. Not only does this obscure the influence of second-wave feminist music on youth cultures today, but it also makes it difficult to consider a diversity of musical styles through which queer articulations of desire and identification have come to shape women's music. Refusing to separate youth and adult music cultures, Gwendolyn D. Pough challenges universalizing white centered feminist approaches in her book *Check It While I Wreck It*, paying close attention to intergenerational contours of young black female hip hop culture. Weaving the cultural productions and receptions of women into an expansive fabric of musical, literary, dance, cinematic, poetic and performance hip hop texts, Pough defies dichotomous formulations that plague women and rock discourses. She elaborates subtle rhetorical actions that "bring wreck—that is, moments when black women's discourses disrupt dominant masculine discourses, break into the public sphere, and in some way impact or influence the U.S. imaginary, even if that influence is fleeting"(76). Calling attention to rhetorical gestures through which inspiration and change is constituted for female youth of the hip hop generation, Pough focuses on living embodied speech acts and performative strategies through which music generates socially relevant meanings. Resistance becomes a dynamic practice that seeks to "bring wreck" to hierarchical systems denigrating black women's embodied voices. Pough provides cross-historical, cross-generational and cross-gender analysis of the political significance of hip hop culture in the lives of young women without reifying identities.

While Pough does not say much about queer hop hop artists,[13] she does explore the heteronormative limitations within hip hop texts and communities without foreclosing messages that contradict them. Several youth I interviewed focused on their ambivalence toward hip hop, valuing representations of defiant and creative women artists who actively challenge racist and sexist ideologies and foster affirmative relations between women. At the same time, they speak about wanting more explicit representations of queer desire. Eighteen year old Iris animates her interest in hip hop as one of the few mass media realms in which she feels included as a black girl to participate in dialogues that address her interests and experiences. Iris says that "hip hop is a way of life that I struggle with and can't live without, even though I get tired when girls sing on and on about their boyfriends. I take so much from the images, beats and lyrics, it is not simple." She talks about reading in nuanced ways, picking up on queer possibilites within music by artists such as Queen Latifah, MC Lyte and Missy Elliot, deriving pleasures that go beyond dominant media messages. In this way queer

girls engage with hip hop music dynamically, tapping into their own experiences to flesh out what they feel is missing as well as what they long for.

Pough critically expands the parameters of black feminist thinking about young women and hip hop cultures through complex intersections of identity, opening up spaces to consider queer readings that "bring wreck" to heterosexist ideals. For the most part, hip hop is marginalized within third wave feminist discussions of queer girl music, turning almost exclusively to punk rock riot grrrl formations in the early 1990s. While there are many limitations to exclusionary feminist accounts of riot grrrl at the expense of other cultural movements, I will argue that in the imaginations of many queer girls, riot grrrl becomes a diffuse symbolic marker of politicized do-it-yourself feminist ethos beyond the contents of any single music genre. It is notable that riot grrrl scholarship was the first to focus attention on the power of female youth musical subcultures challenging stereotypical notions of femininity and assumptions about girls as victims of commodification. In the words of Joanne Gottlieb and Gayle Wald, "by organizing around a certain musical style, riot grrrls seek to forge networks and communities of support to reject the forms of middle-class white, youth culture they have inherited, and to break out of the patriarchal limitation on women's behavior, their access (to the street, to their own bodies, to rock music), and their everyday pleasures" (252). Suggesting a "movement-at-large," riot grrrl extends beyond musical spheres into broader cultural and political forms of participation. As a movement connecting community-based activism, education, and a do-it-yourself ethos of cultural production, including zine publishing, video art, spoken word, activism, sex education, and self-defense, along with girl bands and community-based music events, riot grrrls came to represent innovative development highlighting female youth cultures. Emerging as a unique form of girl-centered political culture, the popular press exploited rebellious images of angry and aggressive female youth, constructing spectacles that trivialized girl bands. Similarly, academic treatments of riot grrrl have tended to focus on the marginal yet groundbreaking status of punk feminist music, reiterating separations between normalized commercial girl music and fringe musical genres. Mavis Bayton addresses some of the more radical edges of women in punk and riot grrrl musical subcultures, yet their cultural significance is diminished by limiting it to a single musical style and a handful of bands that seem relatively insignificant and reactionary when situated in relation to mainstream popular music. Theorized as an underground punk subculture, riot grrrls become sharply distinguished from normalized commercial genres, set apart as a music scene in isolation from broader political and countercultural elements.

Mary Celeste Kearney provides a comprehensive analysis of the ways riot grrrls are misrepresented in media and academic discourses. Kearney reveals not only how riot grrrls become exoticized as young sexy "punkettes," commodifying their surface appearances, but also how they are repeatedly heteronormalized as straight girls. Riot grrrls become framed in terms of female punk rockers at the expense of more layered accounts of queer elements. Kearney writes that "in spite of the coterminous emergence in the US of riot grrrl and queercore bands like Tribe 8, Random Violet, The Mudwimmin and Team Dresch, there have been relatively few links made by the mainstream press between lesbian feminism, queercore and riotgrrl" ("The Missing Link" 222). She goes on to assert that the there has been a systemic attempt to silence and deny desires between girls, claiming that

> While "girl love" is advocated continuously in riot grrrl music, zines, videos and draw- ing, its more obvious meaning—lesbianism—has been downplayed, if not outright ignored, in mainstream accounts of this all-girl community. In an attempt to situate riot grrrls within the larger narrative of homosocial girl cultures, some journalists contextualize the riot grrrl notion of "girl love" as a form of childish play rather than adult sexuality. (223)

Kearney elaborates important ideas about the ways in which "women in rock" becomes a catch-all phrase that privileges hegemonic gender ideals and erases those historical movements of women in music that disrupt neat binary and sex- ual divisions. More specifically, rich and diverse queer women's musical cultures are pushed out of view of dominant historical and popular accounts. Heteronormalizing subcultural movements, such as riot grrrl, results in a reduc- tive understanding of the artistic and political content and practices of female youth cultures and obscures the ways in which queer girls actively participate in and transform contemporary musical cultures.

Queer Girl Subcultures

> This scene is about reaching out to kids who see nothing of themselves in the world when they look in magazines or listen to records. They're invisible, because no one tells them you're allowed to be gay. . . . We need to build communities where kids can come out into something positive and say "Wow, life isn't so bad. I don't have to hate myself. I can do it. I can be gay and be myself."
>
> Jody Bleyle from Team Dresch,
> quoted in Ciminelli and Knox, Homocore (53)

> Pushing the envelope and being on edge is really just a part of the entire musical scene, that can make it easier for queer girl bands than, say, a movie that's been made and is about lesbians. . . . i definitely am more aware of queer girl bands & music than movies. . . . i know of way more queer girl musicians than actors/directors etc . . . way more. so i suppose that says something.

<div align="right">Lyn, age 21</div>

Although media and academic accounts have glossed over productive cultural and community formations that comprise riot grrrl, it is remarkable how queer teen girls (born around the time when the movement was initiated) remain inspired by its music and political ideals. Sixteen-year-old Annie exclaims, "I am a riot grrrl because every day I fight, striving to make things better in my own unique way." Against the sway of heteronormalizing media constructions of girl bands, this generation actively reclaims queer traces of culture that they use and narrate within their own personal accounts of musical influences. While the substance and meaning of riot grrrl is highly contested amongst youth today, it provides an open set of cultural references and ideas. Contributing to an ongoing articulation of young female queer identities, riot grrrl becomes an interesting place to start to consider the symbolic and embodied ways in which girls engage with and trouble research into music subcultures. Reflecting on her position, sixteen-year-old Tyler asserts, "I would consider myself a riot grrrl. even though i was just a small one when it was first starting, i think a girl from any generation can be a riot grrrl." Tyler expresses an inclusive ethos of affiliation that begins with her own personal sense of belonging. Not only does the legacy of riot grrrl seem to resonate with young women across generations, but I also discovered the global reach of this movement as a signifier of queer girl empowerment. Utilizing word of mouth, zines, live performances, recordings, feminist press, and online groups, riot grrrl has spread beyond the borders of a single era or nation. I interviewed a girl from Singapore who currently designs and runs a Web site centered around her self-described riot grrrl punk band. I also heard from many girls a continuing strong sense of affinity to a riot grrrl movement that exceeds any clear-cut historical origin or meaning. Seventeen-year-old Katie writes,

> I caught on to this movement a long time after it had its heyday, but I still think the music is inspiring and fun. I love the DIY ethos of the movement—the idea that anybody can make music and inspire other people! I think it is important that there should be music for and about more elements of society than simply the dominant one(s), and so it's great that groups who feel their lives and their feelings aren't reflected in mainstream music can enjoy bands like Bikini Kill.

Although riot grrrl is situated in the past, it continues to live on within the cultural memory and curiosity of young queer girls, such as Lily, who says, "I like reading about riot grrrl because it's the closest I can come to being part of it." Riot grrrl has acquired the status of a mythology that girls use to hook into collective musical cultures, and, in this way, it empowers them within their current media engagements while also connecting them with previous generations.

Although queer girls acknowledge coming to this movement a decade after its peak, many continue to refer to the inspirational influence of riot grrrl bands. It is interesting to learn how they live on in the imaginations and cultural lives of queer female youth today. Marion Leonard argues that "the growth of riot girl and the expansion of knowledge about this network can be linked to micro, niche and mass media communications" (244). Youth actively seek out, reproduce, and exchange audio recordings (records, tapes, and CDs), visual paraphernalia (zines, posters, t-shirts, and photographs), and articles about riot grrrl culture, extending its relevance into a new era. Working with scattered cultural objects and discourses, girls harness the symbolic power of the riot grrrl movement in contemporary contexts. There is no doubt that girls borrow from and imaginatively embellish stories and musical styles associated with riot grrrl, attaching themselves to it as an open-ended and adaptable subculture. Yet the very pliable methods of identification adopted by girls to reclaim and recontextualize riot grrrl in a spirit of queer expression and empowerment suggests new ways of thinking about subcultural affiliation. Emphasis is not on a clear-cut ideology or identity binding queer and riot grrrls together but on the political refusal to reify the potentials of girl musical cultures. An unstructured and improvised spirit of riot grrrl captures the interest of queer girls searching for musical scenes that validate girls without pinning down norms and ideals. The looseness with which girls connect themselves to musical styles and scenes becomes even more striking as talk about diverse contemporary queer artists, scenes, and events overlaps in unpredictable ways. Leonard writes that "riot grrrls demonstrated an awareness of, and set a challenge to, the academic practice of locating and defining meaning in subcultures." (249)

Drawing upon the collective and grassroots ethos of riot grrrl movements, this generation builds upon and creates alternative queer youth cultures that defy institutionalization. It becomes almost impossible to single out queer girl musical acts or styles, calling attention to a more broad-based network of texts, events, and concerts that bring together music, spoken word, activism, film making, and performance.[14] In this sense, youth have forged cultural scenes that

work to foster queer belonging while deconstructing normative boundaries of girlhood and girl culture activities. And it is precisely the collectively shared aspects of queer girl music cultures that get talked about over and over again, comprising an instance of what Stanley Fish calls an "interpretive community" formulated around "a point of view or way of organizing experience . . . its assumed distinctions, categories of understanding, and stipulations of relevance and irrelevance were the content of consciousness of community members" (150). While Fish conceptualizes such community in ways that collapse interpreter differences into "community property," thereby unifying them into a single entity, I would argue that queer girls' music subcultures are fractious and porous interpretive communities through which shared ideas and interests are fostered by change and recollection. In other words, what matters is an interpretive process that connects queer girls talking about and enjoying music together. Music provides multifarious connections to queer cultures for many girls who otherwise would not have direct access. Tess tells me,

> Most of the time queer music is one of my only connections to queer culture, because I don't live in a very liberal area. There isn't any real queer community at all here. But if I go online to talk to other queer girls and we all talk about Le Tigre or Tegan and Sara, it gives a sense of connection.

In this case, music becomes a focal point of online communication between girls teaching and supporting each other.

A sense of belonging to something bigger, of being connected to others in musical scenes or movements, is avidly communicated by girls as sources of pleasure and learning. Music provides a framework of collective culture utilized by girls in variable ways depending on access to live and recorded music. In this sense, musical community is pragmatic, stressing information sharing and interpersonal dialogues and going to concerts and dancing. Terms used to describe these connections focus on friendship relations with others that are practical and stimulating. Kelly states,

> I have lots of friends that I have made because of their queer grrrl music tastes. We share CDs, books, information about bands, go to concerts together. With some of these friends it is what we mainly talk about. I have converted other queer friends to great homocore and queercore music as well.

Kelly is one of a few girls that I interviewed who referred to *queercore* as a subcultural term of reference. As Jody Bleyle from Team Dresch states, "Queercore is girl rooted. The bands that started the scene—they were all lesbians. There were almost no guys" (qtd. in Ciminelli and Knox 141). Hooking into this legacy, Kelly talks about her interest in queercore for its edgy

punk-oriented styles. Yet unlike the more insular and exclusive subcultural realms described by du Plessis and Chapman in their article "Queercore: The Distinct Identities of Subculture," girls draw upon and rework their sense of belonging in less certain and more flexible and open terms of participation. Chapman and du Plessis portray queercore as a defensively guarded subcultural entity that involves a radical rejection of mainstream culture, a drawing of sharp borders between us and them, commercial and underground, constructing secret signs decipherable to those with authentic queer status. In this way, "the lines are drawn in a symbolic battle over positions . . . the outside is vituperatively imagined to create an inside, a core" (du Plessis and Chapman 47). Such a sharply demarcated queer subcultural boundary does not seem to resonate with queer girls who are less interested in staking out a separate cultural territory and identity than in exploring multiple sites of investment. In this sense, the very meaning of queer subculture is renegotiated by this generation of girls who come into their queer sense of difference with a more expansive relation to mainstream and alternative cultures.

While specific subcultural scenes are referenced by a few girls, for the most part, the youth with whom I spoke resisted choosing any single label or core style that would summarize their musical identifications. It was common for girls to move between musical scenes and historical influences rather than stake a claim within a delimited subcultural sphere. They make references to folk, riot grrrls, hip hop, rock, electronic and punk, shifting their position in relation to specific eras, genres, and artists and generating a sense of cultural belonging that do not follow a linear narrative or fixate on categories. Such orientations suggest new ways of grasping the subcultural lives of queer girls, which are less bound by conventional divisions separating generations and genders. It is difficult to conceptualize the nuances of queer girl subcultural alignments, in part because so little attention has been paid to them. While cultural theories have called attention to subcultural youth styles as complex formations of identification and social resistance, Judith Halberstam argues that they have reinforced hierarchies in which straight male music cultures centered on punks, mods, rockers, metalheads, ravers, and rappers dominate. "At the bottom of the pyramid of subcultures we find girl fan cultures, house drag cultures, and gay sex cultures. Lesbian subcultures almost never appear at all" (165). Working toward a complex validation of dyke subcultural styles, practices, and histories, Halberstam challenges this hierarchical model by analyzing archival, textual, and performative contours of queer subcultures in close detail. Halberstam develops an interpretive framework in which the very status of queer subcultures is reconsidered.

A key feature of Halberstam's argument focuses on alternative temporal and spatial terms of queer subcultural formation. Refusing oedipal models that frame youth subcultures in terms of rebellious rejections of parental values and norms, Halberstam hones in on generational interconnections, showing how the very divisions between youth and adulthood become blurred, promising futures that defy normative conceptions of growing up. According to Halberstam, queerness represents an alternative process of becoming an adult that counters reproductive teleologies of maturation. Passage from youth to adulthood is no longer scripted in oppositional ways, allowing for more dynamic exchanges between ages and more flexible modes of subcultural participation. Halberstam claims that:

> Queer subcultures illustrate vividly the limits of subcultural theories that omit consideration of sexuality and sexual styles. Queer subcultures cannot only be placed in relation to a parent culture, and they tend to form in relation to place as much as in relation to genre of cultural expression, and ultimately, they oppose not only the hegemony of the dominant culture but also the mainstreaming of gay and lesbian culture. (161)

Using examples of queer female bands to demonstrate this point, Halberstam analyzes the styles and influences of young queer musicians, writing that "the Butchies refuse the model of generational conflict, and build a bridge between their raucous spirit of rebellion and the quieter, acoustic world of women's music from the 1970s and 1980s" (172). This quote resonates with queer girls who talk about their musical alignments and influences, juxtaposing and linking artists dialogically.

Halberstam's theory is not only useful as a means of bridging older and younger generations of queer artists and fans, but it also allows for more contradictory and layered understandings of gender and sexual identifications activated within queer subcultures. Writing about the power of dyke punk bands to elicit ambiguous modes of identification, Halberstam draws attention to the critical value of queer subcultural affiliations:

> By focusing on the realization of tomboy desires or youthful femme aspirations in dyke punk bands and forms of fandom, we can see that preadult, preidentitarian girl roles offer a set of opportunities for theorizing gender, sexuality and race and social rebellion precisely because they occupy the space of the "not-yet," the not fully realized. These girl roles are not absolutely predictive of either heterosexual or lesbian adulthoods; rather, the desires, the play, the anguish they access allow us to theorize other relations to identity. (177)

Approaching queer youth subcultures as indeterminate spaces through which identity and desires interrupt conventional reproductive coming-of-age narratives,

The Butchies.

Halberstam provides an interesting opening for thinking about how queer girls inhabit and engage with independent music scenes. Rather than conceptualizing queer subcultural relations as one of fixity and closure, they become the basis for disruptive desires and volatile subjectivities, through which girls are able to explore differences within and between themselves. Similarly, in the personal narratives of queer girls, insistence upon subcultural belonging that crisscrosses musical genres, generations, and genders is striking, throwing into question the very terms through which subcultures have been conventionally defined. What stands out as unique about queer girl subcultural practices and descriptions is a mobility and heterogeneity that constitutes group affiliations and self transformations. While I have remained at a very general level of discussion up to this point, I turn now to hone in on the ways queer girls express the impact of queer music on their lives.

Desires and Identifications

why is it so lonely
in between a boy and a girl
they're so glued down
in this world

and what it means

i'm trans alla that
gender i'm a bender
bi bye girl There's a slap, on my back

<div align="right">Bitch and Animal, "Boy Girl Wonder"</div>

The first time i heard Bitch & Animal singing about loving a girl, about being heart-broken by a girl, about lesbian sex—all of that stuff—i was so relieved, so captivated. i had no idea that there was anyone else out there feeling what i was feeling . . . let alone singing about it! i became a fan instantly and the band has remained my favorite over all these years. . . . they really helped me come to a level of self-acceptance and liberation of my sexual identity.

<div align="right">Lyn, age 21</div>

Musical subcultures provide queer girls with a sense of belonging to something bigger, yet this is an intimate process of identifications with particular artists and songs that underpins a sense of collectivity. Candidly speaking about the deep personalized influences of music in their lives, the girls I interviewed are very reflexive about the transformative impact of music. Lily insists, "I would not be the same person today if I had listened to different music growing up. My choice in music had a primary role in shaping my identity." Finding queer resonance in embodied styles, gestures, words, and rhythms, girls develop responses through which to affirm and come into queer subjectivities. Music critic Simon Frith writes, "our experience of music . . . is best understood as an experience of this self-in-process" (115). This process is especially poignant for queer youth who have very few public languages through which to convey their sensibilities and experiences. For the girls I interviewed, music plays an ongoing part in signifying queer subjectivity without becoming reducible to something prescribed, fixed, and certain. Such a process of influence is touched on by Carrie, who claims that queer music styles and artists "affect the way i dress and some of the friends i have, i've made through a shared love of bands. I started going out with my last ex because we loved almost exactly the same bands." Carrie reflects on the ways music informs how she dresses, her friendship networks, and her sexual relationships. While there is no way to rationalize the correspondence between music and queer girl selves, they converge as a reciprocal emotional and social connection.

Music unfolds queer possibilities, conveyed in lyrics and also performed at the level of corporeal styles. It is important to stress the combined importance of visuals and voices, looks and words, and images and sounds in the responses of girls to queer artists. At the level of visual appearance, queerness is marked

by playful and contradictory enactments of gender and sexuality. Queer musical artists provide a basis for rethinking the very status of girlhood and femininity rather than consolidating or becoming incorporated within a transparent notion of "girls and pop" or "women and rock." Twenty-year-old Tristan refers to Toronto spoken word artist D'bi Young's piece called "gendah bendah"[15] as resonating with her feelings as a queer youth from the Caribbean who does not fit neatly into heterosexual or lesbian, masculine or feminine ways of defining herself. Young's poem opens with powerfully political word play using patois which takes on dramatic physical expression during her performances:

> Gendah bendah/schooling pretendahs
> Defendah's a di box/trap called man
> Gendah bendah/yah nah guh offend har
> If yah tell har she don't look like a woman
>
> She being me/di queen a androgyny
> A put a hole inna yuh philosophy
> (patriarchy)
>
> gendah bendah (92)

Hearing and seeing D'bi perform "gendah bendah" at a local pride event, Tristan was "blown away by D'bi's in-your-face honesty and humor", which gave her a sense of public connection and solidarity with other youth of color resisting racial and gender normativity, while enabling queer Jamaican visual and verbal languages beyond hegemonic white Anglo cultural signifiers. Clear-cut gender meanings are destabilized in the interchange through which musicians and fans mutually construct their queer differences.

For queer artists and fans, notions of masculinity and femininity are analyzed and reconstituted as an integral part of musical expression. Gina Young, a lead singer in the girl band the Bent, talks about the emergence of her queer subjectivity and music:

> I came into my queerness and my art simultaneously . . . my most early songs and poems were oblique attempts to deal with my emerging sexuality. Like in high school, I was writing queer songs before I even knew I was queer! One of my first, "GI Joe," has a first verse that goes
>
> GI Joe was my hero.
> I never played with Barbie Much.
> I don't know why she didn't like me.
> I always found her kind of butch.
>
> (qtd. in Ciminelli and Knox 119)

Queer girl music is one of the few cultural realms in which young female mas-
culinity is talked about, performed, and valued as a locus of identification.[16] The
very process of growing up with tomboy identifications becomes inscribed
within music as reflexive subject matter to remember and share feelings about
growing up as a girl connected to boy cultures and icons.

Butch and transgender artists open up a range of figures queer youth talk
about in the quest for gender flexibility. There is a great deal of interest in the
ways artists embody genderqueerness "just being themselves in public," show-
ing other youth the very ordinariness of living and being accepted as out
transpeople. In contrast to media spectacles that other those marked as dif-
ferent, youth appreciate the ways in which queer music artists show that "it's
no big deal." In this sense, there is emphasis on the creation of cultural spaces
in which gender differences are normalized, not made into special issues.
Twenty-year-old Lorissa affirms representations of transgender lives, referring
to JD Samson from the band Le Tigre, who represents himself in ways such that
"there's no beating around the bush. If they are going to identify and be
known as queer then they are doing something different because they are not
trying to appeal to everyone. They have a lot more things to say politically,
much more about the minority." In this way, girls appreciate cavalier and
unapologetic queer embodiments; they passionately admire the ways these
artists refuse to conform and tame their queerness. While affirming minority
status is important to girl fans, queer musicians are also valued for the ways in
which they provide a passage between subcultural and mainstream visibility.
In twenty-one-year-old Lyn's words, "I remember seeing a music video by Le
Tigre, and thinking 'holy shit, i bet that's the first time an openly trans per-
son has ever been on muchmusic!'[17] and that just thrills me. diversifying gen-
der, blending & challenging roles . . . that is a big part of what queer girl
musicians do. and we need them to keep doing it." The thrill for Lyn is the
entrance of queer artists into commercially "straight" venues such as
MuchMusic. Excitement is generated when artists cross over, disrupting the
boundaries between majority and minority cultures, de-centering binary gen-
der and sexual representations within dominant media circuits. Although
queer youth are wary of commercial appropriation and are shrewdly attuned
to how the music industry regulates gender and sexuality, they appreciate
transgressive moments through which queer artists represent themselves with-
in mass media cultural spheres.

Gender is considered a site of reflexive embodiment and resistance in
queer girl music. Lyrics become a discursive locus of struggle, reiterations of

a politics of visibility. Quoting Le Tigre's song "Viz," youth call attention to an interplay between what is seen and what is lived, wary of the commercialization of gender diversity as something momentarily hip and exotic that works to obscure systemic erasures of those who live queer lives:

I find another butch, hat cocked,
and we—We put our hands, in the crowd

and over and over we jump up and down.

They call it climbing and we call it visibility,
They call it coolness and we call it visibility,
They call it way too rowdy we call it finally free.

Girls repeat lyrics as a part of a collective process of recognition, signifying their refusals to reproduce normalized straight and lesbian ideals as an important sign of their difference from commodified cultures. Interested in the campy "flamboyance" of Le Tigre, the intelligent wit of D'bi Young, the parodic excess of Bitch and Animal, as well as the "regular butch dykiness" of bands such as the Butchies, girls are less interested in a single pattern of identity and style than in a proliferation of self-fashionings. Dana insists that queer musicians are "less subjugated to hegemonic social ideas about femininity and gender roles." Opening up possibilities for female masculinity along with alternative forms of femininity, punk-inspired queer bands distinguish themselves through physical displays of aggression and powerful sexuality. Judith Halberstam refers to the ways in which performers work to transform images of femininity: "Guitarists like Leslie Mah of Tribe 8 as well as vocalists like Kathleen Hanna of Le Tigre and Beth Ditto of the Gossip all articulate the powerful potential of a queer femininity that served as an undercurrent to much of the riot grrrl feminism and is readable as radical style in queer punk" (166). Halberstam emphasizes complex feminine gender displays often overlooked within cultural analysis of punk, going beyond studies of girl punk rock, such as Lauraine LeBlanc's analysis in *Pretty in Punk*, by foregrounding complex dimensions of feminine resistance.[18] While girl punk bands have come to represent the most in-your-face and spectacular examples of gender defiance, they are not the only examples that girls mention when talking about challenging heteronormative gender expectations.

It is interesting that this generation of youth also reads queer culture through ambiguous modes of communications. Many girls talk about the need for music that does not focus obvious attention on gender. In this way, wildly confrontational moments enjoyed in queer punk bands, such as Tribe 8, are talked about

alongside more indirect and muted attempts to transform the representational status of gender. Nineteen-year-old Judith insists that "gender has played too big of a role in music communities for too long." The efforts of queer artists to embody their singularities beyond conventionally gender coded languages of difference become valued by Judith and other youth. While queer gender styles are a source of recognition and identification, they become meaningful in the context of the music as a whole rather than isolated or easily defined as an essential quality. Several girls were adamant that they are trying to see beyond gender obsessions of mainstream culture. Eighteen-year-old Lea says that she listens "for songs that are not gender specific, using 'you' instead of pronouns like 'he,' 'she,' etc. and have an ambiguousness regarding gender when it comes to who they are singing about." Enjoying ambiguity and uncertainty, Lea prefers that gender be left up to the listener, open to the interpretive imagination rather than prescribed within the musical text. Lea goes on to stress that "I really enjoy poetry and lyrics that are ambiguous, where the object of one's affections are not explained or said by mentioning gender/sex in the song." Lea enjoys those traces of gender queerness that are difficult to pin down, precarious dimensions of queer cultures that defy attempts to capture an explicit content and a coherent visual or musical style. What queer girls seem to want most is to be able to forge identifications with queer music artists based on open-ended and contextual readings attuned to subtle body and vocal arrangements. Resistance to sexual binaries is embedded within the lyrics youth reference; Joy quotes from a song that she feels expresses her perspective as a queer girl:

> We're different but the same
> Just one big game
> Get out of your pigeon hole.
> Use your mind and don't lose your soul
>
> Triple Creme, "Different Like Everybody"

Such messages do not merely address girls at the level of their nonheteronormative gender identifications, but simultaneously appeal to them at the level of girl-on-girl eroticism. When talking about their first experiences seeing and hearing queer girls bands, identifications are often indistinguishable from desires. Speaking about her initial encounters with performers Tegan and Sara, eighteen-year-old Lea conveys the erotic force of her attractions:

> I think I was immediately infatuated. Yes, my immediate reaction was not "boy their harmonizing is awesome". I definitely started crushing. All superficial . . . sad to say but just like any other group, one tends to sort of start idol worshipping. So, GO TEGAN AND SARA!

© *Triple Creme*.

Fascination with artists takes on special significance for queer girls who live out their attachments in ways that often blur the lines between admiration and infatuation. Whereas intensities of feeling between girl fans and pop stars have been explored for the underlying homoeroticism, queer girls are remarkably candid and reflexive about their desires. "Idol worshipping" takes on an interesting dynamic as girls admire and desire young female musicians, moving between discussions of how talented and creative they are as song writers and admissions that they are find them "sooooo cute!" Looking up to queer artists as role models, objects of affection, and fantasy ideals intensifies and complicates the emotions and psychic investments forged as part of their listening enjoyments. Even when artists such as Tegan and Sara have not explicitly come out or focused on their sexual orientation, fans are adept at reading sexuality between the lines of songs, in the suggestive poetics of musical storytelling.

Discovering queer musicians is often interwoven into a process of realizing and naming sexual attractions. Gina Young recounts the first time in her youth

when she saw a queer band called Estrojet: "The lead singer was a beautiful woman with Dreadlocks who didn't shave her legs and spoke openly about being queer, and I just remember my jaw being on the floor the entire time" (qtd. in Ciminelli and Knox 115). Surprise and wonder at public displays of queer embodiment are narrated in terms of erotic awakening. Being turned on by other queer females becomes an integral part of the experience of enjoying music. Fans speak about being blown away by the sexual allure of girl bands, viscerally struck by the bold and explicit sexual presence of queer girl artists that is qualitatively distinct from the commodified hyperfeminine sexuality of mainstream popular culture. Eighteen-year-old Joy is amazed at "how hot girl performers are just doing their own thing." Artists connect with queer girl audiences through erotically charged performances focusing young females' gazes on unconventionally sexy bodies and pleasures.

The seductions inciting queer girls as they listen to and watch other queer girls involves a visceral response to what many girls call the sexually "raw and rough" style of dyke artists, as well as more ambiguous traces of desire. Sexuality is conveyed within music on multiple levels. Susan McClary argues that "music is very often concerned with the arousing and channeling of desire, with mapping patterns through the medium of sound that resemble those of sexuality" (8). Nineteen-year-old Doris claims that "generally queer artists are more sexual in their presentation of their relationships i.e. Peaches and early Gossip. Those ladies are way beyond pg13." Doris goes on to say that

> queer women would be more likely to focus on the sex side of love. . . . The Gossip had a few songs in their EP and first full length. "swing low" (sweet chariot) is not a very church-appropriate song. "there's only one thing that could make you my lady, swing low, down low sweet chariot" more of an innuendo than anything else.

Doris is fascinated by the provocative sexual gestures of queer artists. Live and recorded music provide a space in which girls have opportunities to engage with uncensored sexual explorations by young women. Alice recalls first listening to Ani DiFranco sing about "fucking a girl," which for her was a very important message that helped buttress her sexual confidence to be able to speak her desires as a youth. An informal sexual education and sexual politics are recognized by girls who talk about the impact of sexual dialogues within queer musical texts. Moving beyond a private conception of sexuality towards more public discourses centered on power and knowledge, twenty-one-year-old Lyn writes, "to hear a woman sing about loving & fucking another woman, that's just as political as personal. sexual politics are something i am very passionate

about. . . . they confront and deal with stereotypes around womyn and our sexualities, they sing [and scream] about all that is taboo."

While resistant and powerful sexuality becomes a hot spot of queer girl fascination, for other girls, romantic love songs become the focus of their interest, as they speak of the emotional force of girls declaring love for other girls in words they listen to over and over again to the point of knowing them by heart. Romantic feelings between girls are represented in lyrics, providing girls with common languages to talk about experiences of falling in and out of love. In nineteen-year-old Mia's words, "It makes me feel comfortable when queer artists talk about their first heartbreaks and relationships. It makes me feel like they are talking to me because mainstream music doesn't really deal with those issues—everything is boy-girl." Mia is compelled by lyrics that grapple with what it is like to grow up queer, go through relationships, and experience heartbreak by a girl. Lyrics not only touch on general subjects connected to the lives of queer girls, they also constitute detailed romantic narratives of pleasure and suffering that fans use to deal with their specific relational predicaments. Twenty-two-year-old Jenna makes direct ties between the words of a song and her lived experiences:

> When I first heard Team Dresch's song "Freewheel", it felt so good to hear the lines: "I don't need that girl to watch T.V. with / She's just the same girl over and over and over and / You can go back to your boyfriend" because it described exactly the first time I got my heart broken by a girl (even the bit about watching T.V.). Everybody can identify with break up songs in general, but being a lesbian dumped for a man is a different kind of pain than a straight man singing about his wife leaving him for another guy.

For Jenna, engaging with lyrics that are attuned to the contours of queer girl romantic relations becomes a crucial aspect of her understanding and enjoyment of music. In this way, music provides a passage between real romantic relations and cultural representations, mediating the isolated experiences of girls through images and narratives they draw upon to symbolize and interpret their own lives. In her book *They're Playing Our Songs*, Ann Savage calls attention to the ways women appropriate lyrics to help them "cope with transitional and challenging moments in their everyday lives and to feel a little less alone when dealing with them" (96). Music provides an emotionally rich medium utilized by queer girls to express and think through their romantic longings. Songs resonate on many levels, providing a unique means through which deeply intimate emotions become interwoven into collectively shared and politically meaningful discourses.

Healing Rituals and Queer Belongings

Push thru their greatest fears and
live past your memories tears cuz
You don't need to scratch inside just please
Hold on to your pride
So don't let them bring you down and
Don't let them fuck you around cuz
Those are your arms that is your heart and
No no they can't tear you apart cuz
This is your time this is your life and . . .

You gotta keep on (keep on livin!)
Gotta keep on (keep on livin!)

Le Tigre, "Keep on Livin' "

In connecting the experience of living with a history of sexual abuse to the difficulties of coming out, songwriters Kathleen Hanna and JD Samson credit as one of their influences the article I wrote about Tribe 8's 1994 performance. . . . Unapologetically feminist and queer, Le Tigre supplements their songs with videos and slides projected on a screen behind them to create a multimedia forum for the polemical messages inspired by their political commitments. The combined power of song, visuals, and live performance lends itself to the formation of a public culture around trauma that doesn't involve medical diagnoses or victims.

Ann Cvetkovich, *An Archive of Feelings* (1)

Ann Cvetkovich opens her book *An Archive of Feelings* with a tribute to queer bands, including Tribe 8 and Le Tigre, whom she regards as key sites of public cultures through which lesbians articulate and work through traumatic experiences. Cvetkovich writes that "as a name for experiences of socially situated political violence, trauma forges overt connections between politics and emotion" (3). Lesbian subcultures become highlighted as a creative response to the violence of trauma; they "cut through narratives of innocent victims and therapeutic healing to present something that was raw, confrontational and even sexy" (4). Offering affectively charged modes of public engagement by marginalized subjects, musical subcultures, along with other modes of lesbian and queer culture, do not celebrate, victimize, or pathologize but rather foster processes of insight and recovery. What is so remarkable about Cvetkovich's book is her willingness to accord music as text and live performance symbolic powers of psychic reparation and social belonging. Painful experiences become translated into words and sounds, giving collective voice to embodied shame and suffering, providing languages that resonate with many female youth growing up queer. Cvetkovich moves beyond psychologistic interpretations of individual shame and empowerment by emphasizing political dimensions of queer musical

practice, recognizing that it is precisely a combination of emotional intimacy and public performance played out by queer bands that nurtures transformation. Music is unique in its extralinguistic power to relay emotional meaning in ways that exceed more narrow representational forms of culture. As such, music becomes a mode of articulating complex feelings and desires without foreclosing experiential differences.

Cvetkovich's theorization reverberates in the commentary of queer girls. Le Tigre's song "Keep on Livin' " was talked about by many of the girls I interviewed as a meaningful text that touches them intimately while speaking across their social locations and histories. Girls hook into the lyrics precisely because they signify the unique and often silenced vulnerabilities of their lives, while also compelling youth to overcome inertia and move on. Songs like this give youth permission to talk about themselves with the force of music supporting and understanding them. Queer girls are extremely perceptive about the healing and empowering potentials of music, helping them to deal with homophobia, abuse, social isolation, and invisibility. Nineteen-year-old Judith talks about music in connection with art and "contemporary women's liberation," writing, "I was a victim of physical and sexual abuse from being a baby, up until i was sixteen by my father. This predicament led me to search for other women who i could identify with and for inspiration, strength and liberation." Music becomes a crucial part of Judith's ability to transform personal trauma through participation in queer cultures and feminist politics, mediating psychic wounds and elaborating hope for her future.

As an avenue to express vulnerability and ameliorate pain, music instigates a collective process of emotionally charged learning. Youth seem keenly conscious of the emotional value of music in their lives. Twenty-one-year-old Lyn reveals a highly developed knowledge of the healing power of music:

> I think the strength of queercore music is unique—the fact that it can be loud & angry in one song, and passive & mourning in the next . . . the variety of emotions that are touched on, emotions that are specifically unique to being a queer girl in this society. being queer girls is very difficult—the isolation & fears, surviving high school . . . coming out to parents, falling in love . . . the fear of realizing that attractions were different than what we were supposed to be attracted to. it's scary. and overcoming all of that, surviving—that is empowering. that is joyful, to stand up and say i've made it through, i'm alive still. and fighting. and i believe that is what the queercore movement is about . . . a sort of joy that only queer girls know, mixed with a sort of sorrow only queer girls can know . . . a celebration of our lives & survival.

It is striking how reflexive Lyn is about the complex ways music is taken up by girls struggling in their daily lives. Music becomes a salve and an inventive life

force through which queer girls are comforted and activated. Referred to as a source of survival and affirmation, songs and performances are approached as tools that girls use in strategic ways. Lyn goes on to assert: "there is nothing more comforting to me when i break up with a girl than blaring some pissed off heart-broken dyke music . . . to scream along to the lyrics and feel understood & validated. it's very validating just to be able to see my own experiences reflected in another womyn's music." Queer artists also recognize the power of their music to help uplift youth. In the words of the Butchies' band member Melissa York, "When we're have a really good show and the energy is crazy and some kid comes up to us and says we helped keep her from killing herself two years ago . . . that drives us" (qtd. in Ciminelli and Knox 187). Music articulates elements of real-life experience, compelling girls to turn to music as an interactive source of day-to-day self-understanding and enjoyment. A unique aspect of music is not simply explicit queer content, but also its adaptability, mobility, and continuity as a media form; talked about as having an ongoing presence in the life worlds of queer girls at home, on the street, at school, and in bars, music enters multiple social spheres. As a media format that moves fluidly across social boundaries and subjects, recorded music becomes interwoven into girls' "media rituals."[19] The everyday ritualistic practices of listening to, sharing, and exchanging queer music have special value for girls who are faced with pervasive media erasure and assimilation in relation to heteronormative cultural institutions and ideals. Alternative queer music provides ritualistic mediation between self and world. Jenna says that "I pretty much listen to Le Tigre constantly. Walking around listening to queer music on my headphones sometimes feels like I'm wearing armor, or something; it kind of protects me from the straight world i live and work in, especially if I'm having a bad day." Understood in terms of imaginary cultural armor, music reassures girls and connects them in contexts where they are deprived of recognition.

The metaphor of armor used by Jenna signifies more than merely a defensive barrier to outside judgment and marginalization; it also suggests a protective shield that enables girls to assert themselves, struggle, and take risks. Music becomes integral to a symbolic process that girls use to buttress themselves against the daily assaults of homophobia and heterosexism. Lea speaks about how music and artists project a sense of fearless queer sexuality, daring to transgress social norms and boundaries:

I like how there is a sense of "no fear" like the first step was to say "hey, see us? We're here and we're queer" and after letting that out anything goes. They can say more of

whatever the hell they want. They can be pissed off, they can use they're music for advocacy, they just aren't afraid to bring issues out into the forefront. I see it has much to do with being comfortable coming out as queer focused musical performers and once they've overcome that boundary they don't need to stop.

Lea valorizes queer musicians as pushing limits and defying heteronormative codes of behavior. She positions them at the forefront of queer youth cultures, representing an imaginative space of young female queer resistance, the promise of freedom in the face of systemic constraints. Girls admire musicians for their confrontational attitude and advocacy, while also following their cues and expressing interest in imitating them. Referring to the influence of Ani DiFranco, Lorissa comments that "she's more of the best somebody can be so why not aspire to that kind of thing." Queer music artists are not worshiped by girls as abstract celebrities who represent ideals of perfection but rather as strong figures who are smart and savvy, challenging normalizing patterns of perfection and docile consumption. Looking up to queer music figures, girls talk about being motivated to get involved in cultural scenes and projects, to become like their idols by actively doing something, rather then passively mimicking static unachievable qualities. What gets noticed and praised in relation to queer idols such as Ani DiFranco is not unattainable characteristics but the dynamic process of becoming an outspoken cultural subject refusing to buy into prescribed notions of cultural value and beauty.

Situated as queer idols and mentors, musicians inspire girls to think critically, become creative, talk back, and pursue unruly desires. Music compels queer girls to envision themselves outside the lines of dominant representations, yet it is the way it brings them together as lovers, friends, and communities that constitutes its ability to bridge media texts and social embodiments. Although music can be listened to discreetly, it can also be shared in contexts of live musical performance in which cultural texts become corporeally enacted, lived as ephemeral interactions between girls in specific times and places and used as a basis for queer memory and community. The live performance aspects of queer girl music scenes provide unique opportunities for elaborating common cultures that enjoin girls as active participants. Ann Cvetkovich writes that "queer performance creates publics by bringing together live bodies in space, and the theatrical experience is not just about what is on stage but also about who's in the audience creating community" (9). It is precisely this dimension of being part of something spontaneous and dialogical that elicits intensely vivid responses. What emerges are textured memories of live performances and events, memories that come to

constitute situated notions of community. Remembering the details of how artists perform and how fans respond at specific times and places, girls animate stories about going to live concerts that suggest pivotal and enduring meanings. Sixteen-year-old Aly remembers, "Kathleen Hanna actually sent a guy to the back of the room because he was shouting out rude comments. i loved it." It is not merely the songs that catch the attention of those attending these concerts, but also the commentary, activities, and antics surrounding musical acts. Several girls stress how much they love hanging out in the intermission "checking out the cute girls," connecting with acquaintances, and chatting with strangers about other bands. For many girls, going to such concerts provides a rare chance to be amongst large groups of other girls connected through queer culture.

Recounting the first time they attended a queer music event, girls talk about the thrill of being in spaces "filled with lesbians," feeling the sexual excitement of live performance that encompasses the social space where girls interact, flirt, and hang out. Jenna claims that "queer music makes me feel like I'm a part of something bigger, it connects me to others." Narrating the first time she attended a queer concert, she says,

> I saw L.P. in concert this summer and it was one of the most amazing nights of my life. She's fantastic live, just this powerhouse of raw dyke sexuality, it was incredible. I've never been to a queer concert before or experienced that kind of queer space and it was so much fun and so thrilling. Plus I met my girlfriend there that night, so it was perfect.

What is so interesting about this account are the ways in which Jenna combines talk about seeing a particular band with anecdotes about meeting her first girl-friend. Many other girls spoke about going to concerts as extremely memorable moments of socializing, touching them on many levels. An ambiance of queer girls communicating across their differences suggests how vital music concerts are as a means for developing spontaneous forms of queer community. Cohesion in these settings is not fixed around a unified identity but rather a provisional convergence of identifications, which seventeen-year-old Jill suggests when she says that "it was kinda neat to see how everyone is so different even though we are all queer." The importance of a public social space in which to meet other queer girls and experience unstructured conviviality needs to be understood in comparison with the sense of alienation and invisibility felt in predominantly straight environments. Nineteen-year-old Tandy talks about the ways such events generate a feeling of social belonging: "No one looks at you like you are in the wrong place. . . . I would prefer to go to a queer girl concert than go and see a mainstream band. At least I know that I can be myself and no one would judge me."

Inhabiting a public space without having to worry about being judged or marked out as different, Tandy is able to overcome isolation, to feel relaxed and connected. Blending in as queer youth within the immediate surroundings of music events, girls value music venues for the ways they facilitate their embodied participation.

At the same time that some girls feel unconditional acceptance and belonging at concerts, several youth spoke about the racial and cultural dominance of white centered spaces, artists and fan cultures. Tristan talks about how few girls of color she meets at queer music festivals, calling attention to exclusionary racial boundaries in the midst of queer-positive communities. Tristan discusses the hypocrisy of music scenes that claim to be diverse but fail to actively reach out to minority youth, creating divisions rather than forging alliances. She comments that "sometimes I am the only brown face in the crowd and I really wish more girls felt encouraged to come out and dance in queer spaces." Tristan suggests that the very definition of what constitutes queer music and events needs to expand beyond the most obvious and recognizable examples to include a broader range of venues, criss-crossing diverse community formations. Consciousness about racialized divisions and hierarchies gets articulated by youth whose subjectivities and bodies are marked out as different from norms of white queer girlhood reproduced within music subcultures. In contrast, the denial of the importance of issues of race within the narratives of many queer girls talking about their participation within music scenes reveals the perpetuation of class and race privilege which tends to get split off from personal and political discussions of heterosexism and queer resistance.

At their most inclusive, queer girl music cultures engage with questions of social difference and inequality not only at the level of representation but in the social gestures of community building. It is in acts of going out and meeting other queer youth within public venues that girls talk about feeling most engaged and culturally stimulated. Going to see local bands in smaller places or more widely known bands at music festivals and concerts provides girls with opportunities to connect with each other. For those living in cities with access to local queer music scenes, seeing live music on a regular basis with friends provides youth with alternatives to manufactured forms of entertainment, facilitating grassroots cultural involvement. Do-it-yourself forms of queer cultural production are talked about in ways that displace the centrality of consumeristic forms of popular culture. Alice says, "I love being surrounded by queer up and coming activists and musicians in more of a social setting like the Gladstone. . . . [20] I get more out of that now then being in a quiet concert hall."

She goes on to express pleasure in the loud and raw energy of seeing small bands live, which she prefers to the tamed environments of big concerts. Against the tendencies of corporately controlled music to reify formats, what gets emphasized here are unpredictable dynamics of cultural practice that elicit the dancing bodies and unruly screams of fans. In this way, there is a reversal of commodified values, such that music with little commercial success becomes appreciated precisely for its irreducibility to industry norms. In their talk about favorite bands, queer girls oscillate between international crossover pop stars, such as Peaches, and local Toronto lesbian bands, such as Hunter Valentine, reorienting the terms of value and distinction away from marketable criteria towards experientially negotiated tastes and preferences. The very concept of popular culture is reworked from within the emotional and social life worlds of young female queer subjects. Being part of live performance spaces and interacting with other queer girls become a vibrant aspect of public queer female youth cultures. At the same time, the embodied and social impact of music is not limited to concert going. Many girls also talk about being in bands, wanting to form a band, or having friends in bands, combining references to local queer bands alongside commercially popular artists and groups. In this way, there is less of a clear sense of separation between producing and consuming or between grassroots and mass media cultural engagements, not merely de-centering and deprivileging music that is considered mainstream but also blurring the lines between novice and expert, popular and alternative, and amateur and professional musical cultures. There is more room for two-way communication and proximity with the artists, as girls talk about knowing the performers and also being able to become members or promoters of local bands. Jody Bleyle of Team Dresch insists that "the idea is to inspire everybody to get involved and make things and participate. . . . We wanted to find and build a community so we could have friends and date them and go to parties" (qtd. in Ciminelli and Knox 52). Community becomes framed as a process in which to join in, interpret, and enjoy music as an active and integral part of social life. Local queer girl music scenes constitute mobile networks of friends, activists, and artists, eliciting participatory modes of cultural belonging.

Conclusion: Inventing Queer Girl Popular Cultures

With my queer life, it absorbs everything, it is mainstream, but it depends on whose idea of mainstream you are going by. It's a blurry line for me as a Women's Studies student

and a queer in every shape and form. . . . Mainstream for me is not Britney Spears, it's
Ani DiFranco. . . . Lesbians on Ecstasy is modern day popular culture!

<div align="right">Alice, age 22</div>

Focusing on the emotional and political importance of music in their everyday
lives, queer girls reconsider what counts as popular culture. In the quote above,
Alice insists upon the specificity of her favorite queer artists, while refusing to
draw clear boundaries between popular and unpopular, mainstream and sub-
cultural, areas of music. Enjoying mainstream hip hop and rock alongside her
love of queer girl bands, she offers a complex accounting of taste that allows for
the intermingling of multiple styles and contents. Rather than position queer
cultural elements in opposition to a stable heterosexist mainstream standard,
queer girls seem more interested in displacing notions of a stable center of pop-
ular culture. As Alice says, Lesbians on Ecstasy is popular culture, and Ani
DiFranco is mainstream, offering a contingent way of positioning queer artists.
While Alice is fully aware that these are not musicians that get much mass
media attention, they are musicians that "queer girls across Canada know and
love." Alice's conception of queer popular culture is not a naive reversal of dom-
inant and marginal texts, it is a reconfiguration of references and qualities used
to construct what, who, and how cultures become popular. In such evaluations
of music, girls do not reject "straight" songs and artists or uncritically valorize
music by queer subjects but rethink them contextually and reflexively.
Interrupting feminine heterosexual ideals with dissonant queer voices and
musical scenes, girls alter the very configurations through which sex/gender/sex-
ual norms are legitimized. Reappropriating popular culture by, for, and about
queer girls, they are not merely adding what was missing or overcoming invis-
ibility in the move towards positive visibility, but more substantially reframing
the practical, emotional, and theoretical approaches through which girls con-
stitute their lives.

Articulations of queer girl subjectivities become intimately woven into
cultural practices, directing analysis of gender and sexuality away from a focus
on individual traits towards dynamic social relations of representation. Queer
girls become meaningful through their active and creative readings of popular
cultures. In this way, the very question of what constitutes and comprises queer
identities and differences is what is up for grabs over and over again, generat-
ing curiosities and eliciting desires within the flux of watching, listening, and
talking. Girls come to wonder about their queer idiosyncrasies and imagine
commonalities within a dialogical process of addressing themselves in relation
to other selves, learning how to communicate queer perspectives within

interpretations of representations. For many youth, the crux of a queer cultural approach involves an ability to resist containment, remaining open to possibilities of learning new things and becoming something else. While talking specifically about who they are and what kinds of culture they like is important to young people, many girls refuse to name their queer inclinations and interests as things that can be described transparently and pinned down exactly once and for all. Nineteen-year-old Judith remarks that "this is why I think it has more to do with being open to different things and learning to expand your thought process, ideas, and thoughts to the wider picture." Judith provides a reminder that what is most queer is not what is known but what goes beyond the already intelligible. As much as the girls interviewed are captivated by images, moved by songs, and involved in media stories that signify desire in collectively meaningful ways, it is important to respect their continuing ambiguities and uncertainties. For many girls, staying open to what is least expected or predictable is the primary locus of their queer cultural powers and pleasures. In this way, learning how to gesture toward such ephemeral cultural relations with gentle ethical care is the most difficult and important task of queer girl cultural research.

· 8 ·

CONCLUSION

The Imaginative Participation of Queer Girls in Popular Culture

Most young people's lives are . . . full of expressions, signs, symbols through which individuals and groups seek creatively to establish their presence, identity and meaning. Young people are all the time expressing or attempting to express something about their actual or potential *cultural significance*.

Paul Willis, Common Culture (1)

Meaning-making functions less in terms of a "transmission" flow model, and more like the model of a dialogue. It is an ongoing process. It rarely ends at a pre-ordained place.

Du Gay (10)

There is no preordained beginning or ending to this study of queer girls and popular culture. While I have sketched a series of interconnected cultural fragments, I do not offer a grand narrative in which to make sense of queer girls and popular culture as a finalized entity. It is impossible to mark out a clear-cut sphere of media texts pertinent to the lives of queer female youth, and it is equally impossible to name and define these subjects as a coherent collectivity. Rather than fixate on a delimited field of analysis, what interests me is the generation of mediated cultural expressions that defy totalizing rationalization. Writing about queer girls in relation to their creative engagements within popular culture makes it possible to shift away from innocent, victimizing, and

pathologizing notions of sexual minority youth that plague feminist, social science, and policy discourses.[1] Rather than being interpreted according to normative standards of girlhood and heterosexuality, I approach them through the rich contours of their daily cultural practices and social communications. In this sense, the point is not to focus on inert categories of difference that work to other and contain queer girls into manageable research subjects but, on the contrary, to alter ways of reading girls so as to allow for variable perspectives. Staying close to the contradictory and changing facets of queer girls constructed in texts and animated by girls themselves as interlocutors, I am interested in developing ways of moving between them without securing truth claims. More important than knowing exactly who queer girls are and what their cultural investments mean, I argue that listening to girls as they talk back and forth about popular culture, using and embellishing meanings in specific and local ways, opens up possibilities for recognizing girls in new ways. This carries forth the ideas and methodologies presented in Paul Willis' book *Common Culture* in which he explores the creative symbolic enactments of youth in their local environments. Willis attends to the ingenuity of young people faced with limited yet pliable means of articulating common cultures. In a similar vein, I emphasize the ways girls express their queer significance through various circuits of commercial and community media, drawing upon and challenging hegemonic ideologies and conditions of knowledge.

I opened this book pointing to tensions between a proliferation of mass-marketable media images of female youth and passionate readings by queer girls that work to destabilize heteronormative modes of cultural in/visibility and significance. Queer girl cultures emerge on the threshold of this tension. In many ways, this book navigates spaces between dominant representations of sexual and gender minority youth and the heterogeneous ways young people mobilize them in their daily relations and conversations. While mass media are undeniably a central means of expression and communication in the lives of teens today, queer girls broach a wide range of media with a productive sense of curiosity and ambivalence. It is precisely a predicament of being both inside and outside, visible and invisible, represented and unrepresentable within mainstream media circuits that drives cultural negotiations of lesbian, bisexual, transgender, queer, and questioning girls. Media are both intensely pleasurable and seductive as purveyors of shared stories and deeply troubling as they reproduce normative ideals and closures. Establishing an easy sense of belonging and worth is virtually impossible for queer youth growing up today within media environments that both commodify their differences and erase their particularities. At stake for

queer girls is their ability to animate interpretations and uses of media texts in ways that neither reiterate binary ideologies nor deny their powers and influences. Fully implicated within the discursive terms of contemporary media formations, queer girls nevertheless articulate themselves with inquisitive urgency and imaginative insight.

Jennifer Kelly writes in her book *Borrowed Identities* that as part of a "recognition of youth as a complex formation, it should be noted that popular culture and media act as 'institutions to think with' resources to use in the formation and production of identities" (4). It is precisely this activity of thinking through and affectively responding to media signs and institutions as a constitutive dimension of queer girls' identity work that provides a continuous thread throughout this study. Popular culture is experienced by many of the girls I interviewed as a precarious process connecting enjoyment and critical understanding, fantasies and lived realities, fiction and reflection on material social conditions. Using the limited symbolic resources available to them, these youth respond to television, film, magazines, music, and Internet media, pursuing their ambivalent desires to both question conventional meanings and convey alternatives, while staying close to the lifeworlds through which popular culture is experienced. I have focused on the struggles of queer girls to generate identities out of local contexts of experience through popular mediations. In this sense, I am making claims about relations between representation and identity as a dynamic process that is not bound by texts constructed by producers or completely open to the whims of young people's imaginations and subjective longings. What interests me are the perpetual, and often contradictory, encounters between them that constitute the dialogical interactions between queer girls and popular cultures. This is a key challenge of the book: to theorize exchanges between media signs and socially embodied receptions. Each of the preceding chapters in this book unfolds dynamic engagements through which queer girls elaborate meanings, situate themselves, and instigate social dialogues. Whether the subject of analysis is a print advertisement, a film narrative, or a musical concert, what matters are the ways in which meanings are refracted from multiple and intersecting perspectives, spurring reflections across race, gender, sexual, and class lines.

Dialogism is vividly played out in discussions by fans of Willow Rosenberg's character on *Buffy the Vampire Slayer*. As one of the few common reference points for talking about queer girls in media culture, Willow becomes an intense locus of investment and desire. Girls invigorate this text with situated knowledges about themselves connected through close and contextual readings

of media. What unfolds within their conversations about Willow's fictional self are intimate yet collectively shared thoughts about growing up, coming out, and falling in love with girls. This mainstream television example provides an occasion for many of the young people I interviewed to address their own uncertainties about sexual identity and critical insights into media depictions of romance and friendship. The narrative and character constructions of Willow as a transformative subject who changes in complex ways over the course of seven seasons provide a unique televisual visual space through which girls respond with interpretive fervor. Calling forth exchanges with other fans, girls question and debate themes and tensions within the story lines of episodes that loop back into personally inflected readings about their own lives as teens. Talking through events and relations experienced by Willow, such as falling in love and dealing with loss, girls share understandings that do not resolve into consensus or closure but refract socially varied readings. Willow is a productive and open text through which girls contest and challenge the terms of her readability and relevance to their own lives. Willow's complicated transitions as a character mark entry points for girls to publicly discuss ideas and feelings about girl empowerment. At the same time, Willow becomes a cultural discourse through which fans converse about racial hierarchies, censorship, and regulations of mass media portrayals. Queer girl viewers acknowledge the discursive constraints of prime-time portrayals and articulate their own fantasies beyond the prescribed images and scenarios of network TV.

The elaborate fan cultures developed around Willow are enabled by the series' extensive publicity and widespread distribution on cable TV and DVDs. Emerging out of a conglomerate corporate system of niche teen marketing, the institutional conditions producing Willow both enable and inhibit ways of seeing and talking about desire between girls. In contrast to this example of mainstream visibility, many of the girls I interviewed struggle to access other areas of media culture addressing the emotional and embodied variance of nonheteronormative girls. Longing for alternative representations, sexual minority youth scavenge through a broad range of media venues and formats of representation, thrilled when they come upon cultural texts that speak to the specific contours of their everyday lives. While being relatively difficult to find, independent films offer queer girls glimpses of images and narratives that exceed ideologically bound representations of girls. Whereas television shows actively inhibit explicit images of physical affection and lust, films go further in depicting the erotic contours of relations between girls. A body of independent cinema emerged in the 1990s, elaborating sexual and emotional intimacies

at the center of their story lines. What gets noticed by queer female viewers are subtle and vulnerable moments of attraction between girls, driving plotlines in new directions, signifying fictions that do not privilege heterosexual outcomes. Queer girls become emotionally charged film spectators, watching and recounting desires on the screen that overlap and conflict with their histories and relationships. At the same time, independent film representations are difficult for teens to get hold of, which limits their capacity to generate collective responses. Differing from the prolific range of fan cultures surrounding Willow, film viewing does not produce queer girl fan cultures in any coherent or sustained sense. While public conversations between girls about these films are rare, their interpretations remain dialogically driven insofar as they draw extensively upon their personal memories and stories to understand and interpret the visual narratives of these cinematic texts. The organized space of a focus group was very useful for providing a context in which girls could exchange views and share their film commentaries by referencing specific textual details and evaluating their personal and cultural significance.

In many ways, dramatic film portrayals capture the imaginations of girls precisely because they unfold ambiguity and complexity at the heart of a queer reading process. Craving layered representations generated by independent narrative cinema and a long-running television series, many girls preferred media that interrupted simplistic clichés and closed images of lesbians. Weary of the commodified treatments of girls and sexual minorities in visual culture, they approached magazines with skepticism and an ironic sense of pleasure. Magazines elicit a cautious process of enjoyment, providing one of the few commercial venues in which to see and hear about lesbian celebrities, news, events, gossip, and fashion. Disseminating information within familiar conventions of consumer-driven popular entertainment, magazines are especially useful to those youth who crave mass media inclusion and normalization. Nevertheless, while youth are part of the contents and visual styles of lesbian magazines, they are not the direct focus nor are they substantially addressed within the mandate and production of these glossies, which seem geared more fully to an adult lesbian market niche. And it is precisely the corporatization and branding of this niche that provokes youth criticism. Queer girls are often frustrated by what magazines offer, at how they fixate on so-called lesbian identities through normatively racialized, gendered, and classed ideals of feminine beauty and status. The specificities that youth articulate in relation to their transitional psychic, bodily, and social positions are often foreclosed within magazine media oriented towards transparent, unified, and glamorous modes of visibility. Yet

even in relation to magazines, girls express interests that transgress sanitized cor-
porate ideals, seeking out edgy pornographic texts that include kinky young
queer sexualities. They also go beyond the pages of existing magazines to imag-
ine something else, to talk about possibilities for alternative magazines, zines,
and e-zines attuned to queer youth perspectives.

A diverse array of media texts animates queer youth dialogues beyond any
single formulation of taste and value, resignifying cultural texts in hybrid
ways, pushing open boundaries between innovative, local, do-it-yourself
cultural practices and commercially available industries and texts. Some of the
most fluent ways in which queer girls negotiate between these spheres is with-
in online communities where they establish links between diverse cultural
texts and practices relevant to their lives. The Internet becomes a communal
realm through which youth signify who they are by referencing common ele-
ments of popular culture from Hollywood stars to alternative girl bands. In this
way, it becomes a creative medium of self-representation for queer girls who
actively draw upon mass media icons, images, and stories as a way of cultur-
ally crafting their identities. At the same time they become active media
producers themselves, sampling and constructing their own visuals interwo-
ven into nonlinear personal writing styles. Making decisions about the degree
to which they will join in community forums and how they will perform
themselves as subjects, online media provide queer youth with a more partic-
ipatory form of engagement. Within online communities, young people forge
public spaces in which to chat about taboo and excluded topics relating to their
experiences and longings that rarely enter mass media purviews. Unlimited by
market ratings, adult interventions, and moral regulators, online communi-
cation between queer girls forges an extremely important horizon of possibil-
ities for considering not only their relations to existing media but also
expressions excluded or rendered unintelligible within the dominant cultural
imagination.

While online communities provide transnational connections between
queer girls who are often geographically separated, they also promote net-
works through which to exchange information about independent queer music
and performances. Music is one of the most innovative cultural areas of pro-
duction in which artistic and promotional messages contest normalizing con-
ceptions of gender and sexuality while affirming subjugated queer youth
embodiments and relations. Constituting subcultural scenes forged interactively
with queer youth, music cultures emerge in close relation to their historically
changing lifeworlds. Music becomes a basis for connecting youth beyond

isolated texts, eliciting more encompassing feelings of belonging. Girls make use of Internet communities to learn about alternative music artists and publicize local events. As a means of bypassing commercial music industries, networks of queer youth promote independent artists and labels, generating interest and circulating information about bands whose lyrics and performances focus on queer cultural politics. Supporting musicians at the local level by attending events while expanding awareness on Web sites and community forums, youth share music files and spread the word about their favorite groups online, providing a way to glocalize[2] the very experience of becoming a queer girl. Without reducing it to a narrow genre or abstract definition, queer girl music is situated within communities that involve fans as participants, creators, and knowers who come together to enjoy experiences of inhabiting communal spaces, experiencing culture expansively in live, embodied ways. At the same time, the Internet reaches out to youth who have little access to urban scenes, resources, and spaces in which to gather with others, mediating lines of contact and awareness about alternative queer cultures elsewhere.

Attempts throughout this book to stay close to a plurality of shifting and often disparate fields of media representation and reception are inextricable from theoretical concerns with the process through which queer female youth are constituted as viable subjects. My search for languages and frameworks within which to conceptualize the dynamism of cultural practices by, for, and about queer girls has pushed me across disciplinary boundaries. Working to bridge the deconstructive, psychoanalytic, and literary speculations of queer theories with qualitative media research on girls is very difficult and urgently important. The literary and philosophical insights of queer theory have rarely been used to enrich and complicate social science methodologies. On the other hand, the brilliant discursive maneuverings of queer texts become lifeless when they lose touch with mobile social practices and vernacular languages. Applying tools of queer textual analysis to analyze the unpredictable speech acts of queer girls, I am trying to ground cultural discourses of desire through socially attuned research into the everyday articulations of girls. Toward this end, I use the term *queer* to both reference specific young female subjects and to evoke a process of reading popular culture. Dialogical approaches to queer girls and popular culture avert the abstractions of queer theories of performativity, enabling specific voices to articulate themselves relationally and contextually. Performative notions have been used in recent studies of youth to focus attention onto the creative actions through which young people negotiate their cultural lives, providing ways of understanding youth cultural practices and guiding

methodologies. Greg Dimitriadis insists that

> For ethnographic work, the notion of the performative throws into sharp relief how young people perform their own realities in particular times and places with available—though often limited—resources. We thus see how history, tradition, and identity are all performances, all the result of invested actors who position themselves vis-à-vis others in a complex and unfolding social reality not of their own making. Performance, used as such, assumes that the uses of texts and practices are multiple and radically contingent—open, at least potentially, to other pedagogical uses. (11)

Dimitriadis studies the transformative uses of hip hop in the lives of African American youth, writing in detail about how specific icons and songs are taken up by teens to help them come to terms with systemic inequalities and conflicts, as well as personal fears and hopes. He claims that "these texts have become part of the 'performances of the everyday,' deployed moment-to-moment in multiple contexts of use, often by intensely disaffected young people" (3). The crux of performative studies of youth is a willingness to grapple with the ephemeral enactments and insights of youth without preemptively judging them. What much of this research reveals is that youth who are economically, symbolically, and socially marginalized make use of popular culture to mobilize ways of understanding themselves and their worlds in defiance of reified media formulations that exclude and stereotype them. Without being lifted out of the fray of media ideologies or celebrating youth as heroic cultural transgressors, this research traces the provisional maneuverings of youth as they make and unmake meanings. Simultaneously complicit and resistant, the cultural rituals of youth elicit interpretive styles that encourage change and ambiguity. Focusing on young people as performative, my aim is to dislodge knowledges that peg youth down in idealizing or demeaning terms, eliciting and valuing the cultural specificities through which they define and orient themselves.

I am strongly committed to dialogical and performative modes of understanding as an integral part of challenging institutional normalization. Within this project, I have argued that attention needs to be paid to the methods and languages through which queer girls enter public discourses and private conversations. Performative and dialogical notions provide ways not only of framing queer girl voices but also of developing a reflexive process of analysis. It becomes vital to ask not only who and what counts in the constitution of queer girl cultures, but also how these subjects are rendered intelligible to both youth and adult readers. Speaking with queer youth and valuing their self-representational practices is without a doubt an ethical and political imperative. At the

same time, selecting and juxtaposing quotes by youth is neither a neutral nor transparent endeavor; it is marked by my partial and imperfect inclinations to emphasize some words and leave out others. I forge interpretive patterns out of scattered voices of queer girls without laying claim to know them individually or as a collective whole. Such patterns become the basis for further questioning and rethinking that keep going as new ideas emerge and theoretical detours are taken. I try my best to open up, connect, and guide lines of thought, recognizing that I have only taken them a little way, with so much more to be elaborated in the future. Gesturing toward my own interests, blind spots and doubts become a way of spurring further discussions and eliciting feedback. This is the crux of a dialogical method that places value on an infinite play of queer girl talk and textualities that overflow the scope of this book.

While creative cultural engagements by, for, and about queer girls spur my preoccupations as a writer, it is impossible to carry out any research on youth today without acknowledging the systemic power of mass media industries. Affirming, while also questioning, the cultural agency and power of youth becomes increasingly important in an era of intensive corporate control. From experiential branding to blockbuster spectacles, manufactured realms of popular culture for youth are constructed according to multinational capitalist interests. Bill Osgerby argues that "processes of business integration and conglomeration were clearly evident in the youth market and its associated industries, with the production and circulation of media geared to young audiences increasingly dominated by a coterie of massive corporations" (40). What is striking are the ways in which girls who desire girls become incorporated into popular genres, picked up by corporate media for their alluring marketability. While there is no doubt that globalizing commercial forces of media production delimit the scope of mass media representation of queer girls, there are increasing signs that youth are responding in nuanced ways. Throughout this book, I have traced these signs through the imaginative readings of queer female TV fans, film spectators, music culture participants, and passionate members of online communities. It is quite remarkable how adept youth are at making creative use of technologically and economically driven structures of convergence. Examining a broad range of media, including centralized mass media such as television, as well as decentralized and interactive forms of online and musical performances, I soon discovered that youth media overlaps and converges, making it counterproductive to rigidly separate its forms and contents. For example, a television fan site becomes a hypertext platform for exchanging newspaper articles, sharing songs, linking to blogs, posting photos, and upload-

ing video clips. Even mass circulation magazines are not discreet sources of information and entertainment, but they link youth to a myriad of music products, films, fashion, books, Web sites, and live performances. Media texts and technologies are elaborated by young people across multiple and intersecting webs of communication shaping pleasures, identities, and meanings.

Within an era of aggressive commercial interventions in the lives of youth, it becomes even more important to accord value to the inventive ways in which young people deploy media in their everyday lives, deriving pleasures while challenging and questioning hegemonic ideologies. This is vital for all youth, but it has unique implications for those young people whose social, psychic, and embodied differences are at risk of erasure and commodification within hierarchical systems of value. Without simply reversing the terms by which queer girls have been left out of academic consideration, it is important that future studies about their lives balance critical analyses of mass media with attunement to grassroots cultural expressions. While it is tempting to move in one direction or another, understanding them simultaneously opens up imaginative spaces of resistance in-between. Rather than rush in and valorize what has been historically ignored and devalued, researchers need to tread cautiously, respecting queer girl desires for how they destabilize totalizing conceptions of girlhood, allowing for possibilities of being surprised and shocked. While this provokes uncertainty, it also encourages ways of reading those unexpected, volatile and transient dimensions of youth cultures that are difficult to conceptualize. Perhaps a refusal to fall back on conventional assumptions about who girls are and what girls want is what marks the queerness of girls and popular culture. Unlearning comforting knowledges about girls and their media investments is what is at stake throughout this book, as I struggle to think about particular images, stories, and relations without enclosing them in narrative or conceptual formulas. Queer girls and popular culture spur new ideas and promise alternative cultural engagements by, for, and about female youth while defying attempts to define such transformations once and for all.

NOTES

Chapter 1

1. Youth culture theorist Henry Giroux frames popular culture in terms of a process of public pedagogy that goes beyond educational institutions of learning. He writes about the importance of "extending the meaning of pedagogy into other cultural apparatuses such as the media" (Public Pedagogy, 9) and emphasizes how crucial it is to make "connections to those too often ignored institutional forms, social practices, and cultural spheres that powerfully influence young people outside of schools, especially within the ongoing and constantly changing landscape of popular culture with its shift away from a culture of print to an electronic, digitally constructed cultural of images and high-speed hyper-texts" (12).

2. Pseudonyms have been used throughout this book to protect the identities of all the girls interviewed.

3. Deploying the term *queer* as an active cultural process of meaning making, I write this book building upon a growing field of queer theoretical and queer ethnographic work that includes the work of Judith Butler, Eve Sedgwick, Diana Fuss, Elizabeth Grosz, Jose Esteban Munoz, Teresa de Lauretis, Judith Halberstam, The ideas of these theorists will be elaborated throughout the book to direct attention onto interpretive practices against attempts to read queer subjects as fixed and totalizing entities.

4. Sedgwick distinguishes between "minoritizing" and "universalizing" orientations in her book Epistemology of the Closet. Minoritizing approaches frame issues of homosexuality in terms of their narrow relevance to gay and lesbian subjects. In this way, sharp boundaries are constructed to segregate knowledge by, for and about homosexuals. On the contrary, "universalizing" perspectives implicate heterosexuals and homosexuals in the definitional process, calling critical attention to the social and relational status of knowledge about sexual identity.

5. I contacted girls through e-mail addresses and online communities available on Canadian, U.S., and British Web sites, including <http://www.queeryouth.org.uk>, <http://superdyke.com>, http://ikissgirls.com> (this website was accessed in the Summer 2004 but is no longer active), <http://gingerbeer.co.uk>, <http://planetout.com>, <http://girlfriendsmag.com>, <http://curvemag.com>, < http://divamag.co.uk/diva, <http://

oasismag.com>, <http://thekittenboard.com>. I also contacted girls through several LiveJournal communities (<http://www.livejournal.com>) focused on queer girl music and film, as well as more general communities focused on queer youth identities. I will discuss the process and limitations of this methodology later in this chapter, but, at this point, it is important to sketch out the broad terms of this research project.

6. In chapter two, I elaborate Bakhtin's dialogical theory of language as a productive way of understanding the ways queer girl subjects constitute meaning in socially specific and embodied ways while actively negotiating hegemonic media ideologies. Framing this project in terms of dialogism helps to overcome one-sided subjectivizing accounts of popular cultural meaning and institutional theories of discursive power that elide the creative practices of girls as interpreters. My goal is to theorize queer girl cultural engagements as ongoing dialogues involving multiple and intersecting relations of cultural representations, social selves, and media contexts.

7. In their introduction to their book *Curiouser: On the Queerness of Children*, Steven Bruhm and Natasha Hurley discuss the problem of predictable narrative closure as central to a symbolic process that prescribes and disavows the sexual and gender indeterminacy and "perverseness" of children in Western storytelling.

8. While most dominant representations of queer girl sexuality focus on the mutual attractions between girls, it is important to recognize that queer girls articulate their desires in relation to subjects whose gender identifications are not narrowly female or feminine. Many girls I interviewed talked about their attractions to *transboys*, which is a term used to identify transgender youth, girls who identify as boys or who embody female masculinity in diverse ways. At times, girls refer to their attractions to trans or queer boys and reference media texts such as Peirce's film *Boys Don't Cry* or bands such as the Butchies. They also point out how few images there are of transgender girls or boys in mass media texts. In this sense, when it comes to youth media, transgender subjects are largely invisible yet not entirely absent in terms of queer girl perceptions and interests.

9. These accounts often focus on pivotal moments when youth come across a story centered on gay or lesbian experiences. Literacy becomes integral to sexual awakening and self-knowledge as youth learn the codes and rituals of coming out and naming same sex desires. While many authors explore the interesting ways in which youth read not only explicit representations but also engage in complex interpretations of sub-texts, the focus is on the construction of uniform sexual minority identities. See Rob Linne ("Choosing Alternatives to the Well of Loneliness") and Mark Lipton ("To Out the Subtext").

10. I derive this term from Antonio Gramsci's notion of "organic intellectuals" from his *Prison Notebooks*.

11 My choice to focus on mass media texts has limited my ability to study girls as media producers. I feel strongly that comprehensive examinations of grassroots queer girl cultural productions need to be undertaken to complement and supplement work on representation. Judith Halberstam's work on drag king cultures (*Female Masculinity* 1999 and *A Queer Time and Place* 2005) provides useful examples of queer youth theorizing and research in this direction. I am currently in the process of developing a project more closely attuned with Do-It-Yourself performance, video and digital media practices of queer youth.

12 I was a teenager in the late seventies and early eighties when there were few public or personal languages through which to articulate queer youth perspectives. Without a means

to express and speak with others about desires and identifications in-between, those neither lesbian nor heterosexual that I have come to understand as central to my queer femme subjectivity, I lived out heterosexual relations in my youth with a sense of wanting something else. It was not until my early twenties that I hooked into queer movements, cultures, theories, fictions, and communities and began to name myself in queer terms. Looking back, I realize how important representations are in making possible the conditions for becoming a young queer self and of providing the mental concepts and fantasy images through which to imagine a future of possibilities beyond normative prescriptions.

13. The field of feminist qualitative research is too big to reference extensively here, but I would like to acknowledge the importance of the following texts: Norman Denzin ("The Practices and Politics of Interpretation"), Michelle Fine ("Dis-tance and Other Stances"), Patti Lather (*Getting Smart*), A. Oakley ("Interviewing Women"), Jackie Stacey ("Can there be a feminist ethnography?"), and Diane Wolf (*Feminist Dilemmas in Fieldwork*).

14. Judith Halberstam's work on queer subcultures works towards such intergenerational encounters writing that "queer subcultures offer us an opportunity to redefine the binary of adolescence and adulthood. . . . Precisely because many queers refuse and resist the heteronormative imperative of home and family, they prolong the periods of their life devoted to subcultural participation" (*A Queer Time*, 161).

15. Michael Warner stresses the lack of institutionally validated intergenerational transmissions of knowledge between queer youth and adults in his book *The Trouble with Normal*.

16. I sketch out some examples from the field of feminist girl studies in chapter two, but there are a few texts that deserve mention in this introduction for the ways in which they have developed foundations for non-normative girl-centered research and theory. They include the following: Michelle Fine ("Sexuality, Schooling, and Adolescent Females"), Marnina Gonick (*Between Femininities*), Anita Harris (*Future Girl*), Sherrie Inness (*Delinquents and Debutantes*), Mary Celeste Kearny (*Girls Make Media*), Deborah Tolman (*Dilemma's of Desire*).

17. The term *birls* is used by youth within an online community called "Birls" to name themselves as girls who also identify as boys. It signifies the in-between and fluid status of these young people who understand themselves as both female and masculine. This word is used by young people belonging to this community in ways that disrupt closed and binary modes of categorizing girls, and it encompasses a wide range of gender and sexual identifications.

Chapter 2

1. Barbara Hudson's "Femininity and Adolescence" is one of the first scholarly articles to explore the ideological contradictions of growing up as a girl. Her focus is on the tensions between masculine norms of adolescent independence, action and creativity within Western modern capitalist societies and pressures on girls to both attain adolescent status and to embody feminine ideals of passivity and dependence. She offers a starting point for interrogating the ways young femininity is organized as an impossible locus of cultural ideals about gender and generation. In line with feminist research that follows for the next two decades, the very question of female masculinity and non-heterosexual girlhood remains peripheral to critiques of dominant feminine formations.

2. For examples of feminist research focused on intersections of race and class see: Bonnie Leadbeater and Niobe Way's edited collection *Urban Girls*; Kyra D. Gaunt's book *The Games Black Girls Play*; Julie Bettie's book *Women Without Class*.

3. Postmodern feminist theorizations contrast sharply with social science research on girls in which instability, especially sexual instability, becomes read as evidence of being at "at risk" or a "problem" to be solved. While the former generalizes the wayward, yet feminine, desires of girls as symptomatic of broader historical relations, the latter tries to isolate, normalize and pathologize their individual effects. In both instances, it becomes very difficult to hear how girls live out the cultural predicaments surrounding their sex/gender/sexual selves without falling back on either normative or deviant formulations.

4. Grappling with queer gender and sexual dimensions of girls' experiences and meanings qualitatively transforms the kinds of texts, interpretations, and methods used to approach girls and popular culture. Focusing on queer girls also complicates the age dimensions of girl studies. Much academic work on girls has focused on early to mid adolescence, and, while this period is crucial in developmental and educational terms of growth, it is much more difficult to do research on younger queer selves than on older adolescents and young adults. I chose to focus on girls sixteen to twenty-three years of age, which is an age range in which girls are better able to articulate their queer differences in relation to cultural texts, local communities, family, friends, and peers. While selecting this age group is somewhat arbitrary, and girls as young as thirteen years of age spoke eloquently to me about their queer desires and alliances, focusing on older adolescent girls provides me with a clear enough group who are of age to speak with me openly about sexuality and who were interested in elaborating complex and reflexive understandings of their queerness.

5. Freudian ideas about polymorphous perverse sexuality in childhood can be found in his *Three Essays on the Theory of Sexuality* (1905).

6. Bakhtin's notion of the dialogical discusses the coexistence of both centrifugal (away from the center) and centripetal forces (centralizing) of language. (1981)

7. Charles Peirce's *Collected Papers* provide ways of integrating semiotic and materialist theories of language, taking into consideration various modes of interpretants (interlinking sign, object, and meaning), including an action oriented "habit-change" and reflexivity by subjects using cultural signifiers in contextually specific ways.

8. Tracing "experience" across sexual fictions, fantasies, and social relations, de Lauretis uses psychoanalysis as a way of thinking about exchanges between internal and external signifying activities. She writes that "in order to describe the process by which the social subject is produced as a sexual subject and a subjectivity, I consider sexuality as a particular instance of semiosis, the more general process of joining subjectivity to social signification and material reality" (*Technologies of Gender* 15). This disrupts pre-oedipal and oedipal developmental narratives which assume the need for relatively stable gender identifications. By retracing Freud's narration of the normal as "an approximation, a projection, and not a state of being" (*The Practice of Love*), de Lauretis destabilizes oppositions between normal and perverse, rethinking "perversion" in terms of the production of fantasies that have no inherently pathological meaning, indicating a shaky foundation for the "normal." This links up with queer psychoanalytic readings while foregrounding the experiential body as a resisting social process.

9. Many studies use the term "safety" to address both the objective circumstances and the subjective feelings of girls representing themselves in their own Web sites and more generally engaging in a variety of online communications in which control over anonymity and self-identification is negotiated (M. Evard, "So Please Stop, Thank You"; Julian Sefton-Green, *Digital Diversions*; Susannah Stern, "Sexual Selves on the World Wide Web"; Shayla Marie Thiel, " 'IM Me' "). This notion of "safety" is often qualified with the risks and conditional status of feeling safe, pointing to counterexamples in which girls are threatened by unwanted strangers. While there is no fully "safe" space, online communications offer girls a relatively autonomous realm in which both to explore and experiment with self-presentations. I use it cautiously to invoke a contingent sense of being able to openly communicate ideas and experiences with some degree of control over how, when, and where girls represent themselves.

10. Ashley Grisso and David Weiss, "What Are gURLs Talking about?"; Susannah Stern, "Sexual Selves on the World Wide Web"; Shayla Marie Thiel, " 'IM Me.' "

11. Sharon Mazzarella, *Girl Wide Web*; Rhiannon Bury, *Cyberspaces of Their Own*.

Chapter 3

1. Beginning in 1997 on the network WB and ending in 2003 on UPN, the youth drama series *Buffy the Vampire Slayer* became a popular and critically acclaimed show about a girl hero and her friends fighting against demons and vampires in the fictional town of Sunnydale. Along with its development of strong young women characters, *BtVS* offered more sustained and complex representations of love and desire between girls than any other television series. Willow Rosenberg is a central character on this series whose attractions and relationships with both boys and girls open up spaces for considering bisexual, queer, and lesbian identities. Willow's relationship with Tara Maclay becomes the longest televised plot focused on a romantic relationship between female youth, lasting more than two years. In the final season, another lesbian character, Kennedy, is introduced, and an erotic scene between Willow and Kennedy becomes one of the most explicit portrayals of sexuality between girls ever to be showed on television. *BtVS* spurred expansive fan communities around Willow's character and offers unique examples of fictional television characters and narratives that provide girl fans with possibilities for transgressing heteronormative codes of teen romance TV.

2. Glyn Davis makes this point in her insightful essay, " 'Saying it Out Loud': Revealing Television's Queer Teens," in relation to gay characters in teen shows such as *Dawson's Creek* and *My So Called Life*. She argues that the limited representations of gay teens on TV are part of the "liberal conservatism of television representations of queerness" (130).

3. Considering how popular and unique Willow is as a main character on a long-running teen series is significant in that I have found very little formal analysis of Willow's "queer" girl self. There exists a striking gulf between productive dialogues focused on Willow amongst fans and a lack of academic recognition. A few critics, such as Sherman, Mendlesohn, Cover, who have directly grappled with the queer possibilities of *BtVS* refer generally to the show's general symbolic and subtextual possibilities rather than any direct analysis of Willow.

4. "Dopplegangland" is a season-three episode written and directed by Joss Whedon. In this episode, Willow struggles over her personal and public image as a smart "good girl," which

becomes a back drop to an elaborate drama in which she sees a demonic version of herself as a bad and evil other. In the process of doing a spell to retrieve a necklace for Anya (who is presently a mortal who wishes to regain her powers of her previous demon self Anyanka), Willow is transported out of her high school surroundings in Sunnydale, briefly entering an alternate reality, when something goes wrong and an underworld vampire self is called forth as an identical image of Willow. Instead of pulling the necklace out of the alternative reality, Willow brings forth an other self as a vampire who emerges and convinces a group of vampires to work for her as they attempt to kill humans at the Bronze, a local high school hangout. Vamp Willow appears as a dangerous threat, enacting qualities opposed to Willow's quiet gentle "good girl" persona. Vamp Willow is violent, aggressively sexual, bitingly sarcastic, and sadistic. Willow, along with the Scooby gang, works to capture and destroy Vampire Willow, yet this is a complicated process, as Willow confronts her double and is reluctant to kill her, feeling both terrified and repulsed by her, yet also intimately connected to her. This episode stages a series of encounters between Willow and Vamp Willow. In a final fight scene between them, Willow decides to send her double back into the temporal fold of her alternative universe. This episode evokes Willow's fascination and her anxieties about her other self.

5. Excerpt from "Buffy the Vampire Slayer" (episode Dopplegangland) copyright 1999 courtesy of Twentieth Century Fox Television. Written by Joss Whedon.

6. These different interpretations are also staged within the text as Buffy argues that vampires do not share the personality and soul of their human counterparts, while Angel suggests that the boundary is not so clear-cut and that vampires are more closely connected to human selves.

7. "Restless" is an episode in the fourth season that is written and directed by Joss Whedon. This episode frames a series of dream texts. Unable to sleep, Willow, Buffy, Xander, and Giles stay up late at night watching the movie *Apocalypse Now*, and they all fall asleep soon after it begins. One by one, their dreams are elaborated to unfold key aspects of their psychic fears, desires, and social conflicts. The episode begins with Willow painting a Sapphic love poem in Greek on Tara's back, followed by a performance of *Death of a Salesman* as part of a drama class in which she is enrolled. Willow realizes with terror that she does not know her lines, her role, or her position in the drama. Willow is then shown standing up in front of her high school class in her geeky clothes, being laughed at and ridiculed by other students. At the end of the dream, she is attacked and killed by the "First Slayer" with all her classmates watching. "Restless" explores each character's unconscious wishes and anxieties, providing insight into his/her past experiences and also a glimpse of future developments. Willow's uneasiness about her relationship with Tara, her uncertainty about coming out and her struggle to overcome her nerdiness emerge out of this dream segment, focusing attention onto key elements of her emotional and psychic life that will be explored in forthcoming seasons.

8. The *Scooby gang* refers to the group of close friends that support and help Buffy fight against demons and vampires. This group changes over the years, but its core consists of Willow, Xander, and Buffy.

9. This hesitance to use sexual identity labels also jibes with many of the young queer girls I interviewed who have come out yet are hesitant to name themselves "lesbian" as an transparent term of identity.

10. Discussions of network restrictions pervade many online fan sites and popular reviews. On the Web site After Ellen, Sarah Warn writes that "In a May 2000 post on the website The Bronze, Buffy creator Joss Whedon responded to criticism over this issue, writing 'Are we

forced to cut things between Willow and Tara? Well, there are things the network will not allow us to show. As for example kissing.' In an interview in this month's *Girlfriends* Magazine, Amber Benson provides her perspective on the issue: 'Alyson and I thought at times that we needed to be doing more kissing. Part of that was the WB wanting to take it slowly, but when we got to UPN they let us do whatever, and things began to change' " (2003).

11. Willow's transformations are vividly represented in terms of her emotions, words, physical powers, and supernatural capabilities. Not only does Willow change in terms of her assertion of aggressively violent actions, but she also changes in terms of her deeply pessimistic attitude, which becomes embodied in the darkness of her clothes, hair, and skin. Her transformations are also signified in terms of the tone of her voice and speech patterns.

12. A complex and long discussion on the meanings of the lesbian cliché in relation to season six can be found on the fan site The Kitten, The Witches, and the Bad Wardrobe.

13. A frequently referenced essay discussing this is Robert A. Black's "It's Not Homophobia, but That Doesn't Make It Right."

14. Xander is Willow's close friend who has known her since childhood and comments upon her profound changes as she becomes a powerful witch. Xander makes a sharp distinction between the Willow he refers to as the shy nerdy girl from the early seasons of the show and the immensely powerful supernatural woman she represents in terms of her physical might and her "scary veiny" appearance by the end of season six.

15. Excerpt from "Buffy the Vampire Slayer" (Episode "Triangle") copyright 2001 Courtesy of Twentieth Century Fox Telivision. Written by Jan Espenson. All rights reserved.

Chapter 4

1. Although there has been much discussion about a growing body of films referred to as *New Queer Cinema*, the status of teen films as part of this movement has yet to be analyzed in any systematic way. In many cases, those films featuring female youth tend to get dismissed as less queer and innovative, belittled in terms of their marketability and mainstream appeal. Michele Aaron documents a diverse range of genres and texts that refer to New Queer Cinema, yet when she explicitly mentions many of the teen romance films to which I draw attention in this chapter, they are dismissed as "fairly innocuous, and often unremarkable films targeting a narrow, rather than all-inclusive, new queer audience" (*New Queer Cinema*, 8). I argue that, while perhaps films focusing on desire between girls are less "defiant" and "radical" in terms of their textual experimentation and sexual content, they open up complex modes of interpretation and spectatorship that need to be appreciated in queer terms rather than dismissed in abstraction from their specificity.

2. David Considine's *The Cinema of Adolescence* provides an insightful example of early critical analysis of youth that focuses on idealizing moral constructions of girls' sexuality in Hollywood films.

3. Barbara Creed's *The Monstrous-Feminine* offers an extensive discussion of the gendered dimensions of abjection in horror films.

4. There is an expansive and growing range of queer film production and reception literature that includes the following: Michele Aaron, *New Queer Cinema*; Harry M. Benshoff, *Queer Cinema: The Film Reader*; Alexander Doty, *Making Things Perfectly Queer: Interpreting Mass*

Culture; Richard Dyer, *Now You See It: Studies in Lesbian and Gay Film*; Ellis Hanson, *Out Takes: Essays on Queer Theory and Film*; Andrea Weiss, *Vampires and Violets*; Patricia White, *UnInvited: Classical Hollywood Cinema and Lesbian Representability*; and Tamsin Wilton, *Immortal Invisible: Lesbians and the Moving Image*.

5. In "Afterthoughts on 'Visual Pleasure and Narrative Cinema' Inspired by King Vidor's *Duel in the Sun*," Laura Mulvey explores women as spectators, arguing that the heroine of traditional cinema oscillates between masculine and feminine positions, "echoed by the woman spectator's masculine point of view" (30). The female spectator still has to adopt a male perspective, though this is based on the structure of the film narrative and traditions which make trans-sex identification "second nature" (32–3).

6. Some feminist theorists who focus on relations between women in films include Teresa de Lauretis, Karen Hollinger, Mary Celeste Kearney, Judith Mayne, and Jackie Stacey.

7. Feminist theorists grappling with these ideas include Jane Gaines, "Women and Representation: Can We Enjoy Alternative Pleasure?"; Kaja Silverman, *The Acoustic Mirror*; Teresa de Lauretis, *Alice Doesn't* and *The Practice of Love*; Judith Mayne, *Woman at the Keyhole*; and Mary Ann Doane, *Desire to Desire*.

8. Laura Mulvey has theorized this process of fetishization through a psychoanalytic lens in relation to classic cinema in her famous essay "Visual Pleasure and Narrative Cinema." While many feminists, including Jackie Stacey in her article "Desperately Seeking Difference", have attempted to broaden Mulvey's analysis by focusing on the force of women's identifications with each other across differences, the sexual aspects of a girl's gaze have not been elaborated. At this point, I want to gesture toward the need for work in this area that attends to the mobile intersubjective desire of a queer adolescent gaze.

9. Laura Mulvey writes, "In their traditional exhibitionist role women are simultaneously looked at and displayed, with their appearance coded for strong visual and erotic impact so that they can be said to connote to-be-looked-at-ness" ("Visual Pleasure" 487).

10. *But I'm a Cheerleader* has exceeded its meaning as a discrete text to become a subcultural point of reference for queer youth. There are online communities and fan sites devoted to this film as a basis for extended dialogue about the characters, story, celebrities, and campy humor.

Chapter 5

1. To find any magazine that speaks to girls otherwise, it is necessary to look away from the teen rack and into the small scattered section of alternative or low-budget zines and magazines, such as *Bitch*, *Bust*, *Kiss Machine* and *Shameless*. Addressing older teens and young women, these feminist publications work to challenge mass media homogeneity by foregrounding the creative and critical voices of youth. While queer subjects and issues are a small part of the content of these magazines, they remain marginal to a broader third-wave feminist agenda.

2. See Mazzarella, McRobbie, and Peirce.

3. The Butchies are a distinctly queer rock band whose performative embodiments and lyrics consciously play with gender identities and sexualities. While all the band members embody female masculinity, they challenge assumptions about what constitutes binary norms of femininity and masculinity, naming one of their albums "Are We Not Femme?" as a provocative and

uncertain question. The Butchies productively use their images and music to open up the process of queer representation, actively addressing queer youth fans.

4. Diva Mobile is a mobile phone service; it is cross-promotionally connected to *DIVA* magazine.

Chapter 6

1. Online Communities and Website addresses include: Transproud (www.transproud.com/); Transyouth Webring (http://members.aol.com/gendervariant/youth/transring.htm); Superdyke (www.superdyke.com); Lesbotronic (www.lesbotronic.com); Gaydar (www. scarleteen,com/gaydar/index.html); Pink Sofa (www.thepinksofa.com); Technodyke (www.technodyke.com); Pheline (www.pheline.com/).

2. I analyzed archived discussions on ikissgirls and birls LiveJournal communities between August 1-August 8, 2004.

Chapter 7

1. This is a quote by Kaia Wilson from the band the Butchies in which she remarks that "we get a lot of letters from fans and kids coming up to us at shows and saying, 'Your music changed my life. I needed something queer' " (qtd. in Ciminelli and Knox 186).

2. Very little has been written about queer female youth music cultures. Angela Wilson offers a rare examination of lesbian punk rock music in her essay " 'The Galaxy is Gay': Examining the Networks of Lesbian Punk Rock Subculture." But while Wilson traces connections between "dykecore" music and feminist and queer politics, she does not analyze the ways young women engage with this genre.

3. While music is a distinct cultural mode of production and reception, it is complexly interwoven into film and television texts, such that all the independent films discussed in chapter four contain music by queer girl bands and individual artists. Music is also a central focus of print media, such as the lesbian magazines analyzed in chapter five.

4. Kanye West spoke out against homophobia in hip hop during an August 2005 special of MTV.

5. Gopinath expands upon Josh Kun's term "audiotopia" (259) to explore diasporic queer South Asian musical formations, taking into account hybrid styles of musical texts and modes of reception that address subjects marginalized within male dominated postcolonial contexts. Her method overcomes totalizing readings that erase queer diasporic possibilities, honing in on specific and situated moments of queer meanings and desires within globalized economic and cultural systems. Paying close attention to texts that represent and speak to the lives of women marginalized within normative public spheres of cultural value, Gopinath opens spaces for counter-public knowledge about diasporic female queer experiences.

6. t.A.T.u. is a Russian girl pop band including Yulia Volkova and Lena Katina as singers. The band emerged in 2001 with lyrics and images focusing on girl-on-girl desires and romance. By 2003 they reached the top of the sales charts and their explicit images of girls kissing provoked international controversy when BBC1's show Top Of The Pops banned the video

for the song "All the Things She Said," for showing explicit images of two girls kissing. Critics focus on the Lolita and mainstream pornographic stylization of these "lesbian" images, marketed for mainstream consumption and titillation, drawing attention to the fact that they are not "real" lesbians. While the commodification of young lesbian sexuality for publicity is an important element in understanding this band's gimmick, not all the girls I spoke with dismiss t.A.T.u. as an inauthentic representation that exploits girl sexuality for media attention. Some girls talk about the personal importance of seeing media images of sexy girls kissing each other in public, regardless of commercial intention and appropriation, using this pop band to elaborate their own erotic fantasies and interests in mass mediated icons.

7. I use the term "assemblage" to refer to a diverse aggregation of musical styles and receptions. I also use it to gesture towards Deleuze and Guattari's theorization of assemblages in terms of "states of force and regimes of signs to intertwine their relations" (71), as a way of thinking about dispersed powers and pleasures of queer girl musical formations in discursive terms rather than as autonomous and naturalized individual choices.

8. More recent ethnographically oriented cultural studies investigating the importance of hip hop music in the lives of African American and African Canadian youth have honed in on the race, class, and gender specificity of music fans and communities, overcoming abstractions within sociological accounts. Greg Dimitriadis explores the experiential narratives and everyday interactions of black youth in his book *Performing Identity/Performing Culture*, paying close attention to how they engage with hip hop music as a tool for shaping their identities and social interpretations. Rather than conceptualize the general effects and meanings of music, Dimitriadis details the emotional and intellectual negotiations of marginalized youth within contexts of racial violence and class conflict. Music becomes a living text through which youth articulate their belonging, fears, and desires. Within this perspective, youth become creative participants in a flexible process of meaning making, crisscrossing material and cultural realms. But while the subcultural nuances of hip hop are vividly located in the daily relations of boys, girls' voices are muted. Thinking through hip hop cultures across the subjective perceptions of male and female youth, Jennifer Kelly's book *Borrowed Identities* elaborates an inclusive dialogical approach to hip hop youth cultures, providing a richly detailed analysis of "regimes of representation" constituting racial, gender, and sexual discourses interwoven into the musical practices of African Canadian youth. What is so useful about Kelly's approach is her attentiveness to the intimate words of black youth within globalized systems of commodified music production. Kelly suggests that youth experiences of selfhood are ambivalent within a process of mediation that subjects them to dominant discourses without foreclosing active responses, contestation, and contradictions. Although Kelly does not consider the predicaments of queer youth, she provides a textured framework within which to consider a pluralization of identities refracted through global musical formations.

9. Many recent feminist accounts of music have expanded the range and frameworks through which to understand women's music. These include *Women and Popular Music* by Sheila Whiteley, *Frock Rock* by Mavis Bayton, and *Respect: Women and Popular Music* by Dorothy Marcic.

10. Some key examples in this field of third wave feminist writers include: Leslie Heywood and Jennifer Drake (*Third Wave Agenda*), Allyson Mitchell, Lisa Bryn Rundle and Lara Karaian (*Turbo Chicks*), Daisy Hernandez and Bushra Rehman (*Colonize This*), Barbara Findlen

(*Listen Up*), Rory Cooke Dicker and Alison Piepmeier (*Catching a Wave*), and Jo Reger (*Different Wavelengths*).

11. Pratibha Parmar's Film *Righteous Babes* is a key text in articulating intersections between third-wave feminism and women's music.

12. The book *Girls Rock!: Fifty Years of Women Making Music* by Mina Julia Carson does provide a more inclusive consideration of the emergence and experiences of lesbian, queer, and youth-oriented artists working within established and underground musical realms but leaves little room to consider a process of reception and engagement by girls.

13. There is very little discussion of queer sexuality within academic discussions of hip hop. There is however an outstanding documentary called *Pick Up the Mic*, directed by Alex Hinton, which offers a broad representation of U.S. queer hip hop cultures.

14. While girls focused on local concerts, they also referred to annual events such as Ladyfest and Homo A Go Go that work to bridge queer media, genres, and politics.

15. D'bi Young's poem "gendah bendah" is published in her first book *Art on Black*.

16. Drag king performances are another very important cultural realm in which female masculinity is a focal point. See Judith Halberstam's *Female Masculinity* and *The Drag King Book* for extensive discussion of Drag King performances and communities.

17. MuchMusic. MuchMusic is a 24-hour national Canadian cable music and variety television channel based in Toronto, Ontario, Canada.

18. Lauraine Leblanc's book *Pretty in Punk* addresses the constraints on girl punk gender identity within male dominated punk communities while also addressing the ways in which girls resist these constraints and embody elements of masculinity in combination with femininity as part of their sub-cultural style.

19. I use and reorient Nick Couldry's notion of the "media ritual," which he defines as "any actions organized around key media related categories and boundaries, whose performance reinforces, indeed helps to legitimate, the underlying 'value' expressed in the idea that the media is our access point to our social center." Whereas Couldry is focused on dominant media rituals, I borrow this term to think about how marginal social subjects also create rituals using alternative forms of media.

20. The Gladstone is a hotel and performance venue in downtown Toronto that hosts a range of queer positive events which include alternative local bands that appeals to queer girls.

Chapter 8

1. Susan Talburt's work on queer youth cogently explores the limited frameworks within which attempts are made to construct queer youth in terms of a problem or to assimilate them within liberal discourse of normalized sameness. In either case, sexual and gender identity are naturalized and individualized, leaving little room to examine the social and cultural conditions of through which queer youth negotiate meanings for themselves (2000).

2. The notion of *glocalization* refers to the ways in which hegemonic Western cultural texts travel into multiple contexts in ways that do not merely reproduce monolithic meanings but open up texts according to specific local and changing conditions of use and reception (Robertson).

REFERENCES

Aaron, Michele, ed. *New Queer Cinema*. New Brunswick: Rutgers University Press, 2004.

Addison, Joanne, and Michelle Comstock. "Virtually Out." *Generations of Youth*. Ed. Joe Ausin, et al. New York: New York UP, 1998. 367–378.

All Over Me. By Sylvia Sichel. Dir: Alex Sichel. Perf: Alison Folland and Tara Subkoff. Baldini and Medusa Pictures. 1996.

Anderson, Benedict. *Imagined Communities: Reflections on the Origin and Spread of Nationalism*. London: Verso, 1991.

Bakhtin, Mikhail. *The Dialogic Imagination*. Austin: University of Texas Press, 1981.

———. *Speech Genres and Other late Essays*. Austin: University of Texas Press, 1986.

Bartlem, Edwina. "Coming Out on a Mouth of Hell." *Refractory: A Journal of Entertainment Media*. Vol. 2. March 2003. <http://www.refractory.unimelb.edu.au/journalissues/vol2/edwinabartlem.html>. Accessed on December 10, 2004.

Battis, Jes. "She's Not All Grown Yet: Willow as Hybrid/Hero in *Buffy the Vampire Slayer*." *Slayage: The Online International Journal of Buffy Studies*. Vol. 8.,2003. <http://www.slayage.tv/PDF/index.htm>. Accessed on January 20, 2005.

Bayton, Mavis. *Frock Rock: Women, Performing, Popular Music*. Oxford: Oxford UP, 1998.

Beirne, Rebecca. "Queering the Slayer Text: Reading Possibilities in *Buffy the Vampire Slayer*." *Refractory: A Journal of Entertainment Media*. Vol. 5, 2004. http://www.refractory.unimelb.edu.au/journalissues/vol5/beirne.html. Accessed April 4, 2005.

Benshoff, Harry M, and Sean Griffin, eds. *Queer Cinema: The Film Reader*. New York: Routledge, 2004.

Bettie, Julie. *Women Without Class: girls race and identity*. Berkeley: University of California Press, 2003.

Bitch and Animal. "Boy Girl Wonder," *Eternally Hard*, Righteous Babe, 2001.

Black, Robert A. "It's Not Homophobia, but That Doesn't Make It Right." http://www.dykesvision.com/en/articles/homophobia.html. Accessed April, 2004.

Britzman, Deborah. "Precocious Education." *Thinking Queer: Sexuality, Culture, and Education*. Ed. Susan Talburt and Shirley Steinberg. New York: Peter Lang, 2000. 3–60.

Brownworth, Victoria. "De-sexing the Cherry" *Curve* 13.1 (2003).

Bruce, Jean. "Querying/Queering the Nation." *Gendering the Nation: Canadian Women's Cinema*. Ed. Kay Armatage. Toronto: U of Toronto P, 1999.

Bruhm, Steven, and Natasha Hurley, eds. *Curiouser: On the Queerness of Children*. Minneapolis: U of Minnesota P, 2004.

Butchies. "More Rock, More Talk". *Population 1975*. Mr Lady Records, 1999.

Bury, Rhiannon. *Cyberspaces of Their Own: Female Fandoms Online*. New York: Peter Lang, 2005.

But I'm a Cheerleader. By: Jamie Babbit. Dir: Jamie Babbit. Perf: Natasa Lyonne and Clea DuVall. HKM Films. 1999.

Butler, Judith. *Bodies That Matter*. New York: Routledge, 1993.

———. *Gender Trouble*. New York: Routledge, 1989.

———. "Gender Trouble, Feminist Theory, and Psychoanalytic Discourse." *Feminism/Postmodernism*. New York: Routledge, 1990. 324–340.

———. "Imitation and Gender Subordination." *Inside/Out*. Ed. Diana Fuss. New York: Routledge, 1991.

———. *Undoing Gender*. New York: Routledge, 2004. 13–31.

Carpenter, Laura. "From Girls into Women: Scripts for Sexuality and Romance in *Seventeen* Magazine, 1974–1994." *The Journal of Sex Research*. 35.2 (May 1998): 158–68.

Carson, Mina Julia. *Girls Rock!: Fifty Years of Women Making Music*. Lexington, KY: UP of Kentucky, 2004.

Case. Sue Ellen. "Toward a Butch-Femme Aesthetic." *Making a Spectacle: Feminist Essays on Contemporary Women's Theatre*. Ed. Lynda Hart. Ann Arbor: University of Michigan Press, 1989. 282–299.

Chayko, Mary. *Connecting: How We Form Social Bonds and Communities in the Internet Age*. New York: SUNY P, 2002.

Christenson, Peter, and Donald Roberts. *It's Not Only Rock and Roll: Popular Music in the Lives of Adolescents*. Cresskill, NJ: Hampton P, 1997.

Ciasullo, Anne M. "Making Her (In)visible: Cultural Representations of Lesbianism and the Lesbian Body in the 1990s." *Feminist Studies* 27 (2001): 577–609.

Ciminelli, David, and Ken Knox. *Homocore: The Loud and Raucous Rise of Queer Rock*. Los Angeles: Alyson, 2005.

Clark, Danae. "Commodity Lesbianism." *Out in Culture: Gay, Lesbian, and Queer Essays on Popular Culture*. Ed. Corey K. Creekmur. Durham: Duke UP, 1995. 484–99.

Considine, David. *The Cinema of Adolescence*. London: MacFarland, 1985.

Couldry, Nick. Media Rituals: A Critical Approach. New York: Routledge, 2003.

Cover, Rob. "From Butler to Buffy: Notes towards a Strategy for Identity Analysis in Contemporary Television Narrative." *Reconstruction Studies in Contemporary Culture* 4.2 (Spring 2004).

Creed, Barbara. *The Monstrous-Feminine*. London: Routledge UP, 1993.

Currie, Dawn. *Girl Talk: Adolescent Magazines and Their Readers.* Toronto: U of Toronto P, 1999.

Cvetkovich, Ann. *An Archive of Feelings: Trauma, Sexuality, and Lesbian Public Cultures.* Durham: Duke UP, 2003.

Dagget, Gina. "Coming Out, Going Pro." *Girlfriends.* July 2003. 18–21.

Davis, Glyn. " 'Saying It Out Loud': Revealing Television's Queer Teens." *Teen TV: Genre, Consumption, Identity.* Ed. Glyn Davis and Kay Dickinson. London: British Film Institute, 2004. 127–140.

de Certeau, Michel. *Culture in the Plural.* Ed. Luce Giard. Translated by Tom Conley. Minneapolis: University of Minnesota Press, 1998.

de Lauretis, Teresa. *Alice Doesn't: Feminism, Semiotics, Cinema.* Bloomington: Indiana UP, 1984.

———. *The Practice of Love: Lesbian Sexuality and Perverse Desire.* Bloomington: Indiana UP, 1994.

———. *Technologies of Gender.* Bloomington: Indiana UP, 1987.

De Vries, Gina. "Ten Dyke Activists to Watch." *Curve.* April 2005. 22–23.

Denzin, Norman. "The Practices and Politics of Interpretation." *Handbook of Qualitative Research.* Ed. Norman K. Denzin and Yvonna S. Lincoln. London: Sage, 2000. 897–922.

Deleuze, Gilles, and Felix Guattari. *Anti-Oedipus.* Trans. R. Hurley, M. Seem, and H. R. Lane. Capitalism and Schizophrenia, Volume One. Minneapolis: University of Minnesota Press, 1987.

Dicker, Rory Cooke and Alison Piepmeier. *Catching a Wave.* Boston: Northeastern UP, 2003.

Dimitriadis, Greg. *Performing Identity/Performing Culture: Hip Hop as Text, Pedagogy and Lived Practice.* New York: Peter Lang, 2001.

Doane, Mary Ann. *Desire to Desire: The Woman's Film of the 1940s.* Bloomington: Indiana UP, 1987.

"Dopplegangland." *Buffy the Vampire Slayer.* By Joss Whedon. Dir. Joss Whedon. Episode 6.16, 1999.

Doty, Alexander. *Making Things Perfectly Queer: Interpreting Mass Culture.* Minneapolis: U of Minnesota P, 1993.

Driscoll, Catherine. *Girls: Feminine Adolescence in Popular Culture and Cultural Theory.* New York: Columbia UP, 2002.

du Plessis, Michael, and Kathleen Chapman. "Queercore: The Distinct Identities of Subculture." *Queer Utilities: Textual Studies, Theory, Pedagogy, Praxis.* Spec. issue of *College Literature* 24.1 (Feb 1997). 45–58.

Dyer, Richard. *Now You See It: Studies in Lesbian and Gay Film.* London: Routledge, 2003.

Edelman, Lee. *No Future: Queer Theory and the Death Drive.* Durham: Duke UP, 2004.

Edwards, Lynne. "Slaying in Black and White: Kendra as Tragic Mulatto in *Buffy the Vampire Slayer.*" *Fighting the Forces: What's at Stake in* Buffy the Vampire Slayer. Lanham, MD: Rowman & Littlefield, 2002. 85–97.

Evard, M. " 'So Please Stop, Thank You': Girls Online." *Wired Women.* Eds. L. Cherney and E. R. Welse. Seattle: Seal Press, 1996. 188–204.

Findlen, Barbara, ed. *Listen Up: Voices from the Next Feminist Generation.* Seattle: Seal Press, 1995.

Fine, Michelle. "Dis-tance and Other Stances: Negotiations of Power inside Feminist Research." *Power and Method: Political Activism and Educational Research.* Ed. A. Gitlin. New York: Routledge, 1994. 13–35.

————. "Sexuality, Schooling, and Adolescent Females: The Missing Discourse of Desire." *Toward a New Psychology of Gender: A Reader.* Ed. M. Gergen and S. Davis. New York: Routledge, 1988. 375–402.

Fish, Stanley. *Doing What Comes Naturally: Changing Rhetoric and the Practices of Theory in Literary and Legal Studies.* Durham: Duke University Press, 1990.

————. *Is There a Text in this Class?: The Authority of Interpretive Communities.* Cambridge, MA: Harvard UP, 1980.

Freud, Sigmund. *Three essays on the theory of sexuality.* Vol. 7. *The standard edition of the complete psychological works of Sigmund Freud.* Edited and translated by James Strachey. London: Hogarth Press. 1905. 125–243.

Frith, Simon. "Music and Identity." Questions of Cultural Identity. Eds. Stuart Hall and Paul Du Gay. London: Sage, 1996. 108–127.

————. *Sound Effects: Youth, Leisure, and the Politics of Rock.* London: Constable, 1983.

Frost, Liz. *Young Women and the Body: A Feminist Sociology.* New York: Palgrave, 2001.

Fuss, Diana. 1991. *Inside/out: Lesbian Theories, Gay Theories.* New York: Routledge, 1991.

Gaines, Jane. "Women and Representation: Can We Enjoy Alternative Pleasure?" *Jump Cut* 29 (1984). 25–27.

Gaunt, Kyra. *The Games Black Girls Play.* New York: New York University Press, 2006.

Geertz, Clifford. *The Interpretation of Cultures: Selected Essays.* New York: Basic, 1973.

Giroux, Henry. *Stealing Innocence: Youth Corporate Power and the Politics of Culture.* New York: St. Martin's, 2000.

————. "Public Pedagogy and the Politics of Resistance." Education Philosophy and Theory. Vol. 35 (1), January 2003, 5–16.

Go Fish. By: Rose Troche and Guinevere Turner. Dir: Rose Troche. Perf: Guinevere Turner. Dancing Gir. 1994.

Gonick, Marnina. *Between Femininities: Ambivalence, Identity and the Education of Girls.* New York: SUNY Press, 2003.

————. "Sugar and Spice and Something More than Nice? Queer Girls and the Transformations of Social Exclusion." *Girlhood: Redefining the Limits.* Eds. Yasmin Jiwani, Candis Steenbergen, Claudia Mitchell. Montreal: Black Rose Books, 2006.

Gopinath, Gayatri. Impossible Desires: Queer Diasporas and South Asian Public Cultures. Durham: Duke University Press, 2005.

Gottlieb, Joanne, and Gayle Wald. "Smells Like Teen Spirit: Revolution and Women in Independent Rock." *Microphone Fiends: Youth Music and Youth Culture.* Ed. Andrew Ross and Tricia Rose. New York: Routledge, 1994. 250–74.

Gramsci, Antonio. *Prison Notebooks.* Ed. Joseph A. Buttigieg. Trans. Joseph A. Buttigieg and Antonio Callari. New York: Columbia UP, 1992.

Greenfield, Lauren. "Mirror, Mirror." *Girl Culture.* San Francisco: Chronicle, 2002. <http://dizzy.library.arizona.edu/branches/ccp/education/girlculturefacultyguide/essays/green-field.htm>. Accessed on November 5, 2005.

Grisso, Ashley D, and David Weiss. "What Are gURLs Talking about? Adolescent Girls' Construction of Sexual Identity on gURL.com." *Girl Wide Web: Girls, the Internet, and the Negotiation of Identity.* Ed. Sharon Mazzarella. New York: Peter Lang, 2005. 31–50.

Gross, Larry. *Up from Visibility: Lesbians, Gay Men, and the Media in America.* New York: Columbia UP, 2001.

Grosz, Elizabeth. *Time Space and Perversion: Essays on the Politics of Bodies.* New York: Routledge, 1995.

Halberstam, Judith. *Female Masculinity.* Durham: Duke University Press, 1999.

———. *In a Queer Time and Place: Transgender Bodies, Subcultural Lives.* New York: New York UP, 2005.

Hall, Stuart. "Notes on Deconstructing the Popular." *People's History and Socialist Theory.* Ed. Raphael Samuel. London: Routledge & Kegan Paul, 1981. 227–249.

Hanson, Ellis, ed., *Out Takes: Essays on Queer Theory and Film.* Durham: Duke UP, 1999.

Harris, Anita. *All about the Girl: Power, Culture, and Identity.* New York: Routledge, 2004.

———. *Future Girl: Young Women in the Twenty-First Century.* New York: Routledge, 2004.

Hartley, John and Catharine Lumby. "Working Girls or Drop-Dead Gorgeous? Young Girls in Fashion and News." *Youth Cultures: Texts, Images, and Identities.* Ed. Kerry Mallan and Sharyn Pearce. Westport, CT: Praeger, 2003. 47–68. Hebdige, Dick. *Subculture.* New York: Routledge, 1994. 47–67.

Helford, Elyce Rae. " 'My Emotions Give Me Power': The Containment of Girls' Anger in Buffy." *Fighting the Forces: What's at Stake in* Buffy the Vampire Slayer. Lanham, MD: Rowman & Littlefield, 2002. 18–34.

Herbitter, Cara. "Beth Ditto: the punk goddess shoots her mouth off." *On Our Backs.* June-July, 2003, 32–37.

Hernandez, Daisy and Bushra Rehman, eds. *Colonize This.* New York: Seal Press, 2002.

Heywood, Leslie and Jennifer Drake, eds. *Third Wave Agenda.* University of Minnesota, 1997.

Hollinger, Karen. *In the Company of Women.* Minneapolis: U of Minnesota P, 1993.

Huegel, Kelly. *GLBTQ: The Survival Guide for Queer and Questioning Teens.* Minneapolis: Free Spirit, 2003.

Huwig, Pam. "Getting It On With the Butchies." *Curve.* August 2001. 28–29.

Inness, Sherrie. *Delinquents and Debutantes: Twentieth-Century American Girls' Cultures.* New York: New York UP, 1998.

Jet, "Too Cool For School." *Diva.* July 2004. 27–31.

Jhally, Sut. "Image-Based Culture—Advertising and Popular Culture." *Gender, Race and Class in Media.* Ed. Gail Dines and Jean M. Humez. Thousand Oaks: Sage, 2003. 249–57.

Kaplan, Elaine Bell, and Leslie Cole. " 'I Want to Read Stuff on Boys' ": White, Latina, and Black Girls Reading *Seventeen* Magazine and Encountering Adolescence." *Adolescence* 38.149 (Spring 200): 141–58.

Kearney, Mary Celeste. *Girls Make Media.* New York: Routledge. 2006.

———. "Girlfriends and Girl Power: Female Adolescence in Contemporary U.S. Cinema." *Sugar, Spice, and Everything Nice: Cinemas of Girlhood.* Ed. Frances Gateward and Murray Pomerance. Detroit: Wayne State UP, 2002. 125–142.

———. "The Missing Link: Riot Grrrl, Feminism, Lesbian Culture." *Sexing the Groove: Popular Music and Gender.* Ed. S. Whiteley. London: Routledge, 1997. 207–29.

———. "Producing Girls: Rethinking the Study of Female Youth Culture." Delinquents and Debutantes. Ed. Sherrie Inness. New York: New York University Press, 1998. 285–310.

Kelly, Jennifer. *Borrowed Identities.* New York: Peter Lang. 2003.

Klein, Naomi. *No Logo: Taking Aim at the Brand Bullies.* New York: Picador, 2000.

Kovalchik, Aaron. "Femmes on Film." *On Our Backs.* Dec.-Jan. 2003. 22–27.

Kun, Josh. "Rock's Reconquista," Rock over the Edge: Transformations in Popular Music. Ed. Roger Beebe. Durham: Duke University Press, 2002.

Lamos, Colleen. "The Postmodern Lesbian Position: On Our Backs." The Lesbian Postmodern. Ed. Laura Doan. New York: Columbia UP, 1994. 85–103.

Lather, Patti. Getting Smart: Feminist Research and Pedagogy with/in the Postmodern. New York: Routledge, 1991.

Leadbeater, Bonnie J. Ross and Niobe Way, eds. Urban Girls: Resisting Stereotypes, Creating Identities. New York University Press, 1996.

Leblanc, Lauraine. Pretty in Punk: Girls' Gender Resistance in a Boys' Subculture. New Brunswick: Rutgers University Press, 1999.

Leonard, Marion. " 'Rebel Girl, You Are the Queen of My World': Feminism, 'Subculture' and Grrrl Power." Sexing the Groove: Popular Music and Gender. Ed. Sheila Whiteley. New York: Routledge, 1997. 230–55.

Lewis, Jon. The Road to Romance & Ruin: Teen Films and Youth Culture. New York: Routledge, 1992.

Le Tigre. "Keep on Livin." Feminist Sweepstakes. Mr. Lady Records. 2001.

———. "Viz." This Island. Universal Records. 2004.

Linne, Rob. "Choosing Alternatives to the Well of Loneliness." Thinking Queer: Sexuality, Culture and Education. Eds. Susan Talburt and Shirley R. Steinberg. New York: Peter Lang, 2000. 201–214.

Lost and Delirious. By Susan Swan and Judith Thompson. Dir. Lea Pool. Perf. Piper Perabo and Jessica Pare. Dummett Films. 2001.

Mark Lipton. "Queer Readings of Popular Culture: Searching [to] Out the Subtext." Queer Youth Cultures. Ed. Susan Driver. New York: SUNY Press, (forthcoming).

Mallen, Kerry, and John Stephens. "Love's Coming (Out): Sexualizing the Space of Desire." Media Culture Journal 5.6 (2002).

Martindale, Kathleen. Un/Popular Culture: Lesbian Writing after the Sex Wars. New York: SUNY Press, 1997.

Mayne, Judith. Framed: Lesbians, Feminists, and Media Culture. Minneapolis: U of Minnesota P, 2000.

———. The Woman at the Keyhole: Feminism and Women's Cinema. Bloomington: Indiana UP, 1990.

Mazzarella, Sharon, ed. Girl Wide Web: Girls, the Internet, and the Negotiation of Identity. New York: Peter Lang, 2005.

Mazzarella, Sharon, and Norma Pecora, eds. Growing Up Girls: Popular Culture and the Construction of Identity. New York: Peter Lang, 1999.

McCarthy, Anna. "Ellen: Making Queer Television History." GLQ, vol.7, no.4 (2001): 593–620.

McClary, Susan. Feminine Endings: Music, Gender, and Sexuality. Minneapolis: U of Minnesota P, 2002.

McRobbie, Angela. Feminism and Youth Culture. 2nd ed. New York: Routledge, 2000.

———. Feminism and Youth Culture: From 'Jackie' to 'Just Seventeen'. Houndmills: Macmillan, 1991.

———. "Shut Up and Dance: Youth Culture and Changing Modes of Femininity." Feminism and Cultural Studies. Ed. Morag Shiach. Oxford UP, 1999. 65–88.

Mendlesohn, Farah. "Surpassing the Love of Vampires; or, Why (and How) a Queer Reading of the Buffy/Willow Relationship Is Denied." *Fighting the Forces: What's at Stake in* Buffy the Vampire Slayer. Ed. Rhonda Wilcox and David Lavery. New York: Rowman & Littlefield, 2002. 45–60.

Miles, Steven. "Researching Young People as Consumers: Can and Should We Ask Them Why?" *Researching Youth.* Ed. Andy Bennett, Mark Cieslik, and Steven Miles. New York: Palgrave, 2003. 170–85.

Moritz, Meg. "Lesbian Chic: Our Fifteen Minutes of Celebrity?" *Feminism, Multiculturalism, and the Media: Global Diversities.* Ed. A. N. Valdivia. Thousand Oaks, CA: Sage, 1995. 127–44.

Morton, Mavis. "Growing up gay in rural Ontario: The needs and issues facing rural gay, lesbian, bisexual, and transgendered rural youth." Report of the GLBT Planning Group of Haldimand Norfolk. 2003.

Mulvey, Laura. "Afterthoughts on 'Visual Pleasure and Narrative Cinema' Inspired by King Vidor's *Duel in the Sun.*" *Framework* 15–17 (1981). 12–15.

———. "Visual Pleasure and Narrative Cinema." *Feminism and Film Theory.* Ed. C. Penley New York: Routledge, 1988. 57–68.

Munoz, Jose Esteban. *Disidentifications: Queers of Color and the Performance of Politics.* Minneapolis: Minnesota Press, 1999.

Nagel, Jill. "Beyond Child's Play." *On Our Backs.* Oct.-Nov. 2000. 28–29.

"New Moon Rising." Buffy the Vampire Slayer. By Mari Noxon. Dir. James A. Contner. Episode 4.19, 2000.

Oakley, A. "Interviewing Women: A Contradiction in Terms." *Doing Feminist Research.* Ed. Helen Roberts. London: Routledge & Kegan Paul, 1981. 30–61.

Osgerby, Bill. *Youth Media.* New York: Routledge. 2004.

Oldenburg, Ray. *The Great Good Places.* New York: Paragon, 1989.

Ono, Kent A.. " To Be a Vampire on *Buffy the Vampire Slayer*: Race and ("Other") Socially Marginalizing Positions on Horror TV." *Fantasy Girls.* Ed. Elyce Rae Helford. New York: Rowman and Littlefield, 2000. 163–186.

O'Sullivan, Sue. "Girls Who Kiss Girls and Who Cares?" *The Good, the Bad and the Gorgeous: Popular Culture's Romance with Lesbianism.* Ed. Diane Hamer and Belinda Budge. San Francisco: Pandora, 1994.

Owens, Robert. *Queer Kids: The Challenges and Promise of Gay, Lesbian and Bisexual Youth.* New York: Haworth, 1998.

Peirce, Charles Sanders. *Collected Papers.* Vols 1–8/ Cambridge Mass.: Harvard University Press. 1931–1958.

Peirce, Kate. "Socialization Messages in '*Teen* and *Seventeen* Magazines." *Women and Media: Content, Careers and Criticism.* Ed. Cynthia M. Lont. Belmont, CA: Wadsworth, 1995.

Phelan, Peggy. *Unmarked: The Politics of Performance.* New York: Routledge, 1993.

Pick, Anat. "New Queer Cinema: Spectacle, Race, Utopia." *New Queer Cinema.* Ed. Michele Aaron. New Brunswick: Rutgers UP, 2004. 103–18.

Pick Up the Mic, Dir. Alex Hinton. Planet Janice and Rhino Films. 2005.

Pough, Gwendolyn D. *Check It While I Wreck it: Black Womanhood, Hip-Hop Culture, and the Public Sphere.* Boston: Northeaster University Press, 2004.

Renninger, K. Ann, and Wesley Shumar. *Building Virtual Communities: Learning and Change in Cyberspace.* New York: Cambridge UP, 2002.

Reger, Jo. *Different Wavelengths*. New York: Routledge, 2005.

"Restless." *Buffy The Vampire Slayer*. By Joss Whedon. Dir. Joss Whedon. Episode 4.22, 2000.

Rich, Ruby. "Go Girl: The 1980s Gave Us Some Magnificent Lesbian Films. Why Can't We Get back to Those 'Lezbionic' Days?" *Guardian* 28 May 2004.

Richardson, Laurel. "The Consequences of Poetic Representation: Writing the Other, Rewriting the Self." *Investigating Subjectivity: Research on Lived Experience*. Ed. C. Ellis and M. Flaherty. Newbury Park: Sage, 1992. 125–40.

Righteous Babes. Dir: Parmar, Pratibha, Women Make Movies. 1998.

Roberts, Erica. "Lesbian Looks." *Diva*. September 2004. 25–32.

Robertson, Roland. "Glocalization" Global Modernity. Eds. Mike Featherstone, Scott Lash and Roland Robertson. London: Sage. 23–44.

Rubin, Gayle. "Thinking Sex: Notes for a Radical Theory of the Politics of Sexuality." *Pleasure and Danger: Exploring Female Sexuality*. Ed. Carole S. Vance. Boston: Routledge & Kegan Paul, 1984. 267–319.

Ryan, Janet. "Morning Romp." *On Our Backs*. Oct.-Nov. 2000. 12–15.

Savage, Ann. *They're Playing Our Songs: Women Talk about Feminist Rock Music*. Westport, CT: Praeger, 2003.

Sedgwick, Eve. *Epistemology of the Closet*. Berkeley: University of California Press, 1990.

———. "Queer Performativity: Henry James's *The Art of the Novel*." GLQ 1.2 (1993): 1–16.

"Seeing Red." *Buffy the Vampire Slayer*. By Steven DeKnight. Dir. Michael Gershman. Episode 9.19, 2002.

Sefton-Green, Julian, Ed. *Digital Diversions: Youth Culture in the Age of Multi-media*. UCL Press, 1998.

Sender, Katherine. "Sex Sells: Sex, Class and Taste in Commercial Gay and Lesbian Media." GLQ 9.3 (2003): 331–65.

Shary, Timothy. *Generation Multiplex: The Image of Youth in Contemporary American Cinema*. Austin: U of Austin P, 2003.

Sherman, Yael. "Tracing the Carnival Spirit in Buffy the Vampire Slayer: Feminist Reworkings of the Grotesque." Thirdspace 3/2 (March 2004): 89–107.

Show Me Love. By: Lukas Moodyson. Dir: Lukas Moodyson. Perf: Alexandra Dahlstom and Rebecka Liljeberg. Memfis Films. 1998.

Silverman, Kaja. *The Acoustic Mirror: The Female Voice in Psychoanalysis and Cinema*. Bloomington: Indiana UP, 1988.

Sontag, Susan. *Against Interpretation*. New York: Picador, 2001.

Stacey, Jackie. "Desperately Seeking Difference." *Screen* 28.1 (1987): 48–61.

Stacey, Judith. "Can there be a feminist ethnography? Women's Studies International Forum, 11.1, (1988): 21–27.

Stein, Arlene. "All Dressed Up and No Place to Go? Style Wars and the New Lesbianism." *Out in Culture: Gay, Lesbian and Queer Essays on Popular Culture*. Ed. Corey K. Creekmur. Durham: Duke UP, 1995. 476–83.

Stern, Susannah. "Sexual Selves on the World Wide Web: Adolescent Girls' Home Pages as Sites of Sexual Self-expression." *Sexual Teens, Sexual Media*. Ed. Jane Brown, Jeanne Steele, and Kim Walsh Childers. Mahway, NJ: L. Erlbaum, 2002. 265–286.

Talburt, Susan. "Intelligibility and Narrating Youth." *Youth and Sexualities: Pleasure, Subversion, and Insubordination in and out of Schools*. Ed. Mary Louise Rasmussen. New York: Palgrave Macmillan, 2004. 17–41.

———. "Introduction: Some Contradictions and Possibilities of Thinking Queer." *Thinking Queer: Sexuality, Culture, and Education*. Eds. Susan Talburt and Shirley R. Steinberg. New York: Peter Lang. 2000.3–14.

Tamaribuchi, Shawn. "Chris LaBite: young and hung." *On Our Backs*, June-July 2003. 12–15.

Thiel, Shayla Marie. " 'IM Me': Identity Construction and Gender Negotiation in the World of Adolescent Girls and Instant Messaging." *Girl Wide Web: Girls, the Internet, and the Negotiation of Identity*. Ed. Sharon Mazzarella. New York: Peter Lang, 2005.

Thomsen, Steven, Joseph D. Straubhaar, and Drew M. Bolyard. "Ethnomethodology and the Study of Online Communities: Exploring the Cyberstreets." *Information Research* 4.1 (July 1998). http://informationr.net/ir/4–1/paper50.html. Accessed on Sept. 2003.

Tolman, Deborah. *Dilemmas of Desire: Teenage Girls Talk about Sexuality*. Cambridge, MA: Harvard UP, 2002.

"Triangle." *Buffy the Vampire Slayer*. By Jane Espenson. Dir. Christopher Hibler. Episode 5.11, 2001.

Turkle, Sherry. "Who Am We." *Reading Digital Culture*. Ed. David Trend. Oxford: Blackwell, 2001.

Villarejo, Amy. *Lesbian Rule: Cultural Criticism and the Value of Desire*. Durham: Duke UP, 2003.

Von Hollenben, Jan. "Czech Mates." *DIVA*. April 2005. 11.

Walkerdine, Valerie. *Daddy's Girl: Young Girls and Popular Culture*. Cambridge, MA: Harvard UP, 1997.

Warn, Sarah. "*Buffy* to Show First Lesbian Sex Scene on Network TV." *AfterEllen.com*. April 2003. <http://www.afterellen.com/TV/buffy-sex.html>. Accessed Feb.15, 2005.

Warner, Michael. *The Trouble with Normal: Sex, Politics, and the Ethics of Queer Life*. New York: Free Press, 1999.

Watermelon Woman. By Cheryl Dunye. Dir: Cheryl Dunye. Perf: Cheryl Dunye and Guinevere Turner. Dancing Girl Films, 1996.

Weiss, Andrea. *Vampires and Violets: Lesbians in Film*. New York: Penguin, 1993.

Weston, Kath. *Families We Choose: Lesbians, Gays, Kinship*. New York: Columbia UP, 1997.

White, Patricia. *UnInvited: Classical Hollywood Cinema and Lesbian Representability*. Bloomington: Indiana UP, 1999.

Williams, Linda. "Porn Studies: Proliferating Pornographies On/Scene: An Introduction." *Porn Studies*. Ed. Linda Williams. Durham: Duke University Press. 2004. 1–16.

Willis, Paul. Common Culture. San Francisco: Westview Press, 1990.

Wilson, Angela. " 'The Galaxy is Gay': Examining the Networks of Lesbian Punk Rock Subculture." *Queer Youth Cultures*. Ed. Susan Driver. New York: SUNY Press, (forthcoming).

Wilton, Tamsin, ed. *Immortal Invisible: Lesbians and the Moving Image*. London: Routledge, 1995.

Wolf, Diane. *Feminist Dilemmas in Fieldwork*. Boulder Co: Westview Press. 1996.

Wortham, Jenna. "Queer as Life." *Girlfriends*. April 2005. 26.

Young, D'bi. *Art on Black*. Toronto: Women's Press, 2005.

Zacharek, Stephanie. "Willow, Destroyer of Worlds." *Salon.com*. 22 May 2002. 30 May 2002 <http://www.salon.com/ent/tv/feature/2002/05/22/buffy/index.html>. Accessed February 23, 2005.

INDEX

mediated youth

Sharon R. Mazzarella
General Editor

Vol. 2

Grounded in cultural studies, books in this series will study the cultures, artifacts, and media of children, tweens, teens, and college-aged youth. Whether studying television, popular music, fashion, sports, toys, the Internet, self-publishing, leisure, clubs, school, cultures/activities, film, dance, language, tie-in merchandising, concerts, subcultures, or other forms of popular culture, books in this series go beyond the dominant paradigm of traditional scholarship on the effects of media/culture on youth. Instead, authors endeavor to understand the complex relationship between youth and popular culture. Relevant studies would include, but are not limited to studies of how youth negotiate their way through the maze of corporately-produced mass culture; how they themselves have become cultural producers; how youth create "safe spaces" for themselves within the broader culture; the political economy of youth culture industries; the representational politics inherent in mediated coverage and portrayals of youth; and so on. Books that provide a forum for the "voices" of the young are particularly encouraged. The source of such voices can range from in-depth interviews and other ethnographic studies to textual analyses of cultural artifacts created by youth.

For further information about the series and submitting manuscripts, please contact:

SHARON R. MAZZARELLA
Communication Studies Department
Clemson University
Clemson, SC 29634

To order other books in this series, please contact our Customer Service Department at:

(800) 770-LANG (within the U.S.)
(212) 647-7706 (outside the U.S.)
(212) 647-7707 FAX

Or browse online by series at WWW.PETERLANG.COM